WE WEREN'T
MODERN
ENOUGH

To my mother Irene, whose rise like a Phoenix has filled me with joy, and to my beloved partner Graham, always.

WE WEREN'T MODERN ENOUGH

WOMEN ARTISTS AND THE LIMITS OF GERMAN MODERNISM

Marsha Meskimmon

I.B. TAURIS *PUBLISHERS*
LONDON • NEW YORK

Published in 1999 by I.B.Tauris & Co Ltd
Victoria House, Bloomsbury Square, London WC1B 4DZ
175 Fifth Avenue, New York NY 10010
Website: http://www.ibtauris.com

ISBN 1 86064 283 7 hardback
ISBN 1 86064 284 5 paperback

A full CIP record for this book is available from the British Library
A full CIP record for this book is available from the Library of Congress

Library of Congress catalog card: available

Printed and bound in Great Britain by Creative Print and Design Wales

CONTENTS

ACKNOWLEDGEMENTS

I have received a great deal of help and encouragement with this project from many people and I would like to thank them all. Special thanks go to the museums, galleries and private collectors who have permitted us to illustrate their works in the volume, often for little or no remuneration. Additionally, they have encouraged the project fully and, in a number of cases, supplied valuable information with respect to provenance and title details. Jochen Dingkuhn, Irene Fischer-Nagel, Johann P. Räderscheidt and Frauke Schenk-Slemensek have lent enormous support to this project with information and artworks and I hope that they will feel that I have represented adequately the significant contributions of their mothers to the history of the Weimar period.

A number of archives and resources in Germany were invaluable to this project and thanks are owed to Christine Regn at the Künstlerinnen Archiv in Hamburg and to Marion Beckers at Das Verborgene Museum and the Verein der Berliner Künstlerinnen in Berlin. Hildegard Reinhardt has been generous with her help since I first contacted her nearly ten years ago while working on my doctoral thesis and, finally, I can acknowledge publicly her assistance. A number of friends and colleagues read and commented upon drafts of this volume and their close scrutiny and breadth of vision improved the final piece in many ways; thus I send gratitude to Martin Davies, Effie Delphinius, Paul Jobling, Mark Shutes and Shearer West. To my three diligent and thorough student-readers, Paula Aspinall, Ruth Brown and Christine Rolph, further thanks for their unique perspective.

Staffordshire University provided financial assistance for a study-trip to Germany and for some of the illustrations and copyright and I am very grateful for their help. Finally, I would like to thank my editor at I.B.Tauris, Philippa Brewster, for her helpful criticisms of chapters throughout and for the efficiency with which she has handled the project as a whole. This efficiency was mirrored by that of Gwenäelle Fossard at I.B.Tauris who, with speed and determination, sorted out the final and most difficult picture credits – many thanks!

INTRODUCTION

WOMEN ARTISTS IN THE
WEIMAR REPUBLIC

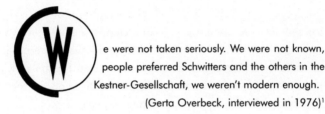

e were not taken seriously. We were not known, people preferred Schwitters and the others in the Kestner-Gesellschaft, we weren't modern enough.
(Gerta Overbeck, interviewed in 1976)[1]

LOOKING BACK on the Hanoverian art scene of the 1920s from the perspective of the 1970s, Gerta Overbeck's assessment was astute. Certainly her artistic affiliation with a small group of realist painters associated with the *neue Sachlichkeit* (sometimes termed New Objectivity), including Grethe Jürgens, Ernst Thoms, Erich Wegner and Hans Mertens, marginalised her from Hanover's flourishing young art scene. This revolved around a few wealthy patrons, the avant-garde exhibitions and events held at the Kestner-Gesellschaft and the circles of Kurt Schwitters and El Lissitzky, who lived for a time in the city. The mainstay of the *modern* art milieu of Hanover was abstraction and the young realist painters from the *Kunstgewerbeschule* (arts and

crafts school) who lived among the proletariat in the city's *Altstadt* ('old town') could not have seemed less fashionable. The art politics of Hanover made the realist painting and the working-class politics of this group seem to exist outside the bounds of modernism. Certainly, political debates surrounding art practices and the construction of 'realism' as a category commonly opposed to 'abstraction' and/or 'expressionism', were typical of wider German modernist criticism. The debates between Ernst Bloch and Georg Lukács were but one well-known manifestation of this tendency.[2]

Significantly, Overbeck was not the only artist working in the period to question the 'modern' appellation: in 1932, the Mexican muralist Diego Rivera reversed the terms of the debate, claiming that radical Russians had rejected abstraction and its proponents as '*not modern enough* to be artists of the proletarian revolution.'[3] Although Overbeck and Rivera argued that the epithet 'modern' belonged to different sides of the 'abstraction/realism' divide within their particular contexts, their use of the self-same terminology is telling. During the inter-war years in Europe and America there was no definitive consensus concerning the 'modern' or 'modernism'; many different factions vied for the privilege to assert their 'modernity' and through this, their cultural dominance.[4] To read the 1920s and 1930s through the sanitised veil of post-Second World War definitions of the modern and modernism is to reduce the complex and multiple discourses and debates of the day into a falsely unified whole. The voices of Overbeck and Rivera remind us that definitions of modernism were in flux throughout this period and that the debates which would homogenise 'modernism' were yet to come.

Overbeck spoke of her own role within modernism with the hindsight of nearly half a century. It was precisely the production of histories of modernity and the modern in the years after the Second World War which forged the limiting and exclusive canonical modernism which made Overbeck marginal. But Overbeck's words are telling: 'We were not taken seriously. We were not known, people preferred...'. Her reminiscences touch upon the active construction of the modernist canon through choices and exclusions made over a period of time. The modernist practices that became mainstream were those which suited the politics and aesthetic theories of dominant patrons, critics and institutions in later years – what these 'people preferred'. By no means does this canon and its theoretical underpinning include all or even most of the diverse work produced during these tumultuous years; indeed, as I argue

throughout this volume, the exclusions frequently say more about the period than the accepted norms.

Overbeck's words are especially revealing in relation to her position as a woman artist in the modern period. Women were an integral part of the social, economic and cultural exchanges characterised as 'modern', yet all too frequently their contributions to modernism as active participants in its debates and definitions have been undervalued if not effaced. Simply, the modernist canon, as it has been constructed, leaves women (and 'woman') outside its frame as 'not modern enough'. Extensive work exists on this marginalisation as well as on the construction of woman/the feminine as 'other' through canonical modernist practices and discourses and there is no need to reiterate this here.[5] Rather, it is a sign of the marginal position of women that, in recent years, so much scholarship has undertaken both to explore 'woman' as other to modernist high culture and to 'find' or reclaim the lost or negated women artists of the modern period.

The earliest feminist work on women artists in modernism necessarily focused upon their exclusion from the masculine-normative paradigms of avant-garde artistic theory and practice and the very different ways women articulated their positions from outside the canon.[6] More recently, however, the polyvocality of the modern period has been emphasised to show that women artists did find a voice within the varied languages of modernism. This work challenges the historical construction of modernism as a unified and singular field.[7] Numerous instances of women's modernist art practices have been used to re-open debates about the cultural history of the period rather than to negate it as a hegemonic and masculine arena neither useful nor interesting to women. Recent work on German modernism argues that women participated actively in modern culture.[8] This is a development from the tacit assumption that women artists were unusual, isolated individuals, best understood with reference to their position vis-à-vis well-known male artists of the day to an acknowledgement that different perspectives are needed to understand women's cultural practices in their own terms.[9]

Quite simply, a *Frauenkultur* existed: women wrote books and articles, edited journals, produced art, mass media imagery and fashion. At the same time, women became doctors, academics and politicians, taking on their most active duties within these spheres in relation to 'women's issues'. Moreover, women became discerning consumers of new products and ideas for and about women as well as forming women-only clubs,

reading-groups, sports associations and, of course, life-long loving part-nerships. Women watched women, spoke to women, read and wrote to women; women worked, women laboured and women found, however tremulous and short-lived, a voice for their own particular positions within the society of their day. This is neither to deny the marginalisation of women within the mainstream institutions of the time nor to overestimate their economic or political power. Had they attained material dominance in the period, we would not be reconstructing this history now. However, women articulated their unique situations in many diverse voices which can neither be overlooked nor explained with reference only to mascu-line-normative histories.

A brief review of the work produced by women in all areas of the arts, in addition to their intellectual, political and socio-economic interven-tions, confirms the fact that women's contribution to the cultural life of the time was important and unique. The *Frauenbewegung* [Women's Movement], for example, was a broad-based socio-political front consisting of diverse women's groups. While the movement as a whole was by no means uniform, these groups gave women a platform from which to voice their ideas and, together with the women who became active in political parties of the period (even holding public office for the first time), they developed so-called 'women's issues' into a major topic of political interest. Similarly, women's increased presence in the labour market, despite the inequities of salary and position which were main-tained between male and female employees throughout the period, gave them greater independence. Women's entry into the professions enabled a variety of hitherto excluded debates about sexuality, maternity and women's legal rights to form a significant part of the Weimar agenda. For women artists particularly, the existence of professional art organisations for women such as the Berlin Women Artists' Union [*Vereinder Berliner Künstlerinnen*, established in 1867] and the GEDOK [*Gemeinschaft Deutscher und Österreichischer Künstlerinnen*, German and Austrian Women Artists' Association, founded in 1927 by Ida Dehmel] were important markers of their status and their determination to have a strong public presence.[10]

While women assumed very different positions on the 'Woman Question', certain marked similarities of approach within their work deserve mention here. Many women politicians and academics writing in this period used other women's scholarship as much as if not more than the work of male authors in their field and there was also a definite

tendency to establish a sense of women's history and legacy. For example, Gertrud Bäumer's *Die Frau im Deutschen Staat* of 1932, cited some 29 women authors in the bibliography and a number of women's journals, yet only four men.[11] Else Wex, nearly as well-known as Bäumer in the period, wrote a history of the ADF (*Allgemeiner Deutscher Frauenverein*) which recounted women's historical contributions to recent German history and asserted the necessity of establishing a national women's library.[12] Significantly, the only analysis of female prostitution of the period in which women themselves were interviewed was produced by a woman sociologist, Elga Kern, and was widely cited by women discussing the topic such as Anna Pappritz and Alice Rühle-Gerstel.[13] Similarly, the study of young female workers produced by Lisbeth Franzen-Hellersberg actually contained detailed information derived from interviewing other women.[14]

These were not isolated trends; there is strong evidence at all levels, from political and academic treatises to popular books and magazines, that women actively sought out the ideas, images and work of other women. Although many women's magazines of the period were established by men, such as the fashionable *Die Dame*, there were many others which were written both by and for women: *Ledige Frauen*, *Die Frau*, *Die Freundin* and *Blätter der Jüdischen Frauenbundes,* to name but a few. Again, without mistaking the iniquitous market economy through which mass culture directed images of woman toward women as consumers, it is clear that women of the period enjoyed reading about and looking at other women. Not surprisingly, women artists were often central to this media blitz, making and consuming the icons of Weimar womanhood. Instead of seeing women as the passive victims of constructions of woman within modernism, such material suggests the need for alternative models of critical praxis, spectatorship and pleasure which can account adequately for the different experience of modernism by women and emphasise their major role in the cultural life of their times. In this volume, a conscious effort has been made to reinstate Weimar's *Frauenkultur* as a significant feature of the context of women's art practice and to emphasise women's cultural agency. Exploring women's art only within the masculine framework of the period by necessity reduces it to 'other' and makes its interventions unintelligible – negating half the story gives false privilege to the remaining narrative.

Anne Middleton Wagner, examining the locations of Georgia O'Keeffe, Lee Krasner and Eva Hesse within constructions of American

modernism, argued with great eloquence that we 'have failed to find the terms in which to see women's art, failed to point to it in ways that make enough cultural or aesthetic sense.'[15] I want to reiterate this point in no uncertain terms in relation to the work of the German modernist women artists considered in this volume. In no way were they 'not modern enough'. To say this entails placing their work into an untenable position through which we either explore their 'failure' to approximate a pre-determined and monolithic definition of the modernist project or argue (from a position of weakness) that they really did 'live up' to this exclusive agenda. Their work exists and was successful in the period. They were professional artists and they examined the crucial debates of their time within their practice. If we cannot 'see' this work, this is the fault of our methods, our paradigms and our theoretical predispositions. We must undertake the project of finding the tools to explore it with sensitivity to its framework and not impose our limits from outside. The methods must suit the practices and not occlude the historical material; for the work of women artists, this requires a subtle model in which material and discourse interact around female subjectivity and the subject of 'woman'.

SUBJECTS AND HISTORIES: SITUATED MAPPING

Walter Benjamin, the Weimar scholar associated with the Frankfurt School, wrote in his 'Thesis on the Philosophy of History':

> The true picture of the past flits by. The past can be seized only as an image which flashes up at the instant when it can be recognized and is never seen again. ... Historical materialism wishes to retain that image of the past which unexpectedly appears to man singled out by history at a moment of danger. The danger affects both the content of the tradition and its receivers. The same threat hangs over both: that of becoming a tool of the ruling classes. In every era the attempt must be made anew to wrest tradition away from a conformism that is about to overpower it. ... [A historical materialist] regards it as his task to brush history against the grain.[16]

Benjamin's comments here are remarkably similar to those made by Wagner; the matter of the past may exist in abundant if fragmentary forms, yet it will not be recognised or 'seen' until our paradigms admit of

it. While Wagner was concerned with the recognition of the work of women artists in modernism specifically, Benjamin cited this phenomenon of recognition as the process of producing histories more generally. To explore the practices of women artists who worked during the Weimar Republic is to brush history against the grain, but the political task of the scholar is to render this material recognisable – to 'see' it and to ensure that others can as well.

The present volume discusses the practice of some two dozen women artists, looking particularly at the work of twenty of these. Most of these artists will be unknown to an English-language audience and even those familiar with the context and the German sources probably will not recognise all of the names. The book, therefore, does represent a 'recovery' of 'lost' women's history and should familiarise its audience with the work of a number of practitioners hitherto excluded from the standard sources on the art of the Weimar Republic. However, all of the artists discussed in this text were independent professional practitioners in the 1920s and 1930s who exhibited work, undertook commissions and earned at least part of their living from their art. They were 'successful' in that sense and their lack of subsequent historical recognition is therefore in no part determined by their 'amateur' status. Hence, this volume explores the structures which marginalized the practices of these women and all those others who participated fully in Weimar cultures; it by necessity asks how these artists were occluded in the historical construction of the German modernist canon.

We have already seen that the construction of histories within pressing political imperatives was one important element in the work of the Frankfurt School and it is also relevant to any project concerned with feminist historical method. Additionally, critiques of rationalisation, urbanism, the role of the intellectual, mass culture, nationalism and race were imperative to the disparate Weimar debates. These manifold debates are recast by considerations of gender difference and the role of women, but they are not lost. Rather, finding and exploring the art of women from the Weimar Republic intervenes in these arguments, shattering the illusion fostered by mainstream narratives that women were but minor players in the story and reminding us how fragile are our own normative exclusions from the historical and cultural sphere.

Significantly, many of Weimar's key debates mobilised both visual and spatial metaphors, particularly those of boundaries, borders and spectacle, and were implicitly or explicitly concerned with gender

difference.[17] Indeed the single most powerful and fiercely-debated visual icon of the period was 'woman'. From the prostitute to the mother and the *neue Frau*, nearly every aspect of the regulation of public and private life was figured in terms of 'woman' and the gendered limits of acceptable and deviant behaviour. It is no mere coincidence that 'woman' was used in constructions of mass culture and urban spectacle in Weimar. Although much of the work done to date on women artists' involvement with modernism has tended to privilege the period before the First World War, I want to argue that the most radical agenda for women was set and, of course, lost in the inter-war years. The Weimar Republic was, as Martin Davies wrote, 'a paradigm of modernity'; that moment first witnessed the full bloom of the urban, technological consumer culture centred upon display, spectacle and mass media with which we are still grappling today.[18] 'Woman' was the cipher for these conditions then and now; women's increasing role in the public sphere led to political action and cultural intervention around issues of gender which remain unresolved.

For contemporary feminist theorists, the features which typified Weimar's *Frauenkultur* are only too familiar: women argued for full partnership in marriage, control over their own bodies, unequivocal rights in the public sphere and modes of performative sexual and gender identity. That many of these interventions were lost during the rise of Fascism and the Second World War meant that they became 'lost' in the subsequent histories of the period. It is against that grain of history, the legacy of just the kind of right-wing totalising narrative which Benjamin and his compatriots abhorred, that scholars of women's history in the Weimar years are now working. And, as Benjamin suggested, the fragments of the past can be 'recognised' only when they resonate with the present. This is why the activity of women artists in Weimar, negotiating their roles in and through the material and symbolic structures of 'woman', is so pertinent to feminist thinkers now.

Contemporary theoretical insights help to explain how women artists in Weimar were made marginal through the very construction of a unified history. But more than just constructions of history have occluded women from the realm of cultural articulation; difference and female subjectivity are themselves rendered theoretically inarticulate by their position as 'other' in western metaphysics and epistemology. We have been unable to hear the different voices of women in history not only because women were materially and historically made marginal but because 'woman'

was structurally denied access to voice. Understanding the lives and works of women artists as the articulation of female subject-positions and thus more than mere 'reflections' of the gendered discourses of their day, asks the feminist art historian/critic to think through difference and subjectivity. A dual strategy is necessary to reconceive the relationship between women's art and Weimar culture – a renegotiation of history and of the female subject.

This volume is centred upon the work of women artists as a deliberate strategy not just to 'reverse' the terms of the debate, but to begin a process of thinking through radical difference. This requires some explanation, since it locates the subsequent chapters within a particular project. To argue that *women* artists are worthy of consideration on their own terms is not just theoretically naive or reactionary. In no way does this volume reassert an antiquated model of transcendent authorship linking the lives of these artists to their artworks in an unmediated expression of their 'real' experiences as women. Nor is there any sense in which women artists are posited as unified through an essential call to their innate or biological status as 'female'; the disparate practices of the artists in this volume refute the assertion of a singular 'feminine aesthetic' based upon biology. To use such vulgar models of female authorship would denigrate the sophistication with which individual subjects have negotiated gender through their lives and practices and would make art into a mere reflection of historical conditions. In this book, it is taken as read that artworks participate actively as a site in the making of cultural meaning and are not simply mirrors held up to reflect, passively, the pre-existent truths of a society.

While much more could be said generally about the inscription of gender difference within language, in the particular instances of women as textual authors and visual artists, a few points are most pertinent. Clearly, emphasising gendered discourse challenges an uncritical relationship between an artist's life and work, the very mechanism through which art history has produced the exclusive canonical narratives of masters and their masterworks. In this way, the decentring of authorship has been useful in formulating histories of art which include for example, women and artists of colour. Furthermore, sophisticated critiques of sexual difference in language have provided powerful tools through which to analyse the ways in which the visual arts actually construct meaning and, again, this has been useful for feminist art historical interventions. However, more totalising forms of textual analysis which all but

completely negate women as authors are more problematic. On the most extreme model, artworks (as 'texts') altogether slip the net of authors, with their confined national, historical and sexed biographies, and signify solely for readers in their own moment.

Many feminist critics have noted that the negation of authorship became a dominant theoretical model at just the historical moment when women and other marginal groups became prominent as authors.[19] Likewise, the theoretical positioning of 'woman' outside the bounds of articulation was used to negate the possibility that women artists and authors might express alternative ideas or concepts, since these were beyond the bounds of articulation itself. Rather, 'the feminine' became merely the principle of linguistic disruption, available for easy appropriation by male authors/artists who had acceded into the realm of the symbolic.[20] In practical terms, the project of seeking in women's historical circumstances and work an alternative position became untenable and the canonical tradition of male artists and masterpieces was instead interrogated yet again for signs of encoded gender difference.

Finding a position between the political assertion of material authorship (the significance of *women* artists) and the acknowledgement that gender difference is produced in and through discourse rather than biology (the significance of *gender* inscribed through artworks), might at first seem to present a paradox. However, I would argue that both strands must be used in tandem lest reductive histories of women's art be revisited. Recent work on female subjectivity by feminist philosophers has tackled this paradoxical situation of woman/women in ways which have crucial repercussions for work on women artists.[21] By exploring radical difference, Rosi Braidotti argued for the reconnection of the materiality of the female subject as a living entity with the discursive structures of 'woman':

> ...one should start politically with the assertion of the need for the presence of real-life women in positions of discursive subjecthood, and theoretically with the recognition of the primacy of the bodily roots of subjectivity, rejecting both the traditional vision of the subject as universal, neutral or gender-free and the binary logic that sustains it. ...One is both born and constructed as a *Woman*/"woman"; the fact of being a woman is neither merely biological nor solely historical, and the polemical edge of the debate should not, in my opinion, go on being polarized in either of these ways.[22]

Thus this project begins with women artists as the 'presence of real-life women in positions of discursive subjecthood' and then explores their active negotiations with 'woman' between material and discourse. In so doing, I am evoking the ideas also of Elizabeth Grosz and Donna Haraway who have reconceived subjectivity as embodied and know-ledges as situated.[23] The subject enshrined by traditional concepts of authorship was a myth which privileged the masculine position as universal and transcendent and *his* modes of knowing as disembodied, objective 'truths'. To assert the female subject as an author, reconceived as embodied and situated, does not just reverse and re-establish the old paradigm, substituting one universal truth claim for another. Embodied subjects acknowledge position and location; the situated knowledges they produce are particular and perspectival. They are no less rigorous for this; in fact multiple, positioned knowledges refute precisely the forms of totalising narrative which render historical, cultural and economic differ-ences unreadable through gross generalisation and over-simplification. Exploring historical meanings from within a framework in which material and discursive practices are never generalised toward an abstract universal position permits us to hear and engage with multiple voices without reducing them to one. Such a conception of the subject and knowledge has crucial implications for women who made and make art. The many individual women artists who negotiated their lived situations as 'women' across a range of disparate, sometimes contradictory, defin-itions of 'woman' did so in multiple and particular ways. Their individual experiences of 'being women' and making art 'as women' were not simply the same, yet they represent a distinct set of sexed perspectives within the cultural sphere of the Weimar Republic.

The dual strands brought together in this work – reconceptions of history and the female subject – operate through a form of multi-layered cartography which also situates me as an active interpreter of the work through my own historical and theoretical location. I do not shirk from this responsibility. I have brought together particular constellations of images, ideas, debates, theories and historical material in order to recon-figure the work of women artists of the Weimar Republic as an important site of meaning both then and now. Crucially, I am seeking to bring them together so that their connections become resonant; I do not wish to enforce one (my/singular) reading, but to open up particular sets of convergences to be 'seen'. Mapping the particular perspectives of women artists into and onto the metaphorical maps of boundaries, margins and

visual languages within Weimar culture reveals new patterns and suggests different correspondences between ideas and issues than might otherwise have been seen or known. The Weimar Republic was characterised by the range and richness of its debates in the cultural sphere; exploring the situation of women within these points to the limits of German modernism as a singular discourse while simultaneously enriching our thinking about the historical moment which was modernity in Germany.

THE CHAPTERS MAPPED

Each of the chapters that follow begins with a deliberate re-centring of the work of women artists in relation to the effaced marker of difference, 'woman'. Each of the five chapters takes as its theme one particular and powerful trope of 'woman' as figured in the writing and visual art of the Weimar Republic. I begin with the prostitute in Chapter One, arguably the single most common trope of woman in European modernism as a whole. Chapter Two moves toward the mother as her opposite in traditional terms. These chapters explore what the traditionally polarised conceptions of woman came to signify within particular modernist debates about female sexuality and maternity. Chapter Three considers the *Hausfrau*, the domestic typology of woman, revised in light of the radical changes occurring through the rationalisation of private life. The *neue Frau*, that visual symbol of the Weimar period, takes the central role in Chapter Four and the final chapter focuses on the threatening character of the transgressive *Garçonne*. These later types were more particular to their moment, yet no less ubiquitous in their representations.

Exploring these specific tropes of woman in the chapters is not meant to reinforce their status as if they were 'accurate' representations of the women of the time or forms of 'true' typological categories. But neither are they straw men, easily undermined and overridden by a knowledge of the 'real' lives of women in the period. Rather, these tropes focus attention on the particular ways in which the 'woman question' was *figured* during the Weimar Republic and they form points of interaction between socio-economic conditions and their symbolic representation. These tropes were debated, portrayed, desired, loathed and reconfigured constantly by women and men from various class, religious, political, intellectual, generational and ethnic positions within Weimar. These were

not simple types, despite their abundant presentation, and their defini-
tions were both formed by and formative of women's changing roles at
the time. Using women's art to explore each of these key tropes acknowl-
edges the agency of women artists in constructing cultural symbols and
their critical placement as female subjects in and between material and
discourse. Moreover, it asserts that women's artwork is a site where
gender identity is negotiated and not just a reflection of pre-existent
social stratification.

Structuring the chapters around these central but constructed forma-
tions of woman sets the tone for the subsequent debates in yet another
sense: there is no 'natural' identity asserted for women in any chapter.
The chapters create a field of charged encounters with identity construc-
tion through difference, otherness and the politics of sexuality as they
worked across the textual and, more significantly, in and through the
visual. Thus differences between the women and their works are not
subsumed under a narrative unity, but made part of a project through
which radical alterity might resonate with history in new and startling
ways. These artists were positioned in relation to the powerful tropes of
woman in ways particular to them as *women* but also in ways which
differed according to, for example, their age, class, ethnicity, sexual pref-
erence and regional aesthetic and political affiliations. Attending to
particular works of art as places where women's ideas and lived identi-
ties cohered and dissolved around contemporary concepts of 'woman'
may render gross generalisations about women's eternal, natural roles
problematic, but that can only enrich the histories of women as active
cultural agents.

This double play of difference in which differences between women
figure as much as their collective difference from 'men' makes each
instance of work shown in this volume a critical renegotiation of history
and female subjectivity between discourse and lived materiality. This is a
particular way of looking at works of art concomitant with the logic of
embodied subjectivity and situated knowledges. That is, women artists
made work which both responded to a pre-existent range of possible
meanings and constituted new possibilities as it joined the polylogue,
reconfiguring its terms. Following the compelling logic of Judith
Butler's work on performative speech acts, I have sought throughout this
volume to attend to the specificities of works of art as constitutive of
meanings and subjects in process.[24] The phenomenological subject is
always already social and political; every subject is not located within the

structures of language and meaning which precede her, and her intersubjective encounters with 'others' constitute the conception of the 'self'. Such
intersubjectivity means that no act of articulation can be an unmediated
'expression' of a 'true', inner self; as Maurice Merleau-Ponty stated
succinctly: '... speech, in the speaker, does not translate ready-made
thought, but accomplishes it.'[25] The particularities of works of art and their
reception within social contexts constitute their meanings as much as any
prior and pure thought or intention on the part of their makers. Hence,
works of art will never enable us to reconstruct the 'real' intentions of the
author, beyond (or *before*) their social mediation, nor would this origin
point be of any use in exploring historically located and embodied subjects.

By reconstructing a set of specific historical and theoretical contexts for
the work of women artists in Weimar, I am not suggesting that I have
exhausted the potential of these works to signify, that I have located their
'true' and single meaning. Instead, the readings of the works which I
open through certain constellations of ideas are meant to be active interventions into the cultural sphere, as significant now in constructing a
different history as they were then in negotiating women's circumstances
as makers of culture. I am here seeking to reconfigure the contexts of
these works in demonstrably different but intellectually rigorous ways,
which permit us to 'see' these works. By privileging women's art and
women's writing in the chapters, I offer an encounter with the mainstream
in which we ask *how* the works mean, rather than just *what* they mean.
To reformulate these works as having but one meaning within the context
of the canon of German modernism, would be to leave those structures
intact and to reduce the works to the status of sidelined minor pieces from
the past, speaking only *in relation to* the masterworks of the tradition.

Some final comments are necessary at this point, since they concern
the implications of producing an extended study of little-known artists
and their works more generally. While this is the only volume to consider
so many women artists from Weimar together, it is not an inclusive survey
of all of the women artists in this period or an attempt to select the
'best' and make a case for them to be included in the current roster of
'great male artists' such as George Grosz or Otto Dix. Indeed, it should
question the very construction of that canon with its untenable value-
judgements, rather than reinforce it. Additionally, many more women
were able and active participants in the visual arts in Weimar than are
here considered and it is left to future research to bring those to wider
attention. A survey volume at this point would, however, serve only to

obscure the differences between women artists yet again through over-general remarks and blank assertions of their connections with one another as 'women' defined as a term of homogeneity. This work is not a survey but a particular theoretical and historical intervention into German modernism and the role of women artists as particular, located female subjects who explored and defined the typologies of 'woman' precisely as a heterogeneous collection of ideas and images. Too often in women's history the broad generalities have been developed at the expense of the particular; 'woman' is discussed at length while 'women' are not explored in their more multiple and sometimes conflicting roles. This book argues for the significance of micro-histories in gender studies which seek to articulate sophisticated patterns of difference and permit marginal subjects a claim to agency. Choosing to focus upon a limited number of works which are examined in some depth and privileging the textual sources written by, and/or directed toward, women produce a forceful archaeology of an alternative viewpoint meant to shift our perception of the landscape of Weimar culture.

Producing the sort of micro-histories which I advocate above entails setting certain limits to the materials under discussion. It is, for example, no 'better' to discuss women artists from Weimar than, for example, women artists from revolutionary Russia. By choosing to explore women's art produced in the context of the Weimar Republic, I am arguing that that period was especially relevant to the debates which typified German modernism and that a particular set of cultural constructs moulded that moment which makes it of great significance for contemporary feminist scholarship, but I am not saying that selecting that period is inherently more worthy than choosing another. I have already explored my motives for placing women's art at the centre of this volume (and what concept of 'authorship' I derive from this), but it is worth explaining briefly how the further selection of these artists and works developed. I selected works from figurative (or 'realist' or 'representational') painters and graphic artists working across the range of fine art, politicised graphics and mass media illustration for this volume for particular reasons. I have, for the most part, excluded sculptors and photographers from this project, not because they were insignificant, but because the aesthetic debates and patterns of practice and patronage centred upon those media were particular to them and to do that work justice would have required far more space than is available in a single volume. I await further work on these areas with interest.[26]

The basic question I sought to explore in this work was how women artists negotiated their subject positions (as 'women' and 'artists') in and through the visual culture of the Weimar Republic, so saturated with typologies of 'woman'. The emphasis upon 'realism' or figurative practice deserves comment since it is often assumed that in modernist contexts figuration was 'outmoded' by abstraction and that this accounts in part for women's exclusion from modernist histories. However, the sheer scale and significance of the visual typologies of 'woman' in Weimar as purveyed through fine art, cinema, the popular revue, mass media, advertising, the new illustrated magazines, fashion, mannequins, scientific journals and 'racial' propaganda make the realist, figurative visual climate of peculiar importance for women engaging with new forms of gender identity in modernity. For women to be both consumers and makers of visual representations of 'woman' is of especial interest to anyone seeking to understand the material and discursive limits of female subjectivity in this period.

Having thus established the basic questions, I found the richness and diversity of the material by women artists startling and it could not be placed neatly within existing frameworks. For instance, women's relationship to avant-garde 'isms' was often problematic and not always a useful way to explore their production. Women artists frequently attended *Kunstgewerbeschulen* [arts and crafts schools] rather than more traditional academies of art and worked at the interstices of fine art and mass culture. That cross-over was crucial to the gender debates of the period since those two areas were the most prolific sources of visual icons of 'woman'. Thus, although women artists working at those borders are significant to this volume, they cannot always be placed within conventional definitions of the movement or tendencies of 'modernism'. Similarly, women's professional connections with dealers, galleries, art organisations, political groups and other artists (sometimes as partners) tend not to follow well-established patterns of male artists' practice and thus cannot be 'seen' within more traditional constructs centred upon male artists as a norm.

In this volume, those differences have not been obscured, nor have the many differences between women artists related to age, class, political affiliation, religious or ethnic identity been subsumed by a narrative unity. The methods of micro-history developed here permit those differences to be seen and the particularities of region and aesthetic identity to be explored as well. These constellations of practices were all located and

coded through gender difference, but in multifaceted and sophisticated ways; these artists all engaged with the constructions of 'woman' yet never reduced it to a monolithic category. Although I include the widest possible range of responses by women artists to 'woman' to indicate the rich diversity in practice and the multiple, yet connected, negotiations they made, these artists and works are necessarily a 'representative' selection, but their practices and situations were various. To choose to explore the diversity of representational art by women artists at this time is to engage in the most critical of practices; it is here that women articulated difference between material and discourse, modernism and mass culture. This remains the site of the most crucial battles for representation in urban culture to this day and, should we choose to make ourselves sensitive to the critical interventions of Weimar's women artists, their past could shatter our present.

NOTES

1 Gerta Overbeck, cited in Ursula Bode, 'Sachlichkeit Lag in der Luft. Zwanziger Jahre: Bilder einer Malprovinz', *Westermann's Monatshefte*, no.8, 1976, pp. 34–41. The original German reads: Wir wurden gar nicht ernstgenommen. Uns kannte keiner, da liefen ja lieber zu Schwitters und den anderen in der Kestner-Gesellschaft, wir waren ja nicht modern genug.(p.36) Italics and translation mine.

2 The arguments between Bloch, Lukács, Brecht, Benjamin and Adorno concerning the political efficacy and relevance of art practices can be found in Ernst Bloch, et.al., *Aesthetics and Politics*, translation editor Ronald Taylor, with an afterword by Fredric Jameson, London, New Left Books, 1977.

3 Diego Rivera. 'The Revolutionary Spirit in Modern Art' (originally published in *Modern Quarterly*, 1932), translated and reprinted in *Art in Theory: An Anthology of Changing Ideas*, edited by Charles Harrison and Paul Wood, Oxford, Blackwell Publishers, 1992, pp. 404–7, p.406. Italics mine.

4 The terms, 'modernity', 'modern' and 'modernism' are used within this volume in their most straightforward senses as a) the period between the late-19th and early-20th centuries in western countries during which time urbanism, technological industrialisation and advanced commodity capitalism became dominant modes, b) those conditions/objects/ideas produced in relation to the conditions of modernity and c) the aesthetics associated with modernity. When I refer to particular constructions of 'modernism' from other moments (such as Greenbergian formalism), I do so explicitly.

5 To investigate the use of 'woman' within modernist discursive practices in the German context, I would point to the outstanding work of Susan Buck-Morss, *The Dialectics of Seeing: Walter Benjamin and the Arcades Project*, Cambridge, MA, MIT Press, 1989; Sabine Hake, 'Girls in Crisis: The Other Side of Diversion', *New German Critique*, no.40, Winter 1987, pp. 147–65; Andreas Huyssen, *After the Great Divide: Modernism, Mass Culture, Postmodernism*, London and New York, Macmillan Press, 1986; and Sigrid Weigel, *Body- and Image-Space: Re-reading Walter Benjamin*, translated by Georgina Paul, London and New York, Routledge, 1997.

6 See Kelly, 'Re-Viewing Modernist Criticism' (1981) in *Art in Theory*, op.cit., pp. 1088-94, and Whitney Chadwick, *Women Artists and the Surrealist Movement*, London, Thames and Hudson, 1985.

7 Two excellent, yet different approaches to the theme of gender and modernism can be found in: Griselda Pollock, 'Inscriptions in the Feminine', in *Inside the Visible: An Elliptical Traverse of 20th Century Art In, Of and From the Feminine*, edited by Catherine de Zegher, Cambridge, MA, MIT Press, 1996, pp.67–87 and Anne Middleton Wagner, *Three Artists (Three Women)*, Berkeley, University of California Press, 1997 who actually discusses the history of feminist critiques of modernism.

8 See the monographs by Maud Lavin, *Cut with the Kitchen Knife: The Weimar Photomontages of Hannah Höch*, New Haven and London, Yale University Press, 1993 and Patrice Petro, *Joyless Streets: Women and Melodramatic Representation in Weimar Germany*, Princeton NJ, Princeton University Press, 1989. Edited volumes include: Katharina Sykora, Annette Dorgerloh, Doris Noell-Rumpeltes, Ada Raev, eds, *Die Neue Frau*, Marburg, Jonas Verlag, 1993; Katharina von Ankum, ed, *Women in the Metropolis: Gender and Modernity in Weimar Culture*, Berkeley, University of California Press, 1997; Marsha Meskimmon and Shearer West, eds,*Visions of the Neue Frau: Women and the Visual Arts in Weimar Germany*, Aldershot, Scolar Press, 1995.

9 The work of early pioneers in the field of Weimar women's studies was absolutely crucial to

the project since they provided the first biographical and bibliographical material needed to do any further work. See especially, Renate Berger, ed., *Und ich sehe nichts, nichts als die Malerei: Autobiographische Texte von Künstlerinnen des 18. – 20.Jahrhunderts*, Frankfurt, Fischer Taschenbuch Verlag, 1987; Ulrike Evers, *Deutsche Künstlerinnen des 20. Jahrhunderts: Malerei – Bildhauerei – Tapisserie*, Hamburg, Ludwig Schulteis, 1983 and Hildegard Reinhardt,'Gerta Overbeck (1898–1977): Eine Westfälische Malerin der Neuen Sachlichkeit in Hannover', *Niederdeutsche Beitrage für Kunstgeschichte*, vol.18, 1979, pp.225–48; 'Jeanne Mammen (1890–1976): Gesellschaftsszenen und Porträt Studien der Zwanziger Jahre', *Niederdeutsche Beitrage für Kunstgeschichte*, vol. XXI, 1982, pp.163–88; Hildegard and Georg Reinhardt with Margarete Jochimsen, *Grethe Jürgens, Gerta Overbeck: Bilder der Zwanziger Jahre*, exhibition catalogue, Bonn, Rheinisches Museum, 1982. In terms of social history, a similar pattern emerges, see: Ute Frevert, *Women in German History: From Bourgeois Emancipation to Sexual Liberation*, translated and reprinted, Oxford, Berg, 1989; *Neue Frauen: die zwanziger Jahre*, edited by Kristine von Soden and Maruta Schmidt, Berlin, Elefanten Press, 1988; *When Biology Became Destiny: Women in Weimar and Nazi Germany*, edited by Renate Bridenthal, Atina Grossmann and Marion Kaplan, NY, Monthly Review Press, 1984. The Berlin publishers Edition Hentrich have produced an especially rich vein of women's history sources and deserve mention.

10 See: *Profession ohne Tradition: 125 Jahre Verein der Berliner Künstlerinnen*, exhibition catalogue, Berlin, Berlinische Galerie, 1992 and Gisela Breitling and Renate Flagmeier, eds, *Das Verborgene Museum I: Dokumentation der Kunst von Frauen in Berliner Öffentlichen Sammlungen* (exhibition catalogue), Berlin, Neue Gesellschaft für Bildende Kunst and Edition Hentrich, 1987. Though not an archive or museum per se, Das Verborgene Museum has archived the information gathered during the production of its exhibitions on women artists and makes this accessible to scholars. Other archives and libraries maintain access to information on women in the period including the Frauenmuseum in Bonn, the Künstlerinnenarchiv in Hamburg (was Nuremberg), the Jeanne-Mammen-Gesellschaft in Berlin and the Feministische Archiv und Dokumentationszentrum Bibliothek in Cologne.

11 Gertrud Bäumer, *Die Frau im Deutschen Staat*, Berlin, Junker und Dünnhaupt Verlag, 1932.

12 Else Wex, *Staatsbürgerliche Arbeit deutscher Frauen 1865-1928*, Berlin, F.A. Herbig Verlagsbuchhandlung, 1929, p.39 cites the women's library.

13 Elga Kern, *Wie Sie dazu Kamen: 35 Lebensfragmente bordellierte Mädchen nach Untersuchungen in badischen Bordellen*, Munich, Verlag von Ernst Reinhardt, 1928; Alice Rühle-Gerstel, *Das Frauenproblem der Gegenwart: Eine Psychologische Bilanz*, Leipzig, Verlag von S. Hirzel, 1932 and Anna Pappritz, *Einführung in das Studium der Prostitutionsfrage*, Leipzig, 1921.

14 Lisbeth Franzen-Hellersberg, *Die Jugendliche Arbeiterin: Ihre Arbeitsweise und Lebensform*, Tübingen, Verlag von J.C.B. Mohr, 1932.

15 Anne Wagner, *Three Artists*, op.cit., p.25

16 Walter Benjamin, 'Thesis on the Philosophy of History' in *Illuminations*, edited and introduced by Hanna Arendt, translated by Henry Zohn, Hammersmith, Fontana, 1992, pp.247–8 nos. v, vi, vii.

17 See Weigel , op.cit. and Helen C. Chapman, *Memory in Perspective: Women Photographers' Encounters with History*, vol. 3 of the series *Nexus: Theory and Practice in Contemporary Women's Photography*, London, Scarlet Press, 1997.

18 Martin Davies, 'Weimar Culture' in *Domesticity and Dissent: The Role of Women Artists in Germany 1918-38*, ex.cat., edited by Marsha Meskimmon, Leicester, Leicestershire Museums, Arts and Records Service, 1992, pp. 9–13.

19 Tania Modleski, *Feminism without Women: Culture and Criticism in a "Postfeminist" Age*, London, Routledge, 1991.

WE WEREN'T MODERN ENOUGH

20 Probably the most notable example of a theorist suggesting that women artists and writers had no access to the feminine was Julia Kristeva. See 'Women's Time' (1979), reprinted in *The Kristeva Reader* edited by Toril Moi, Oxford, Basil Blackwell Ltd, 1986, pp.187–213, pp.206–7.

21 Christine Battersby, *The Phenomenal Woman: Feminist Metaphysics and the Patterns of Identity*, Cambridge, Polity Press, 1998.

22 Rosi Braidotti, *Nomadic Subjects: Embodiment and Sexual Difference in Contemporary Feminist Theory*, New York, Columbia University Press, 1994, p.174, 187.

23 Elizabeth Grosz, *Volatile Bodies: Toward a Corporeal Feminism*, Bloomington, Indiana University Press, 1994 and *Space, Time and Perversion: Essays on the Politics of Bodies*, London and NY, Routledge, 1995; Donna Haraway, *Simians, Cyborgs and Women: The Reinvention of Nature*, London, Free Association Books, 1991.

24 Butler, Judith, *Excitable Speech: A Politics of the Performative*, NY and London, Routledge, 1997, pp. 10–12.

25 Maurice Merleau-Ponty, *The Phenomenology of Perception*, translated by Colin Smith, London, Routledge and Kegan Paul, 1962, p.178.

26 See, for example, the excellent work of Ute Eskildsen on women photographers and that of Erich Ranfft on women sculptors from the period.

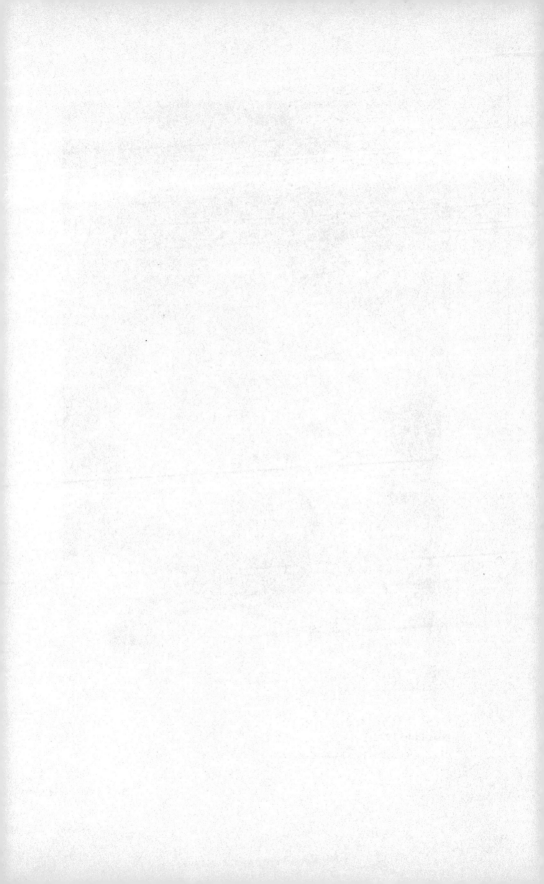

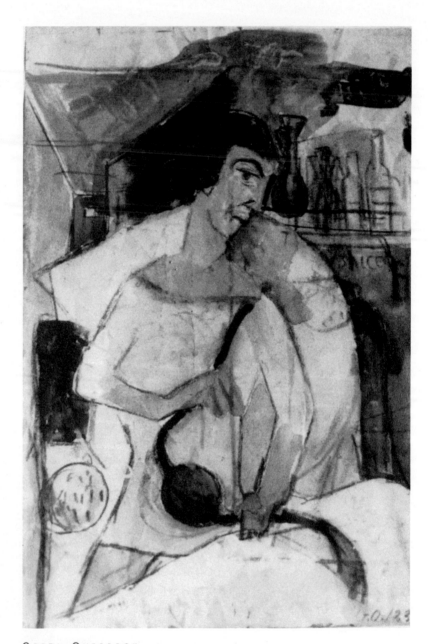

GERTA OVERBECK

Prostitute 1923

Courtesy of Frauke Schenk-Slemensek, Cappenberg

THE
PROSTITUTE

IN 1923, ONE OF THE WORST YEARS OF THE economic crisis which plagued the new Weimar Republic, Gerta Overbeck produced a charcoal sketch of a prostitute. Overbeck's unbearable economic situation as a student had forced her in that same year to leave Hanover and the *Kunstgewerbeschule* and take a job as an art teacher in Dortmund. The nine years Overbeck spent in this region with its heavy industry and radical working-class politics had a lasting effect on her art. Despite this fact her main artistic affiliations remained with a small group of realist painters in Hanover who would later become known as part of the *neue Sachlichkeit*. The change from the mercantile, 'old town' atmosphere of Hanover to the hard, proletarian milieu of the *Ruhrgebiet* was signifi-cant to Overbeck's conception of working-class politics and to her art. During these years, Overbeck's oeuvre developed in the main through the production of small-scale sketches of the workers with whom she lived and the

industrial landscape of the area. These sketches were both a cost-effec-
tive means by which she could carry on her practice and indicative of her
commitment to represent the people and places with which she was most
familiar in a non-elite form. The decidedly direct approach to working-
class subject-matter which Overbeck developed in the Dortmund period
remained a hallmark of her work even after her return to Hanover in
1931.

Overbeck's remarkable *Prostitute* can be understood within the
context of her commitment to working-class themes and the representa-
tion, particularly, of working women. In her sketch, the prostitute is shown
as but one type of woman worker; the setting is a chemist's shop, mid-
day, where she is purchasing a contraceptive douche. It is significant that
the prostitute is not shown in the act of soliciting and that the view of the
woman artist and, by implication, the spectator, is not identical to that of
the client. This viewpoint is unusual; by far the most typical representa-
tional strategy from the period sees the figure of the prostitute as a
dangerous yet desirable commodity on display to the male
artist/viewer/client. Such a viewpoint homogenises the figure of the pros-
titute as 'other' and tends to lose any specificity of space, time or activity.
In Otto Dix's well-known *Three Women on the Street* (1925) for example,
the distorted rendering of the female figures as caricatures of 'flesh' and
allegories of decadence, twisting and pinching their skin or grimacing in
a parody of seduction, distances them from the viewer as 'objects'; they
are like a circus side-show which can be consumed safely by the paying
customer. The call to the viewer in such stereotypical representations of
prostitutes is balanced between frightening seduction, where the viewer is
interpolated as a potential 'client' through the arrangement of the work,
and thrilling *flânerie* in which the viewer is situated as an unseen but all-
seeing voyeur. Both of these viewpoints reiterate the symbolic force of the
prostitute as a trope and belie the possibility of an engagement with the
many different circumstances of female sex workers.

In Overbeck's work, the banality of the daytime shop setting is in stark
contrast to the more usual conventions of placing the prostitute on the
street, in the brothel or the bedroom, to emphasise seduction, decadence
and desire. Overbeck's prostitute is not 'seducing' the viewer and we are
not placed as the empowered consumer, choosing to 'purchase' the
goods. The prostitute of the title is not defined as 'other' through her rela-
tionship to a masculine scheme of looking and desire. We cannot assume
the position of the client or the *flâneur* since our spectatorial situation is

particular and outside the structures which would grant us such distance. We are located with the female figure, we enter into a relation of comparability with this figure through the banal specificity of the representation. We encounter the prostitute as an ordinary working woman buying the tools of her trade, much in the way Overbeck herself encountered the sex workers in her locality. The fact that this image of an ordinary woman is titled 'prostitute' is precisely the point: sex workers were not fantasy-figures or metaphors for debauchery, but working women.

The straightforward representation of contraception is another striking feature of *Prostitute* and one which again differed from the conventions usually associated with modernist representations of prostitution. Unlike the 'allegorical' objects represented in *Three Women on the Street* which enhanced the reading of the prostitutes as symbols of decadence, the introduction of a douche into Overbeck's image reminds the viewer of the realities of prostitution as an occupation and reinserts the daily experiences of sex workers into the frame. Such a reminder of the physical danger of prostitution interrupts any voyeuristic contemplation of the prostitute as a seductive or alluring object displayed for our delectation.[1]

Moreover, contraception was a fiercely debated topic during the Weimar years. Responsibility for contraception amongst the working classes in the Weimar Republic was undertaken almost exclusively by women and without the aid of the medical profession. Although *coitus interruptus* was the most popular form of contraception, the douche was the next most used.[2] Unlike condoms, for which men were responsible, and the diaphragm, which required medical assistance, the douche was a mechanism which women could obtain and use themselves. Furthermore, douches could be modified and used for abortions; they were the basis at the time of a woman-only contraceptive knowledge and practice which subverted the male medical and legal systems. Hence, Overbeck's choice of the douche in *Prostitute* was not random, it represented accurately the most common experience working-class women had of controlling their own fertility. In this way, Overbeck's sober woman-to-woman encounter with the prostitute in the shop marks out the figure's commonalties with other working women and shows aspects of women's sexuality frequently occluded by male artists in the period.

Obviously, *Prostitute* was an unusual and subversive image in the period with its focus upon the work of a prostitute rather than her sexual allure or symbolic potential as a sign of social decay. As we have seen, such a strategy linked the 'outsider' figure of the sex worker to the ordi-

nary experiences of working women and thus both challenged the socially liminal status of prostitutes among women and deflated the hype which surrounded the icon of the prostitute in modernism. Overbeck explored the figure of the prostitute in her work from the position of another working-class woman; the figure is neither an object of scorn nor a commodity on display. That the work is a sketch reinforces the reading of it as a matter-of-fact document of contemporary conditions from a female perspective since it suggests that the mid-day scene of a sex worker buying contraceptives was a viable subject for the young woman artist making visual notes from her surroundings. Such strategies were also deployed by the radical feminist Alice Rühle-Gerstel in her book *Das Frauenproblem der Gegenwart: Eine Psychologische Bilanz* and in the most famous survey of the lives of prostitutes of the period, Elga Kern's *Wie Sie dazu Kamen: 35 Lebensfragmente bordellierte Mädchen nach Untersuchungen in badischen Bordellen*.[3]

In her book, Rühle-Gerstel discussed the situation of prostitutes within the context of women's work and stressed the socio-economic conditions which drove working-class women to prostitution instead of focusing on moral or sexual themes in relation to the topic. Kern's study was cited by Rühle-Gerstel (and many others at the time) and was the only well-known source in which the sex workers were interviewed and permitted to speak for themselves about their experiences of coming into prostitution. The tone of the work distinguishes it from most mainstream literature about prostitution in Weimar which either patronises or vilifies the sex workers as 'other'. Significantly, even sectors of the bourgeois women's movement thought radical in their philanthropic work with prostitutes, such as the JFB (*Jüdischer Frauenbund*, Jewish Women's League), still maintained the difference of the prostitute. In this particular case, the women of the League differentiated themselves not only from 'fallen' women who needed assistance but from the Eastern European Jewish refugees who were being sold into what was then called the 'white slave trade'.[4] To engage with the issue of prostitution was especially difficult for the more conservative factions of the women's movement since it was understood to be a moral, rather than socio-economic, problem. Hence, while still wishing to be part of a 'sisterhood' and help all women, bourgeois women needed to maintain their privileged place within society as 'respectable'.

In Kern's work, the women's stories are ordinary; they come from towns and villages, have more or less strong family and religious ties,

have often been married or had children and, almost invariably, have become prostitutes through economic necessity.[5] Kern stressed their social circumstances and similarities with women who were not prostitutes in order to counter the biological determinism of the day which sought 'genetic' imperatives to explain the 'decadence' of these 'naturally bad' women and to separate them all the more distinctly from 'good' women. For radical female reformers, sociologists and psychologists like Kern and Rühle-Gerstel and, significantly, women artists like Overbeck, such sharp boundaries between 'morally acceptable' women and female sex workers were not tenable.

However, it is the rarity of this theme, both within Overbeck's own *oeuvre* and within the works of women artists of the period more generally, which is most notable. The fact that Overbeck made a *sketch* of a prostitute in a shop both suggested the banality of this encounter and that the image was work-in-progress. The mainstay of Overbeck's public *oeuvre* consisted of paintings produced after 1925, and her early, small-scale drawings from the Dortmund period were not often exhibited in subsequent years. This image of a female sex worker was significant within that early stage of her development, but never became the subject of a full-scale painting after her return to Hanover. This is in keeping with the practices of many women artists in Weimar. While the theme of the female prostitute was ubiquitous in the works of male modernists throughout Europe, women artists rarely represented the subject. On one hand, this is because women were not situated literally as customers of the vast majority of female prostitutes. On the other hand, and more crucially, women were not situated discursively in ways which would make the trope of the prostitute such a powerful symbolic form. The position of the male subject in relation to the prostitute as a sexualised commodity in urban modernity was not shared generally by women in the period and formed the basis of one of the major differences between women's art and that of their male counterparts.

The ubiquity of the female prostitute as a cipher in modern art, literature, social and critical theory attests to an implicit gender bias within modernism itself. The prostitute acted as a symbol, and a highly ambivalent one at that, within a male, heterosexual economy of meaning; the images and descriptions of prostitutes were not about the experiences of women, they signified the fears and desires of the male subject faced with the commodification, urbanisation and alienation of modernity. The prostitute was used as a symbol of sexual freedom, the condition of

commodity capitalism, the terrifying urban masses, the harbinger of social decline and the natural result of female emancipation. Representations of prostitutes in German modernism even began to elide the feared 'prostitute' with the equally troubling figure of the 'New Woman' and the cyborg female mannequin.

Because prostitution was encoded in multiple and sometimes competing discourses at the time, the prostitute was a powerful and seductive metaphor which tended to signify in multiple, rather than singular, ways. The definitive 'good/evil' binary structure of the 'mother/whore' opposition frequently gave way to representations of prostitutes which were internally ambivalent. The prostitute could, simultaneously, be a frightening predator *and* a pathetic victim, a sexually desirable other *and* a disgusting carrier of disease and death, but always she was the 'other'. Still, it is important not to neglect the specificity of debates about prostitution since the symbol was extremely malleable and could signify differently in a range of different contexts.

For example, regional variations in meaning were highly significant within Germany in this period. Although prostitution was sometimes commented upon generally, when the literary, legal, political and sociological studies from the first three decades of the twentieth century are examined, it becomes clear that the debates were usually specific to Berlin and Hamburg. Both of these cities were known for prostitution, but they were thought to indicate different patterns and problems. While Hamburg was the site of the most notorious harbour brothel district, infamously regulated by the police, Berlin was known for the shocking diversity of its prostitution. All tastes (or, at the time, 'perversions') were catered for and the sheer commodification of 'woman' was the city's most noted feature. These strong regional patterns also emerge in the art of the period with artists from Berlin and Hamburg (or those with affiliations therein) being the major producers of representations of prostitution. This was true of both male artists and their female counterparts.

Hence, the prostitute was an important and various symbol, used in many different contexts to imply both the fears and pleasures of boundaries transgressed. The figure of the prostitute crossed socially-inscribed parameters between men and women, social classes, the public and the private spheres and, of course, sexual desire and fear of disease and death. Hence, the near-obsession among male modernists with representing and thus containing, controlling and defining the prostitute had little to do with women who were engaged in prostitution or any of the

women who were experiencing the changes wrought by modernity from their own, female, perspective. Rather, these symbols of woman were about the masculine subject and his attempt to police the crumbling borders of social control.

That is why women *on* the street in their new public roles in the Weimar Republic were so often elided with the woman *of* the street in the discourses of the day. The difficulties of identifying the prostitute as 'other' to the numerous women who were out on the city streets each day in the Weimar years have been noted frequently. [6] All women in public suffered the lewd stares and approaches of men who assumed them to be available merely because they were outside the domestic sphere.[7] Moreover, the burgeoning public careers of women made them liable to accusations of sexual immorality, as in the infamous case of the politician Toni Sender who was slandered as a prostitute. Visually, the well-known work of artists such as George Grosz and Otto Dix consistently elided images of women shopping, having coffee or just walking on the street with highly sexualised depictions of sex workers in an orgy of masculine longing and loathing in the city. All of these instances were attempts to control and define women within a masculine system of meaning as 'good/domestic' or 'evil/public' at a time when these boundaries were rapidly losing meaning.

For women artists, policing boundaries which maintained iniquitous power relations between the sexes was clearly not so necessary. Thus the trope of the prostitute was far less important to women's practice, only figuring frequently in the works of women from Berlin or Hamburg. However, when the trope was used, it became the subject of a large-scale renegotiation of terms. Far from seeking to define a singular and homogeneous symbol of woman through the representation of sex workers, women artists grappled with the numerous issues raised by prostitution and commodified female sexuality in multiple contexts. Women artists turned to the subject of sex workers in ways which countered the heavy-handed symbolism so prevalent in the work of their male counterparts. Just as Overbeck's *Prostitute* challenged the sexual objectification of the imaged prostitute with its sober encounter with a proletarian sex worker, other women artists showed the individuals behind the symbol and pictured prostitution through the representation of encounters between women in public spaces. Moreover, women artists represented lesbian prostitution and the friendships between female sex workers, emphasising the women-only nature of such scenes. Significantly, the prostitutes imaged in these works could be any women

and are not made fantastic ciphers of debauchery. Finally, in terms of the symbolic commodification and mechanisation of women as epitomised by the mannequin-woman, women artists were again able to stand in a different position and critique the trope. In order to understand the critique, it is necessary to explore the conventional strands of representation and the different contexts through which women artists came to these.

MADONNAS AND MAGDALENS

The most typical discursive strategy used to define the prostitute was to place her in opposition to the mother. Not surprisingly, many of the visual representations of prostitutes from the period use the 'mother' as a foil. For example, *The Arrival* (1929) by Otto Lais and *Wretchedness on the Street* (1920) by Franz Maria Jansen both contrast starving proletarian mother-figures with plump, decadent prostitutes to make their messages about the corruption of the city in the Weimar Republic unmistakable. A number of visual features are common to these two prints and are characteristic of the archetypal representation of the prostitute as an evil seductress, determined to destroy the moral fibre of society. First, these works both used highly stylised, expressionistic forms for the rendering of the figures which robbed them of any sense of particularity and emphasised their symbolic, universal qualities as types. This is significant since despite the naturalist and realist tendencies which came to dominate painting and graphics in the period, the subject of the prostitute was frequently pictured through expressionistic distortions of form to make her more fantastic and more emotive. The difference between these distortions and the more 'realistic' portrait images of individual sex workers is very clearly defined, as later works in this section show.

The contrast between the figures of the mothers and the prostitutes are also paradigmatic; the mothers are 'de-sexed' through their visual emaciation and suffering while the prostitutes' sex is emphasised to the point of disgust. In *Wretchedness on the Street*, produced after a trip to Hamburg, the prostitute is shown with full breasts, belly and buttocks and the opening of her vagina is definitively rendered while the mother figure is represented seated (the held infant covering her sex) with breasts shrunken from starvation. The symbolic 'prostitute' is thus the very icon of female sexuality defined in and through its relation to male heterosexuality. The figure of the prostitute in these images, and others like them,

can convey nothing of any particular female sex worker and merely embodies the anonymity of sex for sale. The bodies of the represented prostitutes are fantastic symbols of seduction, exhibitionism and debauchery rather than images of the realities of urban prostitution.

The representation of the figure of the prostitute in works such as *The Arrival* makes her an accomplice to the decay of the social order by figuring her as a willing partner to the men being caricatured. The prostitute figure in this work delights in her allure, parades her decadence and is a participant in her own lurid objectification. The prints of Jansen and Lais were intended to be widely intelligible and it is clear that these female stereotypes responded to a general moral panic concerning the new public roles which women were playing in that they contrasted the debauched woman of the street with the long-suffering woman in the home in obvious ways. Such contrasts create a powerful sense, however false, that exact boundaries exist to define women's status.

Clearly, however, many women were both mothers and prostitutes.[8] Indeed, the boundaries between 'prostitutes' and 'other women' were all but non-existent in the period, particularly among working-class women who could turn occasionally to prostitution in times of financial crisis without risking their social positions as wives, mothers and workers in other areas of the labour market. Moreover, prostitution itself is not always easy to define since 'sexual favours' are sometimes given without literal monetary exchange. In this context, works by women artists which considered prostitutes as individualised working women were particularly powerful counterpoints to prevailing attitudes.[9] Gerta Overbeck's sketch, *Prostitute*, defied the conception of the prostitute as a fantastic 'other' and linked the sex worker, through the viewpoint of the working-class woman artist, to the majority of contemporary working women in setting, activity and experience. Moreover, the representation of the douche signified women's attempts to control their own fertility and thus reminded the viewer just how closely linked the prostitute and the mother could be.

In the late 1920s and early 1930s, the Hamburg-based artist Elsa Haensgen-Dingkuhn made several paintings of the St Pauli district of the city. This district forms the main port area of Hamburg and is known for its bars, clubs and, of course, prostitutes; it was following a trip to the harbour brothels around Hamburg that Otto Dix first began to produce his oil paintings of prostitutes.[10] However, the two most famous streets of the St Pauli district which Haensgen-Dingkuhn represented in her works, the Große Freiheit and the Reeperbahn, were areas of night entertain-

ment in which prostitution formed but one part.[11] This was (and is) in sharp contrast to the smaller side-streets, such as the Davidstraße, into which only those specifically seeking brothels and sexual services may wander unimpeded. Thus the parts of the St Pauli district shown in the work of Haensgen-Dingkuhn were places where a young woman artist could experience clubs, bars and the spectacle of the neon-lit city while seeing dancers, prostitutes, sailors and shopkeepers without danger. This was an encounter with night-life which blurred the boundaries between the participants and did not define the prostitute or the woman artist as an outsider. These works precisely illuminate the difficulty inherent in attempts to define the 'prostitute' as 'other' within the urban milieu and suggest the excitement which young women of the period could experience from the spectacle of the city.

Haensgen-Dingkuhn became a student of painting at the *Kunstgewerbeschule* in Hamburg in 1919 and, in 1922, she married a fellow art student and settled in the city permanently. During the period, Haensgen-Dingkuhn exhibited work in a number of shows locally and further afield, including both the 1929 and 1934 all-women shows *Die Frau von heute* (Woman of Today) organised by the *Verein der Berliner Künstlerinnen* (Union of Berlin Women Artists).[12] The major part of Haensgen-Dingkuhn's *oeuvre* during the Weimar years consisted of representations of families and children, particularly working-class families. Throughout her career, she was known for her 'maternal' sensibility and was heralded as an example of a particularly 'womanly' realist painter. For example, Ludwig Benninghof, writing in 1930 of the artist said: 'So it happens that this woman paints not in spite of, but because she is a mother, because she is a housewife'.[13] Similarly, Rosa Schapire, who wrote about Haensgen-Dingkuhn a year later, used the metaphor of the tree bearing fruit to suggest the 'natural' way in which the artist conceived and produced her artwork.[14] The tendency to associate Haensgen-Dingkuhn with domestic subject-matter and a 'feminine' approach continues to this day.[15]

Only Jochen Dingkuhn, the artist's son, perceptively wrote of her work in retrospect that she clearly demonstrated a strong socially-critical position and that the works were more than mere familial documentary.[16] That was an astute comment upon her social situation as well, since she balanced the demands of being a wife and mother with a full professional career as an artist and understood the new and varied roles which women played in the period. Her works, contrary to the most common

critical response, were not simply family pictures, but rather showed a host of unconventional domestic circumstances and images of women's wide-ranging activities. Haensgen-Dingkuhn represented everything from nurturing fathers with their children to herself as an artist and mother, women in dance halls and on the St Pauli streets. Looking at the St Pauli pictures as part of Haensgen-Dingkuhn's wider *oeuvre*, the challenge these offered to the mother/whore dichotomy itself becomes clear.

The visual approaches taken by the artist to all of her chosen themes were consistent with an adherence to a sober, realist aesthetic akin to the *neue Sachlichkeit*. The women in St Pauli, whether girlfriends of sailors or prostitutes, were rendered as monumental, contemporary and particular in just the way that the figures of mothers in her works were. Moreover, Haensgen-Dingkuhn's 'St Pauli girls' were represented as individualised and ordinary working women rather than as highly stylised images of decadence or seduction, despite the indication that they may be prostitutes. Like Overbeck, Haensgen-Dingkuhn viewed local prostitutes in bars and streets from the position of another woman out in public rather than as a client seeking sexual gratification. But unlike Overbeck, Haensgen-Dingkuhn represented prostitutes in finished paintings on a par with her better-known images of mothers and children. In this way, the artist created the possibility of an exchange between women instead of isolating the 'prostitute' as some form of social degenerate. Rather than opposing the 'mother' and the 'whore' in her works, Haensgen-Dingkuhn treated her female subjects with equanimity and suggested a continuum of female experience in the period. The 'mothers' are given no more pictorial dominance than the women shown on the street in St Pauli, are not depicted as more individual, more significant or more sympathetic figures. Not merely disembodied stereotypes of 'woman' who have meaning only in relation to a masculine subject, Haensgen-Dingkuhn's representations of working-class women, from mothers to sex workers to herself as an artist, are given equal prominence and status as the subjects of her paintings.

For example, *Evening in St Pauli* of 1934 is a night-scene on a street of the district with prostitutes soliciting and sailors looking for entertainment in the background. In the foreground, three main figures engage the viewer; one sailor on the far left of the painting and two women in the centre and on the right. The images of the women take up most of the canvas and are the figures which dominate the scene. Significantly, they are not rendered naked or partially-clad and the viewer has no

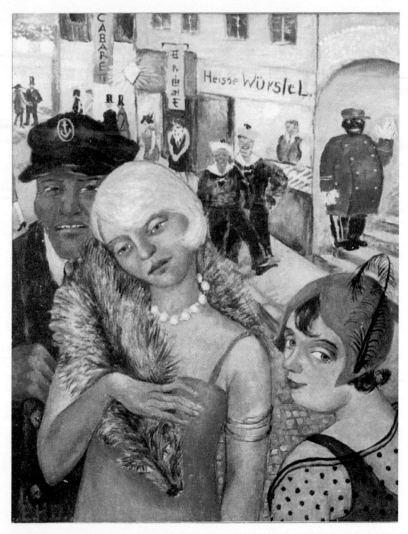

ELSA HAENSGEN-DINGKUHN
Evening in St Pauli 1934
Courtesy of Jochen Dingkuhn, Hamburg

voyeuristic access to their bodies. Moreover, they are not 'soliciting' the spectator. They are represented as 'ordinary' women, not stylised, sexualised fantasies of 'woman'. One female figure is shown with the sailor and appears detached while the second female figure, looking out of the canvas, directly engages the spectator. It is through her, a significant

female figure and not the male 'client', that we gain access to the scene. Such an interchange of looks and positioning within the pictorial space makes it impossible to place yourself as the 'masculine' subject, seduced by these 'others'; rather, the spectator engages, on an equal level, with a woman in the image.

The shift in position is significant: these are some local women out on the street, being seen by a woman artist, not the representation of a sexualised commodity awaiting the consumer. In fact, their relationship to prostitution is highly ambiguous. The location has definitive overtones of prostitution and the sex industry. The conventions of 'the sailor' iconography would also commonly suggest the women in the picture to be 'prostitutes', but this is not visually displayed in any concrete fashion.[17] Their clothing is a bit garish, but not necessarily anything more than clothes for a night out might be. The one figure is certainly with the sailor as a 'girlfriend', but we cannot definitively ascertain whether she has been picked up as any available young local girl might have been or whether there was some financial inducement. The details will not permit us to define simple boundaries between 'good' and 'bad' women or marginalise the prostitute as a fantastic outsider.

In her work of 1929, *Große Freiheit in St Pauli*, Haensgen-Dingkuhn accentuated this mixing and mingling of 'types' and identities on the street at night. This particular street remains famous in St Pauli for its bars, clubs and live-music venues and was an attraction for a wide range of people. In Haensgen-Dingkuhn's work, this variety is heightened; the street swarms with working-class men in flat-caps and wealthier patrons in top-hats and dinner jackets, young, stylish women together or with men in couples, older, matronly women out for an evening and even black figures in inter-racial couples. The pleasure of this urban mix is emphasised with the figures shown smiling, linking arms and looking in the windows and, crucially, female figures are participants in the scene as more than mere objects or sexualised threats to masculine subjects. In this way, *Große Freiheit* is very different from the vast majority of metropolitan pictures produced by male artists in the period, which indicate the alienation of the city and the frightening destruction of legible boundaries between social classes, races and genders. One need merely look at *Metropolis* (1916) by George Grosz to understand the very different atmosphere created by the city street at night in the work by Haensgen-Dingkuhn. Where Grosz and Dix locate the viewer as the threatened, alienated, masculine subject faced with the

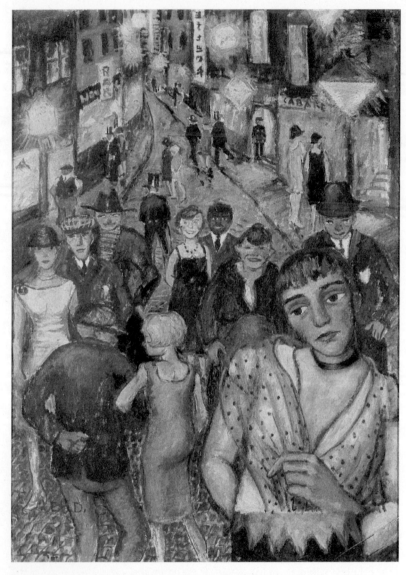

ELSA HAENSGEN-DINGKUHN

Große Freiheit in St Pauli 1929

Courtesy of Jochen Dingkuhn, Hamburg

violence and danger of urban interchange, in the works by Haensgen-Dingkuhn, the viewer is interpolated through pleasurable multiplicity.

Our entry into the scene in *Große Freiheit* is again through our visual relationship with a monumental female figure in the foreground. This

figure is shown alone, sombre and, of all the figures in the work, the most possible to read as a 'prostitute' through clothing, setting and her solitary position on the street. Yet even this figure, represented in a way which suggests a link to prostitution, was not rendered as wholly other to the artist or the viewer. The representation of all of the women in the work emphasises their individuality and ordinariness; they are not out-of-scale, displayed undressed, physically fragmented or shown from positions which permit the viewer visual access to their sex, all of which are common tropes in the unambiguous modernist rendering of the prostitute. Not only do the female figures in Haensgen-Dingkuhn's St Pauli works share the space of the viewer and address the experiences of women in the period in place and activity, they are frequently represented in *tandem*. The emphasis on the shared experiences of the women in the St Pauli district is demonstrated by the representation of the women in the scenes engaging with one another; the women control these spaces and what occurs in them; they are not disembodied markers of difference or sexualised boundaries in the city.

The definition of spaces in which women are neither easily defined by male, heterosexual norms nor disempowered by their separation from other women is significant in relation to the debate about prostitution particular to Hamburg. German laws concerning prostitution in the Weimar years differed slightly from region to region; Hamburg was notorious for its policy of state-maintained, 'legal' brothels and for the fact that prostitution and vice were so localised to one defined region of the city.[18] In this system, women were labelled as prostitutes by the police who kept them to certain houses in certain districts and ensured that they were regularly checked by doctors for venereal disease. Women's groups were particularly outraged by this form of prostitution which, they argued, meant that the police effectively acted as 'pimps' and any woman on the street was possibly subject to accusations of prostitution and official censure.

Such accusations were critical to one of the most heated women's campaigns concerning prostitution in the period.[19] The so-called 'Bremen Morality Scandal', which hit the popular women's press in 1927, inspired fierce debate and action from a wide range of women at the time. The case centred upon the circumstances of one young woman, taken into police custody for suspected soliciting, labelled a 'prostitute' and eventually so mistreated by the legal and medical authorities that she died. The iniquities of this case rested on just the sort of 'legalised brothels' typically found in the region around Hamburg and Bremen. The problem

lay in the procedure by which women could be 'labelled' prostitutes by the police; women did not proclaim themselves prostitutes and willingly submit to the controls of the state, but were found on the street and defined by the authorities. Defining prostitutes rested upon stereotypes (often visual – based on dress, deportment and location) which were no longer viable, if ever they had been. These stereotypes of the 'fantasy prostitute' who could be identified easily as 'other' to the 'virtuous' woman on the street no longer worked and could have disastrous conse-quences for women who transgressed their 'type'.

Haensgen-Dingkuhn's representations of St Pauli are linked to the definition of a 'district' of prostitution, and the fact that she makes women major players in this, and not only as prostitutes, challenged the state-maintained control of women as sex workers or as users of public space more generally. Women walking freely through these districts defied the attempts to locate and fix them within the brothel or the domestic space of the home. Their very ambiguity was politically significant and their potential for self-definition through multiple forms of self-representation was subversive. That prostitutes were ordinary women (represented as equals to the viewer) and that they had significant woman-to-woman relationships contrasted with the symbolic treatment of the 'prostitute' as an isolated (or fragmented) object existent only in and through male desire and control. The matter-of-fact approach to scenes in which women as 'prostitutes', 'new women', wives and mothers shared public space and were represented by women artists, indicates the growing presence and power of women in the public sphere more generally and the failure of attempts to define them from outside.

THE INDIVIDUAL AND THE MASS

Although traditional tropes which opposed the mother and the whore were common during the period, an increasingly ambivalent response to the theme developed in modernist work of the time. Two parallel disjunc-tions in modernist art came into the frame around the ambivalent iconography of the prostitute. The first, as we have begun to explore, was the elision of the woman on the street with the woman of the street and the second was the untenable political response of ostensibly 'radical' male artists faced with female emancipation and the entry of women into the public realm. For example, Otto Dix is well-known for his representa-

tions of prostitutes in the period and he considered the theme in drawings, prints and large-scale paintings. The way in which Dix developed this theme was paradigmatic; using the figure of the prostitute first after travelling to Hamburg, he focused upon brothels and sailors in port. Living in Berlin between 1925 and 1927, his representational strategies changed and the figure of the prostitute became identified with both commodity fetishism and other 'types', such as the lesbian, the transvestite and the neue Frau, thought to be deviant in their gender or sexual orientation.

The early work, Two Victims of Capitalism: Prostitute and Disabled War Veteran (1923) implies that Dix did understand the economic exploitation of sex workers in the financially unstable years of the Weimar Republic and that he could locate this exploitation in a political system, but clearly, it was more lucrative to use the prostitute as a malleable and exciting symbol of decadence. Dix's major works, such as Big City Triptych (1927–8), set the tone for the more common, ambivalent rendering of the figure of the prostitute in the period. In this work, the women who were prostitutes have been transformed into 'woman-as-prostitute'. Ranging from images of battered poor women selling themselves for a pittance to fantastic visions of fetishised femininity presiding over the hellish decadence of the street, the work consistently occluded any sense of the situation of prostitutes as people in favour of the symbol of woman as frightening and desirable 'other'. The figure of 'woman' in this work is simultaneously desirable and revolting; 'she' acts as a symbol of the masculine subject's simultaneous longing and loathing in the face of urban commodity capitalism. 'Woman' is the ideal form through which to project the experience of 'the big city'.[20]

The ambivalence described in these representations signified through associating 'woman' with the 'masses'. As Andreas Huyssen argued, modernist discourse marked both mass culture and the undifferentiated mass as 'woman' or the 'feminine' in an attempt to clarify the role of the masculine, modernist subject as unified and dominant.[21] Mass cultural forms were placed outside the canon of modernism through terminology which feminised them as 'trivial' or 'decorative'. Real intellectual rigour, theory and aesthetic development were cast as 'heroic' or inherently masculine. The concomitant of this was that individual artists and/or intellectuals were differentiated in gendered terms from the anonymous producers of mass culture; the artist-genius of modernism was a man, by definition.[22] In this way, the ubiquitous representations of prostitutes by male modernists (in text and image) are understandable as an indication

of endangered masculinity. The threat which is posed and tamed in these images of symbolic prostitution is the threat of the mass (and of woman) to the masculine subject in modernity.

As Patrice Petro argued in relation to the film produced in the Weimar Republic, these symbolic representations were embedded in the male subject's response to 'woman' rather than being representative of the experiences of women during the period.[23] Encoded in these conceptions of prostitution is a response to the feminised 'mass' more generally. As Walter Benjamin wrote in his essay 'Central Park':

> Prostitution opens up the possibility of a mythical communion with the masses. The rise of the masses is, however, simultaneous with that of mass-production. Prostitution at the same time appears to contain the possibility of surviving in a world in which the objects of our most intimate use have increasingly become mass-produced.[24]

Benjamin's conception of the 'communion with the masses' and the subject faced with mass-produced intimacy infer a masculine subject. That is, Benjamin's language speaks of the encounter with the 'other' in modernity and, if that 'other' is the woman prostitute and a metaphor for the mass, the 'one', the privileged subject, is the male individual who can be her literal or symbolic customer. In this context, the female prostitute in avant-garde art functioned, on the one hand, as a sexual stimulant to the artistic creativity of the male artist, emphasising his virility and power as a force of creative agency. On the other hand, the 'control' of the dangerous territory of the city and the liminal figure of the prostitute were the proof of his ability to 'survive' mass-production and commodification, the things which threatened his privilege most. The ambivalence of the prostitute as a symbol for the male modernist artist stemmed from the sexual enticement he felt, confronted with the spectacle of Weimar's urban nightlife (of which prostitutes were but one feature) and his fear of (creative) impotence in the face of such spectacular display. Moreover, the common association of the male avant-gardist with sites of anti-bour-geois behaviour, such as cafes and brothels, played an important role in obscuring the material conditions of prostitution in a myth of artistic power. The male artist made his mark, literally and figuratively, through the body of the prostitute.

Women's increased presence in the public sphere was not always viewed as a delightfully thrilling encounter with the mass, and frequently

their transgressions of conventional boundaries were met with aggression. For example, in the early years of the Republic there was a marked increase of violence against women; both the rape-murder of women (so-called *Lustmord*) and the battering of working wives by their returning-soldier husbands were viewed as social problems related to new gender roles.[25] As Beth Irwin Lewis suggested, the prevalence in art of the theme of the sex-murder (usually that of the prostitute) portrayed 'domestic violence in its extreme form. . . because of pervasive social anxieties about the role of women'.[26] Lewis also made pertinent connections between this trope and the juxtaposition of the woman *of* the street with the woman *on* the street. The general sexual harassment of women in public spaces in conjunction with domestic violence and the real or symbolic murder of female interlopers who entered the masculine public sphere unaccompanied, provided an effective policing of gendered social boundaries in the period. Significantly, these dangers still face women in our society, and a number of German feminist scholars have pointed to Weimar as a paradigm for the female subject in a modern, Western urban environment. As Anke Gleber wrote:

> The public realities of women's lives still necessitate navigating an obstacle course between their theoretically assured rights and the practical liberties that they can really hope to assume. . . . Within these considerations, the period of Weimar Germany figures as a formative time for both the formulation of a new feminist consciousness and the formidable obstacles that continue to face women in the streets to this day.[27]

As Klaus Theweleit has shown in his pioneering work on masculinities and the returning German soldiers and members of the *Freikorps* at the end of the First World War, such violent acts toward women were made possible by negating the individual women involved in a fantasy of 'woman' as the devouring mass against whom action must be taken.[28] A particular feature of the 'woman-as-devouring-mass' described by the men whom Theweleit used as subjects was their link with the 'whore' or 'hyper-sexual' woman (often countered by a reverence for the 'mother'). These figures were further demonised as physically-deviant types in keeping with the increasing popularity of eugenic theories in the period. Not surprisingly, the threat evinced to masculinity by women in the public sphere was mediated through violence enacted upon the 'prostitute', the symbol of the evil feminine mass often easily identified through recourse

to grotesque visual caricatures. In this way, the prostitute or the whore was elided with any woman who dared take a place in the public sphere; once there, she 'asked for' the leering glances and advances of men. Once there, she 'deserved' what she got.

One of the most disturbing modernist forms which connected the 'prostitute' with any woman in public was the visual dismemberment or fragmentation of the body of the sexually alluring woman. In Otto Dix's *Lustmord* image of 1920, *Self-Portrait as Sex Murderer,* the unified body of the artist is shown surrounded by the fetishised, dismembered body parts of a mutilated woman. As discussed earlier, the *Lustmord* theme was most commonly understood as the rape and murder of a prostitute. The violence done to women in this form was mediated by the status of the woman as other to appropriate forms of femininity. Significantly, however, this same motif of dismemberment appeared in a work by Bruno Voigt, *The Boss: Thoughts of a Man Watching an Attractive Woman in a Cafe* (c. 1930) without the explicit reference to a sex murder. In Voigt's work, the unified male subject in the centre is ensured through his fantasies of dismembering an 'attractive' woman by watching her. These two works are nearly identical in their composition but Voigt's work refers to 'the boss', a powerful establishment figure, and no defined 'prostitute'. Dix's work placed the male artist into the fantasy of the destruction of woman in a violent sexual frenzy. Voigt's work carried out the conceptual dismemberment of woman but linked this more explicitly to commodity capitalism, display and women on the street. The 'boss' enacted his power over women in public through sexual violence of another sort.

As discussed above, the representations of prostitutes by Gerta Overbeck and Elsa Haensgen-Dingkuhn posed alternatives to the simplistic rendering of the 'bad' woman out in public and, indeed, to the 'mother/whore' binary. Moreover, they also conceived of the trope outside the limits of the sexually ambivalent 'other'; their works were much more complicated encounters between the real and imagined structures of the woman on/of the street. By refusing the opportunity to render the figure of the sex worker as a fantasy image, they placed the issue of women's roles in public space onto the agenda and began to fashion visual forms for the female subject in modernity outside the traditional masculine modes.

These images make explicit the different ways in which 'woman' and 'man' were structured in and through the conditions of modernity. Arguably, women did not experience modernity in the same way as men,

literally or figuratively. For example, having had neither a powerful presence in public life, nor a major voice in the discourses which determined the public sphere, women had no status or position to uphold against the feminised 'mass'. Thus, as the works of Haensgen-Dingkuhn suggest, they had fewer investments in maintaining the sharp social boundaries between 'types' of women and between high and low cultural forms. In relation to the trope of the 'prostitute', it is not only that women artists had fewer encounters with prostitutes as 'clients' and more as other working women in public, but that the symbol of the prostitute did not offer the potential of 'mythical communication with the masses' or the experience of a sexualised meeting with the 'other' in the modern city. Women could explore both the individuality of sex workers and the sexuality of other women without recourse to the common masculine forms of the 'prostitute'.

The work Elfriede Lohse-Wächtler made while in Hamburg which centred upon the theme of female prostitutes is a case in point. Lohse-Wächtler's works both heightened the individuality of her female subjects and explored the seamier side of commodified sexuality. By merging these two different approaches, Lohse-Wächtler emphasised the pleasure inherent in displays of female sexuality without losing sight of the women who were her subjects. They were depicted as both enticing and individual; they were neither fantasies of 'woman' nor pathetic victims. In Lissy (1931) for example, the flamboyant and highly individualised representation of the prostitute named in the title is given centre stage, dominant pictorially over the few male customers shown in the background bar setting. Despite the dominance of her form, she is not a fantasy object for the masculine gaze; she is not shown faceless, semi-clad, on display, or in the act of soliciting. The viewpoint we are given is through the active look of 'Lissy' and not through that of any male figures. Reinhold Heller perceptively noted this significant shift in emphasis in the work and wrote of a 'confrontation in equality':

> In her study of Lissy, the frequently elevated or inferior position for the imagined viewer that characterises Dix's or Schlichter's images of women, implying either domination or subordination, is supplanted by direct confrontation. . . . Lohse-Wächtler presents [Lissy] with precision, without commentary except for what is implied in an empathetic confrontation in equality.[29]

This work must be seen in the wider context of Lohse-Wächtler's oeuvre, with its focus on 'outsiders' in Weimar, particularly women outside the

norm. Lohse-Wächtler's artistic and political allegiances in conjunction with her own experiences during the Weimar and Nazi years made her acutely aware of the situation of women defined as 'other' or 'deviant'. Lohse-Wächtler trained and worked until 1925 in Dresden and was part of the left-wing art community in the city which revolved around Otto Dix, Conrad Felixmüller and Otto Griebel.[30] She worked closely with Griebel, who was particularly involved with what came to be known as prole-tarian-revolutionary work which sought forms of positive representation for workers previously excluded from elitist art practices. Despite his 'positive' approach to the theme of the working classes however, Griebel still tended to represent working women as mothers of the proletariat and this strongly contrasted with Lohse-Wächtler's imagery. In her work, women were powerful, but not only within the confines of their roles as wives, mothers and daughters. Dix, of course, provided the strongest contrast, since he was able to make himself a famous and controversial figure by developing the theme of the prostitute extensively in his *oeuvre* whereas Lohse-Wächtler's association with such 'outsider' themes would be her downfall.

Between 1925 and 1931, Lohse-Wächtler worked in Hamburg, where she frequented the bars and clubs of the St Pauli district, painting a number of the women she met there, both prostitutes and not. She also maintained her strong feminist artistic politics through membership of the newly-formed GEDOK (*Gemeinschaft Deutscher und Österreichischer Künstlerinnen*). GEDOK, founded by Ida Dehmel in 1927, was an impor-tant women's art association which explicitly acknowledged that women experienced increased socio-economic difficulties in maintaining a professional art practice and encouraged women's participation in the arts through financial aid as well as exhibition opportunities. A number of politically astute women artists, such as Grethe Jürgens, would be life-long members of the organisation.

In 1929, Lohse-Wächtler suffered her first nervous breakdown and was institutionalised during that year. In 1932 she was institutionalised for a second time, received a final diagnosis as schizophrenic and, in 1935, under Third Reich ordinances, was sterilised. In 1940, Lohse-Wächtler was interred by the Nazis in Pirna-Sonnenstein, gassed and her body burnt. During her periods of incarceration in both mental homes and the camp, Lohse-Wächtler produced series of portrait studies of the other patients/internees. These sensitive studies consistently rendered the indi-viduality of these figures rather than their 'otherness'. During 1930 and

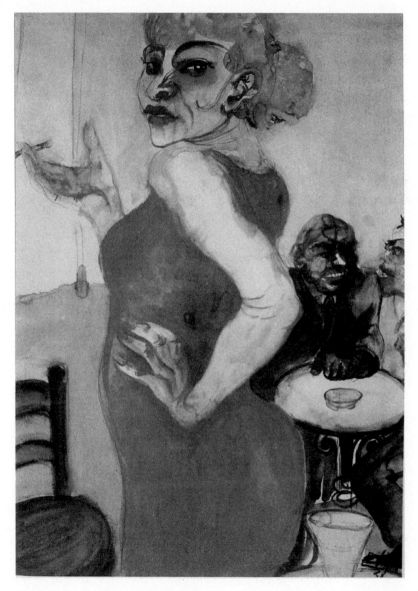

ELFRIEDE LOHSE-WÄCHTLER
Lissy 1931

Courtesy of Marvin and Janet Fishman, Milwaukee, Wisconsin

1931, between two periods of institutionalisation, *Lissy* was painted. In this period, Lohse-Wächtler turned to the subject of prostitutes while living an itinerant life with gypsies. The artist's politics and experiences as an

outsider meant that she was ideally placed to explore the representation of 'unacceptable' women with a sensitivity foreign to her male counter-parts. Not surprisingly, Lohse-Wächtler's *Lissy* does not suffer from the forms of political ambivalence common in the works of mainstream modernists, who both signalled sympathy for particular prostitutes and castigated the 'prostitute', maintaining their distance from this symbol through a myth of masculine creative genius. Lohse-Wächtler's particu-larised rendering of figures conventionally generalised into symbols of the 'other' fostered a communication between the spectator and difference itself. The danger of such a radical strategy for a woman artist was the loss of her own respectability. For Lohse-Wächtler, the communication with liminal social groups had devastating consequences.

Male artists, such as those singled out for attention by Heller, Otto Dix and Rudolf Schlichter, did represent individual, named prostitutes on occasion, but these were used to very different effect. For example, Dix's portrait sketches of prostitutes he knew, such as *Saucy Bertha* (1920), centred upon the tragic decay of their bodies and their pathetic attempt to make themselves desirable commodities for the market with make-up and clothes. Similarly, Schlichter's *Margot* of 1924 is a sympathetic rendering of a poor working-class woman, hardened by the inequities of her profession.[31] Lohse-Wächtler's *Lissy* is not like these. Rather, the sitter for *Lissy* is seen simultaneously as a powerful, seductive image of 'woman' and the named individual represented by the woman artist; the figure is both monumental and particular, 'Lissy' looks out of the picture but not to solicit. The 'equality' of which Heller wrote is a function of the pictorial devices through which the spectator is unable to assume complete mastery over this 'other'. This display of female sexuality is not determined simply by a masculine heterosexual gaze but interpolates the viewer through an 'equality' of looking, an embodied spectatorial posi-tion which suggests interaction rather than domination. The figure is neither rendered as though her sexuality marked her as 'other' to a femi-nine norm nor as the mother of the working-classes (or any other homogenised symbol) interpretable through reference to male institu-tional power. The central figure in *Lissy* conspires to confound any distinct separation between the masculine individual and the feminised mass and its ambiguity is its subversion.

It is worth remembering at this point that women artists also produced images of lesbian brothels (discussed more fully in Chapter 5, 'The Garçonne') which placed woman-to-woman sexual desire centre stage

without occluding the economic exchange of the encounter. These images too reconfigured sexual spectacle through same-sex viewing and suggested alternative pleasures for women in the performance of sexuality in the visual sphere. Significantly, the works of women artists which explored lesbian prostitution did not reproduce the tropes through which the exaggerated figure of the lesbian was elided with that of the prostitute and/or the *neue Frau*. Such common elision of iconography implied that a form of physiological deviance existed in women whose gender or sexual identity did not conform simply to a patriarchal model. By complete contrast, artists such as Jeanne Mammen and Lou Albert-Lasard explored the pleasures to be had by women in performing sexual identity in and through commodified visual forms.

In *Bordello Scene* (c.1926–7) by Lou Albert-Lasard, this form of sexual commodity exchange was represented very directly by an image of two older female figures choosing between young women ('girl' types) who actively displayed themselves as goods. The intergenerational context of the encounter enhances the sense of economic power being at stake, since the older women are well-dressed *bourgeoise* 'shopping' for desirable products. Additionally, the 'customers' are shown seated holding small drinks trays while they make their selection, a scenario not unlike shopping in couture boutiques where the goods are displayed to the wealthy patrons by an endless stream of models on parade. The form of the display enacted inside the brothel (rather than on the street) is also akin to a private 'revue', with the prostitutes conforming to the modern physical type of the 'revue-girl' and taking up theatrical poses in their attempts to entice their female 'audience'. These strands – fashionable female shoppers, 'revue-girls' and the lesbian brothel – are not brought together by accident in the work by Albert-Lasard; in the lesbian underground of Berlin, epitomised by this scene, these connections were definitive.

If Hamburg was singled out for its centre of night-life and prostitution in St Pauli, then Berlin was known in the 1920s for the sheer variety of its underworld.[32] Different districts were known for different forms of entertainment and even the nature of prostitution changed depending upon the section of Berlin you entered. For example, Gotthold Lehnert linked the most common form of female prostitution, the street-walker soliciting 'the little man' (*die Dirne des kleines Mannes*) with the area around the Alexanderplatz in the east of the city.[33] Here too, according to the lesbian press of the day including *Die Freundin*, *Die Garçonne* and *Ledige Frauen*, you could find popular women-only dances and masquerade

balls being held in clubs such as the Alexanderpalast as well as venues for women's poetry readings and discussion groups in the Nikolaiviertel. But, as Katharina Sykora documented, the west end of Berlin, in and around Charlottenberg and Schöneberg, housed clubs like the famous *Eldorado* designed for a wealthier and more stylish lesbian patron.[34] This was in keeping with the atmosphere of the district bisected by the Kurfürstendamm and the Tauentzientstraße with their expensive cafes, department stores, boutiques and large revue theatres.

It was the west end of Berlin which set the scene for the work of Albert-Lasard. Albert-Lasard came to Berlin in 1919 and moved to Paris in 1928. An Alsatian by birth, she had lived and studied art in Switzerland and Munich before the war and had contacts among the expressionist artists of the *Blaue Reiter* group and a very long friendship and collaborative association with the poet Rainer-Maria Rilke.[35] Her Berlin years were marked by the use of a modified expressionist style in paintings and graphic works which centred upon the representation of the night-life and celebrities of the city. In her works representing Berlin's *demi-monde*, Albert-Lasard made deliberate stylistic and thematic links with the 'bohemian' circles of Paris at the turn of the century. She frequented artistic haunts like the Café des Westens and represented the famous *Revue Negre* at the Berlin Zoo which made Josephine Baker a star. She also depicted the well-known dancers Valeska Gert and Rosa Valletti, both in performance and for advertising posters.

In these works, the artist used a painterly and expressionistic style in order to emphasise the activity of her scenes, their exciting, emotive connotations and their 'primitivism' as read through the aesthetics of the day. In many ways, these works signified a romantic vision of bohemian night-life (including a poster which linked Wedding, a working-class district of Berlin, with Montmartre for an evening of song by Valletti in the Café des Westens), but they were a popular and marketable view. For example, in Curt Moreck's well-known guide book for Berlin night-life, *Führer durch das 'lasterhafte' Berlin* from 1931, he reiterated the features of the west of the city which Albert-Lasard had emphasised: the spectacle of fashion and fashionable women shopping, the stylish cafes, clubs and dance-halls and the international flavour of the area, even literally using 'Montmartre' as a signifier for French bohemianism.[36] Albert-Lasard's artwork was popular and sold through a number of the best-known dealers of the city including Alfred Flechtheim and I. B. Neumann. She was commissioned both as an advertising artist and a fine-art printmaker

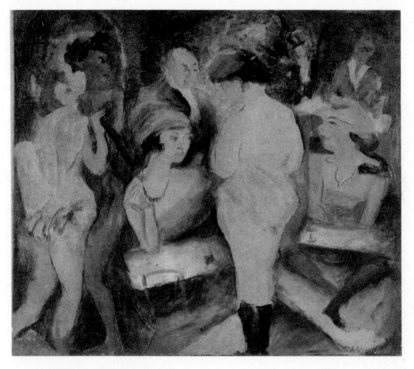

LOU ALBERT-LASARD
Bordello Scene 1926–27
Courtesy of Musée de la Ville de Strasbourg

to produce posters and limited-edition volumes. Significantly, the vast majority of revue theatres, cafes and galleries with which Albert-Lasard was associated were part of the burgeoning west end and, like the work of the artist Jeanne Mammen which will be discussed at greater length in subsequent chapters, Albert-Lasard's representations of women's night-life typified this section of the city's entertainment districts.

Thus it was that *Bordello Scene* played out the fashionable shopping and revue connections in its display of lesbian prostitution. Arguably, the only significant form of female *flânerie* to develop during the Weimar Republic was shopping and this was both part of an exploitative capitalism and a pleasurable liberation of women as participants in public exchange.[37] The revues and films which were extremely popular among women audiences both mimicked the forms of 'window-shopping' and displayed their stars in and through the codes of commercial fashion and

masquerade designed to 'seduce' a female consumer.[38] It is therefore not surprising that Albert-Lasard produced an image of lesbian prostitution within the intelligible codes of female consumerism, including simultaneously the pleasure in the sexual display and the exploitation inherent in such an economic exchange. However contrived the displays of woman-as-commodity for woman-as-consumer might have been, the conjunctions between fashion, mass media, female sexuality and masquerade permitted a new space for women to act as empowered viewers and producers of imagery and identities. In this way, the very scene of a lesbian brothel or the sexualised media icon could challenge the myths of female sexuality as sheer passivity.

CELEBRITIES AND THE PRESS

If the representation of lesbian brothels celebrated female sexuality outside masculine norms, they did so without eschewing the commodification inherent in the activity of prostitution. The contemporary fascination among women in Weimar with dancers and actresses similarly indicates that female consumers could enjoy the display of female sexuality as a commodity in itself and use these pleasurable icons to different ends. Glamorous stars like Asta Nielsen, Marlene Dietrich and Valeska Gert were extremely popular with female audiences, and many women artists, such as Jeanne Mammen, Lotte Jacobi and Liselotte Friedländer, turned to the theme of the 'star' or female celebrity in their work. Women generally became avid readers and consumers of texts and images of other women; popular women's novels and journals (mainly written by women), fashion and lifestyle magazines featuring female stars and 'real-life' stories, and of course movies, dance and sport with women in key roles were all popular with female audiences.[39] In her important work on Hannah Höch, Maud Lavin has described in detail how the recontextualisation of popular images of actresses, dancers and gymnasts in the artist's photomontage created pleasurable viewing strategies for women within the realm of the pictorial commodity-culture itself.[40]

The relationship between stars and prostitution is both literal and figurative; many dancers turned to casual prostitution during the leaner years of the Weimar Republic and figures such as Josephine Baker were cast as overtly sexual and 'primitive' in their publicity. In popular plays and films of the day many of the more famous actresses played prostitutes or

'mistresses'. The forms of 'prostitution' suggested by the films were reso-nant with women's experiences of fashion, shopping and, significantly, in Georg Pabst's *Pandora's Box* (1929), the revue-girl (played by Louise Brooks) as a type. In *Joyless Street* (1925), an earlier film by Pabst in which prostitution was an explicit theme within the plot, the central char-acters, Grete Rumfort (Greta Garbo) and Maria Lechner (Asta Nielsen) faced their first choice about 'prostituting' themselves for food in front of a shop window in which a mannequin displayed glamorous fashions. The metaphor is repeated: later, when Maria is a prostitute, she is displayed as a fashionable mannequin and Grete's proximity to prostitution is signalled by her display (trying on fashionable clothes) in Frau Greifer's shop.

As 'celebrities' too, these stars 'sold' themselves through image to the desirous consumer and their popular representation (for example, in the form of the pin-up) often bore a strong resemblance to the iconography of the prostitute. Generally, the association of a celebrity with prostitution was used by the media to add a form of dangerous titillation to the star's image for a male audience or by contemporary moral or religious commentators to slander a woman assuming too much power, such as occurred in the case of the female member of the *Reichstag*, Toni Sender.[41] For women as artists and consumers of this imagery however, there was little emphasis placed upon the veracity of claims that stars were prostitutes and far more interest in the way that these economically-empowered and highly visible female figures could blur strict boundaries in their social and sexual lives. Indeed, many of the actresses and dancers most beloved by a female audience were not only associated with prostitution but with the lesbian and bisexual underground.[42] The contrast between the masculine mode of representing the 'prostitute' and the more novel explorations of female sexuality by women artists utilising star images is demonstrated graphically in some contemporary Weimar representations of the dancer-turned-actress Anita Berber.

Berber was a young star who had worked her way through Berlin's post-war cabaret scene as a 'naked dancer' (*Nackttanzerin*) to become a controversial film actress. During the 1920s, she was known as much for her outrageous sexual exploits in Berlin's lesbian and gay underground as for her dancing or acting skills and she became a well-known figure in the celebrity press. There were widespread connotations of prostitution associated with cabaret and dance, especially in the early years of the Weimar Republic when dance theatres were banned and the venues were illegal clubs, often with brothels in the back. For revue dancers,

'patronage' from a particular, well-off man (or men) in order to finance elaborate costumes or further careers, was not unheard of.[43] The connection was not simply literal, however. In popular consciousness, the city at night was a dangerous and exciting place in which gambling, drugs and bars were linked with dancers and prostitutes in one breath.[44] It was in this climate that Berber became an icon of liberated female sexuality with both the positive and negative connotations of this inextricably linked to her performances and personal life. She appeared in fashion spreads in *Die Dame* and in lewd caricatures in *Simplicissimus*. Otto Dix would famously paint her portrait in 1925 toward the end of her life (she died through drug and alcohol abuse in 1928 at the age of 29) as, literally, a 'scarlet woman', all body, destroyed by excess. Even recent scholarship repeats this reputation, as for instance in the edited volume of 1988, *Neue Frauen die Zwanziger Jahre: BilderLeseBuch*: 'Anita Berber, the exotic of the night-bars, who between body and cocaine, sought her own ecstasy'.[45]

In 1919, Richard Oswald produced a hygiene film (*Aufklärungsfilm*, literally 'enlightenment film') entitled *Prostitution* (*Die Prostitution*). Already known for his pioneering enlightenment film *Different from the Others*, a sympathetic look at the situation of homosexuals in Weimar made with the help of Magnus Hirschfeld (see Chapter Five), *Prostitution* was meant to further educate the public and change its simplistic attitudes toward prostitutes. As the main star in Oswald's film about prostitution (she had also starred in *Different from the Others*), Berber brought to her rendering of the character of a prostitute the typical attitudes to cabaret dancers, liberated young 'new women' and the popular interest in her own scandalous life. This was, on one hand, good for the film's publicity, but it also retrenched a set of stereotypes about the prostitute which linked her, as explored above, to any emancipated woman on the street in a display of masculine sexual desire.

The advertising poster for *Prostitution* was symptomatic of the ambivalence associated with such forms of emancipated female sexuality. The sympathetic treatment of the 'prostitute' determined by the nature of the film, the media hype surrounding the figure of Berber and the stereotypical representation of prostitutes as 'bad women' were confused in this image. In the poster, the huge figure of the prostitute (Berber) flaunts her seductive power over an assembled group of male figures who leer lasciviously at her. The figure becomes the willing recipient of male attention and desire and our view of her is constructed through this mode of display; we are the potential customers, she is the commodity.

Significantly, the representation was not even a particularised likeness of Berber but instead a stereotype of a 'whore'. In the context of the 'enlightenment film' as an educational tool meant to explore the social problems of the day in sympathetic and informed fashion, such an over-determined image of female debauchery is shocking and merely confirms the common currency of the 'decadent prostitute'. The poster used the most typical iconography associated with the prostitute in order to appeal to the broadest spectrum of the public and attempted to fix the figure of the prostitute firmly outside the acceptable bounds of the 'good' woman.

However, this image also relied upon the popular reputation of its central star, Berber, to be understood. As a 'naked dancer' and actress known in Berlin's lesbian *Eldorado*, she was a complex and threatening icon of liberated female sexuality, needing to be 'tamed' by recourse to old stereotypes determined by male heterosexual models of woman. A satirical cartoon of the period, for example, showed a seated nude image of Berber in her cinematic role with the text 'Enlightenment film – rubbish! The public is going to be enlightened about my form!'[46] Berber, as a sexual 'star' commodity thus exemplified the conflation of the (possibly uncontrollable) public woman with the figure of the (controlled) prostitute. Her power as a famous and sexual woman (in her own terms) in combination with the controversial, liberal attitude of the enlightenment film toward prostitution, were threatening to conventional notions of female sexuality dominated by regulatory heterosexual norms. The popular press and advertising poster thus attempted to reinstate the norm.

A set of lithographs produced by the artist Charlotte Berend-Corinth for the Galerie Gurlitt in the same year, the *Anita Berber Portfolio*, provide a significant point of contrast with these more usual images of the star. [47] In a series of eight prints, Berend-Corinth showed Berber in a number of erotic poses, such as sitting naked and open-legged on a bed, standing in a costume which just revealed her vagina and languidly masturbating in a chair. The link between the star's reputation and liberated female sexuality is played out in the images through a number of theatrical devices including specific references to Berber's dance costumes, her sexually-enticing film roles (in more than one image she was shown in the typical guise of the prostitute) and, significantly, her fashionable publicity images in popular women's journals of the day. Each individual print thus refers to a role performed by Berber – from her named characterisations in dance and film appearances to her publicity photographs and celebrity status as an icon of Berlin's underground. The audience for

C H A R L O T T E B E R E N D - C O R I N T H
Anita Berber Portfolio 1919

Commissioned by the Galerie Gurlitt, Berlin

these prints were fans of the star and thus familiar with the disparate roles and costumes as well as her reputation. The pleasure derived from such a folio of prints depended upon the variety of sexual performances represented; there being eight prints in the series frustrated any attempt to find the 'real' Berber behind the performances and emphasised the multiplicity of female sexuality.

In the *Berber Portfolio*, the sexuality of the actress is not refuted, but neither is it subordinated to the masculine tropes of the prostitute which fragment and generalise the body of woman. There is no single, natural Berber in these prints, nor is there an originary or locatable female sexuality defined through its relationship to male heterosexual norms or with reference to physiological 'deviance'. The multiplicity of the erotic imagery signifies for the woman artist and viewer through its appeal to aspects of unexplored, uncontrolled female sexuality, outside the bounds of masculine heterosexual desire so simply exemplified by Berber's more common publicity. The poses of the star range in the works from outrageous display to self-concerned onanism, from child-like naiveté to womanly seduction. Berend-Corinth's techniques were similarly multiple with some prints undertaken with a crisp, delicate line and others made dark through bold, 'painterly' strokes. The visuals reiterated the exploration of female sexuality and commodified display as performed identities which emphasise the surface rather than pretend to reveal the depths. It is not that a woman artist has here made Berber an asexual figure or refused to explore media images of the dancer which commodified her, it is that the mode of address does not reduce the sexuality of Berber's image to one definable trope. The boundaries between fashion model, nude dancer, controversial star and bisexual celebrity are left ambiguous.

The Galerie Gurlitt was well known during the inter-war years for its trade in expensive print volumes, many of which were erotic, and clearly Anita Berber made a sensational subject for such a volume. The choice of Berend-Corinth as the artist was also significant. Berend-Corinth, who had worked within Berlin's secessionist circles and then with the 'realist' styles of the Weimar Republic, produced three other volumes of prints for the Galerie Gurlitt in these years based on the popular figures of Max Pallenberg (1918), Fritzi Massary (1918) and the dancer Valeska Gert (1919). Each of these volumes used the popular image of the celebrity as the starting point for the limited-edition prints, showing the actors/dancers in well-known roles or poses. Berend-Corinth trained as an academic artist, and her prints are neither like the politicised graphics of an artist such as Lea Grundig (as discussed in the next section of this chapter) nor the fashionable illustration work of Jeanne Mammen for the popular press. The volumes Berend-Corinth produced for the Galerie Gurlitt drew upon the contexts particular to popular culture, but were made as limited-edition art prints, meant to satisfy a consumer accustomed to fine art but aware of the popular construction of stars.

None of her other volumes for Gurlitt were as sexually explicit or as popular as the *Berber Portfolio* and it is a measure of both Berber's sexualised star image and the ability of Berend-Corinth to move between the high art context of the prints and the popular appeal of erotica that these images worked so well. The artist's frequent representation of performers in her work attests to their significance in popular culture of the day and for a female audience particularly. Women's magazines were filled with publicity photos of stars and they became powerful icons of modernity. The female nude, also used frequently by Berend-Corinth in her work, was a mainstay in elite modernist art production. The combination of these two tropes in the *Berber Portfolio* proved a challenge to the distinction between high and low culture as signified through the mute body of woman. Here, a woman considered alternative forms of female sexuality through the unconventional representation of another woman; the sexual economy of the studio and the star system was thus interrupted to permit gender difference to be voiced.

In the *Berber Portfolio* prints, the artist explored the masculine objectification of 'woman' but altered the conventions in ways which allowed the exploration of female sexuality and pleasure on their own terms. The clichés of the 'prostitute' which surrounded the popular conception of the dancer (and her visual representation by male artists at the time) are felt in these works, yet the insistence on her identity as Berber, a woman who performed across a multiplicity of possible roles without ever being collapsed into a 'natural' or essential type, is part of a strategy which mobilised the 'new woman' for the female viewer. It was as a powerful female star with a name that Berber was popular with women in the period and, as an actress masquerading in sexual roles, that she was able to represent aspects of the newly-emergent forms of female identity. Moreover, the fact that her sexuality was *performed* across a range of images, playing with the typology of 'femininity', permitted women multiple identifications with these sexual positions. Finally, the situation of Berber in Berlin's underground scene included her lesbian identity; she was frequently seen with *Freundin* and offered a popularised glimpse of woman-to-woman sexuality to her female fans. As we shall see, such manoeuvres by women as the makers and readers of popular, commodified cultural forms would also defy the association of the prostitute and the mannequin so common in modernist imagery.

WOMEN IN PUBLIC:

CONSUMER AND MANNEQUIN

Both prostitutes and mannequins as manifestations of the masculine subject's response to technological commodity capitalism were over-determined. The prostitute signified the reduction of interpersonal relations to the exchange of commodities for cash, and the mannequin, as 'machine-woman', was the perfect trope for the rationalised human being with her mass-produced, interchangeable body parts. The seductive nature of the prostitute likened her to the commodity fetish, where the subject's desire occludes the material conditions of exchange, while the fetishised femininity of the mannequin, often in fragments, provided a seductive display to sell commodities, both in shop windows and in the mass media. The very display of goods in arcades and shop windows links the sites of prostitution with those of mannequin forms. One could, in the arcades, buy commodities (advertised on or with mannequins) in the lower floors and then purchase the services of prostitutes on the upper floors. The 'beautiful' display mannequin was not only in shop windows but in magazine advertisements of the period which sought to increase desire for commodities through images of 'woman'. In modernist art and film, the mannequin was most frequently represented as a sexually alluring, eroticised 'woman', on display and for sale. Both Andreas Huyssen in his essay on Fritz Lang's Metropolis and Hal Foster, discussing the use of the mannequin-woman by surrealist artists, have made pertinent connections between the development of the machine-woman in modernist art and the experience of technological capitalism by the male subject.[48] The demonic machine-woman, desired and feared, was the ideal 'other' for what Huyssens called the 'ideological imaginary' of the period.[49] And that 'imaginary' was gendered masculine.

It is illuminating to examine briefly the association of the mannequin and the prostitute in the writing and art of the Weimar Republic, since the visual conflation of the two was so common to that masculine 'ideological imaginary'. Comments about prostitution made by Georg Simmel, the social theorist who would later be of great significance to the thinking of the Frankfurt School, are relevant to this trope. The work of the Frankfurt School theorists typifies the orientation of the male subject on the woman question and the conditions of modernity. In 1907, Simmel wrote an essay about prostitution in which he suggested that in interper-

sonal relationships people engage with one another as complete individuals, while in prostitution the impersonal exchange is between the most easily interchangeable body parts of 'woman' and the very mark of all interchangeability, cash:

> In prostitution, the relation of the sexes is reduced to its generic content. . . and all individual differences appear to be of no importance. Therefore, the economic counterpart of this relation is money. . .[50]

Siegfried Kracauer, in 'The Mass Ornament', continued this line with particular reference to Taylorism, that form of technological rationalisation such as the assembly-line and time and motion studies, so commonly deployed in Weimar industry.[51] Kracauer argued that Taylorism had even affected public entertainment forms, which now sought to mimic the rationalised factory for its socially-fragmented mass audience. In discussing the popularity of the Tiller Girls during the period, Kracauer described the forms of these representatives of 'American "distraction factories"' thus:

> . . . no longer individual girls, but indissoluble female units whose movements are mathematical demonstrations. . . . Hereafter, the Tiller Girls can no longer be reassembled as human beings. . . . Arms, thighs and other segments are the smallest components of the composition.[52]

The link between this description, the mannequin form and Simmel's conception of modern prostitution requires no lengthy elaboration. Similarly, in the work of Walter Benjamin, the trope of the prostitute/mannequin is even more directly apparent and, significantly, visual. Take, for example, his comments from *Central Park*:

> The commodity attempts to look itself in the face. It celebrates its becoming human in the whore. . . . In the prostitution of the metropolis the woman herself becomes an article that is mass-produced. . . . In the form which prostitution took in the great cities woman appears not merely as a commodity, but as a mass-produced article. This is indicated in the individual expression in favour of a professional one, such as is brought about by the application of make-up.[53]

The physical form of the prostitute had been changed by the Taylorism and consumerism of the Weimar Republic and the 'technosexual' woman

had been born.[54] It is worth remembering that these changes affected any women who kept abreast of the fashions of the day and not just those defined as 'prostitutes'. Advertisements for make-up in women's magazines of the period most commonly used the mannequin head and shoulders as the idealised image of woman; it was the perfect 'disguise of the individual expression'.[55] As Susan Buck-Morss has argued in this connection: 'Just as the much-admired mannequin has detachable parts, so fashion encourages the fetishistic fragmentation of the living body'.[56] The new mannequin woman was especially suited to fashion and advertising iconography in the pictorial magazines since its very form was determined by technological modes of reproduction and distribution.

The commodification and spectacle colloquially associated with 'woman' in the modern city linked prostitutes with female consumers, fashion and the fetishised mannequin-woman. Kurt Weinhold's work of 1929–30, New Window Display, connected these motifs visually. The work shows a young woman dressing 'mannequins' for a lingerie display in a shop window while a cigar-smoking 'boss' stands watching. Looking in from the outside is the figure of a modern, fashionable 'new woman'. What complicates this representation is the fact that the 'mannequins' are 'women'; they have both armpit and pubic hair. Their display is controlled by a male capitalist while the fashionable young woman looking at the window does not even see them. Instead, she is busy commodifying herself by applying her lipstick.

Significantly, it tends to be the case that the works and writings which made use of this association between the prostitute and the mannequin were produced after 1924, the date associated in Weimar with economic and political stability induced by the introduction of American capital with the Dawes plan and the dominance of the neue Sachlichkeit. This would imply that the economic stability of the period inspired new confidence in rationalisation and urbanism. Indeed, Huyssen has suggested that responses to technology were uniformly positive amongst artists of the neue Sachlichkeit after the initial trepidation elicited in the works of the Expressionists.[57] Such a generalisation needs to be modified in light of the distinct ambivalence of the prostitute/mannequin trope which was common in the works of the neue Sachlichkeit, which suggested both desire for machines and terrible fear of them. Considering the works of women artists makes even more problematic the view that the neue Sachlichkeit and technology had a simple relationship. The very fact that the condition of technological capitalism was figured through the

mannequin and that *she* was elided with that marker of male ambiva-
lence to modernity, the prostitute, indicates that gender difference compli-
cates assertions in regard to style labels. The elision can be seen to indi-
cate the responses of male, heterosexual, middle-class artists and intel-
lectuals in the face of technological, commodity capitalism and these
responses were by no means simply positive.

The work of both Benjamin and Kracauer also responded to this new
social condition; Kracauer was interested in mass entertainment forms
such as revues and the new cinema, and Benjamin wrote about photo-
graphy, the arcades and fashion.[58] Neither writer simply promoted or
castigated these new forms; rather they concerned themselves with
understanding their use and potential. Moreover, both Benjamin and
Kracauer sought to understand their own positions within contemporary
literary forms and the contingencies of the market. Benjamin changed
from the academic form of *The Origin of German Tragedy* (1928) to a
montage style in *One Way Street* (1928), calling this a move toward
'metaphysics in the shop-window'.[59] Much of Kracauer's writing took the
form of reviews for the *Frankfurter Zeitung* during the period from 1927
to 1933 and his own book *Die Angestellten* (*White-Collar Workers*) of
1930 was written in a montage style.[60] These features suggest their
alliance with oppositional and subversive literary ideals, as well as their
awareness of the interrelationship between new technologies and
aesthetics. However, since both Benjamin and Kracauer were intellectu-
ally elite and at least partially supported by institutions of the academic
establishment, their position was markedly ambivalent.

Significantly, the metaphor which Benjamin revived in his work on
Baudelaire to represent this ambivalence was 'the unavoidable necessity
of prostitution for the poet'.[61] As Lloyd Spencer pointed out in his work on
Benjamin, there was a specific link between 'the poet' and the contem-
porary prostitute, one which resonates with the arguments above
concerning the form prostitution took in the big cities in the Weimar
Republic. He wrote: 'she [the prostitute] also embodies the wiles which the
commodity must possess in order to make its way on the open market.'[62]
The poet must not only prostitute himself, but must become a seductive
commodity in order to find success. Succumbing to the contingencies of
consumer capitalism meant relinquishing the social power which male
artists and intellectuals had previously held and abandoning themselves
to what Benjamin described tellingly as 'impotence'.[63] This situation ran
parallel with the experience of left-wing visual artists during the years of

the Weimar Republic in striking ways, though the self-consciousness of Kracauer and Benjamin with regard to their roles was notably absent. As Malcolm Gee pointed out in a paper entitled 'Negotiating the City: Weimar Berlin', the flourishing art market was a feature of city life in the Weimar Republic.[64] Despite economic instability more generally, modern art and its dealers in Weimar were hard-pressed to keep up with the demands of the newly-wealthy industrial patrons eager to purchase the accoutrements of 'culture'. The success of artists such as Dix, Schlichter and Grosz in the period was intimately bound up with this new market. If the metaphor of the prostitute and her shop-window counterpart, the mannequin, was an apt parallel for the experiences of writers and intellectuals in the period, male artists were also implicated by its logic.

Arguably, the obsessive link between the prostitute and the mannequin in the writing and visual art of the period was a function of masculine disavowal. As Huyssen wrote: '. . . it is male vision which puts together and disassembles woman's body, thus denying woman her identity and making her into an object of projection and manipulation.'[65] The fragmented parts of 'women' were fetishised in these representations in the precise sense; their repeated use acted as a form of disavowal for the male subject faced with external threats of emasculation in the face of empowered female consumers and the capitalist system itself. It is the way that the prostitute *becomes* the mannequin, the lack of any critical distance between these two forms of symbolic 'woman', that is notable in these works. The projection of masculine fear and desire requires such an elision; revisiting Weinhold's *New Window Display* in these terms explains the conjunction between the strange living mannequins, the *neue Frau* and the male boss attempting to exert control in the face of woman/technology/capitalism.

By contrast, women artists who considered the theme of the mannequin-woman precisely undermined this form of elision between women on the street and the idealised technosexual forms of woman displayed in magazines, shop windows and on advertising poles. Their works signified through the distance they opened up between these icons of 'woman' and the position of women as makers and consumers of imagery. The pleasure created in these images derived from a knowing look at their falseness, rather than an uncritical absorption by their surface. Particularly artists like Jeanne Mammen and Hannah Höch who worked for the women's magazines in the period used and subverted simultaneously the stereotypical representations of the mannequin-woman. Familiarity

with these new and malleable media gave their work a freshness in rela-
tion to the representation of women and the spectacle of commodification.
Even more obviously, the photographers Ellen Auerbach and Grete Stern
(known professionally as 'Ringl and Pit') actually produced advertisements
in the period which confronted the mannequin image while 'selling' the
commodity. In their advert for *Petrole Hahn* shampoo, for example, they
mixed codes of representation by dressing 'fashionable' mannequins in
old-fashioned grandmothers' clothes.[66]

Ringl and Pit's advertisements signified through the falseness of the
mannequin rather than allowing it to intermingle with, or become, a
representation of a woman. Exploring work such as this questions the
traditional assumption that women were unthinking consumers, easily
convinced by advertisements and images produced for them, or that
female consumers were simply part of the sexualised spectacle of the city.
Moreover, women's concerted effort to maintain a critical distance
between 'woman' types and women manifests their critique of the struc-
ture of modernism itself. They were positioned very differently to, for
example, Benjamin and Kracauer, and thus their response to
consumerism varied from the mainstream modernist tendency.

What is at stake in these debates is the very different relationship of
women to commodity exchange. Both the literal and the figurative rela-
tionships between woman and the market were part of a masculine
economy. Luce Irigaray has written of the commodification of women and
female sexuality in patriarchy in ways which are illuminating in this
context. She wrote: 'In our social order, women are "products" used and
exchanged by men. Their status is that of merchandise, "commodities"'.[67]
Two features of this commodification are the objectification of 'woman' in
a series of external valuations by male standards and the inability of the
commodity to represent itself. As Dorothy Leland has pointed out, Irigaray
tends to argue (after Levi-Strauss) a dubious transhistorical case for the
commodification of women, but if we discuss these features as 'specific
to modern, Western society' they become both more accurate and more
powerful in their critique.[68] Thus one of the difficulties of the prostitute and
mannequin trope is its reiteration of the commodification of 'woman'.
The artists and writers who used this trope assumed certain links to exist
between women and prostitutes and mannequins; male prostitutes were
only rarely represented and male automata were subject to different
treatment.[69] By thus reinforcing assumptions which privilege masculine
subjects as the producers of social exchanges (including that of repre-

sentation and meaning), these representations cannot but be supportive of the status quo.

Significantly, the connection between mannequins and the commodified display of 'woman' in and through the figure of the prostitute underpins the power of the masculine subject only through a veiled dissimilarity of terms. Simply, the mannequin was not actually a commodity but an enticement to the sale of other items. Moreover, the 'purchase' of the prostitute is equally incomplete and impossible; the 'other' cannot be owned, controlled or subsumed to the 'one' through capitalist mechanisms of exchange. The encounter with female sexuality and difference figured through urban modernity as prostitution, spectacle and mass consumption was never 'mastered' by masculine subjects in modernism; the ubiquity of representations of prostitutes and the concomitant elision of the prostitute and the mannequin attest instead to hysterical repetition in the face of threat. These peculiar tropes and the occlusion of their actual dissimilarities served to perform masculinity as stable and central in the face of change. To probe these representations in the light of work by women artists exacerbates the problematics of the tropes and posits new alignments between cities, sexuality and commodification.

Women artists did not engage in the same way as their male counterparts with the theme of the mannequin; representations of mannequins and shop-windows were most commonly used as an informed critique of gendered power relations. As noted above, the representations of 'woman' so common in the art of the period bore little resemblance to the experiences of women working in the Weimar Republic. Neither the 'mother/whore' stereotype nor the conjunction between 'woman' and the feared and desired 'mass' adequately expressed the position of women as public actors in Weimar. Despite the fact that women worked for less pay than men and often in less developed sections of the labour market, the variety of roles which were becoming available to them increased their public visibility and their public voice. The 'woman question' was on the agenda in the Weimar Republic and women spoke to it. Women artists, like other professional women of the period, were part of this increasing visibility and had little of this former 'aura' or status to lose working as they did, most frequently, outside the coopting situation of the high-profile art market. Usually, they were more local in their exhibitions and sales and very rarely had dealers. They were more likely to be connected to the *Kunstgewerbeschule* than the Academy and to radical or feminist art groups than to

bourgeois patrons.[70] The formation of a *Frauenkultur* took place outside the material and metaphorical systems of relations which produced the ambivalent elisions between prostitutes and mannequins described and gave it its strength. Following Irigaray:

> But this situation of oppression is perhaps what can allow women today to elabo-
> rate a 'critique of the political economy', inasmuch as they are in a position
> external to the law of exchange, even though they are included in them as
> 'commodities'. A critique of the political economy that could not, this time,
> dispense with a critique of the discourse in which it is carried out. . .[71]

Such a notion of women's position within the system of exchange explains their ability to elaborate a critique of the mannequin-woman unavailable to their male counterparts and, importantly, a critique in and of the art discourse in which these tropes found their form.

The Dresden-based communist artist Lea Grundig, for example, used the mannequins and commodities of the shop-window display in order to level a stinging criticism of the poverty suffered by the workers under capitalism. In Grundig's *Shop Window* from the series of six 1936 etchings entitled *A Woman's Life*, the mannequins are not represented in such a way as to link them to prostitutes or any other women on display; they are simply clothes racks holding expensive garments. They are not 'feminised' or seductive and they do not act as commodity fetishes, hiding the economic exchange of the market with their wiles. It is clear that the mannequins are not themselves for sale and that they are not 'women' reiterated as commodities. In fact, by complete contrast, the distance between the displayed goods and the working-class women and children shown looking longingly at them could not be greater. The women shown in conjunction with the clothes in this image are not revelling in their own commodification, but suffering in the face of class exploitation which simultaneously creates the desire for the consumer goods and thwarts the ability to have them.

Grundig was a well-known Jewish communist artist who, with her husband Hans, was briefly incarcerated during the early years of the Third Reich for her political affiliations. In no way was she a fashionable artist with rich patrons and dealers supporting her practice; she was a left-wing agitator who used her art as an integral part of her social criticism. Significantly, Grundig's political critique of capitalism was framed both through the representation of women in this series and in many of

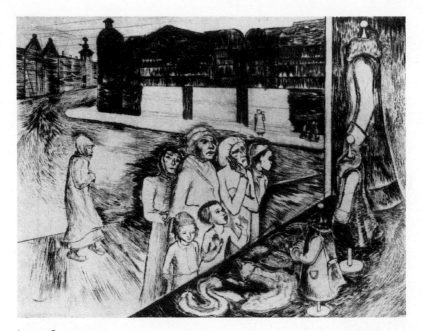

LEA GRUNDIG

Shop Window from the series *A Woman's Life* 1936

Courtesy of the Ladengalerie, Berlin

her images and in the development of a highly political graphic style. Using the techniques of mechanical reproduction as a political form rather than as part of the mass media was an explicit part of much leftist practice in the period, and Grundig exploited this in her work about women's lives. The *Shop Window* thus acted as the inverse of the masculine 'ideological imaginary' which so commonly conflated the woman and the mannequin by reiterating the distinction between the two and showing the material conditions through which women in the period consumed icons of 'woman'. It re-emphasised, in its formal language, its distinct difference from those forms of popular graphic production in which 'woman' was objectified as a commodity in herself.

Gerta Overbeck's *Mother and Child at the Hairdresser's* of 1924 also emphasised the experience of women faced with commodities and the commodified image of 'woman' rather than eliding the two. However, in this image the desirability of the mannequin-woman as a seductive icon is not simply erased as it is in the work by Grundig. Rather, Overbeck explored the pleasure of the stylish *Frisieurpuppen* (hairdresser's

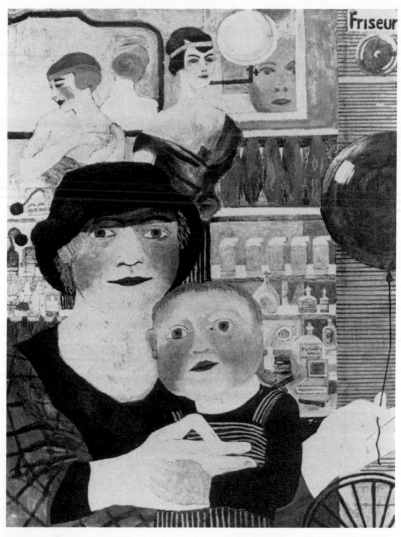

GERTA OVERBECK

Mother and Child at the Hairdresser's 1924

Courtesy of Frauke Schenk-Slemensek, Cappenberg

mannequin) while maintaining the material experience of women as the critical viewing position. The image is structured with a very clear fore- and background; the foreground is taken up with the representation of a mother and child who directly engage the viewer with their gaze and in the background a mannequin and a made-up, modish mannequin-

woman are displayed behind the counter. The mother and child repre-
sented at the front of the work are nothing like the representations of the
head-and-shoulders mannequins displaying goods at the back.

As in the work by Grundig, the difference between the 'real' woman
and the fashionable female icons of the day is visually encoded and
subverts the masculine elision of the two. However, Overbeck also
rendered the mannequin and the display as pleasurable; pleasurable
precisely for the female consumer, the 'mother' at the hairdresser's. Thus
it is not simply a case of playing the 'good' mother in opposition to the
'evil' mannequin; the 'mother' is also a consumer of the image and
coopted by it. The engagement of the spectator through the look of the
'mother' similarly locates us as consumers caught between critical
distance and pleasurable desire. The salon is an interesting setting for
this encounter between the 'ordinary' woman and the fashionable icon
of 'woman' since it is within such spaces that the most radical disjunction
between desire and fulfilment comes into play as 'actual' bodies are
moulded into (always) imperfect approximations of images. Yet the
dialectic of desire between the 'real' and 'fantasy' bodies does not simply
disappear by revealing their disjunction.

The choice of the hairdresser and beauty salon had further reso-
nances in the Weimar period with both the neue Frau and the demi-
monde; many of the young women who became prostitutes in the big
cities of Weimar came from the ranks of displaced domestic servants and
the new service sector typified by stenographers, shop-girls and hair-
dressers.[72] Indeed, as Sabine Hake argued, the very fashions and make-
up associated with prostitutes and night-life in the pre-war period
became the standard of the new young urban woman's daily attire in the
Weimar Republic, as epitomised by saleswomen and those in the beauty
industry.[73] This lends a critical context to the comments of Benjamin on
make-up and mannequins as well as to the conjunction of the 'mother
and child' with the 'hairdresser' in Overbeck's work. Whilst the 'women'
represented by Overbeck do not simply become mannequins, they also
resist the absolute distinction offered by the 'mother/whore' dichotomy;
all women were involved in the increasing spectacle of woman in the
period through fashion and commercial display and sharp boundaries
became fascinating transgressions with the potential to change women's
roles in the future.

Hence, we have come full circle from Overbeck's sketch of the pros-
titute to her image of the mannequin by way of mass media and plea-

surable consumerism. While the iconic forms of commodified female display so prominent in the visual language of modernism and their concomitant coding of sexual difference were produced in the main by men, they were consumed by women as well. There was present for women both a critical distance from the visual types and an engagement with their pleasures. Hence, women's very different placement materially and discursively with respect to these tropes permitted them a critique of the formations of 'woman' in the period and the masculine biases of mainstream modernism itself. The very ambiguity surrounding their representations of 'prostitutes' is an effective technique in its dismantling of the marginality of sex workers as mere symbols of decadence, commodity capitalism and the uncontrollable mass. While the trope of the prostitute was not common in the works of women in Weimar, when it was present it represented one of the most concise challenges to the traditional rendering of the modernist subject as inherently masculine.

NOTES

1 Paul Jobling, 'Playing Safe: The Politics of Pleasure and Gender in the Promotion of Condoms in Britain, 1970–1982', *Journal of Design History*, vol. 10, no. 1, 1997, pp. 53–70.

2 Cornelie Usborne, *The Politics of the Body in Weimar Germany: Women's Reproductive Rights and Duties* (New York and London, Macmillan Press, 1992), p. 27. Usborne also included in an appendix the details of the laws concerning abortion and contraception throughout the period.

3 Alice Rühle-Gerstel, *Das Frauenproblem der Gegenwart: Eine Psychologische Bilanz* (Leipzig, Verlag von S. Hirzel, 1932) and Elga Kern, *Wie Sie dazu Kamen: 35 Lebensfragmente bordellierte Mädchen nach Untersuchungen in badischen Bordellen* (Munich, Verlag von Ernst Reinhardt, 1928).

4 Marion Kaplan, 'Sisterhood under Siege: Feminism and Anti-Feminism in Germany 1904–1938' in *When Biology Became Destiny: Women in Weimar and Nazi Germany*, edited by Renate Bridenthal, Atina Grossmann and Marion Kaplan (New York, Monthly Review Press, 1984), p. 179.

5 See, for example, the case study of Polina Taczewska in Kern, ibid. , pp. 67–70.

6 The confusion between 'prostitutes' and 'new women' is mentioned frequently in recent studies. See, for example, Anke Gleber, 'Female Flanerie and *The Symphony of the City*' in *Women in the Metropolis: Gender and Modernity in Weimar Culture*, edited by Katharina von Ankum (Berkeley, University of California Press, 1997), p. 76; Annelie Lütgens, 'The Conspiracy of Women: Images of City Life in the Work of Jeanne Mammen' in *Women in the Metropolis*, p. 93; Katharina von Ankum, 'Gendered Urban Spaces in Irmgard Keun's *Das kunstseidene Mädchen*', in *Women in the Metropolis*, pp. 162–84, p. 162. An earlier source, not exclusive to the German context, is Elizabeth Wilson, *The Sphinx in the City: Urban Life, The Control of Disorder and Women* (Berkeley, University of California Press, 1991).

7 Gleber, ibid. , pp. 81, 83.

8 Elga Kern documented both wives and mothers as prostitutes in her study (op. cit.); Willi Pröger referred to mothers who prostituted themselves in 'Sites of Berlin Prostitution' (1930) translated and reprinted in *The Weimar Republic Sourcebook*, edited by Martin Jay, Anton Kaes and Edward Dimendberg (Berkeley, University of California Press, 1994), p. 736; and see von Ankum for literary references, op. cit. , p. 166.

9 See Margo Klages-Stange, 'Prostitution' (first published in *Die Weltbühne*, 13 April 1926) where she makes crucial links between low-paid women's work and instances of prostitution. Translated and reprinted in *The Weimar Republic Sourcebook*, op. cit, pp. 728–9.

10 *Otto Dix, 1891–1969*, exhibition catalogue (London, Tate Gallery, 1992), p. 110.

11 Travel information from the German National Tourist Board still refers to this district's reputation as the home of the sex industry in the city.

12 *Elsa Haensgen-Dingkuhn: Arbeiten aus den Jahren 1920–1980*, exhibition catalogue (Hamburg, Kunsthaus, 1981), pp. 7, 65.

13 Ludwig Benninghoff, 'Elsa Haensgen-Dingkuhn', *Der Kreis: Zeitschrift für Kunstlerische Kultur*, vol. 7, no. 6, June 1930, pp. 336–40 reprinted in *Elsa Haensgen-Dingkuhn*, op. cit. , pp. 67–8. Translation the author's.

14 Rosa Schapire, 'Elsa Haensgen-Dingkuhn', *Frau und Gegenwart*, vol. 11, 1930–31, pp. 290–1, reprinted in *Elsa Haensgen-Dingkuhn*, op. cit. , pp. 69–70.

15 See, for example, the most recent exhibition catalogue *Elsa Haensgen-Dingkuhn (1898–1991): Kinder und Heranwachsende im Zentrum eines Malerischen Lebenswerks* (Hamburg, Galerie im Elysee, 1998).

16 Jochen Dingkuhn, 'E. H. D. ' in *Elsa Haensgen-Dingkuhn*, op. cit. , pp. 9–11.

17 Brigid S. Barton, *Otto Dix and Die Neue Sachlichkeit: 1918–1925* (Ann Arbor, MI, University of Michigan Press, 1981), pp. 36–7.

18 Gotthold Lenhert actually names St Pauli and Hamburg's Altona district in *Sexual-Katastrophen: Bilder aus dem modernen Geschlechts- und Eheleben*, edited by Dr Ludwig Leun-Lenz (Leipzig, A. H. Banne, 1926), pp. 239–44 (Das Bordell section).

19 Elizabeth Meyer-Renschausen, 'The Bremen Morality Scandal' in *When Biology Became Destiny*, op. cit. , pp. 87–108.

20 Dorothy Rowe, 'Desiring Berlin: Gender and Modernity in Weimar Germany' in *Visions of the Neue Frau: Women and the Visual Arts in Weimar Germany*, edited by Marsha Meskimmon and Shearer West (Aldershot, Scolar Press, 1995), pp. 143–64 and Patrice Petro, *Joyless Streets: Women and Melodramatic Representation in Weimar Germany* (Princeton NJ, Princeton University Press, 1989).

21 Andreas Huyssen, 'Mass Culture as Woman: Modernism's Other', in *After the Great Divide: Modernism, Mass Culture, Postmodernism* (London and New York, Macmillan Press, 1986), pp. 44–62.

22 Christine Battersby, *Gender and Genius: Towards a Feminist Aesthetics* (London, The Women's Press, 1989).

23 Petro, op. cit. , pp. 33–4.

24 Walter Benjamin, 'Central Park' (1938), translated by Lloyd Spencer in *New German Critique*, no. 34, Winter 1985, pp. 32–58, section 17, p. 40.

25 Beth Irwin Lewis, '*Lustmord*: Inside the Windows of the Metropolis' in *Berlin: Culture and Metropolis*, edited by Charles Haxthausen and Heidrun Suhr (Minneapolis and Oxford, University of Minnesota Press, 1990), pp. 111–40.

26 Ibid.

27 Gleber, op. cit. , p. 75.

28 Klaus Theweleit, *Male Fantasies*, volume I: *Women, Floods, Bodies, History* (Minneapolis, University of Minnesota Press, 1987). Theweleit details in the section 'Attacks on Women' these attitudes and their violent aftermath, pp. 171–82.

29 Reinhold Heller, *Art in Germany: 1909–1936: From Expressionism to Resistance. The Marvin and Janet Fishman Collection* (Munich, Prestel Verlag, 1990), p. 198.

30 Hildegard Reinhardt, 'Elfriede Lohse-Wächtler (1899–1940)' in *Paula Lauenstein, Elfriede Lohse-Wächtler, Alice Sommer: Drei Dresdener Künstlerinnen in den Zwanziger Jahren*, exhibition catalogue (Städtische Galerie Albstadt, 1996–7), pp. 31–2.

31 For a reading of *Margot* like this, see Sergiusz Michalski, *New Objectivity: Painting, Graphic Art and Photography in Weimar Germany 1919–1933* (Cologne, Benedikt Taschen Verlag, 1994), p. 36.

32 There were a number of guides to Berlin's night-life available in the period; the best known was Curt Moreck's *Führer durch das 'lasterhafte' Berlin* (Leipzig, Verlag moderner Stadtführer, 1931).

32 *Sexual-Katastrophen*, op. cit. , p. 179.

33 Katharina Sykora, 'Jeanne Mammen and Christian Schad: Two Illustrators of Homosexuality in Berlin's Twenties' in *Among Men – Among Women* (Amsterdam, 1983), pp. 537–47. No fuller reference exists since this was consulted in copied form at the Hamburg *Künstlerinnenarchiv*.

34 For biographical details and information about her works, there is no better source than the retrospective catalogue *Lou Albert-Lasard: 1885–1969 Gemälde, Aquarelle, Grafik* (Berlin, Berlinische Galerie, 1983).

35 Moreck, op. cit. , pp. 27–9, 46–7.

36 Gleber, op. cit. , p. 71.

37 Peter Jelavich, 'Modernity, Civic Identity, and Metropolitan Entertainment: Vaudeville, Cabaret and Revue in Berlin, 1900–1933' in *Berlin: Culture and Metropolis*, op. cit. , pp. 95–110.

38 Lynne Frame, 'Gretchen, Girl, Garçonne: Weimar Science and Popular Culture in Search of the Ideal New Woman' in *Women in the Metropolis*, op. cit. , pp. 13, 23.

39 Maud Lavin, *Cut with the Kitchen Knife: The Weimar Photomontages of Hannah Höch* (New Haven and London, Yale University Press, 1993).

40 T. W. Mason, 'Women in Germany 1925–40: Family Welfare and Work', *History Workshop Journal*, no. 1, 1976, pp. 74–113 and vol. 2, 1976, pp. 5–32, p. 89 details the slander of Toni Sender by the right.

41 See references to the stars associated with bi-sexuality in Renate Seydel, 'Stars der Zwanziger' in Kristine von Soden and Maruta Schmidt, eds, *Neue Frauen die Zwanziger Jahre: BilderLeseBuch* (Berlin, Elefanten Press, 1988), pp. 138–51 and for photographs of both Anita Berber and Renée Sintenis posing with anonymous *Freundin* in the 1920s, see *Eldorado: Homosexuelle Frauen und Männer in Berlin 1850-1950. Geschichte, Alltag und Kultur*, exhibition catalogue (Berlin Museum, Fröhlich und Kaufmann, 1984); p. 153 shows Berber, Sintenis' page is unnumbered.

42 Renate Berger, 'Moments Can Change Your Life: Creative Crises in the Lives of Dancers in the 1920s', translated by Martin Davies, in *Visions of the Neue Frau,* op. cit. , pp. 77–95.

43 Ernst Engelbrecht and Leo Heller, 'Night Figures of the City' (first published in *Kinder der Nacht. Bilder aus dem Verbrecherleben,* (Berlin, Herman Paetel Verlag, 1926), translated and reprinted in *The Weimar Republic Sourcebook*, op. cit. , pp. 724–6.

44 von Soden and Schmidt, op. cit. , p. 153.

45 *Simplicissimus*, 1919, p. 225.

46 An excellent MA Thesis was prepared on this particular set of lithographs by Lydia O'Ryan: 'Performing Bodies? Locating Charlotte Berend and the *Anita Berber Portfolio, 1919*' (Courtauld Institute, 1997).

47 Huyssen, 'The Vamp and the Machine: Fritz Lang's *Metropolis*' in *After the Great Divide*, op. cit. , pp. 65–81 and Hal Foster, *Compulsive Beauty* (Cambridge, MA, MIT Press, 1993), pp. 103–9.

48 Huyssen, ibid. , p. 66.

49 Georg Simmel, 'Prostitution' from *The Philosophy of Money*, 1907, translated by R. Ash, reprinted in Simmel, *On Individuality and Social Forms: Selected Writings,* edited and with an introduction by D. N. Levine (Chicago and London, University of Chicago Press, 1971), pp. 121–6.

50 Siegfried Kracauer, 'The Mass Ornament' (1927), reprinted excerpts from *Art in Theory,* edited by Charles Harrison and Paul Wood (Oxford, Blackwell, 1992), pp. 462–5.

51 Ibid. p. 464.

52 Benjamin, 'Central Park', op. cit. , section 39, p. 52.

53 I have borrowed this useful phrase from the title of Janet Lungstrum's essay '*Metropolis* and the Technosexual Woman of German Modernity' in *Women in the Metropolis*, op. cit. , pp. 128–44.

54 See, for example, the stylised mannequins in the Gemey perfume advert, *Berliner Illustrirte Zeitung*, no. 51, 21 December 1930, p. 2330.

55 Susan Buck-Morss, *The Dialectics of Seeing: Walter Benjamin and the Arcades Project* (Cambridge, MA, MIT Press, 1989), p. 101.

56 Huyssen, 'The Vamp', op. cit. , pp. 67–8.

57 David Frisby, *Fragments of Modernity: Theories of Modernity in the Work of Simmel, Kracauer and Benjamin* (Cambridge University Press, 1985), pp. 6–7.

58 Buck-Morss, *Dialectics of Seeing,* op. cit. , p. 23.

59 David Frisby, 'Deciphering the Hieroglyphics of Weimar Berlin: Siegfried Kracauer' in *Berlin: Culture and Metropolis*, op. cit. , pp. 153, 162–3.

60 Walter Benjamin, *Central Park* , op. cit. , section 10, p. 36–7.

61 Lloyd Spencer, 'Allegory in the World of the Commodity: The Importance of *Central Park*', *New German Critique*, no. 34, Winter 1985, p. 66.

62 Benjamin, *Central Park*, op. cit. , section 41, p. 53.

63 Malcolm Gee, 'Negotiating the City: Weimar Berlin', delivered at the Urban History Group Meeting, *Imagining the City in Art, Literature and Music*, Nottingham University, 7–8 April 1994.

64 Huyssen, op. cit. , p. 75.

65 Maud Lavin, 'Ringl and Pit: The representation of women in German advertising, 1929–1933', *Print Collector's Newsletter*, vol. XVI, no. 3, July/August 1985, pp. 89–93.

66 Luce Irigaray, 'The Power of Discourse and the Subordination of the Feminine' in *The Irigaray Reader*, edited by Margaret Whitford (Oxford, Basil Blackwell 1991), pp. 118–32.

67 Dorothy Leland, 'Lacanian Psychoanalysis and French Feminism: Toward an Adequate Political Psychology' in *Revaluing French Feminism: Critical Essays on Difference, Agency and Culture*, edited by Nancy Fraser and Sandra L. Bartky (Bloomington and Indianapolis, Indiana University Press, 1992), p. 119.

68 Male prostitution was shown by Christian Schad who represented numerous gay clubs and scenes for such publications as Curt Moreck's *Guide* (op. cit.). For an unusual pre-war source on male prostitution, see Johanna Elberskirchen, *Die Prostitution des Mannes* (Zurich, Verlag Magazin, 1896).

69 In my work for the exhibition *Domesticity and Dissent*, exhibition and catalogue (Leicester Museums, Arts and Records Service, 1992) I traced the collections of works by some 50 women artists in the period; the vast majority never had a dealer, their shows and patrons tended to be local and their *oeuvres* most often passed nearly intact at their deaths to their relatives or a local museum collection.

70 Irigaray, op. cit. p. 131.

71 von Ankum, op. cit. , pp. 164–5 and the case study of Grete Richter, in Kern, op. cit. pp. 24–9.

72 Sabine Hake, 'In the Mirror of Fashion' in *Women in the Metropolis*, op. cit. , p. 189.

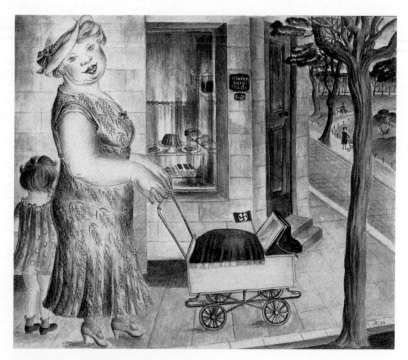

D O R O T H E A W Ü S T E N - K O E P P E N

A Woman of 1934 1934

Courtesy of Marvin and Janet Fishman, Milwaukee, Wisconsin

THE
MOTHER

T HE PAINTING, *A WOMAN OF 1934,* WAS produced in that year by the artist Dorothea Wüsten-Koeppen, signing herself only 'D. W. Koeppen'.[1] The title, the date and the socio-critical style of the piece indicate that the 'mother' was as much a controversial political icon of the day as the centre of home and hearth. The representational strategies of Koeppen's work reveal the complexities surrounding the figure of the mother and the issue of maternity during the Weimar and early Nazi years. The work is a brilliant piece of satire, resting on the knife-edge between pastoral idyll and grotesque caricature, between the joyous evocation of family life and the horrors of ethnic or, in the language of the period, 'racial' hygiene policies. This was also the position of the 'mother' in contemporary discourse and debates concerning maternity, women's work, abortion, contraception and state population policy, all of which were intimately intertwined at the time. Throughout this period there was a

tendency for state intervention into reproductive choices to a degree which might strike contemporary readers as surprising. However, it should be remembered that in Germany these interventions were set against the backdrop of unprecedented decline in the birth-rate and sheer panic at the implications of this for the health of the 'nation'.

Population policy was the remit of any number of institutional bodies: the church, political parties, the medical establishment and even the popular press. The establishment of Mother's Day typified the manifold nature of the debates surrounding maternity. As Karin Hausen described in 'Mother's Day in the Weimar Republic', the development of Mother's Day as a national holiday involved mobilising the diverse ideologies of motherhood into a form useful for merchandising and trade.[2] Such a task was by no means a simple matter and Mother's Day was not met with universal joy. Rather, from 1922 until the Third Reich officially sponsored the holiday, the whole plan was the cause of much contention. Florists and other shopkeepers used it as a marketing tool, conservatives used it as a platform for their versions of anti-feminism and many groups objected to the commercialisation and politicisation of the intimate bond between mother and child as an affront to human feeling. The task-force which actually took responsibility for establishing Mother's Day was comprised of men involved elsewhere with population policy, sex educa-tion, ethics, body politics (the so-called *Körperkultur*) and the censorship of film, thus demonstrating the disparate realms in which the mother figured as an important trope.[3]

While the 'mother' was a powerful symbol which crossed boundaries between scientific, political, racial, medical and social discourses, the situations of individual mothers were rarely articulated through this vast and distanced language. Like the stereotype of the prostitute described in Chapter 1, the mother tended to operate as a monolithic symbol of woman defined in and through relationships to masculine social struc-tures rather than to describe the individual and specific conditions of women in the period. Yet unlike the powerful trope of the prostitute, the figure of the mother was frequently discussed, debated and depicted by women of the period who used the issues around maternity to stage a genuine intervention into popular political arguments of the day.[4] For example, state population policies were a focus for the ever-growing voices of female politicians and doctors in the period, many of whom forged their public careers through their involvement with so-called 'women's issues'. Moreover, these women were, for the most part, the

only campaigners to argue forcibly against complete state control over women's reproductive lives and to emphasise, in a way which is surprisingly modern, the rights of women over their own bodies. Thus they used motherhood as an arguing point but approached it differently, emphasising the various effects it had on the lives of contemporary women.

The significance of the visual arts in these arguments should not be overlooked since popularised scientific theories and ideologies were made manifest in visual languages which 'defined' race, class and 'woman-as-mother' through normalising tropes and deviations from these. Representations of motherhood, from saccharine Madonna-and-child types to politicised poor mothers with starving babies, continued to define maternity in the popular consciousness of the period. What is startling about the representation of maternity by male artists across differences of media, political persuasion and institutional affiliation is its remarkable *lack* of diversity. The 'mother' as a symbol of stability, morality, self-sacrifice, charity and a form of essential feminine nature acted as an unspoken underpinning to both left- and right-wing representations despite their racist, nationalist or communist ideological messages. The now infamous Nazi party propaganda which showed idealised Aryan mothers nurturing their perfectly blond children were not a million miles from the representations of idealised mothers of the proletariat common to the left. What remained unquestioned in this visualisation of maternity was the 'natural' bond between mother and child and, as its corollary, a woman's 'nature' being determined by female natality. This structure of woman's nature is a key support of patriarchy and thus we should not be surprised to find that patriarchal institutions propagated this myth while many women artists of the period made the representation of maternity a far more problematic field by exploring differences between women.

The forms of burgeoning *Frauenkultur,* where women debated maternity from their own positions, and the significance of the visual in defining maternity, meant that women artists were uniquely placed in relation to the multi-stranded themes of motherhood (and abortion). The scope of women's art which explored maternity attests to both the scale of the issue and its ability to be reconfigured in light of the particularities of women's social situation. The works do not reveal a unified and 'natural' response of these artists to maternity; the differences between the works in terms of media, style and subject-matter show such a simplistic response to be untenable. Moreover, there was no single, clear line on reproductive

rights and the art by women artists on this theme is plentiful and varied. This variation in itself is a significant feature of women's art since it combined multiple social contexts of maternity with standard visual tropes of the 'mother' in order to negotiate new and different images of women attempting to combine motherhood with other public roles or to establish a new sense of identity without the experience of maternity.

This is why A Woman of 1934 is fascinating; it negotiated many facets of the argument at once and levelled powerful criticism at both the state and the women willing to be its incubators. At first glance, the work by Koeppen is idyllic: a mother with a perambulator and a pretty toddler strolls down the street of a clean, well-to-do town doing a bit of shopping for the family. She is well-dressed and the bakery in front of which she has paused in this image overflows with sumptuous breads and cakes. Even the sun shines in the picture and the colours are bright. Certainly no politician or individual, regardless of their ideological stance, would pour scorn on the representation of such a healthy, happy mother and her children. Yet there is one disturbing detail in the work: the black of the swastika emblem on a flag attached to the baby's carriage. This is a woman of 1934, and her new-born is displayed proudly as an infant of the Third Reich.

While it is now impossible to see the swastika without knowledge of the Second World War and the unimaginable horror of the Holocaust, we must remember that this work was produced before those events. However, the eugenic theories and policies of the National Socialists were not invented from the ether; throughout the late Wilhelmine and Weimar periods, population debates consistently deployed the language of racial hygiene and the control of the overabundant, undesirable, mass. Thus, while the work by Koeppen cannot be said to refer to or 'prefigure' the Holocaust, the 'happy family' evoked by the image was sponsored through positive state intervention which was but the obverse of a host of negative eugenic policies eventually culminating in the mass extermination of millions. Just as maternity and abortion/contraception were linked together, so too were the positive welfare reforms for mothers and children merely the backdrop for legislation permitting enforced sterilisation and the later mass genocide. The attractive and desirable 'front' for many of these policies was the pretty picture of the mother and child.

Hence Koeppen did not fall upon the year 1934 by accident. Certain dates were pivotal in the period in relation to abortion legislation and family welfare reforms. The establishment of the Weimar Constitution in

1919 put into place the infamous Paragraph 218, the piece of legislation which criminalised abortion and the display and sale of contraceptive devices. Numerous campaigns were waged against this paragraph in the early years of the Republic, culminating in 1926 in slight revisions of the law. 1931 saw another massive wave of pro-choice activism brought about by the pressure on women to limit their families because of the economic depression and the well-publicised cases of two doctors jailed for performing illegal abortions. However, this agitation was, for the most part, in vain, since the National Socialist seizure of power in 1933 meant that it was their family welfare policies and negative eugenic strategies which were in place from 1934. It was no coincidence that the cover of the *Berliner Illustrirte Zeitung* on 31 March 1934, after the Nazis had 'replaced' the editorial board with their own sympathisers, used a sentimental portrait of a mother and child to capture the spirit of the moment. Such a sickly sweet frontispiece was the popular face of National Socialist population policy.

Indeed, 1934 saw a slight statistical upturn in the birth and marriage rates which was claimed as a victory for the Nazi reforms. Much of this policy change was positive; the party introduced tax relief incentive schemes aimed at those segments of the population both desired as parents and with the lowest average fertility rates. Thus civil servants and other professional people were targeted in the initial schemes. The family loan policies made it financially advantageous for young couples to marry and start families and there were even state awards for large families.[5] The cash incentives, though frequently more meagre in reality than in theory, strongly reiterated the message that the mother was not to work outside the home. The financial assistance was given to 'restore' the balance of the nuclear family with the father as the public head of the household and breadwinner and the mother as the private heart of the domestic sphere. The emphasis upon 'racial hygiene' rather than economic/social class meant that even less well-off, small-town and rural Germans were included in these measures, and for those families things were made easier and the quality of life was generally improved. Most of these measures, therefore, proved popular.

A Woman of 1934 is centred upon these changes; the main figure is clearly indicated by dress and activity to be middle class and domestic; she is wife and mother by occupation and not employed outside the home. The location is not urban. Again, this was consistent with the terms of the population debate since young women in white-collar employment

in big cities in Germany had the lowest birthrate in the industrialised world during the 1920s and were a prime target for eugenic fears. Conservatives in Germany throughout the first three decades of the twentieth century incessantly defined the city as a place of social decay in which gender, race and class roles were confused and women lost their 'natural' inclinations toward nurturing motherhood. The Nazi illustrated magazine, *Illustrierter Beobachter*, which for the most part ignored women during the 1920s in favour of features about male members of the party, military demonstrations and blatant anti-semitic attacks, did reserve the odd insult for the urban phenomenon of the *neue Frau*. In the pages of the *Illustrierter Beobachter*, the new woman was linked, visually, to the city, jazz (and thus African-Americans) and the stereotype of 'the Jew'. Shortly after the Nazi accession to power, the *Illustrierter Beobachter* ran a gloating cartoon entitled *Frauenbewegung* (the Women's Movement) which contrasted a 'then' picture of a flapper dancing to jazz and a 'now' picture of a discreetly dressed mother with a pram.[6] The return of the woman to the village home as a mother was seen as a victory for the party over feminism.

For every positive family welfare ordinance brought in by the National Socialists, negative measures were also enacted. The abortion legislation of the Third Reich undid the marginal gains made in 1926 by re-establishing penal servitude for women obtaining terminations and the doctors or other assistants undertaking these. Moreover, in 1934, programmes of compulsory sterilisation for 'unfit' citizens and abortions of potential 'undesirables' became the norm.[7] The designation of desirability for parenthood was most commonly 'racial', that is non-Aryans were liable to sterilisation, but so too were those deemed insane or sub-normal in intellect or 'morality'. Not surprisingly, this group largely extended to the poor and to prostitutes. The prostitute was, of course, the symbolic figure of woman most commonly upheld in opposition to the mother in contemporary discourse and a figure used more to slander and demean women in public than to describe female sex workers. Hence sterilisation was both a state-sponsored programme of racial cleansing and a punitive measure against those women whom the state saw as threatening.

On an even more sinister note, Koeppen's woman is distinctly Aryan in appearance. The figure is blonde, fair and buxom and the blueness of her eyes is so definitive that it appears false, like two painted blue orbs. There would have been no possibility of mistaking the body politics of the figure in relation to that swastika on the perambulator; this was the

mother of the *völkisch* ideal. She was good breeding stock and evidence of this was supplied by the Aryan appearance of the toddler with her. In this way, the figure invokes the eugenic theories of radical right-wingers such as Himmler's close ally Richard Walter (R. W.) Darré, who linked women's pride in motherhood with Germanic racial traditions, anti-feminism and pseudo-scientific genetic theories:

> Let us re-educate our girls to a full understanding of the old German concept of *Züchtigkeit* [chastity]. For our ancestors it was not that bashful girl who had no knowledge of the facts of her sex who was *züchtig* [chaste], but she who consciously prepared herself to become a *mother* and as a *mother* to rule over a large number of children. . . . These women knew about breeding and it was their pride. . . . We are but resuming the best spiritual and moral traditions of our ancestors, while cleansing and clarifying them with the findings and researches of modern genetics.[8] (emphasis on 'mother' is in Darré's text).

The interrelationship between race, maternity and state-sponsored social policy is rendered visible and visual in Koeppen's painting. But therein resides its power to critique this ideal since the visual clues become excessive and begin to destroy the simplistic framing of the work and its immediate message. Contemporary political satire in, for example, the work of George Grosz consistently drew upon a language of visual stereotypes and over-obvious settings to make its point. The 'fat burgher' with his duelling scars was juxtaposed with the emaciated, crippled war veteran on the city street and the critique of capitalism was clear. In Koeppen's work as well, the village setting is too obvious, the figure of the mother too Aryan, too much the evacuated icon of the 'mother' of the party. She has neither the status of a recognised allegorical figure such as 'virtue' or 'charity', nor is she afforded any form of identity as an individual woman; she is 'woman' of 1934, a type circulated merely by and for the establishment of the patriarchy and the state through her procreative function. 'She' has meaning only in relation to '1934'; 'woman' in this sense operates only as an empty vessel for party policy and nationalist sentiment.

The namelessness of the figure, its overburdened references to Nazi family welfare strategies and its implication in the language of racial purity are mirrored by the visual rendering of the figure, caricatured as an empty-headed breeding machine. This figure of the mother who mindlessly and immediately conforms in her very body to the new fascist regime could not have been read as anything other than the sharpest crit-

icism of the conservative ideologies of motherhood and the women who supported them. Particularly given the long, hard struggles of many women during the Weimar years for a modicum of self-determination over their own procreativity, the blind conformism of this figure would have been obvious. Even the fact that Koeppen signed the work with only her initials so possibly to be 'mistaken' for a male artist suggests that the image was dangerous; better to be a male artist using 'woman' to critique the party than an articulate woman engaging in debates about the politics of female reproductive rights. Moreover, a woman who artic- ulated a critique of the mother-child bond and the 'natural' role of women as mothers was herself an anomaly; to envisage a distance between the fulfilment of motherhood and the political over-determina- tion of maternity under National Socialism was beyond the scope of the truly feminine woman defined in and through her natality.

That a woman artist produced this work defied the conventions of a masculine economy in which 'woman' circulated as a monolithic symbol for patriarchal exchange, and to articulate opposition to this structure was theoretically beyond the power of women. The emphasis of Koeppen's work was to criticise the intervention of the masculine state into population control, maternity and female sexuality, not simply to support or condemn motherhood. The shift is significant, since the most striking feature of most women's arguments of the time regarding maternity was not a singular 'pro-or-anti' stance, but their insistence that the decisions be made by and for women rather than by and for men and the patriar- chal state.[9] This fact marks women's interventions into debates about reproduction in Weimar as remarkably similar to those of the 1960s and 1970s and yet again demonstrates at that early date the existence, however tenuous, of a genuine *Frauenkultur*.

'WOMAN-MOTHER': THEN AND NOW

As discussed at length in the last chapter, the prostitute was the male modernist icon *par excellence* and women artists found it a difficult trope to negotiate in their work. Since the mother was the traditional counter- foil to the prostitute, we might expect to find it a popular subject among women artists and this is in fact the case. However, it was by no means a simple symbol for women artists to appropriate, and anyone interested in its significance within the Weimar context needs to be conscious of the

tendency to over-determine the works of women artists on the subject of maternity as somehow 'natural' or inevitable. Contemporary feminist perspectives on maternity are remarkably similar to the debates of the Weimar period since they stress the interaction between myths of the mother and the experiences of motherhood. As Ulrike Sieglohr has described in her book *Focus on the Maternal: Female Subjectivity and Images of Motherhood*, maternity is both a social and a personal phenomenon; motherhood is socially encoded as myth and symbol and then experienced, physically and psychically, by women.[10] This dual nature makes the response to maternity and the expression of maternal subjectivity an area fraught with contradictions. One of the principal contradictions is the status of maternity within feminist discourse itself – both then and now.

The complex significance of motherhood to feminism has been described by a number of theorists, not least Julia Kristeva who, in 'Stabat Mater', pointed out that avant-garde feminist groups have tended either to reject motherhood or to internalise its traditions as a form of essential femininity.[11] Rosi Braidotti, in 'The Politics of Ontological Difference', noted the same polarised responses of feminists to the issue of mother-hood.[12] On the one hand, maternity as it has been established in western society is criticised as a tool of patriarchal power over women who are read as the empty vessels of masculine lineage. On the other hand, maternity provides many feminists with a specific sense of a peculiarly female experience and position from which to explore ideas. In order to overcome this seeming disparity, it is necessary to relate the material conditions of maternity to the cultural systems which give the experience meaning. Since the mother has most frequently been framed within patri-archy in relation to the masculine subject, that bias begs redress.

Historically, women have rarely been in the privileged position of defining motherhood in its social context. Indeed it is clear that mothers themselves have had very little input into the discourses and myths which surround maternity and that the literature, art, legal statutes and medical treatises concerning pregnancy and child-care are traditionally directed *toward* women rather than produced *by* them.[13] Such historical bias has led contemporary theorists to argue that the very institution of mother-hood is in fact a masculine structure meant to support, physically and psychically, male cultural hierarchies. For Kristeva, this has been achieved through the displacement of actual women and the invocation of the triumvirate 'daughter-wife-mother', those disembodied markers of

women's social positions in relation to men.[14] This alienation from the position of what Braidotti has termed 'discursive subjecthood' meant that the 'mother' tended to circulate as a symbol within a masculine economy of meaning rather than reflect the concerns or experiences of the women who were mothers.[15]

The situation was similar during the Weimar Republic where men dominated all discussions of female sexuality and reproductive rights in the name of social health and the good of the nation, and authors like Alice Rühle-Gerstel prefigured Kristeva's later critiques. Rühle-Gerstel powerfully refuted the idea that the family gave women an identity or social position in their own right and instead asserted that the family belonged to men and that, for example, Mother's Day was a male institution celebrating an empty icon of woman.[16] Women, then, have been criticising the alienation of female experience from the social construction of motherhood under patriarchy throughout the century. They simply have not had enough collective political power to enact significant change until quite recently and their voices were marginalised by history. However, understanding the struggles waged by women in Weimar for reproductive self-determination is an important step toward rethinking the history of that period and the role played by women in it.

The argument is not that motherhood was not a social, but wholly private experience and that we merely need to find the 'truth' of this experience for women in Weimar. Rather, what is interesting in relation to these issues is to examine the dynamic relationships between the social and material conditions of maternity in the period, the symbolic structures which gave maternity meaning and the women who defined themselves and were defined by their reproductive choices. The dynamic between the social, symbolic and psychic dimensions of maternity and the potential for women to challenge and expand the definitions of motherhood is resonant with the work of the feminist philosopher Luce Irigaray. Irigaray has demonstrated the way in which women's historical lack of access to production placed them firmly in the realm of reproduction, a move which was characterised by their inarticulation in the social sphere.[17] Woman, as defined by her reproductive function, became a commodity in a masculine system and was 'exchanged' literally as property (the daughter, for example, becoming the wife) and symbolically as the 'mother'.

Irigaray's critique strategically places the material conditions of women into communication with the mythic structures which define

'woman' in order to expose the weaknesses inherent in these structures. With regard to maternity, she thus takes myths and icons seriously. The founding myths of the west, she argues, systematically repudiated the maternal bond in order to sustain the social order.[18] The Virgin Mary, Clytemnestra and Jocasta are not just arbitrary figures for Irigaray; these effaced mothers represent the status of maternal subjectivity as defined in and through male, homosocial relations. To explore women's discourses on maternity in Weimar we need to take the 'myths' of that period seriously too. These ranged from the women described only as 'mothers' in communist papers such as the *Rote Fahne* to the books and articles published by Nazis like Dr Palm (citing such other male experts on motherhood as Adolf Hitler in *Mein Kampf*) which defined the parameters of 'proper' motherhood for women.[19]

In opposition to the effacement of the mother, Irigaray suggests a rather too literal revaluation of 'positive' icons of the mother-daughter relationship (i.e. substituting images of Ann and Elizabeth for the Madonna and Christ) but more subtly, a notion of a female genealogy or, as she also put it, 'women-amongst-themselves'.[20] This concept is resonant with the exploration of women's cultural discourses on maternity and abortion in Weimar, since women doctors, politicians, writers and artists began to voice opinions 'amongst themselves' on these issues which were significantly different from the mainstream male lines of debate. These women were relatively few in number but, as Cornelie Usborne demonstrated, their opinions were taken very seriously by other women.[21] It was in relation to 'women's issues' like women's reproductive rights and female sexuality, that many women newly involved in the public sphere first began to find a powerful, alternative voice for their own position. Thus it was, for example, that Reichstag member Gertrud Bäumer began her influential book on women's social and political situation in the Weimar Republic with a description of the interrelationship between motherhood and the state. Only through an exploration of the interaction between the social and personal experiences of women's lives, she argued, could any sense of women as contemporary political agents be understood.[22]

The mother and all the complicated political issues surrounding her provided women with a foothold in the wider public arena and a sense of solidarity or *Frauenkultur,* yet this engagement was varied; there was not one definitive women's opinion on maternity during this period and it would be a mistake to seek one. Moreover, it would be wrong-headed

to decide from our current position that some women's opinions were 'right' or more appropriate than others. Rather, what becomes apparent is the multiplicity of models of maternity which women endorsed at the time in the face of political parties and male social theorists who were asserting singular, prescriptive definitions. Women argued for their right to choose various models of marriage, maternity and career combinations; they acknowledged differences between women in relation to maternity and challenged the monolithic stereotype of the mother as an icon of feminine behaviour. The art produced by women which considers mothers, children and abortion rights tackles a variety of positions on these issues rather than reinforcing a single 'women's opinion'. Moreover, the concept of maternal subjectivity and the relationship between creativity and procreativity make this aspect of women's artistic production part of their attempt to define themselves as women *and* artists at the time. Situating women as the locus of new conceptions of female sexuality and reproduction began a process of challenging the myths and providing alternative models which is only coming to fruition now.

ECONOMIC DIFFERENCES BETWEEN WOMEN: THE WORKING MOTHER

Koeppen's *A Woman of 1934* was a powerful visual indictment of the discourses which lumped all women together as inarticulate baby-machines for the nation. Crucial to dismantling such an icon is to acknowledge the differences between women and the ways in which these differences determined the various forms of maternal experience. Clearly, there was some acknowledgement from both conservatives and radicals of the differences between women based on economic factors and of the role that financial stability could play in encouraging women to have families or not.[23] This explains both the family welfare reforms described above and a number of radical calls for socialised medicine, child-care facilities and abortion rights for poor women. Yet, both left and right still tended to argue for reform in terms of disembodied stereotypes which suited their claims and thus the 'poor mother' and the 'working mother' quickly became simplified tropes which obscured the complicated interplay between economics and maternity. The 'poor mother' had a long history acting as the visual essence of the emotive struggle for

working-class rights; a strong, nurturing maternal figure reduced through circumstances to desperation could be used both to mobilise working-class feeling and to develop sympathetic bonds with the middle classes. The 'working mother' was a slightly more awkward figure to control, acknowledged both as a capitalist problem by the left and as a social menace (the cause of juvenile delinquency) by the right.[24]

Especially bourgeois women's groups in the period were affected by these powerful stereotypes. For example, the BDF (*Bund Deutscher Frauenverein*), the largest bourgeois feminist organisation in Germany at the time, and its member group of Jewish middle-class women, the League of Jewish Women (JFB, *Jüdischer Frauenbund*), were sympathetic to the plight of poor women, yet generally in favour of measures which would enable them to be non-working mothers rather than remain child-less or become workers using public child-care facilities. Significantly, however, being able to have their say on these issues provided women the space to raise and discuss disparate positions. Thus the BDF's own initial goal to include all women, regardless of party or worldview (*Weltanschauung*), meant that its largely bourgeois interests were some-times called into question by the very diversity of voices it permitted the chance to speak.[25]

Women's organisations, politicians, doctors, writers and artists insisted that their voices be heard in matters concerning their reproduc-tive rights and this meant that a variety of opinions and situations reflecting and constructing the multifaceted conjunctions between economics, ethnicity and maternity were put onto the agenda. These explorations of motherhood as multi-stranded social and personal expe-riences are made manifest in women's art of the time as surely as in Reichstag debates and the popular press – and in just as many disparate forms. Not all women artists were concerned with the same conjunctions of maternity, class, economics and race; they represented a wide variety of maternal situations and combined iconography and media associated with fine art, politicised graphics and popular culture in order to counter the homogeneity of conventional images of motherhood. In fact, it is the active construction of maternity between these positions of gender, gener-ation, class and ethnicity ('race') in the visual which makes their repre-sentations of motherhood so fascinating. For example, *The Labour Exchange* of 1929 by Grethe Jürgens and *Home Worker* of 1927 by Martha Schrag both depict working mothers, yet the economic context, style and mode of the two works could hardly be more different.

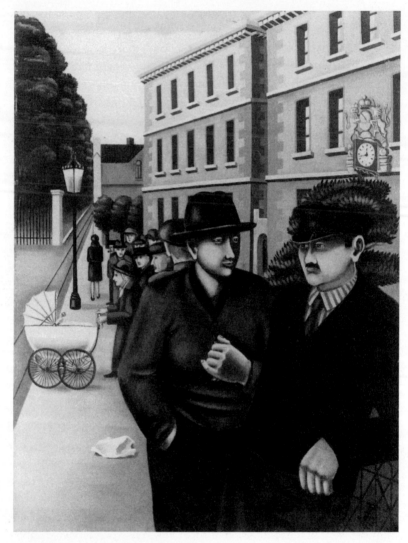

GRETHE JÜRGENS
The Labour Exchange 1929
Courtesy of the Sprengel Museum, Hanover

Jürgens's painting is a sober realist representation of a group of white-collar workers in a queue outside the social security office in Hanover. As an image of the unemployed during the Weimar years, it carried with it a sense of social criticism in keeping with its matter-of-fact style (associated in Hanover with the *neue Sachlichkeit*) and a left-wing, working class

orientation.[26] However, Jürgens was explicit in her representation of one particular facet of the working-classes: the new white-collar sector termed the *Angestellten*.

Jürgens came to Hanover in 1919 to study graphics with Fritz Bürger-Muhlfeld at the *Kunstgewerbeschule* and remained in the city until her death in 1981. During the 1920s, Hanover's art scene developed with unusual pace and it became the centre of a bourgeois art market which favoured abstract work. Kurt Schwitters produced his *Merz* works and Dada poetry here, El Lissitzky enjoyed a residency at the city's museum while he produced a large constructivist piece, and contemporary art from all over Germany and other European centres came to the city in exhibitions held at the Kestner-Gesellschaft. The artists of Hanover's *neue Sachlichkeit*, including Jürgens and Gerta Overbeck, felt estranged from this art scene and concentrated their practice around the old town (*Altstadt*) district of the city with its working-class inhabitants, pawn shops, street vendors and *kneipe,* or local bars. These were the areas associated with the *Angestellten* and the figurative works produced by the young Hanoverian realists centred upon their lives. Most usually shown in Hanover's *Kunstverein*, the audience for Jürgens's and her colleagues' work was also part of this *milieu*.

The group represented by Jürgens in *The Labour Exchange* typified the demographic mix of the local workers; significantly, they included a self-portrait (her figure walks away into the background) and a woman with a perambulator. This reference to a mother as a white-collared, unemployed labourer actually represented with her child at the labour exchange, challenged a number of the most pervasive stereotypes associated with women's work and motherhood. The mother at the labour exchange defied easy placement into any traditional category; she was neither the degraded poor mother nor the rural, non-working mother of the nation. Yet this work by Jürgens is not stinging satire; its sober painting style and intelligible details (the accuracy of place, for example) suggest documentary modes of interpretation. The viewer is neither seduced into an emotive empathy with a distressed maternal figure nor repelled by the horror of a 'bad mother' or vacuous baby-machine. We are situated as the viewers of an ordinary day in an ordinary German city where, as it happens, women's labour patterns were changing rapidly and increasing numbers of ordinary women were becoming working mothers in all sectors of the labour market.

This is the challenge posed by Jürgens's work. The style and repre-

sentational strategies quietly articulated the powerful underlying social changes which constructed such scenes of workers as a regular fact in German cities at the end of the 1920s. Rather than police the boundaries between public and private, Jürgens revealed their instability just by making them visual and visible. Jürgens's representation of the mother and herself in relation to the labour exchange indicated that these new labour roles were being played by both young, unmarried 'new women' and women with children. Her own affiliation with the Hanoverian *neue Sachlichkeit* artists determined the unflinching sobriety of her approach and its accuracy of detail. Yet the way in which the artist rendered this subject as a matter-of-fact realist painting precisely defied contemporary rhetoric which placed both the 'new woman' and the 'working mother' at the centre of furious debates about the dissolution of fixed gender roles and the destruction of the family and the nation by women who did not know their place. In the work's simple and direct representation, those two contentious figures became part of the banal daily life of the city and thus radically decentred the discourses which required them to be fantastic symbols of woman. However, *The Labour Exchange* considered but one aspect of women's complex negotiations of economic life and motherhood and its tactics were not universal.

Schrag's *Home Worker* deployed a far more emotive and traditional visual language in order to engage with the arguments concerning working-class mothers being exploited by factories which gave them piece-work to do in their homes.[27] The drawing depicted a mother machine-sewing at a table with her young son looking on. Both of the figures are small and huddled around a scant source of light, suggesting that the woman is working late into the night in order to support her family on meagre piece-work wages. These figures were recognisable as belonging to the lower end of the proletarian spectrum and the issues which faced working mothers of this economic group were significantly different than those affecting the *Angestellten*. Not surprisingly, the visual language deployed by Schrag differed from that used by Jürgens since the contexts of work and motherhood with which they were concerned were dissimilar.

However, Schrag was not alone in evoking this particular exploitative labour relationship; Käthe Kollwitz famously produced etchings of home workers (see *Deutsche Heimarbeit*, 1925) which also played on close-up facial rendering and the signs of fatigue, starvation and over-work in their figures to make their critical comments unmistakable. It is not

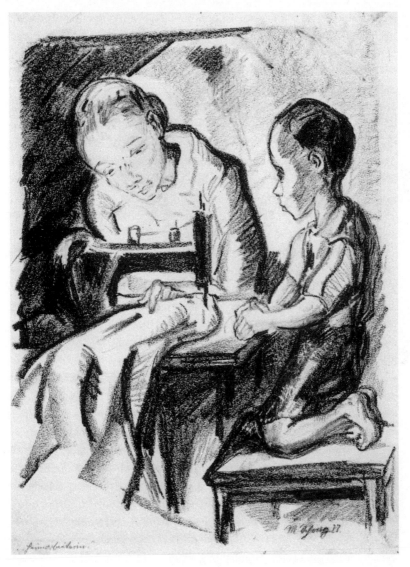

MARTHA SCHRAG

Home Worker 1927

Courtesy of the Städtische Kunstsammlungen Chemnitz

surprising that Schrag and Kollwitz used similar visual motifs since their artistic development and relationship to the issue of home work were equally similar: both artists were a generation older than Jürgens and educated in *Malerinnenschule* before women were able to enter acade-

mies and arts and crafts schools, and both were working-class artists who produced work for the communist cause (in Chemnitz and Berlin respectively).[28] Their 'generational' artistic affiliations were significant since, by the late 1920s, many of the more technologically-inspired forms of mass media had moved to types of 'rationalised' imagery in their evocation of home work and the urban proletariat. The photo-essay from the *Arbeiter Illustrierte Zeitung* of 1927 in which home workers are shown in a sober documentary style with an emphasis upon their sewing machines and appliances is a case in point.[29] Additionally, Schrag worked in relative artistic isolation in Chemnitz which meant that her focus remained fixed upon the conditions of the workers in her city and their industrial surroundings throughout the years of the Weimar Republic and her exposure to new artistic practice in other areas was minimal.[30]

If home work was a complex and emotive visual motif during the Weimar Republic, it was an equally emotive issue in the political arena. In general, there was recognition of the exploitation of the women involved in this labour and real desire to eradicate the problem. However, positions varied according to the interests of the reformers. Some politicians were distressed that German industry was not sufficiently effective to offer everyone a living wage and was instead employing home workers; these politicians had no hesitation in recommending a total ban on home work without any particular consideration of the effects this would have on proletarian families dependent upon home work for their survival. By contrast, women's groups and left-wing organisations focused upon the worker, her family and community and sought reforms in pay, maternity and child-care arrangements and working hours.[31] However, there were still many who opposed mothers working outside the home and thought that women were thereby taking jobs from men. Within the terms of these debates, it was actually preferable for women to be home workers than to take properly paid outside work away from their male counterparts. Significantly, actual reforms introduced to assist working mothers reflected contemporary fears of 'double-earning' and did not cover women in agriculture, domestic service or home work.[32]

The other side of the reform question centred upon the issue of maternity and whether such hard physical labour was conducive to bearing children or raising a family. Luise Scheffen-Döring's book *Frauen von Heute* (*Women of Today*) (1929) described in detail research which demonstrated just how factory and home work was disabling to maternity through physical and economic stress to potential mothers.[33] Like

many others of the period, Scheffen-Döring distinguished between the working situations of proletarian women (who did 'work', *Arbeit*) and white-collar women with 'professions' or 'occupations' (*Beruf*). The proletarian mother who was forced to work to maintain the very lives of her children was a far more sympathetic figure in the period than the 'middle-class' woman who sought to combine a career with motherhood or to forgo maternity altogether. Thus it was that conservatives in Weimar often characterised women's professional activities as 'unfeminine' and potentially dangerous to their procreative function while suggesting that the proletariat were breeding out of control despite the relentless labour of their lives.

This difference between working mothers is significant to the different forms through which Jürgens and Schrag constructed their works. Where Jürgens's work had soberly shown working mothers among white-collar employees as a matter of fact in order to counter their hysterical over-representation by scaremongering conservatives, Schrag's work was bringing to light the unseen exploitation of a different class of working mothers. Hence she used an emotive drawing technique in conjunction with an empathetic subject to evoke widespread sympathy for her topic. The tiny child in the foreground, for example, brings the audience into the work and makes them identify with the figures, inspiring a sense of collective responsibility for the issue. Jürgens's white-collar workers are not objects of empathy in that sense, nor are they intended to inspire philanthropic acts of reformism. These works evoked different and specific issues surrounding working mothers, framed in terms of economics, class and location. This demonstrates yet again the adaptability of women artists to the particular and various terms through which maternity was made manifest in the period and their refusal to reduce the circumstances of different women to a trope of universal 'woman'.

Using the figure of the mother as a sympathetic icon of the working classes was a relatively common political tool of the period. Next to the noble male worker, such a maternal figure was well placed to elicit strong feelings for the plight and the community solidarity of the poor. In the hands of women artists, this iconography could be transformed into a feminisation of the political arena as the famous works of Kollwitz suggest.[34] Kollwitz used figures of working-class mothers and children to comment upon such traditionally masculine political issues as war, capitalist exploitation and economic crises as well as 'women's issues' such as the abortion legislation of the period. Schrag drew on Kollwitz's tech-

niques in her *Home Worker* and a number of other women artists at the time also cited Kollwitz as a powerful inspiration for their practice. It is not surprising to find that women artists were drawn to Kollwitz's use of women's subjects as a tool to produce more wide-reaching political criticisms and that the Dresden-based artist Lea Grundig also took this up in her work. Deploying similar etching techniques as Kollwitz, Grundig produced sympathetic renderings of the difficulties of motherhood for working-class women, but her artistic trajectory brought elements of party politics into conjunction with women's life experiences and the problematics of the domestic in new and unusual ways.

THE DOMESTICATION OF POLITICS

Grundig represented all facets of working-class women's lives in her art during the 1920s and 1930s, from maternity to work, the home to the street. As a communist artist and Jew, Grundig was concerned with the economic implications of the roles of women and her works explored the private and domestic spheres within the context of radical Marxist theory. Trained in the *Kunstgewerbeschule* and in the Academy in Dresden, Grundig was a major figure in the left-wing art circles of the city in the period. As a founder member of the ARBKD in Dresden ('Association of Revolutionary German Artists'), a radical left-wing art group with regional centres throughout Germany during the 1920s, Grundig did not separate her practice as a graphic artist from her committed left-wing politics and developed a style which harmonised the two elements. Many of the best-known figures of the Dresden art scene of the 1920s were also members of the ARBKD and the KPD, including Otto Dix, Conrad Felixmüller, Otto Griebel, Erna Lincke, Eva Schulze-Knabe and her husband, Fritz Schulze. Additionally, after the Second World War and division of Germany into East and West, Grundig, with her husband Hans and Otto Griebel, remained active in the service of the communist state.[35]

That Grundig chose in the main to represent working-class women as political agents and the experiences of working women's lives as significant in political terms was a deliberate strategy. In a series of 12 etchings entitled *A Woman's Life* (1936), Grundig located her critique of capitalism and the new Reich within the circumstances of the domestic, a realm where women were not all happily cooking, cleaning and making babies for the nation. In these etchings, Grundig showed women in a variety of

roles: tired women in the kitchen or tending the sick, mothers with their children and younger, working-class girls with their lovers in the playground at night. In *Shop Window*, the artist depicted a group of mothers with children looking longingly through a shop window at the goods beyond their reach. As discussed in the first chapter, this work was more than just a comment on the interconnection between the prostitute and the mannequin; it was a radical critique of the association of woman with the commodity fetish and spectacle of the street.

Such wide variation in representation reiterated the diversity of women's lives and both criticised the myth of the well-off village mother, thoroughly fulfilled by her domestic duties for the Fatherland, and put alternative views of women's lives, not always acceptable to the establishment, into the frame. This dual response to the representation of the mother as both powerful, political agent and critical tool against capitalism and patriarchy exemplified that seeming dichotomy in women's relationship to maternity described above. It was also an interesting strategy in light of the position of women within the German Communist Party (KPD) and in Dresden's left-wing circles particularly, since Grundig was active in party politics and radical art groups throughout the period and it was within this context that her works had their largest audience.

The KPD was the only major political party to endorse fully the objectives of radical feminism in the period, yet the relationship between feminism and the KPD was more complex than this would suggest. For example, the KPD position on the role of women within the state acknowledged their lack of status and exploitation under capitalism, but saw this purely as a symptom of class and economic conditions rather than as an issue to do with gendered power relations in a patriarchal social order.[36] Thus it was that while supporting women's rights to fair wages and public welfare programmes for the care of children of working mothers, the ideal model still favoured by the party was that described most famously by August Bebel in his book *Woman Under Socialism*: for economic conditions to be stabilised under a communist system to permit women to fulfil their natural function as mothers. [37] Moreover, the KPD party organ, the *Rote Fahne*, maintained its critique of the roles of women well into the Third Reich, publishing a text about the Soviet Union, 'where women have full equality and are not just mothers of the race', yet for the most part carried no mention of women as independent political agents on its pages.[38] Again, the KPD was forthright in its support of women's right to abortion during the Weimar Republic and

even used the slogan 'Your body belongs to you!' Nevertheless, when pressed on the meaning of this call-to-arms, party officials shied away from the full implications of women's self-determination by suggesting that the body which belonged to women was to be understood as a social body with collective responsibilities to the state. [39]

Cornelie Usborne has suggested that the KPD used 'women's issues' in the period in order to elicit positive support from this newly-enfranchised group as much as for any fully-fledged ideological reasons. After gaining the vote, women in Weimar displayed a marked tendency to support the centrist parties in elections and the KPD was, of course, determined to change this situation. Quite correctly, they identified themselves as the one political party which offered the possibility of genuine radical change for women and they did, to their credit, maintain their convictions on feminist debates throughout the period. However, 'women's issues' were always marginal within party politics as a whole and it is no surprise that women's groups frequently operated at some distance from the centre of parties, even while attempting to use their power to gain legislative victories.

In Dresden particularly the KPD was associated with the powerful agitator Otto Rühle, whose relationship to feminist politics is of especial interest. [40] Rühle, an important figure in Dresden's political arena, advocated a form of 'feminisation' of public life in his unorthodox politics which united the perceived 'feminine' aspects of the left, such as pacifism and the advocation of women's rights, with a fuller sense of a communal, almost familial, public sphere. This sensibility was significant for the cultural *milieu* in Dresden, and artists such as Felixmüller used these ideas in his work, making the home/studio and the care of children a centre for political activism. [41] Dresden was a centre with a particularly high number of politicised women artists, such as Grundig, Schulze-Knabe and Lincke. Clearly, there existed a positive environment for women's practice amidst the left-leaning artists living in the city.

Significantly, Otto Rühle was married to Alice Rühle-Gerstel, the well-known socialist feminist writer and psychologist. Rühle-Gerstel wrote numerous books and articles on the 'woman question' during the period which again emphasises the important role of feminism within the Dresden political realm and her powerful voice within *Frauenkultur*. Dresden, therefore, was known in the period for both strong proletarian politics and feminism, and these were connected intimately but were not simply interchangeable. Working within this sphere it is easy to see that

Grundig's use of women and the domestic as a political device in her graphic art would have been intelligible and potent.

However, Grundig did not merely accede to Rühle and the KPD line. Like Rühle-Gerstel herself, the artist maintained a certain critical distance from party ideology, which permitted her to explore the class and economic situation of contemporary women while levelling critiques of the masculine power structures which went beyond these. Even her adherence to Zionism during the 1920s located her ideologically within a radical politics of identity and difference. Zionist debates, as part of the multiple orientation of the German-Jewish community as the 1920s drew to a close, represented the tendency to foster a political awareness among Jews *as* Jews in opposition to models of cultural assimilation. Using the distinctions later made famous by Hannah Arendt, whose own identification as an intellectual German outweighed her interest in specifically Jewish issues until after the Second World War, cultural assimilation was represented by the *'parvenu'* while strong, oppositional Jewish identity was suggested by the 'pariah'. [42] The appeal of Zionism and the position of the 'pariah', especially for young radical women within the Jewish community, was its emphasis upon a politics of identity; as Jews and women, identity politics were a way to voice multiple differences, rather than occlude one in favour of another.

Hence, even Grundig's most personal portrait images of women alone or with their children situated them within this dual framework through titles such as *Comrade Elsa Fröhlich and Sonni* (1935) or *Working Woman – Mutter Ahnert* (1935). The relationship between image and text (title) was a sophisticated one which reinforced the relationship between the personal and the political, the individual humanity of the sitters and their collective roles. Additionally, both of these etched portrait images were sensitive renderings of the individuals shown rather than stylised icons of the worker/mother. The subjects were named and individually detailed in a 'painterly' style which emphasised the unique marks of the artist's hand. In these works, Grundig strategically brought together a number of aesthetic traditions: the mass disseminated form of the etching, the high art portrait sitting, the individualised rendering techniques, the titles which define the sitters by name and political agency. The conjunction of multiple visual conventions defied a reading of the sitters as social types and raised them to the status of portrait sitters. The viewer is invited to understand both their particularity and their social significance simultaneously; while these were the mothers of the new

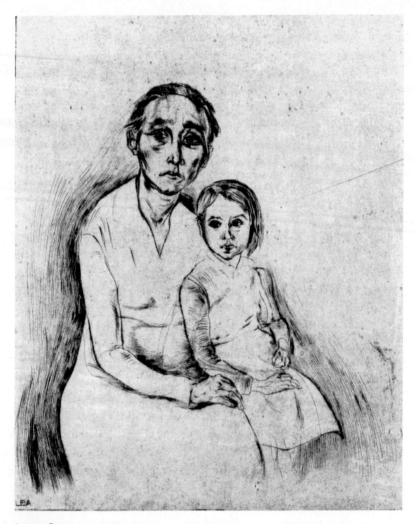

L E A G R U N D I G

Comrade Elsa Fröhlich and Sonni 1935

Courtesy of the Landesmuseum Oldenberg

working class they were not reducible to this single biological function.

Rühle-Gerstel criticised the home and family as a man's sphere with little space for the articulation of women's needs. Such a position suggests that she was sceptical of the followers of Rühle who would simply appropriate the domestic sphere as a nurturing political model without deconstructing the inherent gender-biases of the model. That is,

it was not sufficient for women to have men merely advocate child-care and domesticated politics in the public sphere, since women still went unacknowledged within the domestic order and without a voice in the public realm of the political. In order to obtain a 'domestic politics', the unequal power relations between men and women as they were currently defined in and through the separation of the public and the private spheres would first need to be renegotiated. Thus it was that Rühle-Gerstel and Grundig placed the situation of contemporary women at the centre of their political explorations in order to examine the complex interaction between class, economics and gender. This use of women as the locus through which to understand 'woman' and her role in capitalist structures was a strategy both fostered by Dresden's political climate and slightly distanced from it. The sheer variety of Grundig's representations of mothers and the domestic operated to defeat any single-stranded political ideology centred upon 'woman' and began the process of artic-ulating the many experiences of women.

DIFFERENCES BETWEEN WOMEN:
RACE AND EUGENICS

The multi-faceted approach to the theme of maternity in the work of Grundig suggests that attention was paid not only to the difference between men and women in relation to the domestic, but also to the crucial differences between women. This was a powerful manoeuvre, since it broke with any monolithic concept of woman or the mother in light of the specificities of lived identities as women and mothers. This approach enabled the sophisticated interplay between legislation, coer-cion and individual desire to be articulated and explored. Few women of the period fit neatly into the unsubtle categories which eugenists and ideologues defined in their attempts to label women as fit or unfit for maternity, and individual women could be pulled in different directions by the inherent internal inconsistencies in policy as well as by their own needs and desires in relation to maternity and abortion.

The work of Hanna Nagel epitomised this multiple framing of mater-nity and posed a crucial challenge to static forms of gender difference

which ignored differences in and between women. Nagel went to Karlsruhe in 1925, studying there with both Karl Hubbuch and Wilhelm Schnarrenberger, known for their political graphics. In 1929, she travelled to Berlin to continue her work as the *Meisterschülerin* of Emil Orlik, who likened her to Kollwitz because of her critical use of print-making and drawing.[43] Nagel went to Berlin with a fellow student from Karlsruhe, Hans Fischer, whom she married in 1931. Nagel's *oeuvre* was almost

HANNA NAGEL

Do My Children Really Look So Jewish? 1930

Courtesy of Irene Fischer-Nagel, Karlsruhe; © DACS 1998

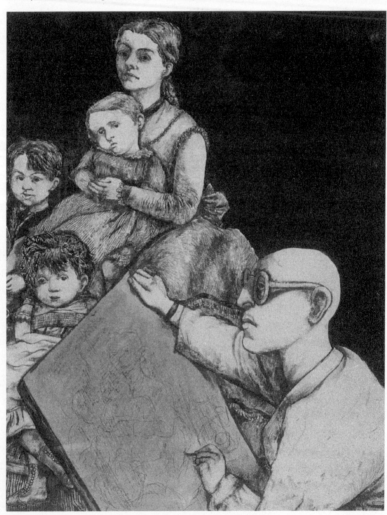

wholly comprised of graphic work and drawing and she had a sophisti-
cated understanding of the diversity of the medium, evidenced by the fact
that during the 1930s she won three prestigious prizes: the Rome Prize
(1933–4), the Dürer Prize (1936) and the Silver Medal for graphic art at
the 1937 Paris World Exhibition. Like the other artists discussed in this
chapter, Nagel used her situation as both a woman and an artist to
produce work on the theme of maternity, consistently framing the circum-
stances of motherhood within the socio-political climate of her day.
Nagel's particular orientation as a socio-critical graphic artist, interested
in exploring the ideological structures of the family, placed her firmly in
opposition to the eugenist policies of conservative factions in Germany.
Indeed, in her work of 1930, *Do My Children Really Look so Jewish?*, a
clear critique of the racial implications of *völkisch* population policy was
staged.

Do My Children shows the figure of Nagel posed as a mother with
three young children sitting for their portrait before a male artist – here a
likeness of Nagel's artist-husband Hans Fischer. The portrait sitting repre-
sented in the image relates to the contemporary significance of visible
racial stereotypes to eugenic theory. Negative eugenic policies relied
upon both documents of family lineage and obscene notions of racial
types, able to be seen and measured. Clearly, there were no justifiable
biological or genetic proofs for these tests of 'race'. They were arbitrary
signifiers of authority for the state which, with measuring implements,
pictorial tables and birth records, decided the fate of those with less
power than itself. Looking at the visual indicators of types and the
pseudo-scientific explanations of their significance in 'sociological' texts
from the 1920s such as *Volk und Rasse* enables the satirical thrust of
Nagel's work to be understood more fully.[44] On the one hand, the
diagrams and photographs of racial and regional types are laughable as
scientific 'proof' of racial or ethnic difference and are ridiculous asser-
tions of ignorance. Nagel's title *Do My Children Really Look so Jewish?*
parodies the utter uselessness of such a trial by sight. Yet at the same time
this was deadly serious; this arbitrary and absurd system would underpin
the extermination of millions.

At the time Nagel produced her work the most immediate threat was
the enforced sterilisation of women deemed racially unfit for mother-
hood, and the resulting complete obliteration of the power of women to
make choices about their reproductive lives. In this sense, *Do My Children*
typified the concerns of Nagel's other work in which she critiqued the

structures of domesticity and maternity through which women's indepen-
dent, individual identities and voices were usurped in favour of homoge-
neous roles as wife or mother. The reference in Nagel's work to the
artistic portrait-sitting suggests yet another context through which the
objectified woman was made inarticulate. In the historical relationship
between art and science, where observation and accurate rendering of
the body were paramount, 'artists' and 'scientists' established themselves
as specialists in positions of power over mute objects of enquiry.[45] In
gender-specific terms, male artists and scientists consistently placed the
female body, and in particular the interiority of women's reproductive
processes, at the centre of their visual explorations. To see what was invis-
ible from outside was to know the secret of genesis and, concomitantly,
to control birth and female sexuality. Traditionally, such a use of imagery
in science and art also placed the male subject at the centre of knowing
and power while situating woman as the object of the gaze, devoid of
self-determination and articulation.

The body of woman particularly became a contested site in the reli-
gious, scientific and political attempt to control the 'body politic'. That is
why eugenic theories are intimately tied to the figure of the mother and
to ideas about female sexuality; to control procreation is to control the
state and this cannot be done by a male establishment except through
the domination of women. Hence Nazi population specialists consistently
supported the widespread sterilisation of 'degenerate' women over that
of men, claiming that degenerate *mothers* were the cause of degeneracy
in children.[46] Moreover, the *sexual* degeneracy of 'racial' others was
always linked to female sexuality. That the 'primitive' sexuality of people
of colour was figured as the 'hyper-sexual' black woman can be demon-
strated, for example, by the popular reception of Josephine Baker as a
thrilling, urban 'primitive'. And, significantly, the 'degeneracy' of Jews
became linked to the trope of the homosexual woman.[47] The connections
within Nagel's work between eugenist policies, pseudo-scientific racial
theories and the power to represent woman in the visual sphere are reso-
nant with such historical links between art, politics and science.

Whether or not Nagel was herself aware of the full implications of
these links, she certainly understood the politics of 'seeing' race in the
period and the sexual politics inherent in the gendered relations of the
artist's studio. In numerous graphic works, Nagel considered the role of
the professional woman artist caught between public and private duties
most usually framed through self-portraiture. These works, such as *The*

Imperfect Marriage (1928) and *Self-Portrait* (1929), consistently expressed the tensions between the desire of the modern young woman artist for professional success in her own right and the demands of marriage and motherhood. In these works, a major dynamic is pictured through the image of the practising artist. In *The Imperfect Marriage* the sexual economy of the studio is maintained through the subjection of the woman artist (pictured here as Nagel herself) to her role as wife, mother, model and muse. This is illustrated graphically by showing the male artist as the active painter of the female nude and the woman artist (Nagel) merely the support of this iniquitous system, literally with her back to the canvas, holding the baby.

By contrast, *Self-Portrait* represented seven figures of Nagel in various situations including cradling an embryo in a jar of formaldehyde, powdering her nose while a male figure clutches imploringly at her legs and posing in the stylish androgynous fashions of the day. The figure at the centre of this work, through which all of these other figures are mediated, is the figure of Nagel at her drawing board, making art. Unlike *The Imperfect Marriage* in its representation of the active woman artist, the sexual *neue Frau* and the aborted foetus, *Self-Portrait* nonetheless considers the same problematic choice between maternity and art practice for young women. Its contemporary references to the many roles played by young women during the Weimar Republic were unmistakable. Figuring the double-burden of the quest for professional success and domestic bliss by young women showed just how the ideology of motherhood as well as the definition of 'woman' could be ambivalent in practice. Women often found themselves torn between their conflicting roles and desires rather than easily occupying one or other position.

Significantly, Nagel deployed different, strategic visual modes and tropes in order to express the variety of meanings which maternity could have for women. In *Do My Children*, Nagel has evoked both the gendered relationship between male artist and female sitter and a highly rendered etching technique which draws on the chiaroscuro of 'old master' drawing traditions. This is in marked contrast to the more linear style associated with contemporary fashion advertising aimed at the 'new woman' which she used, for example, in *Self-Portrait*. These differences were not just arbitrary style changes, but rather they indicated particular interconnections between visual conventions and meanings as they were experienced by women in the period and as they multiplied around the discourses of maternity. The use of the 'modern' visuals in *Self-Portrait*

made it intelligible in relation to the debates confronting young, fashionable, urban women regarding their reproductive choices and the rationalisation of the private sphere. However, the references to tradition in *Do My Children* was suggestive of the more particular context within which Jewish feminists in the period considered the place of motherhood in their lives.

In the official publication of the League of Jewish Women, *Blätter für die Jüdische Frau,* a struggle was taking place throughout the 1920s and early 1930s around the significance of motherhood for contemporary Jewish women situated, as they were, between the Jewish community with its traditions and the modern, urban German environment of which they were also a part. Within Judaism, maternity is especially significant with regard to lineage (and, therefore, 'racial' identity in this period) since it is the mother's line that determines 'Jewishness'. This meant that Jewish women under the burgeoning anti-semitism of the Weimar period carried a double burden: on one hand, they were responsible for the continuation of the Jewish race, on the other, they were responsible for having children whom they knew would be persecuted for being Jewish. The significance of the figure of the mother to visual racial typologies was made explicit by Lea Grundig in *Stormer Masks* (part of the *Guilty Jew* series of 1936), where a family portrait showed the central maternal figure with a hideous 'Jew' mask tied around her neck. The storm troopers' oppression of innocent Jewish children was determined by matrilineage; the 'guilt' of the Jews in Grundig's prophetic work was laid with the mothers. Neither was this a fantastic projection upon maternity, so frequently designated in and through the visual in science, art and mass media. There was no single answer to the dilemma of Jewish motherhood and the insistent, if conflicting, demands of maternity, for Jewish women can be seen as paradigmatic of the significance of differences between women and within the circumstances of individual women themselves.

The JFB was principally composed of middle-class, older Jewish women who recognised their roles within the Jewish community as wives and mothers as well as the changing place of women in the urban economy and within education and politics. Immediately, this produced certain conflicts between generations of Jewish women choosing either to have children or to pursue higher education and a career. The question of assimilation too was particularly important to women of this class and age and they often held their German origins as a significant mark of difference between themselves and Eastern European Jewish immigrants.

Hence, through their dual orientation as middle-class German women *and* as Jews, there could be no simple, singular choices with regard to maternity. Multiple and seemingly inconsistent strategies emerged and thus it was, for example, that the JFB controversially sought to protect unwed mothers and prostitutes while never espousing 'neo-Malthusian' arguments or supporting abortion rights.[48] The debates about Zionism which were voiced in the *Blätter für die Jüdische Frau* indicate how significant the divisions were between Jewish women in terms of their double roles as Germans and Jews and the critical role that choices about maternity played in these constructions of identity. A woman's position with regard to ethnic and religious identity as well as her relationship to her own vocation, socio-economic role and biological self-determination hinged upon her decisions with respect to maternity.

The role of the visual in these racial debates concerning maternity was clear; the pseudo-scientific racial types described above became the racist clichés in the mass media. There were definite fears voiced in the Jewish community about 'appearance': appearing too wealthy and ostentatious as well as 'too Jewish'. Nagel's title about the mother's fear of her children looking too Jewish was on target, as was the sense in the title that the 'mother' felt responsible for the dangerous racial inheritance of her children. Particularly within the pages of the JFB press, the issue of women's appearance was polarised between advertisements using fashionable images of the modern, urban *neue Frau* and those favouring more traditional graphics to represent housewives and mothers with old-fashioned clothes and hairstyles. The former generally advertised beauty products and, tellingly, the latter were mainly concerned with kosher foodstuffs.[49] Hence Nagel's invocation of the traditional rendering of the Jewish mother and her children drew on a contemporary trend which associated a form of imagery with a conventional community role as wife and mother and, perhaps, a longing for an idealised, unthreatening past. This work detailed another fragment of her critiques of maternity within the specificity of women's differing socio-political situations.

Thus Nagel's *oeuvre* could and did easily encompass different trajectories of the maternal in different women's particular circumstances. Moreover, differing visual tropes were deployed to make these points more specific and challenge any singular, prescriptive ideal of motherhood. Motherhood could be a desired, but feared, condition for a Jewish woman caught between her traditional community and the state in which she lived, or maternity could represent the coercive ideal of the state,

forced onto young women just beginning to explore more public roles. Not surprisingly, Nagel also entered the heated debates on abortion rights with an etching on the subject of the infamous Paragraph 218 in 1931. Abortion was an incendiary political and moral issue during the years of the Republic and critically connected to the construction of motherhood within the state. As the other side of the maternity debate, the fight for the right to legal, safe abortion brought the spectre of the mother yet again to prominence as a primary focus for political activism and visual symbolism.

ABORTION: THE RIGHT TO CHOOSE

Arguably the single most significant public political action undertaken by women during the Weimar Republic was the struggle for abortion rights. The scale of women's involvement in this struggle and their considerable public presence made abortion campaigns a crucial platform for the development of Frauenkultur. Like the multiple responses to the issue of maternity during the period, women were not wholly unified on the question of abortion, but there was a marked trend in the debates among women, both those propounded by women's groups in the party political context and those asserted by women doctors within the broader sphere of medical science, toward female self-determination.[50] Although, in the final analysis, the abortion debates led only to minor revisions of the legislation in the 1920s and ultimately to the male-dominated medical authorities gaining further control over women's reproductive rights, the voices of women of the period on this issue should not be ignored or undervalued. The very fact of their participation in the public campaigns and their different viewpoint on the issues significantly altered the terms of the debate itself.

In general, political parties and men in the medical and scientific communities tended toward broad lines of agreement on the issue of abortion, suggesting it only as a last option when motherhood was not physically or economically endurable.[51] Motherhood was still the paradigmatic choice for women and still meant to be encouraged actively. However, by the 1920s only Catholic women's groups, right-wing extremists and former Wilhelminian 'pro-natalists' held that there was no excuse for abortion under any circumstances. For these thinkers, women needed to be taught that maternity was both their joy and their punishment for

sexual transgression. 'Neo-Malthusianism', or the idea of quality rather than quantity in the birthrate, became the more dominant line of thinking by the 1920s and this tempered the views of extreme pro-natalists.[52]

Conservative neo-Malthusians, such as *völkisch* parties of all forms, supported positive measures to encourage birth amongst the 'fit' and compulsory sterilisation and/or abortion for the 'unfit'. The 'fit' and 'unfit' were, of course, those whose racial origins were deemed undesirable by the party. However, neo-Malthusianism was also an operative principle in the centre and left of the political spectrum, where abortion was seen to be advisable in certain circumstances, such as for the physically and mentally ill, raped women or women whose economic conditions made the birth of a child untenable. All of the types of 'circumstance' mentioned by neo-Malthusians were perceived to affect the 'quality' of the offspring and its life more than that of the women involved. Thus, in general, political parties were mainly concerned with collectivist ideals of the health of the populus rather than an individual woman's right to choice and supported abortion only as a necessary evil when the natural role of women could not be fulfilled.

The male medical establishment exhibited similar attitudes toward the issue of abortion, with right-wing doctors being strongly opposed to terminations and more centrist doctors supporting some instances of abortion according to circumstances. For the most part, doctors stressed that abortion was a medical issue and should be taken under the direction of the medical establishment. This was meant to promote safe, hygienic abortions, but also placed female reproductive rights firmly into the hands of a particular group of empowered specialists.[53] Women politicians, social commentators and particularly doctors, of whom there were many practising during this period, argued forcibly and frequently that all decisions regarding the private and public implications of abortion be made by women themselves.[54] As Elsa Hermann, the leader of a sexual advice centre in Berlin Kreuzberg, wrote in 1931, 'It should be help given from woman to woman'.[55] They suggested that only women professionals knew both the public debates and the private experiences of reproduction and thus were in a privileged position to determine policy. Moreover, since women doctors often specialised in the treatment of female patients, and female politicians often campaigned most vociferously for 'women's issues', they again suggested that they were in a unique position in regard to these debates; this position could now be framed as an instance of *Frauenkultur*.

There is clearly an argument that only women in the period could understand to what extent maternity and abortion could affect the lives of women in different circumstances, though that does not mean that women were always in favour of *other* women's rights. Nonetheless, rather than merely reading maternity and abortion in terms of the collective good of the populus, women were uniquely placed to see the indi-

ALICE LEX-NERLINGER

Paragraph 218 1931

Courtesy of the Stadtmuseum Berlin

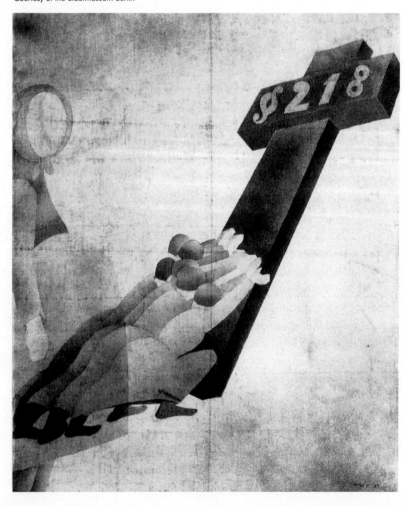

vidual circumstances such as the way positive inducements could be both ideal for women desiring motherhood *and* uncomfortably coercive for women seeking new public identities. It is perhaps unfortunate that the circumstances of maternity were so complex for women that they could not stand as a unified political force in the period and thus were made marginal in the final decisions of the government regarding reproductive rights. Cornelie Usborne, for example, rightly pointed to the polarity of women's opinions on abortion rights during the period as part of their weakened political position.[56] Yet this fact can be seen to have been an inherent problem within the subtle positions of women discussing these issues. It is more suggestive of the inadequacy of the language of the debate itself that women were arguing within terms and structures neither of their own making nor responsive to their own experiences. Hence it is hardly surprising that they took radical and divided lines on the subject.

Women artists who chose to engage directly with the abortion campaigns did so in fairly immediate and compelling mass media forms. For example, Käthe Kollwitz produced a poster for the KPD in 1924 entitled *Down with the Abortion Paragraph*, Hanna Nagel produced an etching entitled *The Paragraph* in 1931 and Alice Lex-Nerlinger in the same year produced a campaign poster, *Paragraph 218*. Significantly, each of these political works used the figure of the mother to illustrate abortion activism. Rather than show a young *neue Frau* for example, the more sympathetic imagery centred upon linking the 'poor mother' with the need for abortion rights to end her suffering and that of future generations of unwanted and impoverished children. In some ways such a strategy was highly traditional, but also evocative and effective within the terms of the abortion debate of the period.

In order to make their case resound with public feeling, anti-abortionists commonly exaggerated the link between abortion and the perception of frivolous, promiscuous sexual activity among young urban women or, as Nazi theorist R. W. Darré put it, '. . . those who apparently understand the highly praised "personal freedom" of the woman to mean only the freedom to taste all the joys of a "bedfellow" at their discretion and preferably without limit'.[57] Consequently, campaigners for abortion rights in a sense were forced to assert the moral and intellectual fitness of women choosing abortion. This was most easily asserted through references to the stereotype of the nurturing mother whose lack of control over her own fertility (the same legislation which made abortion criminal made contraceptive devices and advice difficult to obtain) put her into the

desperate position of seeking an abortion. Thus, it was not that women were stupid or promiscuous, rather that the information and assistance they needed in order to make informed choices were being withheld. They were figures of sympathy, not castigation.

This ploy was clearly the most effective in turning public sympathies toward the campaigners' ends and the literature, theatre and visual arts of the period which were in support of abortion rights used this tack consistently. The play *Cyankali* by the doctor and pro-choice campaigner Friedrich Wolff, who with Dr Else Kienle was imprisoned in 1931 for his role in helping women obtain safe abortions, struck a chord with its focus upon the suffering of mothers. Also, the most famous publication concerning the abortion crisis, Dr Else Kienle's *Diary of a Woman Doctor* from 1931, told emotive tales of the impoverished conditions in which working-class women strove to raise families.[58] The women coming to Kienle for abortions were not promiscuous young girls experimenting with numerous sexual partners and then using abortion as a form of late contraception; they were women who, through no fault of their own, needed to terminate a pregnancy in order to better support the families they already had. Hence the suffering of the 'good mother' was the para-digmatic argument for abortion rights, even amongst such radical campaigners as Kienle, who supported abortion on demand for all women.

Yet there were subtle differences between the representations of the mother within the campaign. As Atina Grossmann perceptively noted, Kollwitz's strategy of using the suffering mother as the central figure in her KPD poster of 1924 was changed by Lex-Nerlinger in 1931 when she produced her poster *Paragraph 218*. Lex-Nerlinger still placed the spectre of the mute pregnant woman on the left of her image, but the central figures in the piece were a group of women together, pushing over the symbol of the paragraph. Grossmann rightly suggested that this shift in emphasis was consistent with a change of perception within the campaign from the mid-1920s to the crisis year of 1931, during which time women began to envisage themselves as active and unified political agents able to effect changes through their own efforts rather than to simply await change from outside. Hence, though the pregnant figure is still part of the language of the piece, she is side-lined by the active agency of women.

The work by Lex-Nerlinger was also different from that of Kollwitz for aesthetic reasons and we must be careful not to forget that 'form' acted

as more than just an empty vessel through which 'content' could be expressed; in themselves, formal devices carried explicit political significance. Alice Lex-Nerlinger and her artist-husband Oskar Nerlinger worked closely together throughout their lives in the service of political art. They were active members of the KPD and the ARBKD during the Weimar Republic and, together, founded a revolutionary artists' group called *Die Zeitgemäßen* ('the contemporaries') in 1924.[59] With her husband she experimented in materials and formal techniques which would convey the proletarian messages of her work best, settling during this period on both photomontage and *Spritzblatt*, a form of spray painting appropriate to posters and other mass-disseminated forms. *Paragraph 218* deployed the *Spritzblatt* technique and was thus intended to demonstrate the technological, constructivist bias of the work. When it was shown in the now-famous *Frau in Not* (literally, Woman in Need/Emergency) exhibition in 1931, its form as well as its content were read as revolutionary and subversive.[60] It was removed and Lex-Nerlinger questioned by the police.

Clearly, the changes within the abortion campaign as a political event were significant in the production of imagery associated with it. The differences between the work by Kollwitz and that by Lex-Nerlinger were, in part, determined by this context. However, the differences in the women's representational strategies also responded to the multiple encoding of the issue amongst women throughout the period and not just to a unified and directed change in perception over time. Thus it was that Hanna Nagel's work of 1931 bore no references in its iconography to collective women's action and concentrated wholly on two suffering pregnant figures, rendered in a 'painterly' etching technique. There was no sense in which Nagel was less critical of the abortion paragraph than Lex-Nerlinger, and in fact her work far more frequently turned on the subject of maternity in women's disparate situations in the Weimar Republic than did that of Lex-Nerlinger.

But it must be remembered that even art in the service of politics does more than merely reflect ideologies; it constructs meanings across a range of possibilities. Hence, Kollwitz's imagery of mothers and children was derived both from her political sympathies and her artistic affiliations with academic conventions and canonical iconographies such as the Madonna and Child and the female nude. Kollwitz's work brought these artistic conventions into conjunction with the contemporary situation of the proletariat in an emotive, painterly etching style. This nexus was

powerful and political, but not simple party-line politics.[61] Differences in age and experience were crucial too, since from a very different perspective and a generation younger than Kollwitz, Lex-Nerlinger adopted a style associated with the objectivity and rational, technological advances of the day. Using this legible formal link with contemporary aesthetic politics associated with the Russian constructivists produced a very different image of the massed proletariat as a unified, mechanised force. Thus, her central female figures were both a political and aesthetic mark of allegiance.

Hence, even women artists with very similar political perspectives deploying similar subject-matter produced different aesthetic forms of articulation in relation to the subjects of maternity and abortion in their works. In this sense, it is worth exploring the subject of maternity as a theme in women's practice from the perspective of the aesthetic debates concerning the role of maternal subjectivity in the creative process itself. During the Weimar Republic, traditional associations of man with culture and woman with nature ensured that masculinity was integrated into the very concept of artistic creativity as a public, cultural act. By contrast, the mother had fulfilled her 'creative' role in her private, 'natural' birth-giving. A number of contemporary feminist theorists have further considered the intimate relationship between maternal subjectivity, the acquisition of language and art practice. They have argued that the appropriation of the maternal by male artists, both through the obsessive rendering of an empty image of the mother and by a cultural inscription of 'birth-giving' as a model for art production by men, is symptomatic of the effacement of maternity in our society. Thus, just as the 'myths' of the mother require exploration, so too does the link between the maternal, women and art practice.

WOMEN ARTISTS AND

MATERNAL SUBJECTIVITY

As the whole of this chapter demonstrates, during the course of the Weimar Republic, women used the theme of motherhood to articulate powerful identities in the public realm. This is interesting since it shows how a seemingly private experience and personal symbol could be mobilised in order to develop a collective, political platform for formerly

marginal subjects. The 'mother' thus provides a case study in finding a voice through using traditional discourses alternatively. And, if women artists were, for the most part, unable to engage fully with the modernist tropes of woman centred upon the sexualised prostitute, model and mannequin, the mother was one stereotype through which they could articulate.

There were distinct social reasons for this. For example, many more women experienced maternity than prostitution, and these experiences were perceived to be important and worthy of attention if only through their mediation by the masculine state. Thus women engaged in debates about maternity may have been marginalised through references to 'women's issues', but they were not castigated as 'whores'. Through maternity, therefore, women had a direct route to intervention in state policy and they used this to their advantage. Moreover, motherhood and the ideologies associated with it affected women directly, if in different ways. This made it a good point of communication between women, a necessary component for any burgeoning political collectivity and a sense of *Frauenkultur*. Either in individual women's decisions to have or not have children, or their fears of economic instability, negative racial policies or the loss of their newly-gained independence, motherhood was part of their life experience. Women artists shared this social climate and moreover often had children and/or made a profit from the representation of mothers and children. [62] Thus, immediate social conditions placed maternity as a significant feature in the lives and artworks of women in the period.

However, it did not give them a unified response to the theme or in any way indicate a particular, biological imperative to be enacted through their artwork. Rather, the sheer diversity of work on the theme attested to its significance and its potential to iterate multiple identifications for women. Rosemary Betterton defined one of these in the work of Kollwitz and Paula Modersohn-Becker. [63] Using the theoretical observations of Kristeva to delve into the theme of the nude mother in the work of both artists, Betterton argued that in these works, Kollwitz and Modersohn-Becker were able to explore their relationship to being both women and artists. Noting that current concepts of creativity would ordinarily have separated the two by asserting artistic creativity to be the realm of masculinity and men, and procreativity to be the domain of women, Betterton demonstrated that in these works Kollwitz and Modersohn-Becker brought those two realms together aesthetically. This

GERTA OVERBECK

Self-Portrait at an Easel 1936

Courtesy of Frauke Schenk-Slemensek, Cappenberg

was a device which confounded the traditional subject/object divide and asserted the potential of maternal subjectivity for women making art, rather than the appropriation of its power by men.

The generation of women artists to mature during the 1920s and 1930s frequently looked to both Modersohn-Becker (who died in 1907) and the still-active Kollwitz as models of successful female practice. Yet the work of this later period rarely imaged the nude mother. Rather, there

were numerous self-portraits of women artists with children and, in a unique work, Gerta Overbeck represented herself pregnant and in the act of painting. *Self-Portrait at an Easel* of 1936, epitomised the complex relationship between women as artists and the tropes and debates centred upon maternity. Its meanings are both social and personal, both determined by and determining the contemporary definitions of women's roles as mothers. Obviously, this work visually joined the pregnant figure with that of the artist; it thus entered into the debates around working mothers, creativity and procreativity and the simultaneity of the subject as the object in self-portraiture.[64] The painting's iconography of the artist at an easel calls to mind the traditions of self-portraiture around the so-called *Berufsporträt* or 'occupational portrait'. By using this traditional visual arrangement and the form of a completed oil painting, Overbeck challenged a fine art tradition in which mothers are occluded as makers of culture. The viewer is positioned both inside and outside this tradition through this visual conjunction and is able to see its inherent gender bias. The situation of women as both mothers and makers of art challenged the public/private divide spatially and ideologically and Overbeck's work placed her own image on the contested border between these spheres. She represented herself as a clothed practising artist in front of the recognisable details of the city of Mannheim, but also as the pregnant woman, indoors.

Significantly, Overbeck was a single mother. She arranged to marry the writer Gustav Schenk, the father of her daughter, to ensure her only child's legal status, but did not live with him. He remained friends with Overbeck and in close contact with his child, but there was never a traditional nuclear family desired or in place. Thus *Self-Portrait at an Easel* was literally as well as figuratively an alternative representation of maternity stressing the independence of the woman as both procreative and a maker of culture. Her status as a mother could not be defined easily within patriarchal institutions; it was an instance of the specificities of maternity during the period and the ways in which women sought to voice their self-determination. It was but one way of exploring the multi-faceted issue and one which stressed the differences between women in the face of overriding monolithic stereotypes.

As argued throughout this chapter, women mobilised the figure of the mother in multiple rather than singular ways in order to articulate complex public identities and the importance of self-determination in reproductive choices throughout the Weimar Republic. The figure of the

mother and the associated issues of abortion, contraception, eugenic policies and women's work provided a key platform for the development of a genuine *Frauenkultur*. This was further developed, as we shall see, through the rationalisation of women's labour, women's negotiation of the media projection of the *neue Frau* and in their speculative engagements with definitions of female sexuality. These were important challenges to static conceptions of gender in their day and the prerequisite of contemporary feminist thinking and the gains achieved for women since the 1960s.

However, in the instance of maternity and state population policy in Weimar, the radical voices of women were able to be marginalised by their very diversity. For example, the *Bund für Mutterschütz* supported single mothers, monogamous marriage and the nuclear family, alternative family structures, abortion rights and, always, freedom of choice. This organisation was immediately disbanded by the National Socialists and had no platform for redress. The problem was that the multiple and individualistic approaches to maternity put on the agenda by the far left and women's groups could not displace the dominant tendency to situate women and their reproductive roles in relation to the state. These positions which defined woman as a monolithic 'mother' to the nation actually served to link left and right. When National Socialism enacted state population policies, there was no ground from which to challenge them since other parties differed only in their definitions of 'fit' and 'unfit', not in their subordination of woman to the state. Women's disparate calls for self-determination provided the only true challenge to the policies which engendered the mass extermination of the Holocaust, but they were not yet powerful enough.

NOTES

1 There is some controversy over the identity of the artist of this work. In his catalogue to the
 Marvin and Janet Fishman collection, of which the Koeppen picture forms a part, Reinhold
 Heller refers to the artist Margarete Koeppen as possibly being the author of the piece. Little is
 known of Margarete Koeppen except some references to her watercolours by Paul Westheim in
 1938. See Reinhold Heller, *Art in Germany 1909–1936: From Expressionism to Resistance. The
 Marvin and Janet Fishman Collection* (Munich, Prestel Verlag, 1990), p. 194. In my enquiries
 regarding the painting, the Fishmans' staff sent me a brief note to confirm the identity of the
 artist as Dorothea Wüsten-Koeppen and I feel compelled to use this since it matches the
 blurred signature. In either case, the fact remains that the work was produced by a woman
 artist now all but completely unknown and signed in such a way as to obscure her identity as a
 woman artist in the period.

2 Karin Hausen, 'Mother's Day in the Weimar Republic' in *When Biology Became Destiny: Women
 in Weimar and Nazi Germany*, edited by Renate Bridenthal, Atina Grossmann and Marion
 Kaplan (New York, Monthly Review Press, 1984), pp. 131–52.

3 Ibid. , p. 136.

4 That is not to say that women did not voice opinions on prostitution during the period, just that
 the issue of motherhood was more commonly discussed and that women began to claim a
 particular authority within these debates.

5 T. W. Mason, 'Women in Germany 1925–40: Family Welfare and Work', *History Workshop
 Journal*, no. 1, 1976, pp. 74–113 and vol. 2, 1976, pp. 5–32, 95–6.

6 See the *Illustrierter Beobachter*, vol 22, 3 June 1933, p. 617.

7 Gisela Bock, 'Racism and Sexism in Nazi Germany: Motherhood, Compulsory Sterilization and
 the State' in *When Biology Became Destiny*, op. cit. , p. 276.

8 R. W. Darré, 'Marriage Laws and the Principle of Breeding' (originally in *Neuadel aus Blut und
 Boden*, [Munich, Lehmanns Verlag, 1930]), translated and reprinted in *The Weimar Republic
 Sourcebook*, edited by Anton Kaes, Martin Jay and Edward Dimendberg (Berkeley, University of
 California Press, 1994), pp. 136–7.

9 Cornelie Usborne, *The Politics of the Body in Weimar Germany: Women's Reproductive Rights
 and Duties* (New York and London, Macmillan Press, 1992), pp. 38–9.

10 Ulrike Sieglohr, *Focus on the Maternal: Female Subjectivity and Images of Motherhood* (London,
 Scarlet Press, 1998).

11 Julia Kristeva, 'Stabat Mater', translated and reprinted in *The Kristeva Reader*, edited by Toril
 Moi (Oxford, Basil Blackwell Ltd, 1986), p. 161.

12 Rosi Braidotti, *Nomadic Subjects: Embodiment and Sexual Difference in Contemporary Feminist
 Theory* (New York, Columbia University Press, 1994), p. 181.

13 Iris Marion Young, 'Pregnant Embodiment: Subjectivity and Alienation' in *Throwing Like a Girl
 and Other Essays in Feminist Philosophy and Social Theory* (Bloomington and Indianapolis,
 Indiana University Press, 1990), pp. 160–76.

14 Kristeva, 'Stabat Mater', op. cit. , p. 169.

15 Braidotti, op. cit. , p. 174.

16 Alice Rühle-Gerstel, *Das Frauenproblem der Gegenwart: Eine Psychologische Bilanz* (Leipzig,
 Verlag von S. Hirzel, 1932), pp. 26–9.

17 Luce Irigaray, 'Women – Mothers, The Silent Substratum of the Social Order', translated and
 reprinted in *The Irgaray Reader*, edited by Margaret Whitford (Oxford, Basil Blackwell, 1991),
 p. 50.

18 Irigaray, 'The Bodily Encounter with the Mother' translated and reprinted in *The Irigaray Reader*,
 op. cit. , pp. 34–46, 39.

19 *Nationalsozialistische Mädchenerziehung*, vol. 4, April 1937, pp. 88–92.

20 Irigaray, 'Women-amongst-Themselves: Creating a Woman-to-Woman Sociality', translated and reprinted in *The Irigaray Reader*, op. cit. , pp. 190–7.

21 Usborne, op. cit. , pp. 192–3.

22 Gertrud Bäumer, *Die Frau im Deutschen Staat* (Berlin, Junker und Dünnhaupt Verlag, 1932).

23 Even during the Third Reich, this economic element was noted. See 'Die Tätigkeit des jungen Mädels in des Nationalsozialistisches Volkswohlfahrt', *junge dame*, no. 23, June 1935, p. 7.

24 Luise Scheffen-Döring, *Frauen von Heute* (Leipzig, Verlag Quelle und Meyer, 1929). Scheffen-Döring devoted whole chapters to the peculiarity of the social order in which mothers worked.

25 See 'Auflösing des Bundes Deutscher Frauenvereine' in the *Blätter für die Jüdische Frau*, no. 7, 30 June 1933, front page.

26 See Georg Reinhardt, 'Zwischen Atelier und Straße: Zur Geschichte und Malerei der Neuen Sachlichkeit in Hannover' in *Neue Sachlichkeit in Hannover*, exhibition catalogue (Hannover Kunstverein, 1974), pp. 8–12.

27 See 'My Workday, My Weekend' (originally in *Mein Arbeitstag, Mein Wochenende. 150 Berichte von Textilarbeiterinnen*, edited by Deutscher Textilarbeiterverband [Berlin, Textilpraxis Verlag, 1930]), translated and reprinted in *The Weimar Republic Sourcebook*, op. cit. , pp. 208–10.

28 Marsha Meskimmon, *Domesticity and Dissent: The Role of Women Artists in Germany 1918–38* exhibition catalogue, compiler A. Wadsley (Leicester, 1992).

29 AIZ 36/1927 reprinted in *Neue Frauen: Die Zwanziger Jahre, BilderLeseBuch*, edited by Kristine von Soden and Maruta Schmidt (Berlin, Elefanten Press, 1988).

30 On Schrag's artistic isolation, see Karl Brix, 'Die Malerin Martha Schrag (1870–1957)', *Bildende Kunst*, vol. 26, pt. 4, 1978, pp. 187–90.

31 Else Wex, *Staatsbürgerliche Arbeit deutscher Frauen 1865–1928* (Berlin, F. A. Herbig Verlagsbuchhandlung, 1929), p. 47.

32 Usborne, op. cit. , p. 49.

33 Scheffen-Döring, op. cit. , pp. 74–6.

34 I refer the reader to the numerous and very well-illustrated volumes on the work of Käthe Kollwitz; since illustrations in the present work were limited, they were used for lesser-known works: see, for example, Elizabeth Prelinger, *Käthe Kollwitz* (New Haven, Yale University Press, 1992).

35 *Lea Grundig: Jüdin, Kommunistin, Grafikerin*, exhibition catalogue (Berlin, Ladengalerie, 1996) (and travelling).

36 'Manifesto for International Women's Day' (originally from *Die Kommunistin*, no. 6, 25 March 1921), translated and reprinted in *The Weimar Republic Sourcebook*, op. cit. , pp. 198–9.

37 August Bebel, *Woman Under Socialism*, translated from the 33rd edition by Daniel de Leon (New York, New York Labor News Press, 1904), pp. 85–6.

38 'Das eigene Land mit vollem Frauen Rechten', *Rote Fahne*, no. 5, 1937, p. 11. Translation the author's.

39 Usborne, op. cit. , pp. 162–3.

40 Otto Rühle even wrote about children; see 'The Psyche of the Proletarian Child' (originally from *Die Seele des proletarischen Kindes* [Dresden, Verlag am Anderen Ufer, 1925]), translated and reprinted in *The Weimar Republic Sourcebook*, op. cit. , pp. 223–4.

41 Shulamith Behr, 'Between Politics and the Studio: Felixmüller as Revolutionary and Degenerate' in *Conrad Felixmüller, 1897–1977: Between Politics and the Studio*, exhibition catalogue, edited by Shulamith Behr and Amanda Wadsley (Leicester, Leicestershire Museums, Arts and Records Service, 1994), pp. 35–45.

42 An illuminating study of the significance of the 'parvenu' and the 'pariah' can be found in Richard J. Bernstein, *Hannah Arendt and the Jewish Question* (Cambridge, Polity Press, 1996).

43 Nagel's association with Kollwitz, including a letter from the artist in response to Nagel's ideas,

are documented in *Ich zeichne weil es mein Leben ist*, edited by Irene Fischer-Nagel (Karlsruhe, Verlag G. Braun, 1977), p. 17 reproduces the letter.

44 *Volk und Rasse*, first founded 1926.

45 The intimate relationship between scientific and 'aesthetic' studies of the body was well-demonstrated in *The Quick and The Dead*, exhibition held at the Royal College of Art and travelling, October–November 1997.

46 Bock, op. cit. , p. 275.

47 Lynne Frame, 'Gretchen, Girl, Garçonne? Weimar Science and Popular Culture in Search of the New Woman', in *Women in the Metropolis: Gender and Modernity in Weimar Culture*, edited by Katharina von Ankum (Berkeley, University of California Press, 1997), pp. 12–40.

48 Marion Kaplan, 'Sisterhood Under Siege: Feminism and Anti-Semitism in Germany, 1904–1938' in *When Biology Became Destiny*, op. cit. , pp. 174–96.

49 See the advert in *Blätter für die Jüdische Frau*, 16 March 1934, for margarine in which an old-fashioned mother figure serves her husband and sons their food at *Sedertisch* in order to understand the very different *visual* evocation of the Jewish woman in such advertising.

50 Usborne, op. cit. , p. 194.

51 Manfred Georg, 'The Right to Abortion' (originally in *Die Weltbühne*, 18, no. 1, 5 January 1922), translated and reprinted in *TheWeimar Republic Sourcebook*, op. cit. , pp. 200–2.

52 For definitions and discussions of the terms 'neo-Malthusian' and 'pro-natalism', see Usborne, op. cit. (especially the introduction to the volume) and Kristine von Soden, *Die Sexualberatungsstellen der Weimarer Republik 1919–1933* (Berlin, Edition Hentrich, 1988), pp. 13–35.

53 Usborne, ibid. , p. 200.

54 Ibid. , p. 193.

55 Elsa Hermann quoted in von Soden, op. cit. , p. 118. Translation the author's.

56 Usborne, op. cit. , p. 200.

57 R. W. Darré, op. cit. , p. 136.

58 Else Kienle, *Frauen: Aus dem Tagebuch einer Ärztin* (Berlin, Gustav Kiepenheuer Verlag, 1932).

59 *Alice Lex-Nerlinger, Oskar Nerlinger: Malerei, Graphik, Foto-Graphik*, exhibition catalogue (Berlin, Akademie der Künste der Deutschen Demokratischen Republik, 1975), p. 12.

60 Interestingly, Oskar Nerlinger, who fully supported his wife's practice, wrote about this. See *Alice Lex-Nerlinger, Oskar Nerlinger*, op. cit. , p. 17.

61 Marsha Meskimmon, 'Politics, The *Neue Sachlichkeit* and Women Artists' in *Visions of the Neue Frau: Women and the Visual Arts in Weimar Germany*, edited by Marsha Meskimmon and Shearer West (Aldershot, Scolar Press, 1995), pp. 9–27.

62 See Chapter 3 for further details of Grethe Jürgens's association with the theme of children.

63 Rosemary Betterton, *An Intimate Distance: Women, Artists and the Body* (London and NY, Routledge, 1996); see chapter 2.

64 Marsha Meskimmon, *The Art of Reflection: Women Artists' Self-Portraiture in the Twentieth Century* (London, Scarlet Press, and NY, Columbia University Press, 1996).

MARTHA HEGEMANN

Family Portrait c.1924

Courtesy of Johann P. Räderscheidt, Cologne

THE
HAUSFRAU

N 1924, THE COLOGNE-BASED PAINTER Marta Hegemann produced a portrait of herself, her two children and her then-husband Anton Räderscheidt, another well-known modernist painter of the day.[1] Hegemann's attitude to domestic bliss in *Family Portrait* was described by Erika Esau in a fascinating essay about the Weimar phenomenon of the 'companionate marriage' between artists as:

> . . . quite different; she mocks the traditional idea of the patriarchal family, presenting the young father as rather ridiculous in his role. Little angels float above his head, holding his stiff hat as if it were a halo. The wife and mother is portrayed with the attributes of the housewife, holding Hegemann's favoured emblem of motherhood and domesticity, a small lamp.[2]

Esau's assessment of this work and the discrepancy between ideal and reality in the 'modern' marriage of Hegemann and Räderscheidt was astute. Despite their adherence

to the fashionable tropes of the young, urban, socially-advanced couple in their aesthetics and their public lives, when things became politically and financially difficult during the 1930s, Räderscheidt abandoned the family and left Hegemann to fend for herself and their children. Underneath the rhetoric, the gendered power relations of the traditional, patriarchal nuclear family still pertained. *Family Portrait* speaks of the problematic figure of the *Hausfrau* during the Weimar Republic, situated as she was between the new and potentially liberating identities for modern women and the conventions which located women securely within the domestic sphere playing the role of wife, mother and caretaker of the household. During the inter-war years, women's relationship to the patriarchal, heterosexual order of domesticity was in flux and the figure of the *Hausfrau*, until this time the bedrock of the family unit, was destabilised.

Family Portrait gave visual form to the tensions underlying the family structure in the face of changes to women's public and private roles. In the image, the figure of Hegemann herself is the most contradictory. The children are represented as especially tiny, cherubic figures, like pretty dolls to be dressed up. The portrait of Räderscheidt, as Esau suggested, is a ludicrous parody of the dominant father-figure with his stiff hat, even stiffer suit and sober expression. Yet the father and children still conform, however amusingly, to highly traditional symbols of the patriarchal unit. The wife and mother, however, is represented through two different and competing visual codes. In one respect, the self-portrait image shows Hegemann in a rigid costume of domesticity; the figure is clothed in a frilly dress with a decorative apron on top and she holds both a doll-child and a lamp. But, contrarily, her image is constructed through the decidedly contemporary codes of the *neue Frau* with mannequin-like, fashionable make-up and her trademark dark *Bubikopf* hairstyle.

There was no way in which such tropes of the new woman entered Hegemann's portrait by accident or coincidence. As is described in the next chapter, the visual clichés of the *neue Frau* were ubiquitous in the period and intelligible to a wide range of viewers irrespective of their position on female emancipation. A woman artist of the day, as both a consumer of images of woman and a maker of visual work, could not have been unaware of this popular iconography. Hegemann herself was known for playing with fashion and masquerade in her role as part of Cologne's 'progressive' art scene. Within the Dada group and the 'Group Stupid' during the 1920s, Hegemann and Räderscheidt used

their appearance (in costume at balls and in modish street clothes) as a form of aesthetic transgression of conventional bourgeois roles. Hegemann, and her friend and fellow artist Anjelika Hoerle, wore modern forms of dress and hairstyle to assert their independence as professional artists and as women with an important role to play in the avant-garde.[3] Even more tellingly, Cologne was the home of the social-realist photographer August Sander who, throughout the 1920s, was engaged on a project to document the entire gamut of social 'types' in contemporary Germany. These photographs were the backbone of published volumes such as *Antlitz der Zeit* (1929) and are now well-known despite large-scale Nazi destruction of negatives in the years of the Third Reich. Hegemann and Räderscheidt were photographed on many occasions by Sander representing typical bohemian 'artist-types' and the modern artist-couple. Hegemann, in particular, was used for his project to epitomise the woman artist and *neue Frau*; there simply could be no way for Hegemann to have remained unaware of her image as a visual icon of artistic female emancipation.[4]

Hence the mixed visual codes through which Hegemann deliberately pictured the *Hausfrau* in the *Family Portrait* were paradigmatic of the changes being wrought in the domestic sphere through the redefinition of the position of women. It was recognised at the time that it was the complexity of women's social roles and their changing situation as both private, domestic care-givers and public, professional and political agents which was altering the nature of the family structure. As Lola Landau, a well-known sex reform campaigner of the period, wrote of the phenomenon of the 'companionate marriage' in 1929:

> At the center of these fermenting forces is the woman of our day. As an autonomous person economically and intellectually independent from the man, the new woman shattered the old morality. The compulsory celibacy of the young woman and the indissolubility of marriage were invalidated by the straightforward reality of life. . . . The marriage of the future. . . will unite the woman, with her informed views and matured heart, to the man as a comrade, and two free person-alities will march along the same path toward a great goal. . . [5]

The roles of women as wives, mothers and care-takers of the home were changed by the active intervention of a generation of women who fought for and won political and economic gains in the public sphere. Additionally, the period saw widespread demographic changes which

affected the traditional arrangements of households and partnerships as well as the introduction of technology which rationalised the domestic sphere. In the face of these emancipatory changes, however slight they may have been in number, duration or practice, the old conventions of domestic order were called into question. It is in relation to these changes that the *Hausfrau* is considered here. The traditional supportive role of woman within patriarchy as heterosexual partner (wife), domestic worker and centre of family life is rarely discussed and usually undervalued. Indeed, it is rare for the 'housewife' to be explored visually except within family portraits or in advertisements and guides explicitly aimed at a domestic market. It is significant in itself that the *Hausfrau* of the Weimar period was similarly unsymbolised except through patriarchal relations – the *wife* of, the *mother* of, or the *centre* of the family or household. The work of women artists which explored heterosexual marriage and part-nership, household organisation, domestic space and the representation of children and child-care operated at the borders of the idea of the *Hausfrau*; the works produced in relation to domesticity chart moments of crisis and destabilisation in the conventional roles of women, rather than reiterate the norm. Hence, very few actually show a 'housewife' *per se* and instead focus on the relationships between women and marriage, home and family as they were called into question during the years of the Weimar Republic.

At this time, even to raise questions about the role of women within domesticity was polemical. It is therefore highly significant that women were asking these questions and voicing discontent with structures which had traditionally defined them in relation to a masculine system. In this way, the controversies surrounding the *Hausfrau* were yet another instance of a burgeoning *Frauenkultur*, women discussing and debating from their own positions the significance of family and domestic struc-tures not of their own making. This is not to suggest that there existed a unified 'women's line' on the function of the *Hausfrau*; far from this, women were sharply divided amongst themselves, particularly in relation to social class and generation, with older, middle-class women tending to preserve the traditional roles against the onslaught of disruptions from outside. Despite their differences of opinion, many women took an active role in finding new models of domesticity or in arguing to re-empower the traditional place of women in the home and did not simply accede to definitions of their roles from outside.

Clearly, the most radical models of new forms of marriage and part-nership tended to be espoused by younger women who sought greater independence and visibility within the public sphere. In this way, scholars such as Kristine von Soden have been correct in linking the phenomenon of the *neue Frau* with new codes of sexual morality.[6] Representatives of the more radical factions of the pre-war women's movement, such as Helene Stöcker, the founder of the *Mutterschütz* league, Gertrud Bäumer and Helene Lange, had all concerned themselves with redefining the structures of the home and family (as well as sexual relations themselves) in ways which would take the needs of women into consideration.[7] However, it was in the 1920s that these ideas and the discourses on the rationalisation of sexuality and marriage generally became a widespread topic of debate. In the Weimar years, the sex reform movement took off and figures such as Magnus Hirschfeld, the sexologist and founder of the *Institut für Sexualwissenschaft,* and Alexandra Kollontai, the Russian marxist advocate of 'free' love and partnerships, became well known through their popular publications and films.[8] Marital and sexual fulfil-ment was a major topic of interest in Weimar and some 400 marital and sexual advice centres operated in Germany during the inter-war years.[9] Two best-selling books, translated into German during 1928, set the period's tone in regard to the reform, on rationalised lines, of the inti-mate relationship between the sexes: Ben Lindsey's *Companionate Marriage (Kameradschaftsehe)* and Theodor van de Velde's *Ideal Marriage (Vollkommene Ehe).*[10] These books emphasised the ideal of full partnerships between married couples with regard to domestic chores, sexual activity and the care of children in the name of equality of interest and rationalised living.

Landau, Lindsey, van de Velde and other proponents of 'new' marriages emphasised the potential personal liberation of such arrange-ments, but these were often hard-won gains on the part of Weimar's women. Balancing home and career within a patriarchal system which could not adjust adequately to such dual activities caused great stress to the individuals renegotiating their duties and responsibilities as well as to the system itself. The extension of rational, scientific principles derived from industry to the human body and social relationships was not always ideal in practice. Sexuality, maternity and interpersonal relationships were subject to studies and advice replete with statistics, charts and indications of the 'normal' (read 'normative') number of children to have, years between these and even the amount of sexual activity expected between

partners. The multiple influences of rationalisation on people's personal lives, technological advancements in the home and the dissolution of clear boundaries between the public and the private spheres meant that domesticity was called into question and the figure of the *Hausfrau* was the point of contention.

In Hegemann's *Family Portrait*, the key features of the debates about women and the domestic sphere were figured visually. The work, as Esau argued, suggested that the personal relationships between husbands and wives or unmarried, heterosexual couples were by no means going uncontested in the period, yet the 'types' for new, modern marriages, such as the *Kameradschaftsehe*, were not necessarily ideal. The association of the new woman type with the domestic scene in the painting, including husband, requisite number of children and little pet cat, identified Hegemann's image with popular typologies of modern marriage and their critics. The representation of the household and children shows that the painting participated in the contemporary debates about the rationalisation of the home and maternity. The spartan, modern urban dwelling depicted by Hegemann was related to *Wohnungsreform* (housing reform) activities of the period with their emphasis upon modern technological innovations, building types and hygiene. The modern *Hausfrau* was a 'domestic scientist' ensuring high levels of cleanliness and health to her whole family through rationalised methods of cooking and cleaning using high-tech appliances.[11] The *Hausfrau* as 'super-woman', a beautiful, stylish, independent public figure who kept a perfect house, raised the children and was a nurturer and an equal sexual partner to her husband, was a key figure in the changing domestic sphere of the Weimar Republic. The brittle self-portrait within the *Family Portrait* was its consequence.

It is, of course, legitimate to ask to what extent any lasting changes took place regarding the position of women within the domestic sphere, since many of the issues considered during the Weimar Republic remain on the agenda to this day. The three critical areas of negotiation in Weimar – the relationship between men and women in heterosexual couples, the role of the woman as keeper of the household and the primary function of the mother as the care-giver to children – are all too familiar as topics on the contemporary feminist agenda. We are faced, yet again, with the fact that the rise of fascism in Europe and the Second World War reversed many of the advances made by women during the 1920s and 1930s and that their gains were marginalised by history in

ways that meant that their struggles had to be re-enacted by feminists of the post-1968 generation. Moreover, the issue of domesticity in Weimar split women along generational and class lines causing differences between women to come to the fore. The socio-economic changes of the day highlighted women's very different expectations and experiences of the household as well as their relationships to domestic duties and privileges. This is why exploring the domestic woman in Weimar as a pivotal figure in the struggle concerning the boundaries between the private and the public, or the personal and the political, is still of significance today.

MANN UND FRAU: MARRIAGE, SEXUALITY AND COMRADESHIP

It is not surprising that women artists in the Weimar Republic were frequently critical of the institution of marriage. Traditionally, this institution subordinated women to their husbands and relegated them exclusively to the private, domestic sphere. Here, a woman artist would be judged according to the success and status of her husband and by her domestic competence while being marginalised in relation to the main artistic trends and debates of the day. Marriage was, for many women of the period seeking artistic and professional independence, at best a burden and at worst an untenable position to undertake.[12]

Twice in paintings made during the 1920s, the Berlin artist Hannah Höch criticised the middle-class conceptions of marriage which still dominated the young Republic despite the claims of modernity made by political and social reformers.[13] In the works *Bourgeois Bridal Couple* (1920) and *The Bride* (1927), Höch's critique operated through montage-like juxtapositions of 'domestic' objects, such as the coffee-mill, cooking pot and stove (all shown in old-fashioned forms), with 'modern' images of high-tech machine parts and traditional symbols of the bourgeois state such as the church. In both works, the figure of the groom is an anonymous, sober, besuited man – the very essence of the emotionally-distant husband and father-figure within the traditional patriarchal family. The figure of the 'bride' in the watercolour *Bourgeois Bridal Couple* is merely a veiled mannequin, the mindless dupe upholding her role in the charade. In *The Bride*, the 'bride' is a complex construction made from the image of a doll's head on a woman's body which models a fashion-

able wedding dress. As an infantilised object of patriarchal subjection, the 'bride' is surrounded by icons of media consumption and feminine stereotypes including references to the rotten apple of Eve and an infant suckling at a disembodied maternal breast.

In these works Höch paralleled the contemporary criticisms of bourgeois marriage made by feminist writers and the women's press which stressed women's passive assumption of a role within the patriarchal order. Alice Rühle-Gerstel, for example, pointedly argued that while marriage was still the main indicator of a woman's social position, it was an institution made by and for men.[14] Arguments in *die junge dame* reiterated the vexed issue of title for women in the period; 'Frau' still carried significantly more social weight than 'Fräulein' and unmarried, professional women wished to adopt the more respectable title in lieu of their age and 'rank'.[15] However, the traditional use of 'Frau' worked through the *husband's* position, so that the *wife* of a doctor was 'Frau Doktor'. Such minor quirks of terminology revealed the underlying significance of marriage to the social position of women and displayed the inequities and rigidity of the system itself.

The challenges posed by a generation of female doctors, academics, writers and artists to a system which still defined their major significance in terms of their male partner/husband and their role as the centre of a household were important. Yet, the status and security gained through marriage never fully departed the scene. Emma Oekinghaus, in her 1925 book *Die Gesellschaftliche und Rechtliche Stellung der Deutschen Frau* (*The Social and Legal Position of the German Woman*), was aware of the continued conferment of rank and status upon women by marriage, and referred to the fact that women were 'classed' according to the social class of their husbands.[16] Current discussions of the *neue Frau* have pointed to the fact that the new economic freedom of the white-collar woman was, more often than not, merely a stage on the way to marriage and domesticity which occurred later in women's lives. This demographic shift was enhanced by the media, but quickly reversed by the Third Reich when it assumed power since many women themselves sought the renewed security offered by domestic life.[17] The fact that traditional concepts of marriage and motherhood continued to underpin ostensible changes in the relations between the sexes in 'modern' Germany is the main thrust of the critiques of marriage offered by women artists in the period and, simultaneously, the main reason why many women acceded to Nazi domestic policies. Around issues of status within the domestic

HANNA NAGEL

The Imperfect Marriage 1928

Courtesy of Irene Fisher-Nagel, Karlsruhe; © DACS 1998

sphere, women's opinions themselves were polarised.

So, for example, the work by Hanna Nagel discussed in the previous chapter *The Imperfect Marriage* (*Die Unvollkommene Ehe*) (1928), alluded to both the modern forms of partnership as defined by the exceptionally popular marriage manual by Theodor van de Velde and the

traditional sexual politics of marriage and the practice of art. In her etching, Nagel used a self-portrait, holding a child on her lap against the background image of a male artist busily at work painting a large-scale female nude. Many of Nagel's works explored the dynamics of domestic duties in relation to women's professional life and used the figures of herself and her artist-husband Hans Fischer as the key characters in such a drama. These works, therefore, considered the general implications of women's dual roles in modern partnerships and the particular instance of the artist-couple. Significantly, Nagel frequently projected these roles into the image and they should be read as critique, not documentary. At the time of *The Imperfect Marriage*, for example, Nagel and Fischer were not yet married and the birth of their daughter was some ten years away. *The Imperfect Marriage* challenged visually the domestic bliss defined through perfect, rationalised models of sharing chores and child-care responsibilities as advocated by van de Velde through a reference to the more usual continuation of iniquitous, gendered power relations in marriage. In Nagel's work, despite the modern ideals, the woman artist is left 'holding the baby' while the male artist is supported in his practice by a wife, mother to his child, model for the nude and muse to his creativity. Hence, Nagel made visible the underlying female support of the successful male artist which can only serve to reiterate his power when it remains invisible. Once seen, the structure locates and negates the myth of the autonomous male creative genius.

Clearly, the work by Nagel shared concerns with the *Family Portrait* painted by Hegemann in 1924. Höch's assault on the bourgeois institution of marriage was also linked to these other artists' criticisms, since she connected the principles of montage and the mass media tropes of the rationalised *neue Frau* with the conventions of middle-class marriage. In this way, she too suggested an underlying continuity in the unseen structures of sexual behaviour despite radical changes to surface forms. Since many authors have provided detailed accounts of the life and work of Höch in the Weimar years, suffice it to say here that her use of these themes was consistent with her own experience of popular constructions of woman in the mass media and her relationship with the artist and fellow dadaist Raoul Hausmann.[18] Hausmann espoused radical views on male-female partnerships and sexuality while remaining married to another woman, twice letting Höch bear the responsibility for their sexual life by having abortions and, on several occasions, being physically violent to her.[19] Following the pattern of women artists being the unseen support

mechanisms of men's art practices, for many years Höch was constructed as Hausmann's lover and muse but not his artistic equal.

Although Hegemann, Nagel and Höch can be seen to have voiced their disillusionment with modern marriages and partnerships along similar lines, their works are very different formally. This is of interest since it suggests that even within different artistic contexts, modern women artists were having similar difficulties reconciling their professional and domestic expectations. The stylistic manifestations also detail the particularities of these domestic circumstances and again demonstrate that women's art was not unified by any simplistic biological 'feminine aesthetic'. Rather, women artists could and did manipulate the most diverse forms for their individual voicing of collective concerns and therein made different calls to a variety of viewers.

Höch, working in Berlin at the interstices of the popular media (she had a job with the Ullstein Verlag throughout the period) and the left-wing, anarchic practices of the dadaists, used montage as a critical tactic through which to denaturalise the popular messages about modernity and male-female interaction. Juxtaposing the compositional elements of montage with the material of paint placed two competing messages in relation to each other and the viewer. These image and material contrasts were a powerful visual form through which to parallel the work's meanings about the role of women caught between tradition and modernity. Nagel was part of a circle of artists in Karlsruhe who deliberately developed their graphic art and drawing in relation to communist political concerns. These artists subverted the illustrative, contemporary media associations of graphics through a call to mass-disseminated and intelligible working-class imagery. Nagel consistently considered the dual roles of women as domestic and professional and demonstrated the significance of these roles to working women at the time. Moreover, her style and mode were intended to be recognisable to as large an audience as possible, hence the reference in the title of The Imperfect Marriage to the popular marriage-guidance manual by van de Velde.

By complete contrast, Hegemann was associated with the trend known as 'Magic Realism', a figurative practice with links to the Italian Pittura Metafisica and early surrealism. Cologne, being the home of both Heinrich Hoerle's 'Progressives' and Max Ernst's Dada, was an ideal centre for Magic Realism. This work neither adhered to particular party politics nor to 'proletarian-revolutionary' concerns for bringing art to the masses. Rather, Magic Realism looked at the contemporary scene

through mythic forms meant to reveal the underlying structures of modern life. In this way, Hegemann's painting was associated with the most avant-garde trends of her region and yet used that formal language to critique the very status of a woman artist within this sphere. Her language of personal, psychologically-inspired symbols and use of a stylised, 'magic' realist representational strategy provided a stinging comment on the 'advanced' ideas of this region's avant-garde. More-over, it permitted Hegemann the chance to adapt hackneyed 'feminine' symbols to her own purposes as a modern practitioner, just as Höch recontextualised mass media stereotypes of 'woman' steeped in clichés. Again, such a development of symbolic language by women as viewers and makers of visual culture asserted their own particular positions and articulated them differently.

Underlying the formal differences between the works of Hegemann, Nagel and Höch were similar criticisms of bourgeois marriage and disil-lusionment with ostensibly 'novel' forms of partnership which, in practice, merely occluded the same iniquitous power relationships they sought to change. Significantly, these critiques were voiced by young, independent women artists who were adopting radical positions within their socio-economic and intellectual/aesthetic lives, and expected forms of partner-ship to keep pace. It would, however, be wrong to assume that no artist-marriages operated beyond traditional patriarchal limitations since, in the cases of a number of communist artist-partnerships, the more utopian aspects of Landau's call for comradeship in marriage would seem to have existed. The cases of Alice Lex-Nerlinger and Oskar Nerlinger in Berlin in addition to both Lea and Hans Grundig and Eva Schulze-Knabe and Fritz Schulze in Dresden indicate that it was possible to redefine gender politics within the domestic sphere as well as within a wider, social, communist project. As discussed in the last chapter, Alice Lex-Nerlinger and her husband Oskar were life-long partners in marriage, art and politics. They worked together, experimenting in photomontage and mural-painting, co-founded the group of radical artists called *Die Zeitgemäßen*, both joined the ARBKD and the KPD and supported one another's visual practice in their written articles and reviews.

Similarly, the Dresden artist-couple Lea and Hans Grundig shared communist and artistic concerns as well as a commitment to radical Jewish politics. They co-founded the Dresden branch of the ARBKD, were active within the Communist Party and, further, shared the extreme dangers of Nazi persecution, periods of imprisonment and exile during

the years of the Third Reich. Their lives and art were joined in the service of their beliefs and this sustained their support of one another in writing and artworks, including Hans Grundig's visual representation of Lea as the icon of truth and justice in his famous anti-war work *The Thousand Year Reich* (1935–8). For her part, Lea Grundig's sensitive cover illustration to *Gesichte und Geschichte (Faces and History)*, the book which charted their experience of political persecution and radical art practice before and during the Second World War, showed herself and a mirror-image of the prisoner Hans united by a blood red heart.[20]

Probably the most moving story of these artist-comrade-couples is that of Eva Schulze-Knabe and her husband Fritz Schulze, also from Dresden. The two met through the radical art students' league at the Dresden Academy and became members of the ARBKD in 1929 and the KPD in 1931, the year of their marriage. From that time, their work served left-wing ideals. This led them to develop anti-academic graphic techniques and focus upon decidedly proletarian themes. At the beginning of the Nazi period, Fritz and Eva were imprisoned, but released again in 1934. This did not stop their political work against fascism and in 1941 they were again imprisoned, but while Eva was given a life sentence (she would be liberated by the Red Army in 1945), Fritz was sentenced to death and executed in 1942. In his final, moving letter to his wife, Fritz Schulze expressed not only his love, but his political and artistic solidarity with her as a *partner*:

> Hold your heart solid and be strong. You have always been my good and brave comrade in life. You will love me and prove your spiritual strength in overcoming this heavy blow. . . and now you will go on your life's way alone. . . and still the commitment, the artistic commitment of two, is carried by you. You have my bequest to fulfil, you must be strong and see our artistic path to the end. The thought that our destination is so near that we cannot turn back is very dear to me . . . Your stance is proof that I have not been mistaken about you.[21]

In the year after their first period of incarceration, Eva Schulze-Knabe produced the *Double-Portrait (Fritz and Eva)* (1934). Throughout their time together, both artists made portraits of themselves and the other, yet this work is notable for placing them together in the image. Unlike Schulze-Knabe's painted *Self-Portrait* of 1929, in which she represented herself through the foil of traditional, academic realist painting, *Fritz and Eva* used a hard-edged linoleum print technique which was associated

explicitly with their political graphic production of the 1930s. The earlier work was in keeping with Eva's academic art education in Dresden and knowledge of painterly realism, as epitomised by artists of the nineteenth-century such as Gustave Courbet, whose works were prominently displayed in Dresden's city art museum. Her *contraposto* stance in the earlier self-portrait was assertive and strong – the ideal image for a young woman artist to evoke while taking up the challenge of a male-dominated academic tradition. This work was produced before she had found solidarity and collaboration with her partner or especial political commitment through communism.

The *Double-Portrait*, therefore, worked through a very different frame-work and toward different ends. Here, the young woman artist did not stand alone, looking down upon the viewer with a challenging, disdainful gaze. Rather, the later work placed both artists on an equal footing with the viewer and one another through a remarkably symmetrical composi-tion. The figures of the artist-couple are shown fully frontal and their gaze meets that of the on-looker directly. Neither artist is dominant, represen-tationally, in the image; Fritz is shown in front of Eva, but slightly lower, her hand is placed upon his shoulder in a gesture of support and tender-ness. This simple gesture of touch is not inconsequential to the image. It acknowledges a legacy of traditional portraiture in which both the face and hands of the sitter are used to carry a wealth of meaning and it contrasts sharply with the *Family Portrait* by Hegemann and *The Imperfect Marriage* by Nagel, where the subjects' alienation was made manifest through their physical and compositional separation. The *Double-Portrait* by Schulze-Knabe links her two figures through the touch, yet marks them as equivalent in position and, most notably, as sharing a viewpoint. They are looking in the same direction, acting together for a common cause.

That young artists could share common artistic and political orienta-tions and form lasting relationships as partners was a sign of the changes taking place in gender roles. Undoubtedly, the genuine instances of full comradeship in marriages and partnerships were more rare than rela-tionships which evinced the struggle between tradition and modernity, yet they are not without significance. Neither is it unremarkable that both the Grundigs and the Schulze-Knabes were part of the same political and artistic community in Dresden. Clearly, in order for any new models of partnership to work well, the context in which they were set needed to be conducive to alternative patterns of male-female relationships. The Dresden communist and artistic *milieu* was particularly inclined toward

Kate Diehn-Bitt amongst them. Male artists such as Conrad Felixmüller and Otto Griebel also explored more radical concepts of partnership and child-care, with Felixmüller being a particularly active father in line with his political beliefs.[23] All of these things made the possibilities of new models of marriage into actualities in practice.

That these new forms of partnership tended to be associated both with young people (particularly the young *neue Frau*) and with leftist political ideals inspired a host of works using the iconography known in the period as the *Liebespaar* or 'lovers'. The term *Liebespaar* was more loaded than the translation suggests, since it nearly always described the representation of young, working-class couples either posed arm-in-arm or locked in more passionate embraces. Many such *Liebespaar* paintings, graphics and drawings were produced in Weimar by male and female artists from a variety of regions.[24] The main connection between these numerous works was the association of this iconography with a new proletarian culture. As Helmut Leppien wrote in 1981 in relation to Elsa Haensgen-Dingkuhn's use of the *Liebespaar*:

> As in Nesch's Schichtwechsel and in Kalkreuth's Harbour Workers, we have the working-classes of Hamburg depicted, but not as a mass, as individuals, such as in Zeller's Unemployed. Elsa Haensgen-Dingkuhn depicted the couple as self-conscious and earnest, and she suggested hope through painting the first green leaves of the young trees.[25]

Ursula Horn took this argument a stage further in her analysis of Grethe Jürgens' *Liebespaar* of 1930–1, which she argued typified the distinct, proletarian politics of the Hanover artists of the *neue Sachlichkeit* more generally:

> Sympathy toward the working-classes is evinced by Grethe Jürgens in her painting Liebespaar (1930–1). Here she developed the formulation for an ideal, forward-looking picture of humanity. Through both the physicality of its rendering and the strong, realistic form, the work articulates our idea of a young, progressive couple from the working-classes in the twenties.[26]

Each of these critical assessments of the use of the *Liebespaar* theme by women realists of the period stressed that the theme was progressive and proletarian and that it indicated that significant changes in interpersonal relationships between men and women were possible. Just as in Bertolt

Brecht's film *Kuhle Wampe* of 1932, where the central couple, a young enlightened working-class pair, suggest hope for the future, the *Liebespaar* was a powerful symbol of change. Jürgens's work does present a positive representation of the bond between two young workers; they are shown gazing into one another's eyes and his hand rests lightly on her shoulder. The combination of gaze and touch provide an especially strong sense of the bond between the two figures since it refutes objectification through distanced looking and reiterates the physicality of their union. Their dress indicates their class, but they are not impoverished or emaciated in this painting. Moreover, they are represented as monumental, individualised portraits and not as mere symbols of 'types'. The female figure, for example, has bobbed hair and 'modern' clothing, but not exaggerated into a parody of the *neue Frau*.

The representation of the couple in *Liebespaar* differed radically from Jürgens's only similar double-portrait of a couple, *Mann und Frau* of 1927. 'Mann und Frau' can be translated either as 'man and woman' or 'husband and wife' which lends a critical edge to the representation of a male and a female figure who are utterly alienated from one another. The 'man/husband', is represented in profile in the background of the work, separated from the 'woman/wife' by both a wooden fence and his own hand, raised to conceal his face. The female figure faces the viewer in the foreground, utterly impassive. The two neither look at each other nor in the same direction; they are represented as if unable to communicate by definition. The mode of dress employed in *Mann und Frau* is decidedly bourgeois, with the male figure sporting a bowler hat and the woman in an expensive cold-weather ensemble. If the couple were read as 'husband and wife', this work acted as a damning comment on the structures of traditional middle-class marriage. If the more generic title was taken, the work suggested that the capitalist structures of conventional bourgeois society rendered men and women perpetually at odds. Additionally, it is through the look of the female figure that the viewer is directed into this awkward scene; our spectatorial position is akin to hers and utterly devoid of contact with conventional codes of distanced masculinity.

Hence, Jürgens's *Liebespaar* was an especially positive image of male-female relationships within her *oeuvre* and indicated her association of progressive social ideals with the working-classes with whom she lived and worked in Hanover during the Weimar years. The artists of Jürgens's circle in Hanover maintained their distance from the strong

bourgeois art market and patrons of the city in favour of a realist prac-
tice and a working-class orientation. The proletarian politics of these
Liebespaar works generally are not difficult to ascertain. However, it is
interesting that so many women artists took up this iconography, and it
implies that the model of the new young couple of the working classes
was resonant with the objectives of these modern, professional women in
some specific ways. Particularly, it emphasised the connections between
the *neue Frau* and the more politically advanced sectors of the female
urban proletariat who sought reform within marriage and in the legal
and economic structures within which they maintained both their public
and domestic labour.

Stöcker, discussing the problematics of marriage in 1929 at the Sex
Reform Congress, may shed some further light on women's interest in the
Liebespaar. Having asserted that young people have already managed
by actual practice to form companionate marriages through knowledge
gained from the vast increase of research into sexology, Stöcker reiter-
ated the crucial role of the independent woman in sustaining these
improved conditions:

> The progress towards a final understanding between man and woman is very slow
> because it is only in very recent times that women themselves have begun to take
> any part in the study of sex problems. Fortunately even the blindest can see today
> that a change is taking place in the distribution of power between the sexes. . . .
> This change must go further in proportion as care of her body, satisfaction in a
> vocation which she has chosen for herself, and increase in mental and economic
> independence make woman into a personality centred in herself.[27]

Stöcker stated here the fundamental significance of women's physical
and intellectual development to their participation as equals in relation-
ships and again emphasised the importance of women's voices in the
debates concerning marriage and partnerships. Significantly, in the same
speech, Stöcker suggested that these ideals must begin to influence older
women and couples; for Stöcker, the young were finding more egali-
tarian forms of partnership through necessity, but older women and men
were far more reluctant to change.

This intergenerational element is of great significance in the debate
since the broad-based bourgeois arm of the German women's move-
ment tended to alienate women under the age of thirty.[28] The BDF (*Bund
Deutscher Frauenverein*), the central, mainly bourgeois, German

Women's Association kept a number of splinter groups within it as a loose confederation. These included women's groups with religious affiliations (Catholic, Protestant and Jewish), housewives, unions and slightly more radical, secular groups such as the ADF (*Allgemeiner Deutscher Frauenverein*). Nearly all of these groups attracted middle-class women who sought reform rather than revolution and to uphold ideals of feminine, nurturing behaviour as part of a fully-functional German state. There were, of course, differences between them, not least with regard to the anti-semitism of the more right-wing nationalist groups, but generally they represented the more domestic interests of older women rather than the situation of the *neue Frau*. Thus, emancipated young women in Weimar tended to be more closely aligned with communist and socialist women's groups, regardless of their class origins, since these were far more radical in their calls for women's freedoms.

Thus it was not surprising to find young women artists turning away from the middle-class women's movement of their mothers and towards an alliance with radical left politics, even in relation to the issue of marriage and partnership. The central place accorded to independent women within new models of 'companionate' marriage and the association of the young, radical left with comradeship and self-conscious personal development through physical and intellectual activities made women artists supportive of these trends. From their own positions as independent artists it was imperative to develop models of partnerships in harmony with their changing socio-economic, artistic and gender interests. Moreover, the emphasis upon sexology placed women's sexual pleasure within the sphere of these new partnerships while stressing the control of fertility. This too was of interest to women seeking to maintain professional careers since maternity often halted their practice, and yet the choice of celibacy or single life could often seem punitive.

The theme of the *Liebespaar* was connected with the political artist-comrade-couples described above inasmuch as they each represented the most progressive and most utopian models of male-female interaction in the period. However, the *Liebespaar* did not merely show the reality of changes being wrought in contemporary society, it also pointed toward aspirations for the future and the directions which might later be taken. Despite concerns that the 'companionate marriage' so widely discussed in the popular press of the period was frequently a facade which hid conventional tendencies beneath its surface, there were genuine attempts to renegotiate the gender-politics of partnerships

during the Weimar Republic. This was negotiated as much through the visual as elsewhere and the remarkable flexibility of style and form which women artists used and changed in order to articulate alternative partnership structures was notable. The goals and aspirations of women were frequently at the heart of these progressive developments and, within particular social and political contexts, they were able to establish novel forms of partnership.

THE HOUSEHOLD: RATIONALISATION AND DOMESTIC SERVICE

It is pertinent to consider the household within the context of the utopian aspirations of modernism since technological and design developments in domestic architecture and interiors were thought to herald the dawning of a new age. Yet again, the changes wrought to the house itself altered the relationship between the *Hausfrau* and her domain in ways which went well beyond the mere addition of domestic appliances to the home. In the struggle over the socio-economic definition of the modern household, traditional housewives were frequently displaced from the very source of their social status and personal identity. The issues which faced the *Hausfrau* centred upon the renegotiation of the boundaries between the public and the private spheres. The difficulties women faced in relation to these issues again emphasised the differences between them, in terms of generation and class.

The rationalisation of the household, like the rationalisation of marriage and partnerships in Weimar, was a by-product of the Taylorism which swept German industries and cities in the 1920s. Time and motion studies were done to ensure the most 'rational' means were used by housewives of washing clothes, cooking potatoes and cleaning windows.[29] Clearly there were discussions of household and domestic architectural reform even before this period, owing to rapid urban expansion and changes in the domestic economy, but the rationalisation of German industry brought these debates to a head. Throughout the interwar years, designers worked with manufacturers to produce and market ever-newer labour-saving devices for the home, and the fitted kitchen appeared in progressive housing estates. The Bauhaus redesigned objects of everyday use, from lamps to children's toys, and the 'Frankfurt

kitchen', the model for modern housewives, was designed by Grete Lihotsky.

Lihotsky brought many of the significant strands of the debate together in her very interesting statement of 1926 regarding the ratio-nalisation of the household, published in the architectural journal *Neue Frankfurter* on the occasion of an exhibition of the kitchen and new domestic design.[30] First, she reiterated the significance of industrial models of rationalised design for the home. This, she argued, was impor-tant for women since many changes in their circumstances now made it more difficult for them to carry out their domestic responsibilities. Lihotsky also stressed that women, industry and architects should work together in the design of the house. Finally, she made reference to the ubiquity of exhibitions from the period concerned with domestic design and hygiene and re-emphasised the role of the *Hausfrau* as a domestic professional who maintained health and hygiene for her whole family. All of these strands give a picture of the new ideal of the technologically advanced, middle-class home, run by the efficient new model *Hausfrau*. More signif-icantly, it hinted at the changes taking place with regard to the labour arrangements within bourgeois households in which the position of the *Hausfrau* was no longer supported fully by the work of domestic servants. Hence, the technological rationalisation of the household was intimately intertwined with changing economic and demographic patterns; domestic duties were not devolved evenly to all women in Germany and thus such change impacted upon their lives in different ways.

While not suggesting that domestic design and technological innova-tion were detrimental, it is still important to raise questions about the particular circumstances of women faced with major changes to their roles in the period. For working-class women, new domestic technologies were mainly beneficial, since they most commonly had sole responsibility for the upkeep of their households and the added burden of outside work. Their roles were thus already both private and public and any form of 'labour-saving' device or better-constructed housing was an improve-ment upon the very poor living conditions usual among the urban prole-tariat of the time.[31] However, with the exception of a few progressive housing projects built in Germany in the period (such as the *Weissenhof Siedlung*, Stuttgart, 1927), the advances in the household, and debates pertinent to these, were confined to the middle-classes who could afford the new houses and appliances. As a pictorial feature on the new house-hold in the left-wing *Arbeiter Illustrierte Zeitung* made clear in 1928, its

appliances were far more efficient, practical and useful, but also 'far too dear for the worker'.[32] Thus, the significance of the rationalisation of the household must really be explored in conjunction with the changes taking place around the bourgeois *Hausfrau*. Simultaneous with the rationalisation of the middle class home through technological appliances which 'eased' the burdens of housewifery came the development of organised labour unions for domestic servants, who challenged for better working conditions from their *Hausfrau* employers. With fewer and more professional domestic servants available, the new appliances for housework became a necessity rather than a novelty. Moreover, middle-class women were frequently hostile to the changes in their labour arrangements and their status and could voice exceptionally reactionary opinions on the place of domesticity in society.

Traditionally, as Oekinghaus argued, the main role of the married middle-class woman was to run the household, but this position came under siege after the First World War.[33] In the first place, women had found during the war that the household was not their only option and many women continued to pursue careers in the public sphere after the Republic was born. Moreover, women's entry into paid professions had made the unpaid domestic labour of the *Hausfrau* seem less prestigious and undervalued. Thus it was that middle-class women's organisations began to argue for the classification of domestic work as a profession (*Beruf*) with the attendant status and income for those who had remained true to this under-represented role.[34] Professional housewives' organisations, such as the RDH (National Federation of German Housewives Associations) sought recognition for housewifery and, significantly, representation as a professional body on local council committees for housing and design reform. In this way they were fairly successful and women from these associations were included by industrialists and community councils in the decision-making processes of *Wohnungsreform* (housing reforms).

Regarding the actual labour within the household, however, these organisations proved to be hide-bound by class affiliations and far from progressive. As Alice Rühle-Gerstel wrote in her book on the 'woman question', the prototype of the *Hausfrau* was the '*nur Hausfrau*', the woman who has no occupation other than the care of the house.[35] This was a fallacy, argued Rühle-Gerstel, since modern women, even in the middle classes, were rarely in positions which permitted them such leisurely occupations. It has since been recognised in numerous studies

of the rationalisation of the household in Europe and America during the early years of this century that this did not 'save the labour' of the housewife but increased it by making her the sole provider of cleanliness, nutrition and hygiene for her family and by making it 'possible' for her to increase her activities, paid and charitable, outside the home.[36] The rationalisation of the household was the start of the 'super-woman' (*Hyperfrau*) who simultaneously maintained a perfect house and a professional career (not to mention raising children). The pressure exerted upon middle-class women through the new household was exacerbated by the loss of status of housewives generally and by the economic advances being made by servants during the post-war years.

Indeed, it was around the figure of the 'servant-girl' (*Dienstmädchen*) that the class interests of women outweighed their identification with their 'sisters' and eventually provided burgeoning reactionary political forces with an important bit of leverage against the German women's movement. It is the figure of the new, urban servant who threw into sharp relief the differences between women in relation to the trope of the *Hausfrau* and, in particular, to the changing circumstances of household labour. Servants made public the private workings of the household and made the implicit labour of women within the domestic realm the subject of explicit definition by the legal mechanisms of the state. In this way, the debates about the rights and working conditions (and, indeed, the moral health) of servants was predicated upon the *Hausfrau* and constitutive of its changing status in the period. Women artists exploring the representation of public domestic labour brought into view the underpinnings of women's differential power within and through the home.

In 1929, Gerta Overbeck painted a head-and-shoulders portrait of a young woman entitled *Servant Girl*. This image is fascinating in conjunction with the discourses which surrounded servants and housewives of the period. Overbeck's work is a completed oil painting, rather than just a watercolour sketch of her surroundings, and this fact constitutes part of its meaning. As discussed in Chapter 1, Overbeck was associated with the Hanover group of the *neue Sachlichkeit* in the inter-war years, but lived at a distance from Hanover from 1923 to 1931. During that period, she made frequent painting visits to Hanover at weekends and school holidays (she was working as an art teacher in Dortmund) and maintained her strong artistic affiliations with the Hanoverians. Her practice was two-fold throughout this time: in Dortmund she principally made numerous charcoal, pencil and watercolour sketches of the industrial

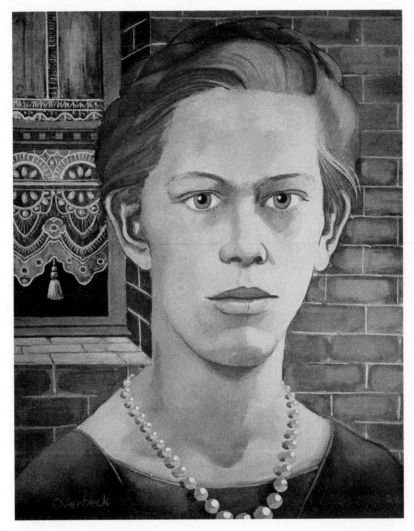

GERTA OVERBECK

Servant Girl 1929

Courtesy of Frauke Schenk-Slemensek, Cappenberg

landscape and the workers with whom she lived, and in Hanover she was able to develop some of these themes into larger-scale paintings. Dortmund and Hanover were also very different centres and Overbeck was both immersed in the politics of the proletariat in the heavy industrial region of the *Ruhrgebiet* and in the struggles between the bourgeois, mercantile establishment of Hanover and its small minority of left-wing

realist artists. Hence, this representation of a servant crossed the 'high' status of the portrait painting with the 'low' status of its sitter within a regional context rife with controversies concerning the changing middle classes to make a sophisticated point about women and domesticity.

In *Servant Girl*, Overbeck produced a portrait likeness of a young woman in a monumental figural style standing before the window of a house, yet did not name the sitter, preferring to designate her occupation. The individuality of the figure is in contrast with this lack of name and it calls into question the visualisation of the 'servant girl' as a 'type' in the period. The work engaged with the popular debates about domestic service by so clearly identifying the figure by her labour role, yet it did not typify any of the common assumptions surrounding this 'type'; the visual construction of Overbeck's portrait challenged the limits of the 'servant' as defined in and through popular discourses. For example, following the work of Anna Pappritz, Oekinghaus defined the 'servant girl' as a figure in distress, requiring the ministrations of the enlightened middle classes to ease her plight. She referred to the awkward economic position of servants who frequently found themselves without work at short notice, the high proportion of servants who had children out of wedlock or became prostitutes through economic necessity. Finally, she ended her section on 'the position of women in service occupations' with the statistics confirming the high rate of suicide among servant girls.[37] While all of this information addressed the serious economic issues which faced young women in service, it nonetheless smacked of Victorian philanthropy, a tendency to see working-class women in service as 'others' needing guidance from their 'superiors' in the middle-classes. These ideas suggest the 'servant girl' to be the equivalent of the sympathetic figure of the 'seamstress' or 'governess' of the nineteenth century – a woman in distress, poised at the brink of moral collapse and reliant upon the centre of home and hearth, the *Hausfrau* herself, to guide her.

Overbeck's representation does not show a woman in distress awaiting a saviour from outside. The figure is well dressed (even wearing a strand of pearls) and shown returning the gaze of the viewer with a direct and sober look. She is young and her hair is 'modern', but she is not the media stereotype of the *neue Frau* as a frivolous fashion icon. These details remind us of the demographic patterns which linked servants with the *neue Frau* in the post-war period. As opposed to the period of the late nineteenth century, when large numbers of young women came from the country to bigger towns and cities to enter

domestic service, the women going into service after the war were more likely to be the daughters of the urban proletariat. These women were fewer in number, more sophisticated in terms of their experiences of the city and more demanding in relation to their working conditions.[38] Increasingly, young women were moving from domestic service into the white-collar service sector typified by clerical and office work: yet another link with the *neue Frau*.[39] Thus the same woman could experience domestic service and life as part of the new white-collar service sector – the servant was not 'other' to the economic group of which the new woman was a part. The direct identification of this type as an equal in compositional terms within Overbeck's painting and her status as a 'portrait-sitter', dressed fashionably (not as a 'country girl' in the big city), implied Overbeck's relationship of equivalence with the 'type'.

At the heart of this representation of the servant girl were intergenerational and class conflicts between women in Weimar over the function of the *Hausfrau*. Servants in the years following the First World War became both class-conscious and scarce enough to begin to mobilise into unions and fight for improved wages and better working conditions. Until this period, a semi-feudal regime operated within bourgeois households in which servants had no legal rights to limit their hours or tasks in any way and were at the mercy of their employers. These were almost exclusively middle-class housewives who lost both labour and status when they could no longer afford to employ servants. Throughout the Weimar Republic, radical feminists and socialists fought to gain full employment equality for servants, including maternity rights and wage scales. At the centre of the opposition to this were middle-class housewives' organisations protecting their status and economic position against the rights of these working women.[40]

One of the most powerful and effective housewives' associations was in Hanover, led by Bertha Hindenberg-Delbrück, who opposed the rights of servants and unions throughout the 1920s and became a loyal Nazi in 1933. While there is no information to suggest that Overbeck knew directly of the work of Hindenberg-Delbrück, the mercantile bourgeois climate of Hanover and its women's groups were certainly opposed by the artists of the *neue Sachlichkeit* who aligned themselves and their art with the interests of the workers in the area. Hence, Overbeck's *Servant Girl* was a powerful and positive image of a woman of the working-classes and by definition part of a younger, more radical woman's experience of labour and solidarity. A new relationship between the public and

the private sphere was investigated by Overbeck's *Servant Girl* in which the figure of a domestic woman is simultaneously that of a professional public agent. The figure stands outside the house, literally and metaphorically, no longer in need of the protection of the interior, indicated by a decorative lace-curtain toward the left of the work. Unlike the housewives' associations who would be undermined by their very focus on restoring domestic labour as *the* occupation of women, Overbeck and like-minded women of her generation knew that the traditional security offered by the distinct separation of the public from the private sphere, both gendered and classed, was no longer the goal for which to strive.

CHILDREN: NATURAL BONDS, SOCIAL RULES

Just as the traditional roles of wife and keeper of the household were being changed by 'modernising' the private sphere, so too was the position of the housewife at the centre of the family. The last chapter, which concentrated solely upon the figure of the mother and issues surrounding maternity, abortion and natality as a feature of female creativity, demonstrated the importance of this theme to women artists and will not be revisited here. On the agenda in this section is the role of the *Hausfrau* as primary care-giver to children within the domestic order and the traditional link between women artists and the representation of children. Conventionally, there is assumed to be a *natural* link between women's social roles as nurturers of children and their biological procreative function. Maternal bonding is here assumed to underpin the social order, and to suggest alternative family structures or methods of childcare which do not depend principally upon the biological mother is to go against 'nature'.

The artistic corollary of this maternal bonding is the legacy of women artists representing children/maternity in their art. Again, the conservative position on the interconnection between women's art practice and the representation of children goes beyond the suggestion that women frequently represented children because they were easily available models and part of the woman artist's daily life. Rather, women are assumed to have a natural inclination toward the subject of children derived from biological imperatives, which makes them 'better' at expressing maternal feeling and more akin to the children they depict.

This line of debate has been part of a more general tendency to minimise the significance of women in the arts since it reiterates the ostensibly natural and unmediated aspects of women's practice. Why take the works of women artists representing children seriously if this is just the way women see 'naturally' and not a thoughtful intervention into art practice? How can women's art be deemed professional rather than amateur when it is derived merely from their bodily impulses? Such arguments assert a biologically-based feminine aesthetic which joins women artists together across time and place through a reductive paradigm and implies that women's art is unmediated, immediate and naive work by definition. As the evidence of this whole volume suggests, women artists were unified only through their active participation in the debates on the 'woman question' and their situation as 'others' to the norm. Their discourses were marked by diversity and multiplicity and to simply use a form of biological determinism to define their entry into the discursive realm of art is to do them a major injustice.

Obviously, these traditional, biological associations of women with children (and women artists with the subject of children in their art) can be countered with reference to the socio-historical specificities of class, nationality and chronology. For example, in exploring the work of the women Impressionists, many of whom were known for their particularly 'feminine' representations of children or maternal bonding, Tamar Garb argued decisively that these images were part of a nationalist emphasis upon bourgeois maternité, rather than the result of any biological impetus.[41] Not denying that women could and did bond powerfully with their infants, Garb pointed out that works of art use symbolic visual languages to construct meanings within a social frame in which they must be intelligible to be 'read'. Since these works were made and understood by bourgeois French artists and critics of the Third Republic, discourses surrounding motherhood within that class and culture must in some way have coloured their form and they, in turn, must have engaged in the discursive interchanges of their day. The most suggestive feature of the discourse of maternité in the Third Republic was the way in which it actually challenged then-contemporary practices of motherhood among members of the middle classes who commonly placed children into the principal care of wet-nurses and nannies instead of their biological mothers. Hence, even the notion of the maternal bond, so crucial to Western conceptions of motherhood throughout the twentieth century, can be seen to have been subject to social fluctuations.

During the years of the Weimar Republic, maternity and childcare were hotly debated. The economic instability of both the beginning and the end of the period, as well as the rationalisation of the domestic sphere and the 'emancipation' of women more generally, caused the structure of the family to be in flux. As early as 1900, women's groups such as the ADF called for forms of communal childcare to replace traditional nuclear family models and enable women who worked outside the home to be secure in the fact that their children were well cared for.[42] These facilities were intended to assist middle-class women whose childcare responsibilities were increasingly difficult to combine with their public roles. While the boundaries between public and private remained intact, and they had been located firmly within the domestic sphere, there had been no call for communal facilities. Such schemes were expensive to introduce and too controversial for many political parties to support fully, but among many working-class families, such systems operated on more-or-less official lines from sheer necessity. The architectural structures of urban dwellings in Germany, as typified by Berlin's *Hinterhof* ('backyard', the enclosed courtyard space overlooked by all the flats in a tenement), enabled children to gather and be watched by one or more mothers as they went about their daily chores, whilst others were working out of the home. Moreover, within these neighbourhoods many fathers participated in this communal care of children as well, since they often moved into and out of employment for periods of time or worked shifts in Weimar's industries. The development of strong working-class neighbourhood identities (and, indeed, political identities) were fostered by such ordinary forms of communal childcare and should not be underestimated.[43]

These simple discussions of communal child-care point to a more significant discrepancy between women's experiences of the changes in family structures during the years of the Republic – namely the issue of class. The 'new' experience of working outside the home and raising children at the same time was only new for those who had the privilege of the near-complete separation of the professional from the domestic sphere. For the urban proletariat, arguments concerning the combination of child-care and outside work were long overdue; working-class women had been combining these tasks for generations. The very fact that home work hit the wider public agenda during the period was a feature of middle-class interest in women's working conditions more than an indication of the novelty of this problem. Proletarian women had always

taken outside work into their homes in order simultaneously to earn money and care for their children. Communal child-care arrangements among neighbours in working-class districts were not new, nor were the spaces of communal child-care, such as the *Hinterhof* or the playground. Indeed, a feature on a new playground was run in the pages of *Weg der Frau* in 1931, right next to the review of the *Frau in Not* exhibition.[44] This conjunction between a politically radical exhibition concerning abortion and maternity rights for women and the development of a new playground for workers' children ('auf Höfen und Straßen', 'from backyard and street') indicates the importance of such communal spaces for proletarian women.

The representation of children and child-care within women's art of the period operated at the interstices of these various concepts and debates. On one hand, women artists were able to gain recognition for art which drew upon conventional links between creativity and procreativity. Thus it was that Kollwitz's powerful political comments were particularly well-received during the Weimar years since the language through which they were voiced was thought to be the most 'natural' for a woman artist to use. By couching her critique within emotive representations of mothers and children, Kollwitz merged a traditional, feminine form with radical alternative social messages and gained a position as the foremost woman artist of the day. Lea Grundig, Martha Schrag, Sella Hasse and Hannah Nagel all took Kollwitz as a role-model for women's political practice and combined stinging social commentary with works representing women, children and families. Similarly, the artist Elsa Haensgen-Dingkuhn was known as a great woman painter because she drew upon her experiences as a wife and mother in her art.[45] The artist Grethe Jürgens, never herself a mother, made her living during the 1930s and 1940s painting children's portraits; these and her illustrations for children's books were commissions which assumed again a natural connection between women artists and children.

These were not merely cynical manoeuvres on the part of women artists to forge careers based upon commonplace connections between women, children and the inherent femininity of women's art, but women were often able to find success within more 'traditional' areas of representational practice in the period. Such themes were intelligible within women's art and thus were more easily open to critical comment and discussion than art which defied all gendered norms. Additionally, many women artists did turn to the theme of children, still a relatively unusual

subject in work by male artists.[46] However, it was not the case that women artists in Weimar made particularly clichéd images of children or domesticity. No saccharine cherubs or hackneyed Madonna-types provided the mainstay of this imagery. In fact, the children and families represented by women artists tended to engage with class issues and the politics of the family structure so pertinent to debates about the *Hausfrau* of the time. Artists such as Gerta Overbeck and Lea Grundig showed working-class communal child-care and children playing on grimy city streets. Haensgen-Dingkuhn portrayed nurturing fathers looking after children and herself as a very modern *Hausfrau* while Nagel showed pretty infants as the scourge of their career-oriented mothers rather than as a source of great joy.

Nowhere was the alternative representation of children more marked than in the work of Tina Bauer-Pezellen, an artist particularly known as a painter of children throughout her career. Bauer-Pezellen was raised in Reichenberg and Neuhaus, the daughter of an Austrian military officer. From 1921 to 1922, she attended the *Kunstgewerbeschule* in Vienna, becoming familiar with the Austrian expressionists Oskar Kokoschka and Egon Schiele, and between 1923 and 1924, Bauer-Pezellen studied at the *Kunstgewerbeschule* in Munich. Her art centred upon figurative studies of peasants and workers in the communities in which she lived and, as southern, mainly Catholic communities, there were many large families to be represented by Bauer-Pezellen. Having used families and children especially as the subject-matter of her art and book illustration (she illustrated seven children's books between 1928 and 1930), it might be difficult now to understand why her practice was declared 'degenerate' as early as 1933 by the Nazis. Yet it was, and in fact the declaration of degeneracy focused upon a large-scale painting of a group of children playing – *Children's Playground* of 1933.[47]

As early as 1923, with the work *Proletarian Children in Neuhaus,* Bauer-Pezellen began to explore the dynamics of class and poverty through naive renderings of families and children. In this work, a large group of poor children are clustered around a man who is looking after them, presumably the father of some of the children. The image is clearly one of alternative proletarian familial structures in operation where one adult cares for a number of children so that the other adults can work away from home. The emphasis upon the male figure as a care-giver further removed this image from the idealised Madonna-and-child iconography typical of fine art representations of children. Bauer-Pezellen's representa-

tions of children were never idealised despite their simple, almost carica-
tured, stylised form. If anything, the child-like rendering techniques make
the discrepancy between idealised images of children and these harsh
scenes of growing up in poverty more pointed. The stylistic device suggests
a child's point of view which, when combined with the social criticism
implied by the choice of subject-matter, is a powerful strategy. Thus, in
Children's Playground, the work which was of particular offence to the Nazi
party, the scene depicts the massed ranks of humanity, from the bullies to
the victims, the happy to the miserable, the strong to the weak, played out
in the 'innocent' realm of the children's play area.

As Bauer-Pezellen herself suggested, her love of the subject of prole-
tarian children was due to the fact that they expressed the fullness of the
human condition in all its forms.[48] Such a use of children in artworks was
not necessarily traditional despite the fact that the artist was a woman.
On The Street (1933) typified the approaches taken to images of children
by Bauer-Pezellen. The work was painted in subtle colours and with a
simplified, almost child-like rendering of the figures which made them
appear awkward and ungainly, rather than cool, sophisticated or aloof.
Two children walk hand-in-hand down the street in the picture: a toddler
and an older girl, not old enough to be the child's mother, but still in the
position of responsibility for her younger sibling. This child here acts as a
supplementary Hausfrau, another under-represented support of the poor
household. This 'version' of the family was, of course, unacceptable to
the conservative factions of the period, yet it was a definitive part of the
lives of young working-class women.[49] These two figures are clearly
represented as poor by dress, posture and the sheer emaciation of their
bodies, yet they are not helpless figures of pity. The girl and toddler are
walking by the window of a lower-middle-class house from which two
more children stare as they pass. The house is tidy, but the window is not
dressed, so this is not a house in a well-off suburb. The children inside
the house gesture and stare at the ones on the street but to no avail.

This scene mimicked the urban life of adults with its class struggles,
transgressions of public and private boundaries and even physical and
emotional alienation. None of these children were shown as the coddled
dolls of a stay-at-home mother or nanny, nor were they pretty accou-
trements to the middle-class nuclear family. Rather, they were subjects like
any others attempting to live with and through the socio-economic prob-
lems of the day. Children in many of Bauer-Pezellen's works fend for
themselves (and sometimes for each other) and they develop the survival

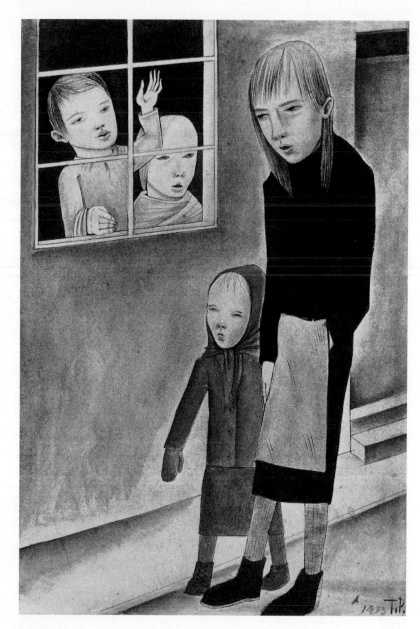

TINA BAUER-PEZELLEN

On the Street 1933

Courtesy of the Kunstammlungen zu Weimar

skills of adults in the city. Representing children in this way belied the myth of the domestic as an exclusively private realm; modern children were 'raised' as much in the exterior circumstances of the urban street as within the safe space of the interior of the home. Clearly, these representations were not the stuff of the family myths of the National Socialists, and Bauer-Pezellen, despite being a woman artist making images of children, was declared degenerate within their scheme.

One final work serves to summarise the debates raised thus far in relation to the figure of the *Hausfrau*, namely *Self-Portrait with Little Son in the Studio* (1928) by Elsa Haensgen-Dingkuhn. The dynamics of women's changing roles professionally and within the home as wife, mother and domestic care-taker are confronted by this fascinating self-portrait in which the artist is also the domestic mother.[50] As discussed in Chapter 1, Haensgen-Dingkuhn was particularly well-known in the Weimar years for her representation of families and children presumed to be a natural extension of her own situation as a mother and *Hausfrau*. In this way, she and many other women artists of the period were able to form successful professional careers and make use of their own surroundings and experiences as the staple of their artistic production. However, to assert that a professional woman artist was a traditional domestic type would be to misunderstand the whole question of the *Hausfrau* and the changing relationship between women and domesticity.

Haensgen-Dingkuhn drew upon her simultaneous roles as mother and artist in making this image; she was both a maternal, domestic woman and an active participant in the changing social circumstances of women as public actors and agents of social change. The fact that she combined the self-portrait with the picture of her son placed the traditional position of 'woman-as-mother' into conjunction with the woman as the empowered maker of visual art. The very spaces delineated by the image confounded the traditional separation of the public from the private spheres. The studio was the home; the artist worked and cared for a family in the same space. And if the interior of the home could not be constructed solely as a private space, neither could the care of a household and children be understood without any reference to the public spaces of modernity. The new interrelationship between public and private for modern women in Weimar ended the masculine-normative construction of separate spheres and made the boundaries between their professional and domestic responsibilities that much more integrated. Indeed it was only by maintaining the figure of the *Hausfrau* and her

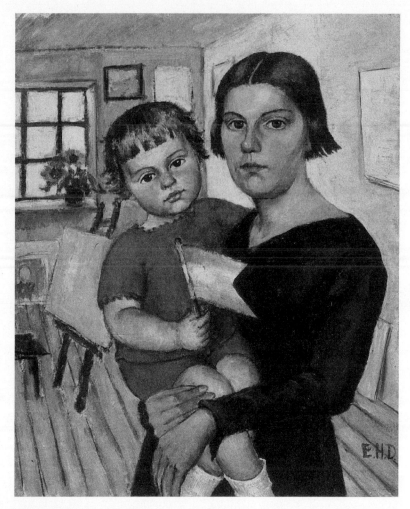

ELSA HAENSGEN-DINGKUHN

Self-Portrait with Little Son in the Studio 1928

Courtesy of Jochen Dingkuhn, Hamburg

activities as unseen or unspoken that the myth of the complete separation of the public from the private could be maintained. The changing definitions of the *Hausfrau* as wife, mother and heart of the household are brought into play in Haensgen-Dingkuhn's work to mark a moment of crisis in the traditional *schema*.

In keeping with the other work discussed in this chapter, the representation of the figure of the *Hausfrau* occurred where the trope was

being put under stress through technological, demographic and socio-economic changes to the roles of women as the domestic supporters of patriarchal order. The *Hausfrau* maintained the status quo best when it remained unseen; where it came into view, it tended to reveal the gender, generational and class differentials inherent in the structures which underpinned myths of ideal family life. Women artists, exploring their roles within the heterosexual couple, the domestic sphere and the family as these altered throughout the years of the Weimar Republic, questioned the order of the household and its central figure, the *Hausfrau*, in no uncertain terms. It remains to see the kinds of new, more public, models of women's roles put on the agenda by the insistent appearance of the *neue Frau*.

NOTES

1 In the Kölnisches Stadtmuseum catalogue, *Marta Hegemann (1894–1970): Leben und Werk*, edited by Michael Euler-Schmidt (Cologne, 1990), the picture is dated to 'circa 1924' (p. 12). Since it has now been lost, it is not possible to confirm this definitively.

2 Erika Esau, 'The *Künstlerehepaar*: Ideal and Reality' in *Visions of the Neue Frau: Women and the Visual Arts in Weimar Germany*, edited by Marsha Meskimmon and Shearer West (Aldershot, Scolar Press, 1995), p. 38.

3 Anjelika Hoerle was the first wife of Heinrich Hoerle, who died tragically at the age of twenty-four in 1923. She played a major role in the Cologne Dada scene and was a close friend of Hegemann.

4 See Erika Esau and the *Marta Hegemann* catalogue for reproductions of these images.

5 Lola Landau, 'The Companionate Marriage' ('*Kameradschaftsehe*') (originally published in *Die Tat*, 20 November 1929), translated and reprinted in *The Weimar Republic Sourcebook*, edited by Anton Kaes, Martin Jay and Edward Dimendberg (Berkeley, University of California Press, 1994), pp. 702–3.

6 Kristine von Soden, *Die Sexualberatungsstellen der Weimarer Republik, 1919–1933* (Berlin, Edition Hentrich, 1988), pp. 44–57.

7 An interesting example of the pre-war sex and marriage critique resides in the book *Frauenbewegung und Sexualethik: Beiträge zur modernen Ehekritik*, by Gertrud Bäumer, Agnes Bluhm, Ika Freudenberg, Anna Kraußneck, Helene Lange, Anna Pappritz, Alice Salomon and Marianne Weber (Heilbronn am Neckar, 1909).

8 Alexandra Kollontai published two widely-read texts: *Die neue Moral und die Arbeiterklasse* (Berlin, 1918) and *Wege der Liebe* (Berlin, Malik Verlag, 1925); Hirschfeld's films included *Anders die Andern* (1918) and *Prostitution* (1919).

9 von Soden, *Die Sexualberatungsstelle*, op. cit. , p. 9.

10 Ben Lindsey, *The Companionate Marriage* (1927) (New York, Arno Press, 1972); Theodor van de Velde, *Die Vollkommene Ehe* (Rüschlikon, Muller, 1967).

11 Ute Frevert, *Women in German History: From Bourgeois Emancipation to Sexual Liberation* (1986), translated by Stuart McKinnon-Evans (New York and Oxford, Berg, 1989), p. 195.

12 Cases in point would be Charlotte Berend-Corinth, whose marriage to Lovis Corinth meant a significant decrease in her practice for long periods while she tended to her husband and children, and Lotte Laserstein, who from the outset chose to remain unmarried in order to protect her career prospects.

13 Both of these works are illustrated in colour in the catalogue of Höch's works *Hannah Höch 1889–1978: Ihr Werk, Ihr Leben, Ihre Freunde* (Berlin, Berlinische Galerie, 1989).

14 Alice Rühle-Gerstel, *Das Frauenproblem der Gegenwart: Eine Psychologische Bilanz* (Leipzig, Verlag von S. Hirzel, 1932), p. 178–80

15 As late as 1935 a conservative journal, *die junge dame*, was still running articles debating titles for women: no. 23, 9 June 1935, p. 19.

16 Emma Oekinghaus, *Die Gesellschaftliche und Rechtlich Stellung der Deutschen Frau* (Jena Verlag von Gustav Fischer, 1925), p. 44.

17 Katharina von Ankum, 'Introduction' to *Women in the Metropolis: Gender and Modernity in Weimar Culture*, edited by von Ankum (Berkeley, University of California Press, 1997), p. 4; and Renate Bridenthal, 'Beyond *Kinder, Küche, Kirche*: Weimar Women at Work', *Central European History*, vol. 6, no. 2, 1973, pp. 148–66.

18 For details of Höch's critiques of male-female relationships, see Maud Lavin, *Cut with the Kitchen Knife: The Weimar Photomontages of Hannah Höch* (New Haven, Yale University Press, 1993); Maria Makela, 'The Misogynist Machine: Images of Technology in the Work of

Hannah Höch' in *Women in the Metropolis*, op. cit. , pp. 106–27.

19 Makela, 'The Misogynist Machine', op. cit. , p. 121.

20 Lea Grundig, *Gesichte und Geschichte* (Berlin, Dietz Verlag, 1960). She also authored another retrospective volume on Hans' work entitled *Über Hans Grundig und des Kunst der Bildermachens* (Berlin, Volk und Wissen Volkseigener Verlag, 1978).

21 Fritz to Eva cited in Eva-Maria Herkt, *Eva Schulze-Knabe* in the series *Maler und Werke* (Dresden, VEB, Verlag der Kunst, 1977), p. 7. Translation the author's.

22 Helene Stöcker, 'Marriage as a Psychological Problem' (originally published in *Sexual Reform Congress*, 1929) translated and reprinted in *The Weimar Republic Sourcebook*, op. cit. , pp. 705–8; von Soden, *Die Sexualberatungsstellen*, op. cit. , p. 122.

23 See Shulamith Behr, 'Between Politics and the Studio: Felixmüller as Revolutionary and Degenerate' in *Conrad Felixmüller, 1897–1977: Between Politics and the Studio*, exhibition catalogue, edited by Shulamith Behr and Amanda Wadsley (Leicester, Leicestershire Museums, Arts and Records Service, 1994), pp. 35–45.

24 The artists who used this theme include Grundig, Felixmüller, Overbeck, Haensgen-Dingkuhn, Dix and Hubbuch, to name but a few.

25 Helmut Leppien, 'Vorwort' in *Elsa Haensgen-Dingkuhn: Arbeiten aus den Jahren 1920–1980*, exhibition catalogue (Hamburg, Kunsthaus, 1981), p. 3. Translation the author's.

26 Ursula Horn, 'Zum Schaffen einer progressiven Künstlergruppe der zwanziger Jahre – in Hannover', *Bildende Kunst*, vol. 23, pt. 4, 1975, p. 175. Translation the author's.

27 Stöcker, op. cit. , pp. 706–7.

28 See Marion Kaplan, 'Sisterhood under Siege: Feminism and Anti-Feminism in Germany 1904–1938' in *When Biology Became Destiny: Women in Weimar and Nazi Germany*, edited by Renate Bridenthal, Atina Grossmann and Marion Kaplan (New York, Monthly Review Press, 1984), pp. 174–96.

29 To see some of the time and motion diagrams of women washing and cleaning from the period, see Christiane Hoch, 'Schreibmaschine, Bügeleisen und Mutterstagsträusse: Der bescheidene Frauenalltag in den zwanziger Jahren' in *Die Neue Frauen: Die Zwanziger Jahre, BilderLeseBuch*, edited by Kristine von Soden and Maruta Schmidt (Berlin, Elefanten Press, 1988), p. 92.

30 Grete Lihotsky, 'The Rationalisation in the Household' (originally published in *Das neue Frankfurt*, 1926–7), translated and reprinted in *The Weimar Republic Sourcebook*, op. cit. , pp. 462–5.

31 There are many discussions of German working-class housing conditions and much documentary evidence to show the terrible physical circumstances. See, for instance, von Soden, *Die Sexualberatungsstellen*, op. cit. , p. 59 for a photograph of a woman with three children living in one room.

32 'Alter und Neuer Haushalt' in *Arbeiter Illustrierte Zeitang*, no. 14, 1928, p. 7.

33 Oekinghaus, op. cit. , pp. 46–7, 54–5.

34 Regarding housewifery as a profession, see Else Wex, *Staatsbürgerliche Arbeit deutscher Frauen 1865–1928* (Berlin, F. A. Herbig Verlagsbuchhandlung, 1929), pp. 91ff (on the ADF response) ; Renate Bridenthal, '"Professional" Housewives: Stepsisters of the Women's Movement' in *When Biology Became Destiny*, op. cit. , pp. 153–73.

35 Rühle-Gerstel, op. cit. , pp. 245–6.

36 Frevert, op. cit. , pp. 192, 196.

37 Oekinghaus, op. cit. , pp. 100–101 (Oekinghaus consistently footnotes Pappritz here, from her book *Einführung in das Studium der Prostitutionsfrage*, [Leipzig, 1921]).

38 Not surprisingly, it was during the Weimar Republic that servants formed workers' associations and fought the restrictive laws under which they had laboured for a generation. See Violet Schultz, *In Berlin in Stellung: Dienstmädchen im Berlin der Jahrhundertwende*

(Berlin, Edition Hentrich, 1989), pp. 79–81.

39 Katharina von Ankum, 'Gendered Urban Spaces in Irmgard Keun's *Das kunstseidene Mädchen*' in *Women in the Metropolis*, op. cit. , pp. 162–84, p. 163.

40 Bridenthal, 'Professional Housewives', op. cit.

41 See Tamar Garb, *Sisters of the Brush: Women's Artistic Culture in Late Nineteenth-Century Paris* (New Haven, Yale University Press, 1994).

42 Wex, op. cit. , pp. 45–6.

43 For a discussion of the centrality of the neighborhood for working-class women's politics see Brian Peterson, 'The Politics of Working-Class Women in the Weimar Republic', *Central European History*, vol. 10, 1977, pp. 87–111.

44 *Weg der Frau*, September 1931, no. 4, p. 7.

45 See the critiques of Haensgen-Dingkuhn in chapter 1 for detail.

46 Felixmüller and Schlichter made portraits of workers' children and Dix represented his own daughter Nelly in his work, but generally the representations were few and far between and explicable as exceptions to the rule.

47 Biographical information for Tina Bauer-Pezellen can be found in the catalogue *Tina Bauer-Pezellen* (Weimar, Galerie im Scloß, 1977) with an essay by Helmut Scherf, and the small booklet by Jutta Penndorf, *Tina Bauer-Pezellen* (Dresden, VEB Verlag der Kunst, 1987).

48 Penndorf, ibid. , p. 5.

49 Young working-class women, whether part of the new white-collar sector (*Angestellten*) or not, most commonly lived at home while they were unmarried and did a large proportion of the household work and the raising of younger siblings. Hence, domestic responsibilities and outside work were shared by a number of women in these families, often from an early age; the typical construction of the *Hausfrau* does not reveal this common occurence. See Susanne Suhr, *Die weibliche Angestellten: Arbeits- und Lebensverhältnisse* (Berlin, Verlag: Zentralverband der Angestellten, 1930).

50 I have elsewhere considered this work within the context of women's self-portraiture more generally. See Martha Meskimmon, *The Art of Reflection: Women Artists' Self-Portraiture in the Twentieth Century* (London, Scarlet Press and NY, Columbia University Press, 1996).

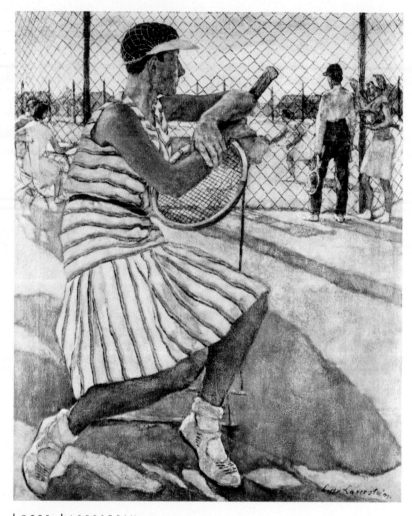

LOTTE LASERSTEIN

The Tennis Player 1930

Courtesy of Bryan Byfield, London

CHAPTER 4

THE
NEUE FRAU

IN 1930, THE BERLIN-BASED FIGURATIVE painter Lotte Laserstein produced *The Tennis Player*, using her close friend, Traute Rose, as the sitter for the main figure. This was not an unusual choice for Laserstein, since Rose was both her favourite model, posing for many of the artist's best-known paintings, and her tennis coach. Moreover, both Rose and Laserstein belonged to the generation of women who, during the Weimar Republic, would come to be known popularly as 'New Women'; they were young, independent, urban, sporty and, significantly, 'modern'. The *neue Frau* was first and foremost an icon of her time, and the imagery associated with this type, even when mere media hype, always hinted at the complexities and contradictions surrounding women's emancipation in the inter-war years.

The eponymous tennis player of Laserstein's work epitomised both the modish typology of the *neue Frau* and the wider, more positive implications of women's changing roles during

the period. The figure is shown as a young, physically-fit woman wearing a fashionable *Herrenschnitt* (literally, 'man's cut') hairstyle and stylish, modern tennis dress. The other female figures in the background, playing or watching the game, are also shown in the stylish, androgynous garb of the *neue Frau*, including one figure on the right of the canvas wearing sports trousers. The clothing, hairstyles and participation in sport were clear and legible signs for the *neue Frau* in the period and this work was popular enough to have been illustrated in the lifestyle journal *Mode und Kultur* in the year it was painted.[1] Thus, the work itself paralleled the position of the *neue Frau*, situated as she was on the borders of *Körperkultur* ('body culture', the body politics of the day), fashion, mass media and the socio-economic changes in the position of women in the period. It was produced (and consumed) between the realms of high art and mass culture by a woman artist who successfully forged a career in a male-dominated establishment not least through her renegotiation of such gendered visual tropes as the 'artist and model' and the *neue Frau*.

Laserstein's *The Tennis Player*, with its depiction of an all-woman scene of sport, not only indicated the significance of body politics to the concept of the *neue Frau*; it was also suggestive of the politics of female emancipation and the challenges of *Frauenkultur* more generally. New forms of women's sport and popular dance were culturally encoded as signs of both fashionable lifestyle changes for women in the Weimar Republic and new female roles which emphasised movement, strength and physical power. Like the other features which typified the 'look' of the *neue Frau*, sport was simultaneously a commodified fashion and the harbinger of real change. Hence, popular pictorial magazines of the period, such as the *Berliner Illustrirte Zeitung (BIZ)* and *Die Dame*, frequently carried advertisements for everything from hair pomade to hosiery illustrated by images of women playing sport – often tennis.[2] In these advertisements, the sport was usually just an indication of modish activity and a chance to draw or photograph pretty girls in scant clothing, moving in appealing ways – it sold products. However, it was more than that as well.

Women's groups and the mass media advocated new, healthier lifestyles which rid women of corsets and passivity in favour of comfortable clothes and outdoor activities. Female athletes were featured in the press as positive new role models for young women alongside women pilots, artists and politicians. The physical fitness of these figures was part of a more general trend which emphasised women taking more active

social roles. Associating sport with social change was no mere mass media invention either, with writers such as Bertolt Brecht using sport as a metaphor for a genuine popular culture.[3] Moreover, films were filled with active female characters (sometimes in *Hosenrolle*, literally 'trouser roles', where they masqueraded as male characters for dramatic effect) and the stars who played them, such as Marlene Dietrich and Tilla Durieux, were known for their physical prowess as well as economic independence. Magazines showed 'ordinary' women playing sport and driving cars and even the *Wandervogel* associations (akin to the Scouts) began to include young women. Sport was not only thought to be a particular feature of the modern, urban life of the *neue Frau* but, as Dr Edith Lölhöffel argued in 1931, it was also a key factor in the development of women's physical and spiritual independence and strength.[4] While many sports were encouraged for women, activities such as tennis, swimming, gymnastics and, of course, dance were the most popular.

Indeed dance holds a particular place in both the debates about *Körperkultur* and in the relationship between *Frauenkultur* and the so-called *Girlkultur*. Dancers, as a cross between athletes and 'stars', were extremely popular media figures throughout the Weimar years and most especially among women.[5] The 'revue-girl' became a desirable icon in the period both because of her svelte physique and her ability, in rare but famous instances, to transcend her humble origins and either marry a wealthy patron or become a major, economically powerful, celebrity. Irmgard Keun's famous women's novel *Die Kunstseidene Mädchen* ('the artificial silk/rayon girl'), in which the central character Doris acted as an archetype of the conflicting experiences and desires of the *neue Frau*, emphasised this desire in a day-dreaming sequence:

> That was a day. I had my premiere at the Wallenstein. I received more flowers than all the other actresses combined. There had been rumours that I was going to perform and every man to whom I had ever been attached, excepting Hubert, was there. I never realised how many there were. Already the theatre was full. Besides my men, there was hardly an audience. . . . (the audience applaud) 'Bravo for the young artist!' I hold every look in the hall.[6]

This capacity for 'success' was, literally, embodied by the physical form of 'the dancer', whose ubiquitous image covered the pages of the new illustrated magazines, advertising posters, theatre stages, cinema screens and even pulp fiction. The lithe 'girlish' body of the dancer was associ-

ated with American-style technology and the rationalisation of popular cultural forms as well as American commodity success and the Hollywood 'dream-machine'. Particularly in the precision line formations of the Tiller Girls, the Lawrence Girls and Ossi Oswalda, the concept of a *Girlkultur*, a popular culture centred upon the commodified spectacle of young, lean, androgynous and successful women, developed in the press.[7]

This *Girlkultur* was, for the most part, an evacuated media invention which disempowered women through an overdetermined emphasis upon physical appearance and commodity display. But, like today's media creation 'Girl Power', the possibility of challenging seemingly static gender roles offered some women the potential to develop alternative identifications. So although the messages of magazines such as *Die Dame* and the *BIZ* could be contradictory, the fact that they showed numerous images of active women offered different possibilities to viewers. One of the largest and most elaborate advertisements of the period to mobilise the multiple activities now available to the New Woman was for Bemberg hosiery.[8] In a full-page spread, accompanied by the caption 'Whether early at 8 or late at 10, whether working or going with the flow. . .', multiple images of the fashionable 'girl' – dancing with a partner in a club and, in another illustration, in a preci-sion line-formation, typing at work, pushing a pram and playing tennis – clamour for the attention of the young urban consumer. Any or all of these roles were now possible and, clearly, desirable enough to sell prod-ucts. Advertisements used the 'sporty woman' as a modern, urban consumer, pictorials showed the beautiful bodies of women who worked with light weights and even pictured a celebrity artist such as Renée Sintenis riding a horse.[9] Women's fascination with active, physically-powerful female figures went beyond simple consumerism and became part of a burgeoning *Frauenkultur*. Laserstein's tennis-playing women, for example, suit the 'girl' image in terms of body type and fashion, but the scene developed in the work goes well beyond this. The women repre-sented in the painting are engaged fully in their own, all-woman, activity; they play and watch the game in earnest. The absence of male figures in the image and the refusal to display the female figures as sexual commodities suggests that women's sport, in this context, was a genuine part of a newly-emergent women's culture among a generation of women reaching maturity in 1930.

As the above discussion of sport and the *neue Frau* implies, the main vehicle for the popular dissemination of this type in Weimar was the mass

media and, particularly, the illustrated press and advertising. Over 4000 titles appeared during the Weimar period and many of these magazines were focused on a female audience and made their visual mark through the representation of women.[10] The illustrated press mobilised the image of the *neue Frau* in features, celebrity at-homes, star pin-ups and vast quantities of advertising by the mid-1920s, just as the economic situation of the republic stabilised with the introduction of capital from America. In these years, German technology rationalised industry and commodity capitalism, especially in the cities, boomed. Even radical left- and right-wing political journals, such as the *Rote Fahne* and the *Illustrierter Beobachter*, which rarely carried 'frivolous' advertisements in the early 1920s, succumbed to the overwhelming popularity of the illustrated press by 1926 and placed the *neue Frau* into their illustrated pages. While the visual image of the *neue Frau* became an icon of the Weimar era, responses to this media sensation were mixed.

In the first place, the illustrated press, advertisements and the cinema were frequently denigrated as mass, or low, cultural forms. Thought of as modes of non-intellectual communication, the emphasis upon the immediacy and the visuality of these forms marked them as oppositional to high literature or philosophy. Significantly, the popular press and entertainment media were feminised by commentators; they were associated with a female audience and a feminine, or shallow, sensibility.[11] Hence, any major invention of the popular media was liable to be met with intellectual scepticism at the time and the *neue Frau* was no exception. In fact, at the very same time that magazines were advertising products with 'girls' and featuring famous dancers and celebrities in their main articles, they were carrying satirical graphics which parodied the figure of the *neue Frau* as a slavish follower of fashion. One of the most famous graphic artists to produce satires of the *neue Frau*, Karl Arnold, even used sport in one such image, *Winter Sport in Berlin* (1927). In *Winter Sport* he criticised the ostensible independence of the *neue Frau* in no uncertain terms. The 'sport' is simple: the fashionable, mannequin-like figures of women in his illustration are hunting for husbands. Their lean, sporty bodies are merely the latest marketable commodities in their quest for men.

Many feminist critics, both during the Weimar Republic and today, have responded to the problematic relationship between the media and the emancipation of women. As Katharina Sykora argued, the *neue Frau* of the 1920s was the popularised and depoliticised version of the New Woman first discussed at the turn of the century.[12] In many ways, the legal

and political advances made by the earlier generation were taken for granted by young women maturing in the years after the First World War and this meant that the more radical aspects of the *neue Frau* were able to be usurped and commodified by the mainstream culture industry. Moreover, as Ute Frevert argued in *Women in German History*, the New Woman was 'a projection of the men of the time who, either from fear or from an exaggerated sense of progress, painted a distorted picture of female modernity'.[13]

Such messages were also articulated in the period by women who could see that the *neue Frau* of the popular media was a stereotype and yet one which could imply possibilities for change and advancement for women. This position was in marked contrast to conservatives, who simply reacted to the trope with venom or spurious biological scare-tactics, and the mass media itself, which increasingly evacuated the *neue Frau* of all political potential in order to make it the more palatable for consumers. Writing in 1933, the communist commentator Alice Rühle-Gerstel lamented what she perceived as the loss of the potential of the New Woman in a wave of anti-feminist backlash.[14] Significantly, Rühle-Gerstel felt that the *neue Frau*, marked out as a new economic, political, physical and 'intellectual-psychological' type of woman, was first under siege around 1930, the very year that Laserstein painted *The Tennis Player*. Having experienced a high-point in the mid-1920s, the economic instability of the start of the Depression led to sharp criticism of women who had transgressed traditional gender roles in favour of independence, whether financial, social or sexual.

It is within this context that Laserstein's work can reveal its full implications as a form of cultural critique since it defined possibilities for women at the very interstices of changing gender identities and a wave of backlash. Laserstein consistently practised as a fine artist throughout her career in Germany. She attended the Academy in Berlin, winning the Gold Medal in 1925, and developed her *oeuvre* through portraiture and traditional forms of monumental figurative painting. She thus established herself within a strongly male-dominated area of art practice and was, in contemporary criticism, likened to Old Masters.[15] This self-conscious identification with the history of Western fine art was also significant in relation to her Jewish ancestry since her family were strongly assimilated and not devout. Culturally, Laserstein was rooted in German tradition, yet she was very aware that her position as a Jewish woman made her access to that tradition tangential.

So, for example, Laserstein eschewed marriage and lived throughout the Weimar years as an independent artist in Berlin, arguing that this was the only route available to a woman who wished to prioritise her art practice.[16] Significantly, she kept her studio in Wilmersdorf, one of the newer and more fashionable areas of the west of Berlin, associated with the mass media, shopping and the spectacle of the *neue Frau* on the street. Her relationship to both high art and popular culture was therefore determined by her gender and the means of access that were available to women in the period. She frequently represented female figures in her art and these too were located at the interstices of traditional painting and modern, urban types. Traute Rose, for example, figured both as the 'nude model' and the tennis-playing *neue Frau*. Despite her acceptance by the artistic establishment of the period and, indeed, the attempt by the City of Berlin to purchase one of her large-scale works at the Paris World Fair in 1937, Laserstein was forced to flee Nazi persecution and settle in Sweden in that same year. Clearly her own life and career were a challenge to the traditional definitions which constructed the 'fine artist' in terms of gender and race.

These details make her choice of subject-matter in *The Tennis Player* especially notable. This image of contemporary women engaging together in sport was the subject of a carefully-rendered work of fine art by a woman artist vying for status among conventional male painters. It took aspects of the denigrated media stereotype very seriously indeed as a way to make a statement about changing gender roles and developing new circumstances for women amongst themselves. The work combined high art and mass culture just as it crossed boundaries between masculine and feminine roles in its subject and conditions of production; thus it provided alternative models for women's roles at the interstices of aesthetic and gender borders. The visual structure of the work reinforced these new models by integrating the viewer within the frame and implying a matter-of-fact familiarity with the fashions and activity. This was not an extraordinary scene of spectacular otherness to be observed with distanced fascination; these female figures were a recognisable part of the changing definitions of gender in Weimar. Similar negotiations with new roles for women continued in Laserstein's *oeuvre* through her self-representations, such as *Self-Portrait with Model, Berlin Wilmersdorf* (1927) and *Self-Portrait with Cat* (1925) which cast her decidedly in the role of the *neue Frau*, working at her easel with *Herrenschnitt* and androgynous smock. Laserstein's main sitter, Traute Rose, was not

Laserstein's paid, anonymous model, but rather part of the culture of the modern woman which the artist represented in her works. Therefore, Laserstein used the evacuated visual stereotype of the fashionable *neue Frau* to another end, just as many other women artists of the period began to do in a variety of different media and styles.

Indeed, the *neue Frau* provided women artists and writers with a fruitful area of iconography and was a highly significant theme in their work. Women artists were, by definition, 'new women' and many clearly identified with the image.[17] As independent, usually young and urban makers of culture, women artists experienced at first hand the economic changes which were altering the positions of women in urban society and the popular debates about women's roles in modernity. The *neue Frau* was of immediate significance to a woman artist in Weimar and women's works attest to both the pleasure which this symbol could offer them and the critique they could provide of it. Exploring women artists' use of the figure is a challenge to the dominant conception of modern, urban women in the first decades of this century and it presents an opportunity to understand how women of the period constructed their own identities in relation to material changes and discursive stereotypes.

LABOUR: WOMEN AS WHITE-COLLAR WORKERS

May I introduce you to Ypsi, the small, very modern woman whom you have certainly seen a thousand times, at premieres, races, boxing matches, and celebrities' funerals. So, this is Ypsi (unfortunately, she doesn't look her best today for the Lindbergh-style hat doesn't become her, but, my God, dear lady, one does have to follow fashion, no?) . . . One does have to admire how much she takes on herself. Adultery, cocaine, operations, uncomfortable chairs made of aluminum in her strictly au courant apartment, riding with a man's saddle (devilishly painful around the bottom), plucking her eyebrows, reading boring books, shoes too small, hats too small, undergarments too thin in winter, tennis matches in ninety-degree heat in July, no children and stomach complaints, nicotine poisoning and slimming diets.[18]

Thus begins Vicki Baum's well-known essay 'People of Today' ('*Leute von heute*') from *Die Dame* in 1927 and serialised in the *BIZ*. The piece has

become famous for its harsh satire about the affectations of the *neue Frau*, desperately trying to be original, yet always just a fashion victim and parody of her 'type'. The original article was illustrated with caricatures of the *neue Frau*, produced by the graphic artist Karl Arnold, which deployed the cliché visual tropes as ammunition with which to burst the myth of this type. However, these criticisms are only aimed at the surface appearance of the New Woman and whatever the *neue Frau* may have embodied in terms of alternative manners and mores, at the heart of the type was women's increased presence in the rationalised, urban labour market. Elsa Hermann, author of the 1929 book *This is the New Woman* (*So ist die neue Frau*), explained the connection between changes in the labour structure and the concept of the New Woman thus:

> She [the 'woman of today'] refuses to be regarded as a physically weak being in need of assistance – the role the woman of yesterday continued to adopt artificially – and therefore no longer lives by means supplied to her from elsewhere, whether income from her parents or her husband. For the sake of her economic independence, the necessary precondition for the development of a self-reliant personality, she seeks to support herself through gainful employment. . . . The new woman is therefore no artificially conjured phenomenon, consciously conceived in opposition to an existing system; rather, she is organically bound up with the economic and cultural developments of the last few decades.[19]

The existence of the *neue Frau* (even as a type) would have been inconceivable without the economic changes which brought women into the cities as workers. Women's work was an issue hotly debated throughout the Weimar Republic by politicians, social critics and women's groups on both left and right. The most common cause for concern remained the shift of women's labour from the private, domestic sphere of the home to the public labour market. For conservatives, this was a sign of the destruction of the family (thus, the nation) and an unnatural realignment of gender roles. Those on the political left and women's groups, however, tended to be more concerned with what Alice Rühle-Gerstel termed the 'proletarianization of woman' as under-paid, over-worked employees and piece-workers.[20] As Ute Frevert has demonstrated, overarching attitudes toward women's work differed according to the economic conditions of the time: during stable periods attitudes were more lenient, and during times of economic crisis women were frequently scapegoated.[21] The concept of the *Doppelverdiener* ('double-earner') was commonly

deployed as both a means to keep women's wages lower than men's and to discourage female employment full stop. 'Double-earners', women who worked merely from 'boredom' to earn extra cash, were in fact extremely rare, yet legislation continued to be in force which determined women's wages at 10–25 per cent lower than those of their male colleagues throughout the years of the Republic.[22]

Such legislation, and indeed the terms of the debate about women's employment more generally, reinforced the notion that women were either fully domestic or fully public labourers. Even Emma Oekinghaus, who in 1925 wrote an influential and liberal volume concerning the contemporary situation of women, *Die Gesellschaftliche und Rechtliche Stellung der Frau* (*The Social and Legal Position of Woman*), divided her text into two main sections, one for 'married women' (*Ehefrau*) and one for those 'commercially-employed' (*Ewerbstätigen Frau*). [23] Such a division between the public and the private spheres of female employment is not sustainable in light of the demographic information and it can be seen that the actual situation of working women in Weimar was far more complex.

For example, although women entered the urban, white-collar market in ever-greater numbers during the period, it remained the case that over 50 per cent of employed women were still in agriculture, home industries or domestic service throughout the inter-war years.[24] Thus the majority of working women were still involved in domestic labour or labour within the confines of the home. Add to this the large numbers of women who took piece-work from local factories into their homes (as described at greater length in Chapter 2) and the women who worked in family businesses where the same premises were domestic and professional, and women's working patterns can be seen to further confound the simple division between public and private. Moreover, large numbers of working women were married and had children, another hidden anomaly of the system's ostensible operation. For married women and mothers, labour was certainly not confined to the public sphere. As astute contemporary observers and current scholars of women's history would now suggest, the stereotypes of women's labour and its connection to the phenomenon of the *neue Frau* referred only to one small portion of the labour market: young, urban (usually single) white-collar workers.

The form of white-collar work most commonly associated with the *neue Frau* was determined by the technological and commercial changes which accompanied the growth of commodity capitalism in the big cities.

Young women flocked to the clerical and service sectors of the market in droves. Mainly as secretaries, typists, stenographers and sales personnel, this segment of working women began to define themselves as a new body of workers who, while frequently being financially worse-off than their sisters on the factory floor, occupied positions of greater status.[25] This status was derived from the relative absence in their jobs of manual labour and the presence of fashionable accoutrements of urban, working life, such as modish clothes and modern forms of entertainment. These consumer accessories were both aimed at young working women and determined, in form, by them. Advertisements focused upon the acquisition of a stylish look through make-up, hair treatments and clothes, and in turn this very look was paraded as the ideal for the working girl in movies, magazines and shop-window displays. The mechanisms of consumer identification will be discussed at length in the next section of this chapter so it suffices here to remember that such displays were manufactured by the media and served to occlude the variety and difficulties of women's experiences of labour in the Weimar Republic.

But even this distinction between the female white-collar worker (*die weibliche Angestellte*) and the young, modern urban woman who worked in industry was nebulous. Thus it was that in Lisbeth Franzen-Hellersberg's sensitive study of young women workers, features of the lives and labour of her subjects seemed to join the stereotype of the *neue Frau* with the young proletarian woman.[26] The subjects of the study worked in factories and in other sectors of the labour market which stressed their physical, manual work. They were not clerks, shop assistants or stenographers. Yet, their 'attitudes' and habits were those typically associated with the *neue Frau*; Franzen-Hellersberg argued that they spent their meagre wages buying jewellery, make-up and clothes to go to the cinema or dancing. As young, modish urban shoppers, they must have been indistinguishable from their white-collar sisters. A similar conjunction between young workers and the New Woman took place in the writing of the well-known marxist sex-reformer Alexandra Kollontai. In her work, *Die neue Moral und die Arbeiterklasse* (1918, translated from the Russian and published in Berlin 1920), Kollontai asserted the reality of the phenomenon of the New Woman in no uncertain terms: '. . . the *neue Frau* is there – she exists.'[27] This new female type was neither bourgeois, nor part of the old-fashioned, unenlightened working classes; she was independent, strong, right-thinking and the way forward to a revolution in social life. And, she was a working woman. These arguments

support the demographic information concerning changing labour patterns for women discussed above; the *neue Frau* as a part of the female white-collar sector may have been the daughter of a lower-middle-class family now needing to work or desiring a career before marriage, or she may have been the daughter of a working-class family moving 'up' the scale from domestic service or factory work to an office job. In the *neue Frau*, simple class distinctions dissolved since this figure was a worker, but with new status and aspirations. Only the media, however, obfuscated the genuine labour at the heart of the type.

Hilde Walter's sensitive piece from 1931 about working women and their opponents expressed eloquently the distinction between the conditions of women's labour and the media ideals:

> . . . the phenomenon of working women in general is being twisted to meet the needs of a variety of propagandistic goals. . . . In addition, all the consumer-goods industries geared to female customers were very quick to recognize the attractiveness of such catchwords and make full use of them in their advertisements. Even the most poorly paid saleswoman or typist is an effective billboard; in a provocative get-up she becomes the very emblem of endless weekend amusements and the eternal freshness of youth. Women's moderate professional successes, often deficiently compensated, are glorified in annuals and wall calendars. . .[28]

Walter suggested that to counter these media stereotypes (against which so many people were reacting negatively), statistics concerning the actual working conditions of women in white-collar occupations should be deployed. This would displace the notion of the supercilious *neue Frau*, going into her stylish office only to pick up her huge pay-cheque before breezing out to the cafe and cinema for the evening, which Walter saw as the single most damaging stereotype of women's work. Thus the author identified both the myth of the *neue Frau* and the material conditions which were operating to propound such an icon, and sought to critique these. Significantly, she did not suggest that women should no longer work, nor that they should keep silent about their situation. Rather, Walter called for women themselves to 'do away with the fiction of the united front of all working women' and to voice their experiences of the various conditions under which they now worked in the public sphere.[29] This position on the subject of the *neue Frau* and women's labour is critical; it places women themselves as the central commentators on the 'woman question' and seeks not to find one 'solution' to the problem, but

rather many perspectives on, and negotiations of, the new roles available. Thus it neither dispenses with the *neue Frau* as a mere myth, nor simply celebrates it. It is precisely this form of active engagement with the trope of the new working woman which is so powerful in the art produced by women in the Weimar Republic.

The Hanoverian artist, Grethe Jürgens, painted *The Labour Exchange* in 1929, just as she herself had left her job with an electrical firm where she had been employed as a mechanical draughtsperson. As described in the second chapter of this volume, *The Labour Exchange* showed the scene outside Hanover's social services building where, each morning, those white-collar workers fortunate enough to receive unemployment benefit queued for payment. During the economically unstable years at the beginning and end of the Weimar Republic, the unemployed were frequently used in art to critique the government and the inequities of the capitalist system. Jürgens's work operated on this level, documenting a scene which was embarrassing to the establishment, particularly in a well-off mercantile centre such as Hanover. However, in terms of women and white-collar work, the painting was even more significant since it refuted the one-dimensional stereotype of the *neue Frau* as secretary or shop-girl.

Very few of the masses of unemployed workers in Germany during the inter-war years were eligible to receive state benefit. This was only available through a form of national insurance to those white-collar workers employed by firms in the scheme. Thus the workers portrayed outside the labour exchange in the image by Jürgens were part of that new social division of relatively privileged white-collar labour and not just the massed proletariat. Included amongst the represented workers in the picture is the figure of a woman with a perambulator and a self-portrait of the artist, walking off into the distance. The structure of the image places two male figures in the foreground and these two female figures on the perspectival axis of the middle- and background. Hence the working mother and the young woman artist enjoy compositional significance in the work equivalent to the male figures. The presence in the painting of these female workers was in marked contrast to the more usual representation of women workers in the period as either suffering proletarian homeworkers or decadent 'office girls'. The female figures in Jürgens's work document the existence, however unsensational, of a number of different women in white-collar occupations, from mothers and wives to the young artist herself.

This work demonstrates the way that Jürgens, as a woman artist, negotiated the type of the *neue Frau* and her new position in the labour market. Jürgens trained in Hanover at the *Kunstgewerbeschule* in graphics and was an independent professional artist from 1928 until her death in Hanover in 1981.[30] Though she was part of the Hanoverian *neue Sachlichkeit* circle, she used her graphics training to work, periodically, as an illustrator and mechanical draughtsperson. That affiliation with graphic art and her decidedly realist style throughout the 1920s and 1930s placed her in opposition to Hanover's mainstream art scene at this time, which was dominated by abstract art. Jürgens and the other young realist painters of the city used their choice of ordinary subject-matter in tandem with their 'realism' to carry a left-wing political commitment and a working-class orientation. Jürgens was also a member of the local branch of the GEDOK (*Gemeinschaft Deutscher und Österreichischer Künstlerinnen*) from 1928, a fact which meant that she was well aware of the politics associated with independent women who wished to maintain professional art careers. Many of her works concerned the situation of working women in the period and she also produced a number of self-portraits in which she represented herself as a New Woman.

The Labour Exchange signified on both of these levels, providing a glimpse of women's lives in Hanover and including a self-portrait reference. The work suggested the diversity of women's roles within the new labour market and affirmed their position within the public sphere. The figure of Jürgens reasserted the new young female employee, but as more than just a bland stereotype and in conjunction with other women (mothers in this case) also involved with white-collar work, if less sensationalised by the media. The painting carried with it a distinct politics, both through its critique and display of the unemployed white-collar workers and the depiction of women as crucial members of the new labour force. The inclusion of a 'self-portrait' in an image concerning labour emphasised the personal investment in socio-economic change which young, independent women such as Jürgens had; the artist could, simultaneously, desire the freedoms of the working *neue Frau* and expose the one-dimensionality of the media icon. It is no surprise that this painting was returned to Jürgens in 1937 by a sympathetic curator of the local museum who assumed the Nazi regime would destroy it.[31]

It was not just that the female white-collar worker was associated with the figure of the *neue Frau*; shop-girls and young office workers on the streets of big cities were themselves on display. Gerta Overbeck, the other

woman artist associated with the Hanoverian *neue Sachlichkeit*, explored this in her work *Mother and Child at the Hairdresser's* (1924). In Overbeck's work, the literal fore- and background distance between the 'mother' and the 'hairdresser' emphasises the distance between their positions; the one is the icon of the *neue Frau* and the other a mere aspirant. The foregrounded 'mother' is rendered akin to the spectator through her gaze and position and, like her, we are made to feel as though the desirable icon of 'woman' is a long way off. As in Jürgens's work *The Labour Exchange*, Overbeck has not just denied the presence or the pleasurable power exerted by the stereotype of the New Woman in favour of a 'real' woman. Instead, these works reveal the continual process of incorporation and development of women's disparate experiences in light of changing economic and cultural conditions.

Here the hairdresser is the archetypal *neue Frau* with her modish clothes and mannequin-like hair and make-up. She conforms in her image to one of the key features of the female-dominated service industries: the use of femininity or 'feminine wiles' as part of the occupation itself. [32] Secretaries and office workers, saleswomen and hairdressers alike were meant to 'sell' their products through their own personal charm and the stylish accoutrements of their position. The hairdresser could not simply be a technician, she needed to exemplify the style she hoped to sell to her customers. Moreover, women in white-collar work (the so-called *weibliche Angestellten*) were the main market to whom make-up and fashionable clothing and accessories were sold. [33]

The association of the female white-collar worker with a particular, surface-oriented image and an intellectually shallow lifestyle was of concern to many contemporary cultural critics, including Alice Rühle-Gerstel and Siegfried Kracauer. In *Die Angestellten* (*The White-Collar Workers*) and a number of his essays for the *Frankfurter Allgemeine Zeitung*, such as 'Cult of Distraction: On Berlin's Picture Palaces' (1926) and 'The Mass Ornament' (1927), Kracauer explored the possibility of a novel form of class consciousness for this group with little optimism. [34] His fear was that the group was neither bourgeois nor proletarian. Rühle-Gerstel thought similarly and wrote in 1932 of female white-collar workers: 'Economic situation: proletarian; ideology: bourgeois; type of occupation: male; attitude to work: female'. [35] For Kracauer, the *Angestellten* were 'homeless', wandering restlessly through the empty consumerism of modernity with nothing to give meaning or value to their lives. The culture industry simply exploited this 'homelessness' and, espe-

cially in the case of female white-collar workers, seduced and then aban-
doned them with vast quantities of cinema, popular press and advertise-
ment. The key concept at the heart of these gendered critiques of the
female white-collar worker and the vacuity of her cultural life was the
loathing of consumerism in its widest sense. Yet it assumes that women
could not but be seduced by the most banal of consumerist displays, a
fact which is refuted by examining the work of women artists on the
theme.

THE NEUE FRAU AND CONSUMERISM

Probably the most instantly recognisable visual features of the *neue Frau*
are those derived from the growing consumer culture of the Weimar
Republic. The fashion, hairstyles and make-up of the New Woman, her
appearance in the burgeoning women's magazines, advertisements and
cinema of the period and the (female) spectacle which was the city with
its shop-windows, variety revues, dance-halls and cafes, were all associ-
ated in literal and figurative terms with the commodity consumption of
the *neue Frau*. It would be too simple to suggest that these forms of
consumerist display were merely surface phenomena and that the labour
situation described above was the 'real' condition which defined the New
Woman. Both labour and consumerism worked in tandem to produce the
neue Frau; the material conditions in which urban women worked were
intimately connected to the forms of cultural change demonstrated by
fashion, cinema and the mass media and these, in turn, affected the
labour market. The constant ebb and flow between socio-economic
changes for women workers and the development of new cultural
constructs of gender were grist to the mill for women artists concerned
with representing contemporary women's lives.

Before looking in detail at the ways in which women artists were able
to use the techniques and tropes of consumer culture to investigate
changing gender roles, it is important to examine briefly the contempo-
rary conceptions of these cultural forms. The mass culture of the city in
Weimar included such diverse elements as window displays, cinema, the
mass media, popular dance, variety revues, advertisements and even
shopping itself. Critics tended to comment either on the thrilling, yet over-
whelming 'display' of the city or the fact that mass culture was nothing
but empty decoration, designed to pacify the beleaguered worker and

city-dweller. As Kracauer wrote in 'Cult of Distraction', Berlin audiences preferred the 'surface glamor (sic) of the stars, films, revues and production values' to conventional forms of fine art.[36] Significantly, most critics were pessimistic about popular cultural forms and, at the same time, linked these to 'woman', literally or figuratively. Hence, Hanns Kropff in 1926 wrote disparagingly of women shoppers that they 'love a simple and personal language. . . are pleased by easily understood explanations of the use of an item. . . are captivated by a pretty and skilful speech, even if the calculation is wrong. . .'[37] Franz Hessel, in his article 'On Fashion' of 1929, went one step further regarding the links between women and shopping by asserting that the very spectacle of attractive, fashionable women going to shops and examining the products in the windows was part of the aesthetic pleasure of the city.[38]

Katharina Sykora placed these ideas of gendered spectacle into the context of the political and aesthetic debates of the period, arguing that women's increased public access destabilised male sexual voyeurism and confused the body of woman with consumer objects themselves.[39] Andreas Huyssen also claimed convincingly that mass cultural forms were defined in the feminine, as 'other' in order to maintain the centrality of an elite, 'masculine' high culture.[40] Hence the association of 'mindless' consumption with women was not merely coincidental; the conflation of 'woman' with consumerist, popular culture was a structural necessity. Even Kracauer, arguably the most prolific and influential critic of mass culture in the period, connected 'woman' to these new cultural forms. Kracauer explicitly referred to the 'maids and shopgirls' who formed the new audience for cinematic melodrama and described the significance of rationalised female dance troupes such as the Jackson Girls in his work.[41] As Sabine Hake argued, 'Kracauer's misogyny', his tendency to associate all mindless, surface-oriented consumerism and consumerist cultural forms with women and 'woman', underpinned his whole critique of mass culture.[42] Significantly, the 'woman' he associated with these forms was the young, urban white-collar worker: the neue Frau.

Although it is possible to criticise the gender politics of Kracauer's position, his insights into the nature of rationalised consumer culture were and are significant. It was Kracauer who attempted to explain the appeal of contemporary cinema and revues in terms of the new audience whose lives were accustomed to the pace and repetition of technological forms of production. In the essays, 'The Mass Ornament' and 'Girls and Crisis', for example, Kracauer described the very form of precision line dancing

in terms of the factory floor and the endless replication of interchangeable parts on the assembly line. And although Kracauer paid serious attention to popular cultural forms he nevertheless exhibited a relatively pessimistic assessment of these as part of a 'cult of distraction/diversion'.[43] That is, the mechanisms of popular culture were designed to foster a false consciousness in their audience. Drawing on the Marxist concept of ideology, Kracauer argued that mass cultural forms were ideological tools in the hands of the establishment, 'diverting' the new white-collar workers from the possibility of political action. Rather than these forms being useful new markers of identification and consciousness for an emergent class, Kracauer felt that the Angestellten sought escape and oblivion in consumerism and entertainment.

This sort of pessimism about the new culture industry was, in many ways, justified. However, to assert its subject and audience to be women or 'woman' is to suggest that a critique of the system can be levelled only through the masculine position. This is a common feature of high modernism and its gender bias, and the trope of the male genius creator who wages battle against bourgeois sensibility through the representation of woman was its most common form. Mobilising the neue Frau as a one-dimensional stereotype to be scapegoated as the archetype of the new, empty-headed consumer worked precisely in this way. In order to level the elite, masculine critique of consumerism, the New Woman was evacuated of her potentially liberating aspects, paraded as a mere image in the media and described as the duped consumer by male critics. This left no space in which to take seriously the women who were emerging as independent agents in the period and their negotiations of the tropes of the neue Frau, spectatorship and consumerism.

Recent feminist scholarship concerning the neue Frau and female cultural consumption in the Weimar Republic has begun to question such obvious omissions from the traditional arguments. Just as Hake reread Kracauer in relation to the female audiences he mentioned but dismissed, scholars such as Shulamith Behr, Maud Lavin and Patrice Petro have argued that women as patrons, spectators and consumers in the period engaged in multiple and complex negotiations with the concept of the New Woman and the spectacle of the culture industry.[44] While women were entering the realms of high art and popular culture as patrons, artists, critics, consumers and spectators, they neither experienced these roles in the same way as men of the period, nor did they become the easily 'dismissable' objects within new trajectories of public space and

spectacle. Their position was at the nexus of the subject and the object; they were consumers and consumed. As yet, there have not been adequate accounts offered by masculine-normative theories of cultural consumption, or as Petro argued in relationship to mainstream conceptions of female cinematic spectatorship in Weimar:

> Following from Kracauer's observations, we may suspect that women's relationship to modernity was entirely different from what was commonly projected onto the figure of woman during the Weimar period. Indeed it would seem that women's relationship to modernity and mass culture has all too frequently been confused with male desire, and with male perceptions of gender difference.[45]

Significantly, Petro neither denied the useful work of Kracauer on cinematic spectatorship, nor acceded to its gender-blindness. Similarly, Anke Gleber took the concept of the *flâneur* seriously and argued the case for a particularly feminine form of *flânerie* in the new forms of urban window-shopping of the period.[46] Here again, woman was both viewer and viewed; intimately connected to the spectacle of the urban scene yet not merely absorbed by it. This simultaneity of subject and object, engagement with consumerism and distance from it, was typified by the work of women artists in the period.

Women artists did not simply operate as mindless consumers of popular forms; their deliberate interventions into the gender debates of the time were defined through their critical position on such female stereotypes as the mother, the prostitute and, of course, the *neue Frau*. Jeanne Mammen's image *Boring Dollies* (1927–30) is a case in point. As Kracauer proposed, the antithesis to the *Verstreuung* ('distraction') of modern, rationalised existence was *Langeweile* or 'boredom'.[47] Mammen's work, with its emphasis on the boredom of the *neue Frau*, is in keeping with Kracauer's analysis, and she would, in another drawing from the 1920s (actually entitled *Boredom*), again play out the tedium of modernity through the figures of two jaded, fashionable women sitting in a bar. But the critical links between the images produced by Mammen and the theories of Kracauer are greater than mere chance titular juxtapositions; Mammen actually described in imagery the situation Kracauer critiqued *without* being subsumed by it. Mammen's location of a critique within the cycle of pleasurable consumption suggests an embodied maker and viewer of art and media imagery and reveals the distanced position of the elite masculine critic to be untenable. There was no place

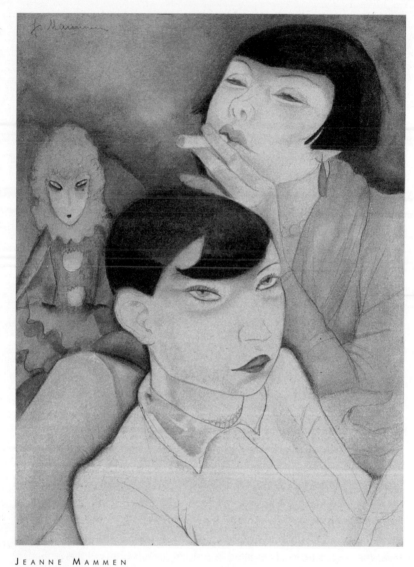

JEANNE MAMMEN

Boring Dollies 1927–30

Courtesy of Marvin and Janet Fishman, Milwaukee, Wisconsin

outside this spectacular commodity culture from which to argue against it; negotiations of power and pleasure took place from inside. As a woman artist, and one working in both fashion illustration and in Berlin's lesbian underground, Mammen was ideally situated to explore the multi-

faceted nature of the *neue Frau* stereotype, and her work refutes the argument that women consumed mass media imagery uncritically.

Mammen's artistic career spanned six decades in Berlin, and during the Weimar Republic she worked as an illustrator for well-known magazines, such as *Die Dame*, *Uhu* and *Simplicissimus*, designed film and fashion posters, took commissions to illustrate books like Curt Moreck's underground guide *Führer durch das 'lasterhafte' Berlin* and to produce fine art print portfolios.[48] The popular magazine *Die Dame* published by the Ullstein house throughout the inter-war years epitomised the modern, fashionable women's journals of the period with their mix of photojournalism, fashion and make-up tips and vast pages of advertisements directed toward women. Mammen's own fashion illustrations demonstrated her intimate familiarity with the marketable icon of the *neue Frau*. Moreover, living on the Kurfürstendamm, she was centred in the most modern section of Berlin in which fashionable shops vied for space with cafes, dance-clubs and revue-palaces; all the haunts of the young independent women of the day. Not surprisingly, Mammen's commissioned work was produced in addition to a large quantity of uncommissioned paintings, drawings and graphics on the theme of contemporary urban women. Thus, Mammen was not only a *neue Frau* by occupation and urban location, she was intimately tied to the very media forms which were most crucial in defining the image of the New Woman throughout the period.

One type of advertisement common in the Weimar years stylised the female figure as a faceless mannequin-woman. For example, in many illustrations from the *BIZ* showing the latest hairstyles and sports clothes in 1926, the line-drawings of the female figures rendered them identical and without any individualised features; the impression of their mannequin-like interchangeability was emphasised further by the fact that they were shown in multiples, standing in exactly the same pose. This imagery was used to sell everything from underwear to Three Flowers powder. The link between the interchangeability of mannequin parts and the rationalised dancers described by Kracauer is discussed at length in Chapter 1 in relation to the iconography of the prostitute and the increasing presence of women in public, and need not be reiterated here. However, it should be pointed out that as readers of magazines such as the *BIZ*, women would have been very familiar with this sort of rationalised, stylised female form – indeed they were the intended consumers of this icon in advertising. The fact that this type of repeated woman-icon

was used for the cover-logo of the lesbian journal *Ledige Frauen* points to its common currency as an icon for women. Moreover, as the hairstyles, clothes and settings of these advertisements suggest, this mannequin-type was modern: she was one particular visual code for the *neue Frau*.

Mammen's own fashion illustration from the period drew upon these linear, stylised icons of modern woman while her uncommissioned artwork explored the intricacies of the lives of her female contemporaries. Hence she understood how complex the interactions between the experiences and representations of women in the period were and her *Boring Dollies* critiqued precisely the typology of the evacuated, meaningless mannequin-woman displayed by the media. Two female figures, like the bland china doll with which they are represented, are shown in the modish make-up and hairstyles of the period which, rather than grant the wearers a mark of originality, merely serve to homogenise them. They are made into 'dollies', rather than women, by the very consumer products designed to make them 'special'. The reference to the 'dolly' is a reminder of the insistent use of the 'girl' and the 'doll' in relation to popularised icons of woman. In such vacant stereotypes, women are infantilised as mere objects. And, of course, they are 'bored'; their very image produces visual tedium through constant repetition and this empty consumerist icon of woman holds no promise of change.

By tapping into the mode of fashion illustration, yet parodying it, Mammen has used the very form against itself and created the distance necessary for women to challenge this iconography in their own terms and from within. Her work demonstrated what is emptied from the representation of *women* by the mass-produced and consumed commodity display of *woman*. She therefore presents the possibility of a peculiarly female form through which to counter the association of woman with 'distraction'. Moreover, such work situated the maker and the viewer within the codes of consumer culture without suggesting that proximity denied critical thought. Thus this work enables us to think through embodied modes of interaction with visual pleasures which are not merely coopting by definition. Like the potential for female *flânerie* and self-conscious engagement with the spectacle of woman posited by such women authors of the period as Irmgard Keun, Mammen's work implies the need to rethink the gendering of 'distraction' in the modernist tradition.[49]

Thus Mammen and other women artists who considered the media forms of the *neue Frau*, such as Hannah Höch and the photographers

Ringl and Pit (see Chapter 1), could be as stinging as Kracauer in their analysis of the popularised New Woman, which fact challenges the assumption that women were too caught up in the system to criticise it. Their work renders visible the blind spot of modernist theory and practice which made the implicit and over-simple equation of 'woman' with mass culture and consumerism. Women's striking critiques of stereotypes of the neue Frau demonstrate that they were not thoughtless consumers of popular culture and its ideologies, nor was the imagery in any simple sense representative of them. Even more significant, however, is the fact that women artists did not stop at such overt criticism but developed the gendered tropes to their own advantage. Their work explored the diversity of women's responses to imaged gender roles in the period and could show the pleasure and potential of the neue Frau as well as expose the myth.

FROM STENOGRAPHER TO REVUE-GIRL

In 1929, the artist Elsa Haensgen-Dingkuhn painted Dancers in a Hall, which juxtaposed a troupe of revue girls performing a line-dance with a female spectator of the performance. This work reiterates the critique of the mindless woman-mannequin-dancer described above, but also reminds us of the pleasure had by women in the period in consuming popular cultural forms. In the work, what seems to be a revue is taking place on stage in the background while a man and woman are shown together at a table in the foreground. The figures of the dancers played on the clichés associated both with the 'girl' dancing troupes and the 'mass ornament' described by Kracauer. They were depicted in a line-formation, all identical in their appearance and co-ordinated movement, and thus they become interchangeable elements within the larger composition. However, the couple pictured in the foreground by Haensgen-Dingkuhn act in quite the opposite way. These figures were rendered with great individual attention by the artist and, significantly, while the male figure is seen to be staring blankly before him, the figure of the woman engages the viewer. As in many other works by Haensgen-Dingkuhn (see Chapters 1 and 3), it is through the look of a central, female figure that we gain access to the scene. She was not represented as mesmerised or 'diverted/distracted' by the dancers, but neither was she shown 'bored' or jaded. Rather, the female figure was represented as

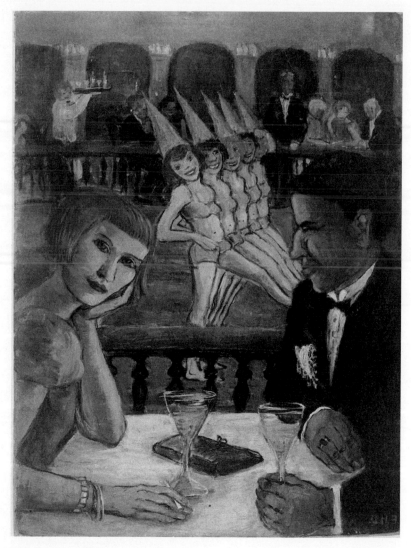

ELSA HAENSGEN-DINGKUHN

Dancers in a Hall 1929

Courtesy of Jochen Dingkuhn, Hamburg

both a willing participant in urban spectacle and nightlife, with all its pleasures, and as a subject able to maintain her distance from it.

This fact implies another important feature of the encounter between women artists and the commodified display of the *neue Frau*: namely the pleasure taken in consuming and reworking the imagery. A well-known

example of this can be found in the work of Hannah Höch. Throughout the Weimar years, the Berlin artist Höch produced photomontage works which actually used the commercial photographs reproduced in the illustrated press of the period, particularly images from women's magazines. Frequently, Höch manipulated images of popular actresses, dancers and other famous icons of the *neue Frau* in her *oeuvre*. Maud Lavin has demonstrated with great skill the complexity of Höch's responses to the media representations of the *neue Frau* in her photomontage works and the fact that she exhibited neither a simple rejection nor celebration of these figures or the system in which they circulated. It is worth quoting Lavin at some length regarding the use of modern female celebrities in the artist's *oeuvre*:

> To reproduce the image of a recognisable mass media star, even if fragmented, was in and of itself to celebrate the star system, a method that presents anew the pleasures of viewing media images. . . . For example, Höch could have seen Asta Nielsen live on stage and on the screen, in newspaper photographs reporting on or publicising her performances, in "candid" shots in Die Dame and other magazines, and in advertising. To repeat images of this admired star in an avant-garde context (as Höch did later in her painting Roma) was, for Höch, to participate in this thoroughly pleasurable cycle of media reproduction. However, to deconstruct a Weimar Illustrierte subject using examples of newspaper photography was also to counter the widespread reverence for the media and its technologies. To combine the two was to turn technological progressivism in on itself and, at the same time, to express the desire for a new order.[50]

What Lavin has recognised here is that women artists could participate in the 'pleasurable cycle' offered by the culture industry without simply being absorbed by it. Women were actually in the ideal situation to explore the multi-faceted nature of this trope and then to challenge and develop new constructions of gender identity in imagery. It is worth examining the connected pleasures of consuming the performed and represented images of the New Woman as embodied by dance, cinema and the mass media and the production of images of these female stars by women artists in the period.

The popular stars of the day were available through more than just their performances in exciting, modern cinematic roles or in physically demanding dance routines; they were sold as icons by the mass media in a variety of ways. The image of a star was enhanced by publicity

photos, posed and staged to emphasise the 'type' or best-loved features of the particular figure, such as Anna May Wong's 'exoticism' or Dietrich's legs. More than this, though, familiarity with these figures was fostered by alternative forms of photojournalism. Stars were shown in 'candid' photographs out on the town in glamorous clothes, relaxing on holiday, or even 'at home'. Fritzi Massary was shown 'at home' with her own car to emphasise her modernity while, for example, Anita Berber was often seen out in Berlin's underground gay and lesbian scene, known at the time as 'Eldorado', suggesting her more dangerous reputation. Furthermore, interviews with celebrities and their own written columns in papers proved very popular as a way of having access to their 'real' lives. Valeska Gert's popularity was increased by the fact that she wrote articles about her life as a dancer in the popular press, and there were many fictionalised accounts of young women becoming dancers and celebrities which made fantasies of such transformation the stock-in-trade of pulp fiction.[51] One such piece published in *Querschnitt* in 1927, 'How I became a Revue-Girl', traced the rags-to-riches story of a young working-class woman and proved highly successful in drawing a female readership to the journal. The idea of moving from stenographer to revue-girl encapsulated the strange interconnection between women's white-collar work and the celebrity *neue Frau* which typified this moment in Weimar.[52]

Images of dancers particularly were at the centre of new modes of *Körperkultur*, and their lean, muscular bodies were often shown in aestheticised nude photographs for female consumers to enjoy in the pages of women's magazines. In this way, these new modes of imaged female sexuality became mainstream for women as spectators. For example, the woman photographer Madame d'Ora produced a series of highly aestheticised nude images of Josephine Baker for the illustrated press which played the darkness of her oiled body against the sheen of her *Bubikopf* and jewellery; such imagery reinforced the exotic 'primitive' readings of Baker in conjunction with her position as a modern dancer and celebrity. The makers and consumers of these features, and the many other nude stills of dancers in the pages of illustrated journals in the period, were very often women. This fact points to women's engagement with images of female sexuality, rather than the more common assumption of the presence of the 'male gaze' alone as a structuring principle. Female viewers of iconic images of woman frequently experienced a narcissistic fascination with them through simultaneous identifi-

cation with their 'sameness' and pleasurable desire for their difference, and this could be a heady combination. However, this is not to argue that popular representations of dancers and actresses were uniformly emancipatory or even empowering for women. Rather, their ubiquity and aesthetic desirability produced open spaces into which women as consumers could place their own interpretations and their own readings of the new possibilities available to them.

The consumption of female icons, from pleasurable star images to 'real-life' stories of fame and fortune, permitted women in the period to glimpse changes which they rarely experienced personally and to identify with these new, young role models against the tide of traditional gender boundaries. So, while mainstream consumer interests may have been served by parading these stars simply to sell commodities, their very exposure and desirability as icons made them potentially subversive for women. The impetus for media display and access to stars may have formed a unified marketing ploy, but the images themselves differentiated between 'types' of modern, fashionable identities for women in no uncertain terms and their consumers were sophisticated readers of these variations. It is because of this internal ambiguity in the position of female celebrities and in the concept of the *neue Frau* more generally that women artists could both maintain a distance from and find new forms for pleasurable identification with these images.

There was a form of pleasurable closure available to women artists through engaging in this cycle as both producers and consumers and they certainly experienced this. Jeanne Mammen's circumstances as both a consumer and maker of popularised imagery were very similar to those of Hannah Höch defined by Lavin, and just as Höch used dancers and actresses such as Asta Nielsen, Niddy Impekoven and Marlene Dietrich as sources for her art, Mammen represented revue girls and well-known dancers such as Valeska Gert. Indeed, many more women artists than their male contemporaries looked to dancers and actresses for subject-matter; Asta Nielsen was painted by Liselotte Friedländer and, as discussed at greater length in the first chapter, Lou Albert-Lasard represented Josephine Baker and Rosa Valletti while Charlotte Berend-Corinth used Anita Berber, Valeska Gert and Fritzi Massary as subjects for sets of lithographs commissioned by the Galerie Gurlitt in 1918 and 1919. Cinema stars and revue-girls were figures of fascination and fantasy for many women during the period, yet it would be unfair to say that they were unaware that these star icons were constructed. Women artists'

representations even revealed their awareness of the differences between these stars (as constructed by their publicity) and the variations in women's roles which they could represent to women viewers.

For example, Mammen's representation of Gert did not merely mimic the tame publicity photos of the star but showed the dancer in ecstasy, her eyes tightly closed and head raised dramatically. Indeed, she was known at the time for her 'expressive', intuitive form of dancing and lifestyle. The *Berber Portfolio* produced by Berend-Corinth was a frankly sexual consideration of Berber which drew upon and recontextualised her dances, film roles, fashion photographs and popular reputation in order to make its point. The print portfolio explored the variations of explicitly female sensual pleasures through media tropes and, while certainly open to dangerous reappropriation, it did not merely objectify the star within traditional heterosexual norms of 'femininity'. If Berend-Corinth used Anita Berber and the exciting connotations of sexual liberation which went with her to open up the issue of female sensuality in the *Berber Portfolio*, women artists often began with a media icon only to develop this beyond the scope of its original publication. Their recontextualisation of these media icons both drew upon and changed their status; they could become more than just consumable images and indicate new directions for female identity. Moreover, the possibilities revealed through such female imagery impinged upon the representation of other women. For example, Gerta Overbeck's painting of her sister, *Portrait of Toni Overbeck* (1926), used stylistic features determined by the visual tropes of the *neue Frau*, yet melded these with the representation of an actual, known sitter. The result was both 'personal' and 'political'; the sitter was a New Woman, but no mere stereotype.

Toni Overbeck was a dancer and part of the Hanoverian artist circle with whom Gerta Overbeck was most closely affiliated during the Weimar Republic. The two sisters, who came from a large, traditional family, were engaged in the redefinition of female roles in the period through their professional lives and as young, unmarried urban women. Their career choices, as dancer and artist, both carried strong, particularly visual, connotations of the *neue Frau*; the figures of dancers were critical in determining images of the new female *Körperkultur* and women artists were both makers of modern female iconography and seen as part of the spectacle of urban 'bohemia'. In the very act of representing her sister, Overbeck encountered the construction of the *neue Frau*. As a practising, professional artist, painting the portrait of a contemporary female

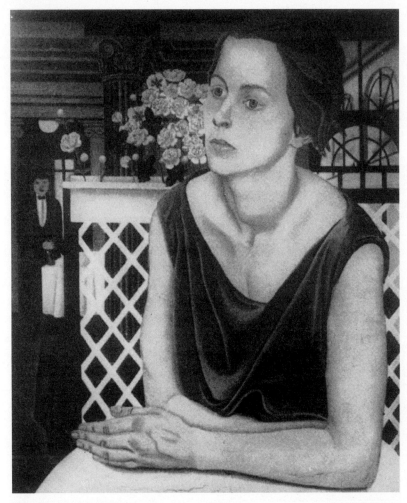

GERTA OVERBECK
Portrait of Toni Overbeck 1926

Courtesy of Frauke Schenk-Slemensek, Cappenberg

dancer, it was impossible to ignore the gender politics which coloured the activity and the final work. Yet this was also a portrait of a loved relative and not a distanced 'star' or fashionable media icon.

The finished portrait combined these features and, in so doing, made the *neue Frau* a lived (and liveable) reality. In the painting, Toni Overbeck is represented seated at a table in a quiet cafe. The half-length portrait monumentalised the sitter and particular attention was paid to the

rendering of the face, hands and arms. The young dancer was shown in a modish, draped green blouse and her hair, fashionably cut, was simply swept off her face. These details and the setting of the image mark the sitter out as 'modern', yet they are not the exaggerated details of the caricatured *neue Frau*, such as a man's suit and tie or mannequin-like make-up. They have been softened to emphasise the individuality of the portrait sitter. The details of Toni Overbeck's body are also significant. The figure's neck, arms and hands are strong and muscular. She is lean, powerful and graceful – the ideal type of the dancer and a new ideal for women. Again, however, these details are not overplayed and the sensitive portrayal of the sitter's face counteracts any tendency to generalise her body as 'the dancer'.

It is interesting to compare Overbeck's portrait of her sister with the other portrait of the dancer produced in the same year by the male Hanoverian realist, Ernst Thoms. Thoms was the best known of the artists affiliated with the Hanoverian *neue Sachlichkeit* and had made a reputation in centres as distant as Berlin, Munich and Karlsruhe by this time. His *oeuvre* called upon the more traditional tropes of the male artists of the period, such as the prostitute and the unemployed, and his representation of Toni Overbeck is far more conventional than that of her sister. In Thoms's work the dancer was shown as small and delicate in a wicker chair set in a domestic interior. Rather than the monumental, muscular and empowered public visage she attained in Overbeck's portrait, Thoms's work made her the pretty, passive female sitter. The sitter gazes demurely out of the canvas and folds her arms protectively over her chest. Thom's image contrasts sharply with that of Overbeck in which the figure's body language and gaze indicate her self-possession. His representation was not born of a shared *Frauenkultur* in which artist and sitter communicated their new female identities, but rather the meeting of the powerful male artist and his delightful female model.

This shared experience of *Frauenkultur* between artist and model is reminiscent of the circumstances in which Laserstein painted the work with which this chapter opened, *The Tennis Player*. Both Laserstein and Overbeck were young, independent women artists representing contemporary women in their work. They produced these representations as insiders and revealed the diversity of gender roles in this changing climate, rather than a set of bland types. In representing women who were close to them and who shared their experiences, as they did in *Portrait of Toni Overbeck* and *The Tennis Player*, the artists found a visual

form for the burgeoning *Frauenkultur* of the period. These works expressed a negotiation of the more general problematic of women's changing socio-economic position in the Weimar Republic since they pictured types derived from altered demographic patterns, yet did not merely present caricatures. This form of experimentation fell between the commodified celebration of the *neue Frau* and the obvious satires of it. For women living through fast-changing gender roles, the possibility of experimenting with image and identity was crucial. Laserstein's sporting friend and Overbeck's sister were active participants with the artists in the attempt to find alternative forms for new women beyond stereotypes.

Feminist scholars of Weimar cinema, such as Patrice Petro and Sabine Hake, have indicated the critical ambiguity of the form for contemporary female audiences. On the one hand, cinema was often escapist 'distraction' with little to offer women of their actual life experience; on the other, film and mass media could provide a Utopian forum for women's explorations of new identities and desires.[53] A similar argument can be made for women artists' consideration of the *neue Frau*. While it is obvious that the stereotype of the New Woman was, in many ways, an empty media invention, the opportunity to develop new models and definitions of 'woman' was an invaluable tool for women seeking to understand their changing circumstances in the period. As an icon, the *neue Frau* was both the subject of critique and pleasurable investment for women artists who could see through the cliché and explore its potential simultaneously. The works discussed in the preceding sections used and developed the stereotypical iconography of the New Woman in ways which made it a viable trope for women, rather than an empty type to be read in opposition to a masculine elite culture. The works demonstrate that women's engagement with the *neue Frau* subverted traditional, masculine constructions of the modern woman on all fronts. Stereotypes in mass media, ideologically hide-bound concepts of women's work and critical theorists' work on consumer culture and 'woman' are all questioned by the existence of this body of work by women artists. The *neue Frau*, in the hands of contemporary women artists, operated as part of an emergent *Frauenkultur*, a space in which women began to explore, in their own terms, their relationship to modernity and modernism.

NOTES

1 Caroline Stroude, *Lotte Laserstein: Paintings and Drawings from Germany and Sweden, 1920–1970*, exhibition catalogue (London, Agnew and Belgrave Galleries, 1987) mentions in the catalogue of works that the *Mode und Kultur* article was May 1930, p. 5.

2 The advert for dry hair-wash, *Schwarzkopf Trocken Schaumpon*, in *Berliner Illustrirte Zeitung*, vol. 33, 19 August 1928, p. 1401 shows a very 'feminine' tennis player and her male companion.

3 Bertolt Brecht, 'More Good Sports' (originally in *Beriner-Börsen-Courier*, 6 February 1926), translated and reprinted in *The Weimar Republic Sourcebook*, edited by Martin Jay, Anton Kaes and Edward Dimendberg (Berkeley, University of California Press, 1994), pp. 536–8.

4 Edith Lölhöffel, 'Die Frau im Sport' (from Ada Schmidt-Beit, *Die Kultur der Frau* [Berlin, 1931]), reprinted in *Neue Frauen: Die Zwanziger Jahre, BilderLeseBuch*, edited by Kristine von Soden and Maruta Schmidt (Berlin, Elefanten Press, 1988), pp. 167–8.

5 See Anita, 'Sex Appeal: A New Catchword for an Old Thing' (originally published in *Uhu*, October 1928), translated and reprinted in *The Weimar Republic Sourcebook*, op. cit. , pp. 667–8.

6 Irmgard Keun, *Das kunstseidene Mädchen*, excerpt reprinted in *Weltstadtsinfonie: Berliner Realismus 1900–1950*, exhibition catalogue, edited by Eberhard Roters and Wolfgang Jean Stock, Munich, Kunstverein, 1984, p. 66. Translation the author's.

7 Günter Berghaus, 'Girlkultur – Feminism, Americanism and Popular Entertainment in Weimar Germany', *Journal of Design History*, vol. 1, no. 3–4, 1988, p. 201.

8 *BIZ*, no. 7, 17 February 1929, p. 260.

9 *Die Dame: Ein deutsches Journal für den verwöhnten Geschmack 1912 bis 1943*, collected and edited by Christian Ferber (Berlin, Ullstein Verlag, 1980), pp. 111, 247.

10 See the introduction of this volume for details of the numerous publications directed toward women especially.

11 Andreas Huyssen, 'Mass Culture as Woman, Modernism's Other' in *After the Great Divide: Modernism, Mass Culture, Postmodernism* (London and New York, Macmillan Press, 1986), pp. 44–62; Edlef Köppen, 'The Magazine as a Sign of the Times' (originally in *Der Hellweg*, 1925), translated and reprinted in *The Weimar Republic Sourcebook*, pp. 644–5.

12 Katharina Sykora, 'Die Neue Frau: Ein Alltagsmythos der Zwanziger Jahre', in *Die Neue Frau*, edited by Katharina Sykora, Annette Dorgerloh, Doris Noell-Rumpeltes, Ada Raev (Marburg, Jonas Verlag, 1993), pp. 9–24.

13 Ute Frevert, *Women in German History: From Bourgeois Emancipation to Sexual Liberation* (1986), translated by Stuart McKinnon-Evans (New York and Oxford, Berg, 1989), p. 179.

14 Alice Rühle-Gerstel, 'Back to the Good Old Days?' (originally published in *Die literarsche Welt*, 27 January 1933), translated and reprinted in *The Weimar Republic Sourcebook*, op. cit. , pp. 218–9.

15 Stroude, op. cit. , no pages.

16 Marsha Meskimmon, *Domesticity and Dissent: The Role of Women Artists in Germany 1918–1938*, exhibition catalogue, (Leicester, 19920, p. 84.

17 Artists as diverse as the Berliners Jeanne Mammen and Hannah Höch, the Dresden communist artists Hanna Nagel and Eva Schulze-Knabe, the Hanoverians, Grethe Jürgens and Gerta Overbeck and the Cologne-based artist associated with Magic Realism, Marta Hegemann, all made pictorial reference to themselves as New Women.

18 Vicki Baum, 'People of Today' (originally published in *Die Dame*, 27 November 1927), translated and reprinted in *The Weimar Republic Sourcebook*, op. cit. , pp. 664–66, also reprinted with the original illustrations in *Die Dame*, op. cit. , pp. 164–7.

19 Elsa Herrmann, *This Is the New Woman* (originally published as *So ist die neue Frau* [Hellerau, Avalon Verlag, 1929]), translated and reprinted excerpts in *The Weimar Republic Sourcebook*, op. cit. , pp. 207–8.

20 Alice Rühle-Gerstel, *Das Frauenproblem der Gegenwart: Eine Psychologische Bilanz* (Leipzig, Verlag von S. Hirzel, 1932), p. 26.

21 Frevert, op. cit. , p. 185.

22 Ibid. , p. 179.

23 Emma Oekinghaus, *Die Gesellschaftliche und Rechtliche Stellung der Deutschen Frau* (Jena, Verlag von Gustav Fischer, 1925). See contents page.

24 Renate Bridenthal, 'Beyond *Kinder, Küche, Kirche*: Weimar Women at Work', *Central European History*, vol. 6, no. 2, 1973, pp. 148–66.

25 Frevert, op. cit. , p. 181.

26 Lisbeth Franzen-Hellersberg, *Die Jugendliche Arbeiterin: Ihre Arbeitsweise und Lebensform* (Tübingen, Verlag von J. C. B. Mohr, 1932).

27 Alexandra Kollontai, *Die neue Moral und die Arbeiterklasse* (written 1918, published Berlin 1918), excerpts reprinted in *Die Neue Frauen: Die Zwanziger Jahre*, op. cit. , pp. 6–7. Translation the author's.

28 Hilde Walter, 'Twilight for Women?' (originally published in *Die Weltbühne*, 1931) translated and reprinted in *The Weimar Republic Sourcebook*, op. cit. , pp. 210–11.

29 Ibid. , p. 211.

30 Meskimmon, op. cit. , p. 78.

31 From an interview with her sole surviving heir.

32 Hilde Walter, op. cit. and Berghaus, op. cit. , p. 195.

33 Sabine Hake, 'In the Mirror of Fashion' in *Women in the Metropolis: Gender and Modernity in Weimar Culture*, edited by Katharina von Ankum (Berkeley, University of California Press, 1997), pp. 185–201, p. 194.

34 Siegfried Kracauer, *Die Angestellten: Aus dem neuesten Deutschland* (1930) (Frankfurt, Suhrkamp, 1971); Kracauer, 'The Mass Ornament' and 'Cult of Distraction: On Berlin's Picture Palaces' in *The Mass Ornament: Weimar Essays*, translated, edited and with an introduction by Thomas Y. Levin (Cambridge, MA and London, Harvard University Press, 1995), pp. 75–86 and 323–8, respectively.

35 Rühle-Gerstel cited in Frevert, op. cit. , p. 178.

36 Kracauer, 'Cult of Distraction', op. cit. , p. 326.

37 Hanns Kropff, 'Women as Shoppers' (originally published in *Die Reklame: Zeitschrift des Verbandes deutscher Reklamefachleute*, July 1926), translated and reprinted in *The Weimar Republic Sourcebook*, op. cit. pp. 660–2, pp. 660–1.

38 Franz Hessell, 'On Fashion' (originally published in *Spazieren in Berlin*, 1929), translated and reprinted in *The Weimar Republic Sourcebook*, op. cit. , p. 670.

39 Katharina Sykora, 'Die "Hure Babylon" und die "Mädchen mit dem Eiligen Gang": Zum Verhältnis "Weiblichkeit und Metropole" Im Straßenfilm der Zwanziger Jahre' in *Die Neue Frau*, op. cit. , pp. 119–140, p. 131.

40 Huyssen, op. cit.

41 Siegfried Kracauer, 'Girls and Crisis' (originally published in the *Frankfurter Zeitung*, May 1931), translated and reprinted in *The Weimar Republic Sourcebook*, op. cit. , pp. 565–6.

42 Sabine Hake, 'Girls in Crisis: The Other Side of Diversion', *New German Critique*, no. 40, Winter 1987, p. 159.

43 Hake distinguishes between these two German terms, ibid. , p. 147.

44 Shulamith Behr, 'Anatomy of the Woman as Collector and Dealer in the Weimar Period: Rosa Schapire and Johanna Ey' in *Visions of the Neue Frau: Women and the Visual Arts in Weimar Germany*, edited by Marsha Meskimmon and Shearer West (Aldershot, Scolar Press, 1995),

pp. 96–107; Maud Lavin, *Cut with the Kitchen Knife: The Weimar Photomontages of Hanna Höch* (New Haven, Yale University Press, 1993); Patrice Petro, *Joyless Streets: Women and Melodramatic Representation in Weimar Germany* (New Jersey, Princeton University Press, 1989); Petro, 'Perceptions of Difference: Woman as Spectator and Spectacle' in *Women in the Metropolis*, op. cit, pp. 41–66.

45 Petro, 'Perceptions of Difference', op. cit. , pp. 57–8.

46 Anke Gleber, 'Female Flânerie and *The Symphony of the City*' in *Women in the Metropolis*, op. cit. , pp. 67–88.

47 Hake, 'Girls in Crisis', op. cit. , p. 153.

48 See *Jeanne Mammen, 1890–1976*, edited by the Jeanne-Mammen Gesellschaft in connection with the Berlinische Galerie (Berlin, 1978).

49 Gleber, op. cit. , p. 67; Katharina von Ankum, 'Gendered Urban Spaces in Irmgard Keun's *Das kunstseidene Mädchen*' in *Women in the Metropolis*, op. cit. , p 171.

50 Lavin, op. cit. , p. 34.

51 For dancers' own stories and writings see Rahel Sanzara, *Die Glückliche Hand* (1936) (Frankfurt, Suhrkamp, 1985); Mary Wigman, 'Dance and Gymnastics' (originally published in *Der Tanz*, November 1927), translated and reprinted in *The Weimar Republic Sourcebook*, op. cit. , pp. 685–7; Valeska Gert, 'Dancing' (originally published in *Schrifttanz*, June 1931), ibid, pp. 690–1.

52 Kirten Beuth, 'Die Wilde Zeit der Schönen Beine: Die inszenierte Frau als Körper-Masse' in *Die Neue Frau*, op. cit. , pp. 95–106.

53 Hake, 'Girls in Crisis', op. cit. , p. 158; Petro, op. cit. , p. 23.

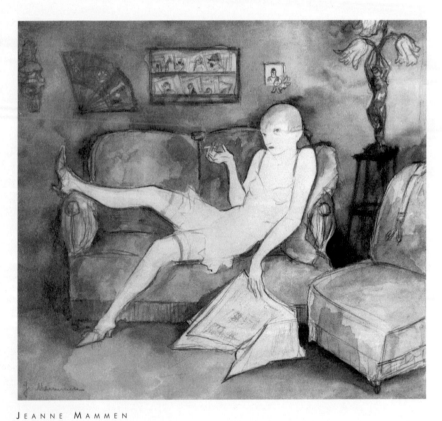

JEANNE MAMMEN

The Garçonne c.1931

Courtesy of Jeanne-Mammen-Gesellschaft, Berlin, © DACS

THE
GARÇONNE

OR THE 1931 PUBLICATION OF MAGNUS Hirschfeld's *Moral History of the Post-War Period* (*Sittengeschichte der Nachkriegszeit*) the artist Jeanne Mammen produced the illustration known in the work as *The Garçonne*, an image of a young, modish woman reclining languidly in her urban flat.[1] This work gave a visual form to what Hirschfeld famously termed the 'Third Sex': the homosexual as an 'in-between' androgynous type. The reading of Mammen's image is intimately tied to the contemporary understanding of Hirschfeld's theories.[2] Hirschfeld's work as a sexologist and gay rights campaigner in the Weimar Republic was well known and highly influential. His Institute for Sexual Science (*Institut für Sexualwissenschaft*), which opened in Berlin in 1919 and was plundered and closed by the Nazis in 1933, was typical of the period in its rational approach to matters of sexual research and its liberal attitudes toward differences in sexual orientation. Hirschfeld's Scientific

Humanitarian Committee (WhK, *Wissenschaftlich humanitären Komitees*) was the main wing of the gay rights movement in the Weimar Republic, campaigning actively against paragraph 175 which criminalised consensual sexual relations between men.[3]

A major tool in the early campaigns for decriminalising homosexuality was the argument that homosexuality was 'natural'. Rather than seeing it as a criminal deviance, moral outrage or aberrant perversion, Hirschfeld and other sex reformers argued for its equal status as a regular variation of nature. Though the limitations of this argument are today quite obvious, during the first decades of this century such an argument was radical and powerful in its opposition to legislative and cultural forms of discrimination against homosexuality. Hirschfeld wrote many books and articles which used this biological argument (*Berlin's Third Sex* [1904], *The Homosexuality of Men and Women* [1914]) and was joined by others, such as Kurt Hiller ('The Law and Sexual Minorities' [1921]) arguing for more humane legislation with regard to consensual sexual activity.[4]

Hirschfeld and other sex reformers recognised the importance of the visual arts and mass media in any attempt to change public opinion in favour of their cause and, in 1919, Hirschfeld collaborated with Richard Oswald on the first gay film *Different from the Others* (*Anders als die Andern*). That this film should be made in the Weimar Republic is itself significant and points to the widespread and popular nature of the debates on sexuality in the period. While a host of scientific and sociological studies were conducted on the nature of changing gender roles and sexual mores of the time, it was also the stock-in-trade of Weimar's rapidly expanding popular media to glamorise and/or demonise the spectacle of contemporary sexuality. Films, revues and countless pages of pictorial magazines explored androgyny, the *neue Frau* and the dangerous new sexual terrain which these crossed-boundaries made possible. The theme of the Third Sex was by no means merely a topic of intellectual, scientific enquiry and even a film made to educate a wide audience about a serious social issue could be popular and controversial.

It is as an 'Enlightenment Film' (*Aufklärungsfilm*), a genre particularly associated with Oswald, that the film's content and structure are especially noteworthy.[5] The film is divided into two interspersed sections: one, a drama about the tragic suicide of a man being blackmailed because his sexuality places him outside the law, and the second a series of 'lectures' by Hirschfeld himself about homosexuality and the legal inequities of the current system. Such an interrelationship between the

'scientific' and the 'dramatic' in this film is interesting in light of the debate about homosexuality more generally in the Weimar Republic. Gender and sexuality were critical topics in the discourses of German modernism, from political and social theories through to aesthetic deliberations and mass media sensationalism. The debate concerning homosexuality was both a rational quest for scientific definitions and at the same time an argument for cultural change waged through such forms as film, theatre, popular press, fashion and art. As such, the sex reform movement was typical of the cultural politics of German modernism itself with its mixture of theoretical discourse and practical intervention.

Thus, the figure of the garçonne in the eponymous image by Jeanne Mammen acted, in one sense, as did the dramatic story in Different from the Others. It was a current visual trope for the Third Sex which could be recognised and understood by a contemporary audience. It illustrated the ideas of Hirschfeld in a popular form, making the 'scientific' discourses more intelligible to mass viewers and enabling difficult concepts to find particular and immediate representation. However, it is far too simple to see The Garçonne as a mere illustration of Hirschfeld's text; images of the Third Sex were themselves a factor in determining the paths which the debates on sexuality took. Mammen's work exceeds the limits of illustration in its contemporary links with fashion, the women's movement and Frauenkultur. Moreover, as an image of a lesbian produced by a woman artist within the complex constellation of the debates concerning female sexuality, the work engaged with issues concerning the voicing of female identity in the period.

As theorists have argued, 'naming' is a difficult activity with regard to lesbianism since it brings with it both the positive possibility of identity and visibility and the negative corollary of fixing and defining as 'other' to a centred norm.[6] Following a Foucauldian explication of the significance of scientific definitions of human sexuality in the development of 'regimes of power' over individuals in the West, gay and lesbian theorists have pointed to the ways in which concepts of 'homosexuality' have operated to reinforce the perceived norm of 'heterosexuality'.[7] To name and define the 'homosexual' has acted as a crucial tool in such regimes. Contrarily, one of the most awkward features of naming the 'lesbian', as scholars seeking to develop lesbian history and theory point out, is that lesbianism has remained almost 'un-named', nearly invisible.[8] Unlike male homosexuality, which has been definitively placed as other to heterosexual norms through legislative, medical and religious discourses in the West

over a period of centuries, lesbianism escaped this net, seeming almost not to exist in any 'official', 'named' way until late in the nineteenth century. As Butler argues, this constitutes a special case for the alterity of the lesbian position:

> Lesbianism is not specifically prohibited because it has not even made its way into the thinkable, the imaginable, that grid of cultural intelligibility that regulates the real and the nameable. . . . To be prohibited explicitly is to occupy a discursive site from which something like a reverse-discourse can be articulated; to be implicitly proscribed is not even to qualify as an object of prohibition.[9]

The attempts to find names and definitions for lesbianism attest to its unusual and difficult position within the 'grid of cultural intelligibility'. The definitions it has been given either work in relation to homosexual men or to a male-biased concept of heterosexuality. Hence lesbianism suffers a double burden with regard to 'naming': rendered invisible (and impossible) when un-named, it is subordinated to masculine sexual terminology when it is spoken.

The 'naming' of lesbianism in the German legal context is an especially telling case in relation to these ideas. During the eighteenth century there were laws against sexual activity between women in regions such as Prussia, but when these principalities were joined in 1871 and the new Reich formed, women were excluded from the paragraph (175), which defined homosexual activities as illegal and exclusive to men. It was not until 1910 that lesbianism again was 'named' in law in Germany.[10] Clearly, the codes of the law followed contemporary theories of homosexuality which only sometimes recognised even the possibility of same-sex relations between women. As and when women were negatively defined as 'passive' objects for male desire, the concept of woman-to-woman sexuality was, literally, unthinkable.

Yet the naming of lesbianism 'in relation to' male homosexuality has not always been an adequate strategy. For example, contemporary lesbian feminist critics have argued that definitions of lesbianism subsumed under those more appropriate for male homosexuality have often negated the possibility of 'woman-centredness' in favour of proof of physical, sexual encounters between women.[11] Arguably, this excludes a rich vein of lesbian history and cultural awareness. Moreover, although political unions between gay men and lesbians have been very important from a strategic position throughout this century, specific lesbian concerns

have been marginalised within these groups. This was clearly the case in the Weimar Republic, where campaigns against paragraph 175 by gay men were far more influential than the struggles of lesbians for political voice in the period and where the sheer volume of media representation available to male homosexuals as opposed to their lesbian counterparts gave them far more scope to voice their dissent.[12]

The difficulties are even greater when lesbianism is defined in relation to conventional heterosexual concepts of femininity and female sexuality. For example, defined in relation to typical characterisations of heterosexual relationships, lesbians have suffered the accusation of being derivative; butch/femme (in Weimar, 'Bubi' and 'Damen') identifications are argued to be merely poor imitations of masculine/feminine roles enacted by straight couples. As Butler rightly pointed out, the 'bad copy' argument has been used to make the heterosexual union under patriarchy seem 'natural' and inevitable and thus to mark homosexual relationships as perpetually subordinate and derivative.[13] This masks the inherent danger of alternative sexual relationships, which is their potential to destabilise the norm.

Similarly, the challenge of lesbianism to the heterosexual order has been nullified in representations of the 'lesbian' as titillation for heterosexual men. Again, this presupposes that lesbian encounters are a mere variation on heterosexual sex meant to add 'spice' for the male partner. Numerous images of lesbian sexuality are produced currently within this framework and were during the Weimar Republic as well. Christian Schad's 1928 painting Freundinnen (Girlfriends: 'Freundin' was a common euphemism for a lesbian partner at the time) is typical of this tendency. In Schad's work, the female figures are displayed nude for the delectation of the viewer and, in one case, masturbating. Despite the ostensible relationship between the two women represented, they do not engage with each other at all; the address of the image is to the (male) artist and viewer.

When not a source of excitement to the heterosexual male, the lesbian was seen as a dangerous and psychotic deviation from 'proper' female sexual orientation. Freudian psychoanalysis heralded this tradition of understanding the lesbian as a mis-identified (thus deviant or in need of re-orientation) woman. Whilst Freud's work on lesbians was ambiguous, his very inability to define lesbianism in and through the models he developed for femininity and female sexuality set the tone for future work. The lesbian's sexuality is active rather than passive and her object is female

rather than male. Hence, she occupies the 'masculine' position by 'mistake' or error.[14] The writings of Rudolf Klare, a judicial expert of the 1920s and 1930s, reinforced the negative, unnatural stereotype of the lesbian, associating her with the destruction of the family, crimes against her 'race' and the community as a whole. In 1932, Klare called on the men of the Republic to protect the country by outlawing lesbianism.[15]

The inadequacies of these definitions spring from the fact that the models through which they are seeking to identify the lesbian are, ultimately, male homosocial and patriarchal. Both the invisibility of lesbianism and the virulence with which it is assaulted when it 'dare speak its name' are part of this troubling context. That is, its naming is a fundamental challenge to the masculine/feminine, heterosexual/ homosexual binaries which support patriarchy as a system of power and knowledge.[16] Hence, lesbian knowledge and self-identification are forms of patriarchal subversion. The example of the first lesbian film in the Weimar Republic, Mädchen in Uniform, makes these links abundantly clear. The same-sex love between the teacher (Fräulein von Bernberg) and her student (Manuela) disrupts the masculine order of the Prussian military school and mobilises the young female students in the film to rebel against this patriarchal establishment. At the time, these elements were all noted by commentators; the picture was seen to be a 'feminine' or women's film, have a central, inter-generational lesbian theme and be highly critical of the form of patriarchy known through state institutions.[17]

It is precisely in the development of a space where women could debate issues of their own identity and orientation (sexual, political, etc.), that critical challenges to the predominantly masculine structures of German society could be voiced. Indeed, much of the early radicalism of the Frauenbewegung (women's movement) focused on finding ways in which to gain a political and social voice for women who were represented only from outside. Not insignificantly, the early women's movement in Germany had a disproportionate number of lesbians as leaders and activists. Women as well-known in the movement as Lida Gustava Heymann, Anita Augsburg, Helene Lange, Gertrud Bäumer, Käthe Schirmacher and Klara Schleker lived as 'woman-centred' partners or 'out' lesbians throughout their careers.[18] Within this context, it is not surprising to find that many of the diaries and memoirs of the lesbian activists involved in the movement contain 'coming out' stories; precisely stories about finding a name for their alterity and defining themselves in the face of inadequate external definitions.[19] These forms of self-definition and naming were political actions.[20]

This reiterates the crucial link between challenges to patriarchy in the form of an organised women's movement and through 'lesbian' identification itself. Such links were noted at the time, particularly by those who opposed women's rights. Rudolf Klare attached his illiberal views on lesbianism to the *Frauenbewegung*, suggesting in 1938 that the destruction of the women's movement and lesbian tendencies would be the only clear path to genuine equality. [21] And, of course, the Nazi party would link lesbianism to the women's movement and to the concept of a *Frauenwelt* ('women's world', a culture of women).[22] The *Frauenbewegung*, therefore, was an important new space which offered women in the Weimar Republic the opportunity to challenge the system in and through 'naming'. What was especially notable about these articulations of identity from within was their plurality. In the face of outside discourses which sought to normalise lesbian identity as a monolithic category in order to dismiss it the more readily, women discussing their own sexuality stressed the variety of their experiences and the differences between them. It is in this complex context that *The Garçonne* by Mammen begins to operate as far more than an illustration to Hirschfeld's text. The work is an articulation of possibilities from within.

The central figure in Mammen's work, the androgynous woman who is *named* as the *garçonne*, is intelligible through the interwoven contexts of sexual science, fashion, mass media, the women's movement and the new roles available to modern women in Germany. The *garçonne* which Mammen represented is both a physical (biological) and a contemporary social type. She is a lean figure with slender hips and small breasts, which suited the biological ideal of androgyny associated with the Third Sex and the typology of the 'inter-sexual' woman.[23] Far more significantly, however, are the social signs which locate this type for the contemporary viewer. The figure is shown as a young, urban woman with a *Herrenschnitt*, reclining on a sofa in her modish undergarments, dangling a newspaper from one hand and a cigarette from the other. These 'lifestyle' details mark the figure out as a 'type' far more consistently than any biological features signal her as a 'specimen'. She is not shown, for example, as was the figure in the infamous 1925 *Simplicissimus* cartoon *Lotte at the Crossroads*, a suited 'garçonne' type unable to decide whether to use the men's or women's toilets because of the indeterminacy of her biology. Nor is Mammen's *garçonne* the cynically masculinised type used by Otto Dix in *Eldorado* of 1927. In Mammen's work, the figure's biology is not the issue. Even the naming of

this type as the *garçonne*, indicating a 'boy' in the French yet linguistically feminised, had more familiar repercussions in the period as a social than as a biological term.

La Garçonne was the title of a French novel by Victor Margueritte which centred on the character of a young lesbian career-girl and caused a great deal of interest when it was published in 1922.[24] It is from this source, rather than biological science, that the term *garçonne* was derived in the period and used to describe the fashionable 'flappers' of the day. The visual type was also familiar in the lesbian press and underground which played on variations of the fashionable *neue Frau* as sorts of lesbian drag. Cropped hair (*Herrenschnitt* or *Bubikopf*), men's suits, ties and dinner jackets were part of the fashionable cross-over between lesbian subculture and New Woman couture. *Garçonne* was also the name of a lesbian club opened in 1931 by Susi Wannowsky.[25]

Additionally, just before Mammen produced her illustration, *Die Garçonne* became the title of a well-subscribed lesbian journal (running from 1930 to 1932) which had been called *Frauenliebe* before its re-launch with the more modish title. Thus, this name had a common currency as a lesbian type in the popular media of the period which was produced and consumed by women. And 'naming' itself was important to all of the well-known lesbian journals of the day, not just in relation to the shift from *Frauenliebe* to *Garçonne*. *Die Freundin*, the longest-running journal (1924–33) was the official voice of the League for Human Rights (*Bund für Menschenrecht*) and published a regular page for transvestites in the community, articles by Magnus Hirschfeld and other doctors and researchers as well as advertisements for women's clubs and activities. Its title was the least 'sexually-loaded' and its sub-title, 'Weekly Paper for Ideal Women's Friendship', suggested the Greek ideal of homosexuality described later in this chapter. *Ledige Frauen*, the most pictorial of the main magazines, drew upon the 'single woman' title popular among sex reformers like Alexandra Kollontai when describing fashionable, young urban women. Thus, it was less to do with the political end of the gay and lesbian movement and more to do with the modish forms of women's culture. Thus the *garçonne* as a term entered into multiple contexts – media, fashion, scientific typology and literature – through which sexuality was framed in the Weimar Republic and thus suggested manifold readings of the 'type' and the 'name'.

Jeanne Mammen's perfect capture of this cross-over and the choice of Mammen as the illustrator of Hirschfeld's book were not coincidental.

As described in Chapter 4, Mammen was a Berlin-based graphic artist and illustrator who was well-known during the Weimar period for her images of women. Mammen specialised in showing the urban lifestyles of modern young women and frequently concentrated upon woman-to-woman scenarios such as women talking together, trying on hats or even mother-daughter scenes. Male figures, when included in her works, are almost always marginal to the activities of female characters.[26] In 1930, she illustrated Estherhazy's *The Immoral Woman* (*Das lasterhafte Weib*) with scenes from contemporary lesbian nightclubs and bars and in 1931 produced illustrations for Curt Moreck's *Guide to Immoral Berlin* (*Führer durch das 'lasterhafte' Berlin*). Moreck's *Guide* was the best-known guide to Berlin's gay and lesbian scene of the day.

This is not meant to assert that Mammen was an 'out' lesbian in the period or to attempt to 'out' her now. Nor is it a dubious attempt to 'prove' the lesbian nature of the works by asserting a stable and definitive link between the life of the (lesbian) artist and the meanings of her work. Rather, as Richard Dyer has argued persuasively in his essay concerning homosexual authorship for film:

> Not believing in sole and all-determining authorship does not mean that one must not attach any importance whatsoever to those who make films and believing that being lesbian/gay is a culturally and historically specific phenomenon does not mean that sexual identity is of no cultural and historical consequence. . . . What is significant is the authors' material social position in relation to discourse, the access to discourses they have on account of who they are.[27]

Mammen was a young, independent woman artist working in Berlin producing fashion illustrations for women's magazines and representing the lesbian underground in her works. One of the key features which determined the atmosphere of the lesbian night-life of Berlin was the link it had with actresses and women singers, dancers and artists who may or may not have been defined as 'out' lesbians.[28] It was more than just a sexual scene for women, it was a place where artistic and independent women could go to be out in public without the intrusion of men and a place where new, modish female identities could be played out through fashion and performance. It represented a woman-to-woman cultural *milieu*; within the lesbian underground of clubs, organisations and media, women could explore with one another their ideas about female identity. Women communicated directly with other women in and through

these organisations, activities and media forms. The sheer variety of the activities and groups is notable; there were nightclubs, theatres and discussion groups as well as the political organisations and the lesbian press.[29] Mammen, whether 'out' as a lesbian or not, was ideally placed to produce the images of this scene and to make *The Garçonne* intelligible as a trope of this fashionable, urban, women's *milieu*.

Such images, produced by women artists, represent some of the earliest visual explorations from within the lesbian community of new and potential identities this century. The conjunction between debates about sexuality and the *neue Frau*, fashion and mass media, women artists and struggles for self-affirmation and definition in the lesbian community proved a powerful constellation in the Germany of the Weimar Republic. In films of the period, journals such as *Die Garçonne*, *Ledige Frauen* and *Die Freundin*, theatre and the visual arts, new ways of conceiving lesbian identity were debated and embodied. These ideas were far more diverse than the definitions which came from the traditional, male-oriented institutions of the period, such as the medical profession or legal establishment, and more challenging than the representations of female sexuality typical of male modernists. The imagery produced by women artists of the Weimar Republic were not only empowering possibilities for 'out' lesbians, but for the modish 'new women' who were affected by the widening definitions of 'woman' which went along with these ideas.[30]

During the later 1920s, as the various public fora for lesbian debate became more plentiful, the definitions multiplied and became more diverse. The Third Sex (even in Hirschfeld's own later writing) lost its exclusive association with biology, and the manifestation of the person of the Third Sex centred on ways of combining masculine and feminine qualities within individuals in new forms. The works of women artists engaged with these complex debates and the visualisation of female sexuality beyond the framework of masculine, heterosexual desire proved to be significant moves toward articulating difference.

SAPPHIC LOVE

The development of the lesbian press and woman-centred organisations meant that debates about lesbian identity flourished and new types emerged. Moreover, the two most common tropes for the lesbian of the period, the Third Sex and the Sapphic Woman, were recast. The figure of

RENÉE SINTENIS

Illustrations from Hans Rupé's *Sappho* 1921

Courtesy of Erich Ranfft

Sappho, in particular, was reworked in ways which made it viable for modern women. In 1921, for example, Renée Sintenis illustrated the translation of the work of Sappho produced by Hans Rupé.[31] The form of these images by Sintenis differed dramatically from the work of Jeanne Mammen discussed above. Sintenis produced stylised line-drawings of classicised, nude or partially draped female figures posed without background details or props. The simplicity and timelessness of the representations suited their placement within the frame of the text as a 'Greek revival', but again, the choice of Sintenis as the maker, the context of the debates about Sappho during the period and the structure of the images themselves mean that the works can be read as far more than mere illustration.

One of the most pervasive tropes in the West for the lesbian woman is certainly the figure of Sappho, which continues to spawn debate and discussion within the lesbian community and more generally throughout

feminist studies.[32] Without seeking here to establish the historical 'truth' of Sappho or the meanings of the works attributed to her, it suffices to say that Sappho enjoyed a popular currency all over Europe and that, during the Weimar Republic, Sappho and the 'Greek ideal' which the figure embodied were powerful models for lesbian identification.[33] Even Magnus Hirschfeld summoned the figure of Sappho (and the classical context) to his aid in his earliest text on homosexuality, *Socrates and Sappho* (1896).

Richard Dyer, in his discussions of gay men's cinema in the Weimar Republic, distinguishes between those films which used a Third Sex trope ('in-between-ism') and those which developed a neo-classical 'male-identified' stylisation of homosexuality (such as *Wege zu Kraft und Schönheit*).[34] In the latter, the ideal was a 'Greek' homosocial community of men who may or may not have been sexually involved with one another. The platonic love which they espoused was often more that of 'mentor-student', although the 'classicised' scenes of nude male athletes and bathers which typified the representational strategies of this 'Greek' ideal were frequently highly erotic.[35] What is critical to Dyer about this trope is its representation of a male homosocial community, the possibilities it embodies of male-to-male interaction and love represented by more than just sexual activity and desire. Such a 'female-identified' conception of lesbian identity also acted as a contrast to the Third Sex ideal in Weimar and, again, Dyer explored this.[36] He pointed to the fact that it was very much indebted to the ideal of Sappho, who represented a powerful model for lesbianism in the period. However, in his work on this trope, he focused on the ideas of lesbianism as 'total' or complete womanhood (as opposed to the 'in-between-ism' of the *garçonne*, for example), the significance of the girls' school and the mother and daughter relationship as a model. While this is certainly part of it, the emphasis upon a 'woman-to-woman' community is also a key feature of this paradigm and one which was, as described above, more frequently evoked by the female commentators of the day.

As we have seen throughout this volume, the concept of *Frauenkultur*, women exploring between themselves issues about their own identities, was highly significant in Weimar. Even the popular, commodified concept of a *Girlkultur*, fostered by the mass media, was part of the development of women's voice in the wider society. Having access to spaces in which to pursue these ideas cannot be underestimated, and the lesbian underground provided a significant location for the burgeoning *Frauenkultur* to

germinate. The parallels between Sapphic ideals of woman-to-woman collectivity and this environment are obvious and made it all the more crucial a feature of the contemporary scene. The reclamation of the figure of Sappho herself is part of the construction of such an environment inasmuch as it represents the sense of a history of woman-centred activity. Sappho and other reclaimed 'lesbian' figures from myth and history provided a context and a genealogy for the contemporary women who sought to found their own forms of social interaction.[37] Hence, Sintenis's illustrations to Sappho are explicable more within the economy of neo-classicising ideals of women's culture than as any direct pictorial equivalent to the text itself.

That Sintenis should produce such work is not surprising. Renée Sintenis was a well-known sculptor of the period and only occasionally produced book illustrations. The majority of her work consisted of small-scale animal sculptures, a number of portrait and self-portrait busts, and work using the nude female figure. In the Weimar years, one of her best-known and most-widely-discussed pieces was a small sculpture of the Greek nymph Daphne (two versions, 1918 and 1927).[38] Additionally, Sintenis produced sinuous line etchings in a portfolio volume, Daphne and Chloë, in 1930. The style of these was very similar to the Sappho work. The illustrations Sintenis produced for Sappho did not use contemporary modish signs of the neue Frau, but the physical types she portrayed (young, lean, androgynous, supple) characterised the body type of the New Woman with the young, slight appearance of the female figures increased through sport and outdoor activities. This body type was that of the 'Girl', both popularised in forms of Girlkultur such as films and revues and clearly identifiable in the women's magazines of the day as a stereotype of the modern young urbanite.[39]

In all of these works, Sintenis combined the classicising ideal typical of western figural sculpture with the modern, Girl type; the Daphne drew on both the contemporary body-types of dancers working within the constructs of Ausdrucktanz, such as Valeska Gert and Anita Berber, and the clean, spartan lines of the classical tradition. The body politics of her imagery linked both the Sapphic and the Third Sex ideals and permitted interesting variations to be explored. The androgyny of the Third Sex was akin to the body type of the neue Frau while the Girl imagery suggested a community of young women (Girlkultur) and the 'daughter/student' side of the classicising ideal of intergenerational homosexual relationships. The conjunction between classical and rational, even technological,

tropes of modernity was a key feature of German modernist aesthetics and one which also harmonised with representations of the female nude in women's popular press. Indeed, each issue of *Ledige Frauen* had a different nude Girl-type on its cover, most commonly aestheticised through a classical pose or swathe of drapery. To unite the Greek ideal with the *neue Frau* was to form a potent and legible combination.

Sintenis herself must have been familiar with these 'types'; she was a popular woman artist, pictured in the press, known in the club-scene of Berlin, critically well-received and described consistently as a 'new woman'. Sintenis was associated with both the popular and the subversive elements of this designation since she was a successful independent sculptor and an icon in the illustrated press. Though married, Sintenis frequented the bars and clubs of the lesbian underground of Berlin and her carefully-cultivated image played on the fashionable androgyny of the period, from men's suit to *Bubikopf* and numerous *Freundin* with whom she was pictured.[40] Her own publicity photos staged her as the epitome of the fashionable *neue Frau* with stylish androgynous clothing and *Bubikopf*. Hence Sintenis in her life and art, like Mammen, operated at the interstices between high art and popular culture where female sexuality was explored as image and identity.

As Dyer suggested of the 'Greek' ideal in gay circles, this represented the more acceptable face of homosexuality in the period since its emphasis was on the health of the body and the 'mentor-student' relationship, rather than the overt assertion of the sexual nature of the relationships between the men represented. So too this Sapphic ideal shifted the emphasis away from the morally-dangerous New Woman and toward a community of idealised, young females, equally consumable as imagery by the male heterosexual population as by the lesbian community. Sintenis, as the popular face of the New Woman artist, herself existed on the border between respectability (popularity) and the potentially subversive. The illustrations to *Sappho* can be seen to exist in a similar space. Sintenis was also a marketable commodity as the modern *neue Frau* and her illustrations to such a popular text would have increased its selling power. The 'Greek' ideal was clearly marketable to the mainstream.

However, exploring the illustrations to *Sappho* within their 'acceptable' classicising context provides a model of the contemporary reading of the works but does not exhaust their potential. Another strand in the consumption of 'Greek' imagery in lesbian circles in western Europe in

the period concerned the more thrilling aspects of 'orientalism'. These links can also be discerned in the context of the reception of lesbian iconography within the Weimar Republic. Emily Apter, in her essay 'Acting Out Orientalism: Sapphic Theatricality in Turn-of-the-Century Paris', outlined the way in which particular forms of orientalist theatre were used as vehicles for 'Sapphic' performances of identity in Paris during the 1910s and 1920s.[41] These plays, operas and ballets were often composed at the turn of the century, when 'orientalism' in the arts was at its peak, but it was in the early part of this century that these were brought into play in order to voice the alterity of lesbianism. Clearly, a key feature of these works was their potential to establish strong female figures from myth or history, such as Cleopatra, Thais, the Amazon and, of course, Sappho, as counterpoints to traditional feminine roles in France of the period. These figures provided a rallying point around which the woman-to-woman dramas could be enacted. And these dramas took place both inside and outside the theatre, with 'out' lesbian actresses frequently playing these female roles as well as posing as these characters for press photographs and at well-publicised parties and clubs. The 'oriental' otherness of these characters could be used to suggest sexual alterity and both the characters and the actresses who played them were highly popular with female audiences of the day.

Significantly, Apter points out that 'oriental' was as confused a term as 'primitive' in the period, linking everything from the Greek, Turkish and Egyptian to the Far Eastern and the Latin. Hence the 'Greek' figure of Sappho and the neo-classical stylistic treatment of the illustrations by Sintenis could evoke the interrelationship between the mythic 'otherness' of the oriental as well as empowering the lesbian figure. An exhibition held in Berlin during the mid-1920s makes this particular cross-over even more explicit. Loulou Albert-Lasard showed a group of portraits together with 12 lithographs entitled *The Montmartre Suite* in a Berlin show in 1924, followed by a Paris show in 1926. *The Montmartre Suite* was inspired by Rainer Maria Rilke with whom Albert-Lasard had worked closely since 1914.[42] The lithographs showed a variety of 'typical' bohemian scenes of Montmartre in the period including an image entitled *Lesbos*. *Lesbos* represented a lesbian nightclub with a number of female figures dancing together, drinking, talking or watching one another. Despite the title reference to the island of Lesbos (to which Sappho is said to have been exiled), the scene was not classicised in any way: the details were all particular to contemporary lesbian nightlife.

Hence the work made the crucial link between the Sapphic ideal and modern life.

Moreover, the concept of ethnicity was employed as part of the very meaning and critical reception of these lithographs. Albert-Lasard was from Metz in Alsace and maintained her practice in Paris from 1914 until her arrival in Berlin in 1918. She returned to Paris in 1928. As a franco-deutsch practitioner in the period, she was bilingual, had links to the art centres and the main artistic figures of both Paris and Berlin and consistently refused to declare herself either 'French' or 'German'. The indeterminacy of her own origins and self-definition was read in her work. As one Parisian critic explicitly noted in relation to *The Montmartre Suite*, 'She [Albert-Lasard] remains securely under the influence of German expressionism through which she reins in a Latin temperament'.[43] As discussed in Chapter 1, Lasard lived and worked in the west end of Berlin in this period and, amongst her wider *oeuvre*, made posters for clubs which played on connections between the contemporary German scene and turn-of-the-century Paris as typified by the Montmartre of Henri Toulouse-Lautrec. Moreck's guide book to Berlin reiterated this fascination with the 'exotic' intermingling of people from many different countries, referring to the 'international' flavour of the shops, cafes, clubs and bars of Berlin's west as part of its charm.[44]

The sale of the 'exotic' mirrored the role of French art in the German market during this period more generally and well into the years of Vichy. French 'decadence' was both expected by the German establishment and tolerated for its excitement. More than that, the *Montmartre Suite* lithographs, showing the sexual underside of the district and the women who inhabited it, were seen as an encounter between the Germanic and the Latin, the urban and the exotic. The frisson of alterity is in-built: from the 'Greek' of Lesbos, to the 'German' of expressionism, to the 'Latin' of the works' decadence. In this way, the works played upon one of the key features of post-war German modernism – the encounter between the thrill of the 'primitive' made commodity through the codes of urban, rationalised consumption.[45] Furthermore, the thrill of exotic female types set the tone for the display of the female nude in such lesbian magazines as *Ledige Frauen* which, for example, had a different 'exotic' nude featured each month in 1928 with captions such as 'Oriental Beauty' and 'Romany Village Beauty'.[46] In working within and between all of these contexts, the show of the *Montmartre Suite* works was a great success in Berlin and they were published as a volume by the Kiepenheuer Verlag.

Underlying this complex interchange between ethnicity and sexual alterity for lesbian identity is the concept of 'performance'. The central thesis of the essay by Apter concerning the orientalist drama of the period is that there are crucial links between actual performances and the concept of 'performativity' as espoused by such thinkers as Judith Butler in order to elaborate working models for sexual/gender identity. The instances of theatrical performances which could be read as 'coming-out dramas' helped to develop models for the performance of lesbian identity in the wider context. In the Weimar Republic, the same sorts of theatrical performances can be seen to have prefigured forms of sexual 'performance' in the broader sense. For example, the success with female audiences of the so-called Hosenrolle ('trouser-roles') in the popular cinema of the Weimar period is well noted. These roles, in which a form of lesbian drag is enacted by the central character (who masquerades as a male figure for reasons explicable within the context of the film) were popular among women who identified multiply with these characters.[47] On-screen, women enjoyed the masquerade and the dramas which ensued in which female characters were central to the action of the plot rather than purely passive objects in male-determined scenarios. Off-screen, many of the actresses associated with these roles were seen as 'new women': empowered, independent and enacting some of the potential possibilities for women in this changing period. The actresses were as popular with lesbians as with 'straight' women of the time.

Such a cross-over begins to demonstrate the ways in which the exploration of lesbian identity in women-centred environments could have a wider impact on the female population as a whole. Such literal theatrical performances in the films spilled over into 'publicity' performances and the consumption of fashion and mass media images developed in the burgeoning women's press of the day. The play of lesbian drag and modish image in the lesbian press and in the bars and clubs of the scene carried this to its logical conclusion. In this environment, which was, as described earlier, explicitly associated with women artists, women performed gender and sexual identities with and to other women. Women were defining their own sexuality at the interstices of high and popular culture, art, fashion, mass media and urban consumerism. Women artists as makers of visual imagery were able to capture these in-between spaces and pull together the different threads from which new concepts of female sexual identity could be woven.

MASQUERADE, PERFORMANCE

AND MULTIPLICITY

At this point, the work of Jeanne Mammen must re-enter the debate, situated as it was so centrally in this interchange between the mass media and the new women's culture of the period. In 1928, Mammen produced the watercolour *Masked Ball*, one of many images she made of the lesbian clubs of Berlin and one which would come to illustrate Moreck's infamous underground guide, *Guide to Immoral Berlin,* in 1931. This work was not produced initially as an illustration to any particular text, nor was it a commission for any particular patron. Rather, the work epitomised the variety of performative masquerades which women in the lesbian underground were exploring in developing their own perspectives on the issue of female sexual identity in the Weimar Republic.

In *Masked Ball*, a central female figure poses dramatically, looking out of the canvas directly at the viewer. Arms akimbo, legs astride, she is wearing a drag version of a man's dinner suit (without the jacket), silk scarf and a top hat. A cigarette dangles from the *garçonne's* half-sneering lips. This figure literally *poses*; the body language is theatrical, demonstrative. She is playing the 'Bubi', acting a version of 'masculinity' for the viewer. Another female figure behind her is dressed in highly 'feminine' clothing (the 'Dame'), dancing with her arm on the shoulder of the central figure. Behind these two, all is chaotic dancing and striking fashion. The picture as a whole is a fascinating glimpse of the women-only balls held frequently in the lesbian clubs in Berlin. These were moments where the most outrageous of visual identities could be tried on and out within the safety of the all-woman environment and where new roles could be enacted and made into possibilities. On the one hand, these balls were only masquerades and performances in a *milieu* which was structured through its links to the artistic community of the period as a kind of 'theatre'. On the other, however, such activities served to throw open the concept of fixed gender and sexual identity to debate and revision.

Significantly, the work was also titled by the artist as *She Represents* and subtitled *Carnival Scene*. The subtle connotations of these alternate titles along with the multiplicity of 'roles' played out on the lesbian scene link the 'performance' (or 're-presentation') shown in the work with the critical category of 'performativity', marking the debates about female

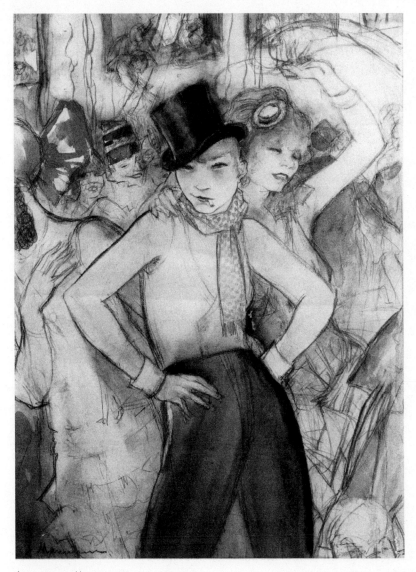

JEANNE MAMMEN
Masked Ball 1928

Courtesy of Jeanne-Mammen-Gesellschaft, Berlin

sexuality in the Weimar Republic as very modern indeed. Numerous theo-
rists of gender and sexuality are currently using the concept of performa-
tivity as a model which permits the possibility of voicing alterity without

fixing it as a monolithic category of the 'other'. Performing identity and 'representing' the 'self', often in the form of carnivalesque display, are crucial to this debate since they make manifest the impossibility of locating the underlying essence of gender, sexual or, indeed, racial identities. These ideas are increasingly significant to the field of 'queer' theory which has seen what Diana Fuss has termed an 'important shift away from the interrogative mode and towards the performative mode – toward the imaginative enactment of sexual redefinitions, reborderisations, and rearticulations'.[48]

This move toward the performative enables one to think through sexual difference without finally determining it (or predetermining it) through claims to biological or ontological truth. The concept suggests that every subject performs their gender/sexuality through various means of repetitious ritual and that no identity is ever full, complete or 'natural'. We create ourselves, for example, as 'heterosexual women' through our appearance, language, and so forth, at each instance and in different ways. So, the 'heterosexual woman' is neither a fixed entity, behaving/ being in precisely the same way in every situation, nor is she a natural norm. Rather, the ubiquitous performances of normative gender and sexual identities in our society are produced in order to naturalise and centralise that which can never be natural or central.

These concepts lead back to the earlier discussion within this chapter of the 'bad copy' model of lesbian relationships and the threat that new forms of identity pose to static regulatory norms. When the lesbian couple in Mammen's *Masked Ball* are read, for example, as a mere derivative of the conventional masculine/feminine pairing of heterosexual partners, the possible challenge of same-sex relationships is neutralised as a 'butch-femme' copy of what is 'natural'. However, when we acknowledge the figures' active play and performance of roles within the image, it suggests that there are no 'natural' norms or models, *just* such performances. Hence, the masquerading figures in the image or in Weimar's clubs threw all notions of fixed gender and sexual identity into flux. For women who sought self-determination over their sexual lives, the dissolution of such fixed boundaries was critical. Rather than maintaining monolithic categories of woman defined in and through compulsory heterosexuality, new and multiple identities could be explored and discarded in a perpetual negotiation of terms from within a women-centred community.

If the subversive potential of performance is its critique of normative gender identity, the key strategies for performing gender and sexuality

are masquerade and mimicry. The exaggerated miming of 'the feminine' or 'the masculine', for example, points to the construction of these categories as cultural rather than natural. Mimicry and masquerade permit a distance to open up between the 'performer' of the mimed identity and the symbolic structures of the masque. This distance can be used to critical effect both by, as Luce Irigaray calls it, '"destroying" the discursive mechanism' which normalises gender and sexual identities and by creating a space in which new forms can be actualised.[49] Hence, by bringing alterity into view through mimicry and masquerade, performativity can be mobilised as a useful paradigm which both gives form to the 'other' and refuses to fix it with one, final definition. Moreover, it points to the inherent construction of all such identifications and critiques and normative structures operative in these.

The concept of 'performativity' need not, of course, be linked to any particular theatrical performances. Nor need there be some stable ego who 'self-consciously' performs; the performances themselves create the illusion of a stable ego-identity.[50] Nevertheless, the significance of having the opportunity to perform 'differently' in such forms as 'drag', performance art and in the mass media has been widely acknowledged as a cornerstone in challenging dominant modes of social identification.[51] Similarly, the lesbian nightlife of the Weimar Republic and the access to mass media and artistic representation in the period for increasing numbers of women were important steps toward refashioning forms of female identity more generally. Sabine Hake convincingly associated the importance of Weimar fashion with women's performative explorations of new and potentially more positive gender identities:

> Precisely because the new fashions still defined woman through the body, she could realise her desires under the disguise of traditional images and become aware of the artificiality of gender roles. That is why Weimar fashion always involved the staging of ambivalences. It foregrounded the promises and betrayals of modernity itself and, through that association, became a powerful tool of self-reflection.[52]

It is no surprise that within this *milieu*, debates about female sexuality and gender became multiple, rather than monolithic, and increasingly left the concept of biology behind in favour of socially-constructed models. In this way, the debates of Weimar prefigured the de-centred sense of identity described by the performativity model where no 'natural', biological imperative can determine fully a gender or sexual orientation. That is not

to say that there were self-conscious theorists of 'performativity' in the period, but rather that the spaces which were made available to women in Weimar enabled them to begin to question gender and sexual roles in ways which are only now resurfacing in theoretical circles.

The central figure in the *Masked Ball* openly paraded her constructed identity which, while only provisional, placed an alternative onto the wider agenda. This marked a departure from the norm, suggested new role models and permitted the possibility of future change. It was this very experimentation with provisional identities that became the most pervasive trope for the lesbian in the period when defined by and for women. To attach one definition to 'the lesbian' (or, indeed, to any aspect of female sexuality) was to falsify the multiplicity of women's own experiences and their articulation of these. The last series of illustrations ever produced by Jeanne Mammen demonstrates this perfectly.

In 1930, Mammen held a successful one-woman exhibition in Berlin's Galerie Gurlitt from which she then received a commission to produce a luxury volume of prints based on the lesbian love poetry of *The Songs of Bilitis* by Pierre Louÿs (1894). Throughout the Weimar period, the Galerie Gurlitt produced volumes of artists' prints as both a publicity strategy for the artists they showed and a lucrative sales technique. It was not at all unusual for the gallery to court scandal with these volumes; many were considered sexually explicit and one was even prosecuted as pornography.[53] Neither was the gallery averse to publishing prints by women artists in the period, as the volume of works by Charlotte Berend-Corinth of 1926 demonstrates. In fact, women artists as diverse as Mammen, Laserstein and Berend-Corinth were all sponsored by the gallery during the 1920s and 1930s with individual shows and/or volumes of prints. The commission given to Mammen was thus in keeping with the more daring aspects of the Galerie Gurlitt's policy both in terms of women's practice and the sale of exotic and popular print volumes.

Mammen's work from the period, from fashion illustration to her images of modern, young urban women and the works based on Berlin's lesbian scene described above, made her the obvious choice for a volume concerning lesbian love, and she undertook the commission between 1931 and 1932, completing seven of the proposed 12 two-colour lithographs. The controversial series was an aspect of the commercial side of Mammen's practice and would have been expected to sell well. Yet the commission was Mammen's last set of book illustrations and was left incomplete when the Nazi Party assumed power in

1933 and stopped the work's progress.[54] Despite the gallery's reputation, and Fritz Gurlitt's own position as Hermann Goering's art advisor, the theme was deemed inappropriate by the Nazi Party, whose views on women would not have permitted the types of experimentation with roles which Mammen's series implied.

The lithographs which remain are remarkable in their treatment of the source material, their sensitivity to the subject-matter and the sheer variety of subject positions they envision for lesbians of the period. In these ways, they encapsulate what has been the theme of this entire chapter: that having the space in which to begin to question sexual and gender identity from within produced for 'out' lesbians and other women of the period the most diverse and striking new possibilities. The diversity itself became the paradigm. The illustrations for The Songs of Bilitis operated within the complex constellations of meaning outlined above, utilising Third Sex and Sapphic ideals, mass media imagery and contemporary spaces to develop a wide range of different 'performative' identities rather than a single concept of the lesbian woman.

Pierre Louÿs was a popular 'orientalising' poet and dramatist in turn-of-the-century Paris who wrote a number of 'neo-classical' volumes of love poetry of which Bilitis is but one example. Typically, Louÿs's works mixed the 'classical' with the 'oriental' in tantalising and popular ways, and drew upon his own experiences of travelling throughout North Africa.[55] In Bilitis, the central character is a Turkish priestess and contemporary of Sappho who travels to the island of Lesbos and falls in love with numerous nymphs. Generally, the volume is overwhelmingly sentimental and melodramatic. However, the insistence on beginning the text with a Greek passage from Sappho herself and the unflinching revelation of woman-to-woman love and desire made Bilitis very popular in 1920s Europe among the burgeoning lesbian community.[56] The section of the text which Mammen illustrated was the central part 'Elégies a Mytilène', where Bilitis sings odes to the women of Lesbos which explicitly refer to sleeping, bathing, touching and kissing.

Clearly, there are many links between the Louÿs text, 1920s Sapphic ideals, performances and lesbian identity in the Weimar Republic, but the treatment of the source in Mammen's work suggests more than just a straightforward 'illustration' of a Sapphic text. The influence of Japanese prints on Mammen's lithography has been noted elsewhere in stylistic terms, but it is also a critical lynchpin between contemporary modernist production and the 'oriental' other. This japonisme would be the perfect

accompaniment to the 'orientalism' of Louÿs's text, yet Mammen's *Bilitis* works ignored the classicising setting of the work in favour of contemporary images of Weimar women. By refusing the classicism of the text, Mammen drew upon her own context of fashion, mass media and the lesbian underground to make the concepts intelligible. This conjunction between the 'classicism' of the text and the contemporaneity of the illustrations staged a confrontation between the Third Sex and Sapphic ideals of the period which was not able to be resolved by exclusive recourse to either model. Such a move increased the sense of the multiplicity of the debates about female sexuality and refused any monolithic, external definition.

The debates about lesbian identity in the women's press of the period were increasingly moving away from biology and into the realm of the construction of various roles. For example, primary bisexuality was asserted for women which developed into the concept that each individual woman was, in varying degrees, 'masculine' and 'feminine'.[57] In 1929, *Die Freundin* published excerpts from the 1904 text 'The Love of the Third Sex' ('*Die Liebe des Dritten Geschlechts*') by Johanna Elberskirchen to begin a debate in its pages on the topic of defining homosexuality. Significantly, Elberskirchen began: 'There is no absolute man. There is no absolute woman. There are only bisexual variations'.[58] Although when Elberskirchen wrote the text, it linked these 'variations' to biology and asserted that homosexuals belonged to a 'third' sex, in the connext of its reprint in *Die Freundin* it participated in the dismantling of such biologically-fixed gender stereotypes. Since there could be no natural 'men' and 'women' and only a whole host of variations, each instance would be unique. For the readers of *Die Freundin*, as evinced in the letters to the journal, there were no 'natural' womanly heterosexuals and 'unnatural' manly lesbians, but a whole range of women identifying along a gender and sexual spectrum.[59] Women from the period were both responsive to and critical of the butch/femme stereotypes, recognising them but feeling they were not all-encompassing models of lesbian experience. In the *Bilitis* illustrations, Mammen referred to the *Bubi* and *Damen* stereotypes, but without exclusive recourse to such simple paradigms. Her work was marked by the nature of the current debates among women which used these stereotypes but also exceeded them in the sheer variety of woman-to-woman experience described.

The variety represented in these works by Mammen is reiterated through the many different settings and characters shown. Each work is

set in an individual space and centres upon a changing cast of charac-
ters who enact a variety of roles in relation to one another. Five of the
images are focused on the interaction between two female figures who
embrace, dress one another or argue with great fury. The two remaining
lithographs show more than just two figures within the context of a
lesbian bar and a brothel respectively. Such variety makes it impossible
to view the series as an illustration of one lesbian's experience and to
extrapolate that singular experience into a 'norm'. The works mark each
of the very different demonstrations of lesbian identity as valid in its own
context. In this way, they are most akin to the concept of performativity
through their embodiment of alterity and refusal to fix a final and
absolute definition to the 'lesbian'.

The lithograph which illustrated the lesbian bar, *Damenbar*, is the
most stereotypical in its treatment of the scene. This is perhaps because
of the nature of the setting itself; in the clubs, 'out' lesbians would be
most conspicuously enacting masquerade as part of the frisson of the
public spectacle of the bar. Despite this, the figures are clearly portrayed
as 'wearing' this identity rather than having any biological/physical
gender determination. The dancing couple in the foreground wear,
respectively, the exaggerated men's suit and 'feminine' dress of the
butch/femme mode. This is in keeping with the rest of Mammen's series
in which there is no single physical type represented as some form of
'biological explanation' of lesbianism, but rather a host of masquerades.
There is also no single form of woman-to-woman interaction in the
series, with the figures sometimes passionate, sexual, tender, maternal
and even exploitative in their representations. This seeks to defy any
sense that all woman are nurturing and maternal and that their interac-
tion will conform to this 'natural' mode of behaviour.

The sexual and erotic works are interesting in this context since they
simultaneously assert the positive and active sexuality of women and yet
refuse the spectator voyeuristic titillation from the spectacle of women
together. Both of these things challenge common modes for the repre-
sentation of female sexuality and lesbianism. For example, *Freundinnen*,
Siesta and *In the Morning* each represent couples, nude or semi-clothed
in close embraces or in bed together. The women are clearly shown to be
sexual and this sexuality is directed toward other women. This conception
of female sexuality as active and able to be directed toward women
confronts the description of female sexuality as passive and of lesbianism
as misdirection or illness. Further, these images do not invite a spectator

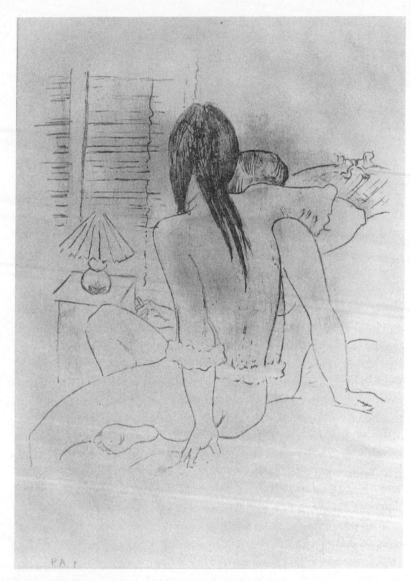

JEANNE MAMMEN

In the Morning from *The Songs of Bilitis* 1931

Courtesy of the Berlinische Galerie, Berlin, © DACS

to assume a dominant position within the viewing. These are not images of lesbian display or spectacle produced for a heterosexual male viewer. Again, this subverts another very common stereotype in representations

of female-to-female sexuality which we have seen typified in Christian Schad's *Freundinnen,* where the masturbation of the one figure is displayed to the viewer in an exciting scene of sexual 'deviation'.

Mammen's choice of a lesbian brothel as one of the settings to the series also confounds common stereotypes by placing a female figure into the role of the economically-empowered client of female prostitutes. Given the ubiquitous representation of prostitution amongst male modernists of the period which assumes female prostitutes and male clients, such a work renegotiates clichés of modernism as it asserts the variety of female sexuality which requires no legitimation by men. *The Choice*, as the image is titled, refers to the choice of the central female figure; the prostitutes are not posing for an outside viewer, they are not displayed as objects for our delectation, they are directed toward the female figure on the sofa. The work pivots on power relations between women, rather than between women and men, and demonstrates again the variety of forms of interaction, both consensual and economic, which lesbian desire could take.

Mammen's lithographs for *Bilitis* also reveal the passion and tenderness between women in more than specifically sexual contexts. *Putting on Make-Up*, for example, shows two women dressing, the one helping the other into her shoes while she applies lipstick. This scene is also constructed through the foil of an intergenerational couple, an important feature of the lesbian scene at the time and rarely seen in a positive light in traditional popular media. *Siesta* reiterates the ordinariness of living together, where the women relax and are drowsy in one another's arms. *Jealousy*, by contrast, is an impassioned scene in which one woman clings to the other desperately while being scorned. These scenes, in their diversity of setting and characters, exceed the Louÿs text which Mammen was commissioned to illustrate by the Galerie Gurlitt in ways which were intimately associated with the context of the Weimar Republic itself. It is within the newly-formed lesbian underground of the period that such possibilities of identification could be thought and enacted publicly for the first time and through which Mammen was able to find visual form for her works.

The *Bilitis* series can be seen as a microcosm of women's own interventions into the debates about female sexuality and lesbian identity in Weimar. While German social theory and mainstream modernist artistic practice frequently explored women and sexuality as topics, these were most commonly taken up as 'other' to a masculine norm. 'Woman' was

over-represented while women had little voice. The lesbian, when not completely ignored or overshadowed by the discussion of male homo-sexuality, was paraded as a figure of fun, derision, fear, loathing or titil-lation by male modernists, the popular press and traditional German institutions alike. The ability to 'name' was of key significance in these misrepresentations and the establishment of all-woman centres for debate and activity in the period was a major factor in the development of new and exciting potential definitions of lesbian identity. These women-centred spaces were able to put challenging new roles for all women onto the agenda and the part played by women artists in this *milieu* cannot be overestimated. The ways in which the *Frauenkultur* of the Weimar Republic operated at the intersection of fashion, media, art and politics mirror our own contemporary explorations of sexuality and the body. Their insistence upon the multiple, performed definitions of gender and sexual identity bears a striking resemblance to current ways of thinking and provides yet another reason to take seriously the history of women and seek means by which to understand it in its own terms.

NOTES

1 Hirschfeld's publication marked the first appearance of this work in print and it was titled 'The Garçonne'; it is to that original title and first use of the work that I refer. The Jeanne-Mammen-Gesellschaft also has a note of its appearance in an exhibition of 1977 under the title 'Blonde Woman' and, more interestingly, it is catalogued as 'Prostitute on a Green Sofa' (*Dirne auf grüner Couch*). In light of the discussions in Chapter 1, the work's shifting titles from 'Garçonne' (i. e. *neue Frau*) to *Mädchen* to prostitute are symptomatic of the typological questions central to debates about modern, young urban women of the period. Exploring female identity in the visual meant crossing borders of all sorts.

2 The interpretation of the work is also dependent upon the interlocking contexts through which the *neue Frau*, the lesbian and the prostitute were figured – the work has been reproduced in some instances with the title *Prostitute on a Green Couch*. This brings the difficulties inherent in defining 'woman', described in Chapter One, full-circle.

3 For a history of the Institut and Hirschfeld's work, see Manfred Baumgardt, 'Das Institut für Sexualwissenschaft und die Homosexuellen-Bewegung in der Weimarer Republik' in *Eldorado: Homosexuelle Frauen und Männer in Berlin 1850–1950. Geschichte, Alltag und Kultur*, exhibition catalogue (Berlin Museum, Fröhlich und Kaufmann, 1984), pp. 31–43.

4 Magnus Hirschfeld, *Berlins Drittes Geschlecht* (Berlin, 1904); *Die Homosexualität des Mannes und des Weibes* (Berlin, 1914); Kurt Hiller, 'The Law and Sexual Minorities' (originally published in *Das Tagebuch*, 19 November 1921), translated and reprinted in *The Weimar Republic Sourcebook*, edited by Anton Kaes, Martin Jay and Edward Dimendberg (Berkeley, University of California Press, 1994), pp. 696–7.

5 Richard Dyer, *Now You See It: Studies on Lesbian and Gay Film* (London and NY, Routledge, 1990), p. 13.

6 Judith Butler, 'Imitation and Gender Insubordination' in *Inside/Out: Lesbian Theories, Gay Theories*, edited by Diana Fuss (NY and London, Routledge, 1991), pp. 13–31.

7 Sheila Jeffreys, 'The Spinster and Her Enemies: Feminism and Sexuality 1880–1930' in *Women's Studies: A Reader*, edited by Stevi Jackson, et. al. (NY and London, Harvester Wheatsheaf, 1993), pp. 127–8.

8 Adrienne Rich, 'Compulsory Heterosexuality and Lesbian Existence' (1980), excerpt in *Feminisms: A Reader*, edited by Maggie Humm (NY and London, Harvester Wheatsheaf, 1992), pp. 176–80, p. 177 and Bonnie Zimmerman, 'What Has Never Been: An Overview of Lesbian Feminist Literary Criticism' in *Feminisms: An Anthology of Literary Theory and Criticism*, edited by Robyn R. Warhol and Diane Price Herndl (NJ, Rutgers University Press, 1991), p. 117.

9 Butler, 'Imitation and Gender Insubordination', op. cit. , p. 20.

10 Mecki Pieper, 'Die Frauenbewegung und ihre Bedeutung für lesbische Frauen' in *Eldorado*, op. cit. , pp. 121–22.

11 See Rich, op. cit. , and Deborah Cameron, 'Ten Years On: "Compulsory Heterosexuality and Lesbian Existence"', *Women's Studies*, op. cit. , pp. 246–7.

12 Pieper, op. cit, p. 125.

13 Butler, 'Imitation and Gender Insubordination', op. cit. , p. 21.

14 On the numerous psychoanalytical readings of lesbian identity see Elizabeth Grosz, *Space, Time and Perversion: Essays on the Politics of Bodies* (London and NY, Routledge, 1995), pp. 174–5.

15 Rudolf Klare, *Homosexualität und Stafrecht* (1932) cited in Ilse Kokula, 'Lesbische leben von Weimar bis zur Nachkriegszeit' in *Eldorado*, op. cit. , p. 153.

16 Diana Fuss, 'Inside/Out', in *Inside/Out* op. cit. , p. 2.

17 Rich, op. cit.

18 Pieper, op. cit. , pp. 116–7.

19 A few of these memoirs were published both at the time and in the 1960s and 1970s as part of the second generation feminists' reclamation of history. See Christiane von Lengerke, '"Homosexuelle Frauen": Tribaden, Freundinnen, Urninden' in Eldorado, op. cit. , p. 138.

20 Zimmerman, op. cit. , pp. 117, 123–4.

21 Klare in Kokula, op. cit. , p. 155.

22 Ibid. p. 154.

23 For an excellent study of the inter-relationship between visual typologies and definitions of female sexuality, see Lynne Frame, 'Gretchen, Girl, Garçonne? Weimar Science and Popular Culture in Search of the New Woman' in Women in the Metropolis: Gender and Modernity in Weimar Culture, edited by Katharina von Ankum (Berkeley, University of California Press, 1997), pp. 12–40.

24 Sabine Hake, 'In the Mirror of Fashion' in Women in the Metropolis, op. cit. , p. 186.

25 Kokula, op. cit. , p. 149.

26 Marsha Meskimmon, 'Jeanne Mammen' in Delia Gaze (ed.), Dictionary of Women Artists (2 vols) (London and Chicago, Fitzroy Dearborn, 1997), vol. 2, pp. 909–12.

27 Richard Dyer, 'Believing in Fairies: The Author and the Homosexual' in Inside/Out, op. cit. , pp. 187–8.

28 Kokula, op. cit. , p. 151; Katharina Vogel, 'Zum Selbstverständnis lesbischer Frauen in der Weimarer Republik: Eine Analyse der Zeitschrift "Die Freundin" 1924–1933' in Eldorado, op. cit. , p. 168.

29 Vogel, op. cit. , pp. 162–3.

30 Jeffreys, op. cit.

31 Confirming the exact date of the first publication of Sappho is difficult; many copies were printed without a date mark and further editions came out in 1936 and 1946. However, a reference to 1921 for a volume published in Munich by Vingenti duo Carmina can be found in the Georg Kolbe Museum, Berlin catalogue of Sintenis, Renée Sintenis: Plastiken, Zeichnungen, Druckgraphik (1984), p. 107. Since Rupé's later Ilias was published by the same house in 1940, it can be assumed that this represents the earliest edition of Sappho. The German edition from the 1920s, used here as the source for illustrations, was published by Holle & Co Verlag, Berlin. Thanks to Erich Ranfft for lending his copy to me.

32 Ibid. , p. 130.

33 Ibid. , p. 144

34 Dyer, Now You See It, op. cit. , p. 22.

35 The programme notes (1924) to the film are striking in this context, since they utterly idealised the platonic relationships embodied by the film and made no mention of any homoeroticism. They are translated and reprinted as 'Ways to Strength and Beauty' in The Weimar Republic Sourcebook, op. cit. , p. 677.

36 Dyer, Now You See It, op. cit. , pp. 38–40.

37 Rich, op. cit. , pp. 177–8; Zimmerman, op. cit. , p. 124.

38 Frauen in der Kunst, eds, Künstlerinnen International 1877–1977 (exhibition catalogue) (Berlin, 1977), p. 211.

39 See Günter Berghaus, 'Girlkultur – Feminism, Americanism and Popular Entertainment in Weimar Germany', Journal of Design History, vol. 1, no. 3–4, 1988, pp. 193–219.

40 On some aspects of Sintenis's publicity see Erich Ranfft, 'German Women Sculptors 1918–1936: Gender Differences and Status' in Visions of the Neue Frau: Women and the Visual Arts in Weimar Germany, edited by Marsha Meskimmon and Shearer West (Aldershot, Scolar Press, 1995), pp. 42–61.

41 Emily Apter, 'Acting Out Orientalism: Sapphic Theatricality in Turn-of-the-Century Paris' in Performance and Cultural Politics, edited by Elin Diamond (London and New York, Routledge,

1996), pp. 19–20.

42 Jacques Paul Dauriac, 'Die "Montmartre-Suite" von Loulou Albert-Lasard', *Kunst und das Schöne Heim*, vol. 88. pt. 3, March 1976, pp. 161–8.

43 Ibid. , p. 166.

44 Curt Moreck, *Führer durch das 'lasterhafte' Berlin* (Leipzig, Verlag moderner Stadtführer, 1931), p. 36.

45 In a stimulating essay on the reception of Josephine Baker in Berlin, Nancy Nenno explored the relationship between the 'primitive' and the 'American' in her iconic representation. See 'Femininity, the Primitive and Modern Urban Space: Josephine Baker in Berlin' in *Women in the Metropolis*, op. cit. , pp. 145–61.

46 *Ledige Frau*, vol. 6 and vol. 7, 1928.

47 There had existed a tradition of women's masculine masquerade in the theatre since at least the eighteenth century in Europe.

48 Fuss, op. cit. , p. 7.

49 Luce Irigaray, 'The Power of Discourse and the Subordination of the Feminine', in *The Irigaray Reader,* edited by Margaret Whitford (Oxford, Basil Blackwell 1991), p. 124.

50 Judith Butler, *Bodies That Matter: On the Discursive Limits of 'Sex'* (London and New York, Routledge, 1993), pp. 9–11.

51 Marvin Carlson, *Performance: A Critical Introduction* (London and New York, Routledge, 1996).

52 Hake, op. cit. , p. 199.

53 Malcolm Gee, 'The "Art Business" in Berlin c. 1916–24', paper given at the Association of Art Historians' annual conference *Structures and Practices* (London, Courtauld Institute, 1997).

54 Hildegard Reinhardt, 'Die Lieder der Bilitis' in *Jeanne Mammen: Köpfe und Szenen Berlin 1920 bis 1933*, exhibition catalogue (Berlin, Jeanne-Mammen-Gesellschaft, 1991).

55 Ibid. , p. 55.

56 Apter, op. cit.

57 Alice Rühle-Gerstel, *Das Frauenproblem der Gegenwart: Eine Psychologische Bilanz* (Leipzig, Verlag von S. Hirzel, 1932), pp. 149–78 (sections on sexuality).

58 Cited in Vogel, op. cit. , p. 164.

59 See Vogel, op. cit. , pp. 164–5 for debates in *Die Freundin* and Petra Schlierkamp, 'Die Garçonne' in *Eldorado*, op. cit. , pp. 173–4.

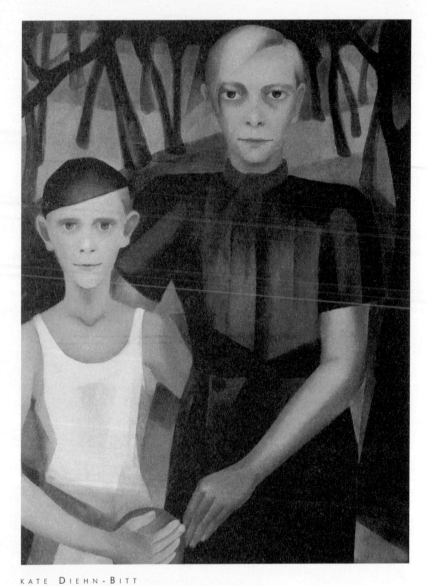

KATE DIEHN-BITT

Self-Portrait with Son 1930

Courtesy of Städtische Museen der Hansestadt Rostock

CONCLUSIONS

WOMAN AS ARTIST IN THE
WEIMAR REPUBLIC

IN 1928, HANS HILDEBRANDT PUBLISHED HIS well-known volume on women artists, *Die Frau als Künstlerin*.[1] While Hildebrandt's apologist tome frequently evinced attitudes toward women's art practice derived from crude biological determinism and outright male chauvinism, the book nonetheless stands as a watershed in twentieth-century scholarship on the theme of women as artists. Hildebrandt took his subject very seriously; he tried to collect information about what he saw as a significant trend in his own historical moment – the increasing presence of women in the arts. In Germany during the first three decades of the twentieth century, interest in women artists increased rapidly and they became the subject of numerous brief reviews as well as more substantial studies.[2] All-women exhibitions, usually revolved around so-called 'woman's themes', made women's presence in the arts more prominent and, seemingly, more cohesive.[3] By virtue of the sheer volume of material available

by and about women artists in the period, simplistic stereotypes of women's art began to yield to more sophisticated accounts of gender difference in practice and aesthetics.

Women critics, writers and patrons supported women's art practice, adding yet another element to Weimar's *Frauenkultur*. Many of these wrote of or commissioned work from women artists with whom they were friends, but other authors were concerned with the particular conse-quences of women's practice for the conception of a 'feminine' aesthetic.[4] Critics such as Rosa Schapire and Lu Märten, who devoted a whole book to the topic of women artists in 1914, stressed the intercon-nection between female emancipation in the socio-political sphere and the articulation of female identity in cultural life.[5] Märten's book framed questions about women's creativity (and the significance of this to the public life of the community) within the social sphere, asking whether it was possible to combine professional and domestic tasks effectively in the current climate of gender inequality. Following the work of Schapire and Märten, Margot Riess argued that the significance of women's creativity was its potential to initiate social change.[6]

This important strand of women's art criticism linked the social with the creative development of women. Similarly, the two largest and most influential women's art organisations of the period, the GEDOK and the *Verein der Berliner Künstlerinnen*, combined practical, financial support of women's practice with exhibitions and workshops meant to enhance the confidence and professional standing of their members. Women artists were influential in this process of self-support, writing and working with one another.[7] Networking between women artists in Weimar was excep-tionally prolific, and it was as common for them to relate their works to a context comprised of other women artists as to any male-dominated canon. Like the writings of Gertrud Bäumer, Alice Rühle-Gerstel and Else Wex discussed before, women artists were part of a significant, if not dominant, trend which privileged a form of female intellectual and artistic genealogy.

Debates and discussions about women artists and their works found their way into more popular fora too, especially into magazines and books produced for a female audience. Women artists were newsworthy and *Die Dame*, for example, carried everything from illustrated articles by women artists to celebrity photo-shoots of Leni Riefenstahl at a Berlin Sezession ball, Charlotte Berend-Corinth meeting patrons and dignitaries and Renée Sintenis out horse-back riding.[8] Even Tamara de Lempicka's

iconic self-portrait, *Tamara in the Green Bugatti* (1925), in which the artist posed as a rich, fashionable *neue Frau* at the wheel of a fast sports car, was made famous as the cover of *Die Dame* in July of 1929. Serialised lesbian love-stories in *Die Freundin* made use of the exciting bohemian type of the woman artist as a central character and, of course, women artists were welcome and well-known participants in the underground lesbian scene in Berlin.[9]

Without overstating the point, during the Weimar Republic the increased interest in women as artists began to develop into a 'typology'; women artists were constructed most commonly as 'creative' or 'bohemian' versions of the modern, urban *neue Frau* manifesting 'feminine' or 'womanly' sensibilities in their art. Linking women artists and writers with a 'feminine' aesthetic was both an observation of the fact that many turned to the subject of contemporary women's lives in their work and a more generalised assumption that biological imperatives could be read through cultural artefacts. Thus it was that women artists working within very different contexts could be received critically in relation to blanket concepts of gendered creativity. By contrast, throughout this volume we have seen that women artists attended to complex constructions of woman in and through the visual field and that their works explored multiple definitions of female subjects across difference. The situation of women artists in Weimar's visual culture was particular: as woman-objects, they were encoded as part of the spectacle of modernity and yet, as artist-subjects, they negotiated with this very sphere in making art. Far from demonstrating a single, unified aesthetic in relation to 'woman', women artists were able to appropriate, manipulate and challenge monolithic stereotypes of woman as other, definable only in relation to a masculine subject. In so doing, they questioned the centrality of the masculine subject and the canonical constructions of art and history premised upon the marginalisation of woman/women.

Women artists entered into the exciting specular realm of the Weimar Republic as embodied viewers *and* makers, located at the intersection between material and discourse, seeing and being seen. Nowhere was this more marked than in their self-portraits, where the relationship between subject and object is embedded in the very form of the work.[10] Weimar's women artists made many self-portraits, using these to explore issues as diverse as maternity, alternative partnership, labour relations, race, sexuality and the typology of the *neue Frau*. These works emphasised their location *within* the visual and their production of particular,

situated histories and knowledges. The reconnection of the body to history and knowledge through the 'woman-as-artist' explodes the myth of the disembodied masculine artist/intellectual commenting upon society from an objective vantage point located beyond its hold. In this way, the woman artist as a multi-faceted 'trope' epitomised the potential for women in Weimar to articulate female subjectivity. For us now seeking to 'see' women as cultural agents during this period and beyond, their representation of the 'self' within the multiple material and discursive constructions of 'woman' sets up a new paradigm of the embodied female subject as articulate.

What is at stake in making a final leap and using the woman-as-artist as a paradigmatic figure through which to conclude this volume? Clearly, women artists did not attain dominance in the cultural sphere during the Weimar Republic or after the Second World War and have had to fight hard over the past three decades to make up a modicum of ground in the international art market. To suggest that the figure of the woman-as-artist might be significant in rethinking aspects of cultural politics then does not entail falsely arguing that women artists have 'made it' or that we can now look forward to a brave, new, post-feminist world. Rather, I would like to point to the burgeoning signs within the Weimar Republic that the woman-as-artist was a recognisable, if frequently stereotyped, trope which offered women a unique way with which to engage in the increasingly visual forms of female identity developing at the time. I want to explore the types of engagement possible once the position of the woman artist, as both subject and object of the look, is taken as a model of intersubjective practice. Finally, I want to ask in what ways the woman artist trope might, by definition, place the performative nature of gender identity at the centre of visual culture, a task with which we are only now coming to terms some three-quarters of a century after the artists here considered worked with this. By looking at three particular self-portrait variations, the key themes at the heart of this study of women artists in Weimar can be surfaced and allowed to signify in our context: the bio-cultural morphology of the body of woman and embodied knowledge, the structures connecting visuality, aesthetics and power and the construction of histories through radical difference.

THE BIO-CULTURAL BODY

OF THE WOMAN AS ARTIST

Kate Diehn-Bitt's 1930 painting, *Self-Portrait with Son*, in which she represented herself as a New Woman, artist and mother, questioned the link between biology and destiny. When this work was produced, Diehn-Bitt was studying at the Academy in Dresden and raising her young son. These dual roles are described by the title of the work, but their complex strategic conjunction operated more distinctively at the level of the visual itself. The self-portrait combined seemingly discordant elements: the mother with the *neue Frau*, the creative artist with the procreative woman, symbols for nature with the signs of avant-garde culture. The transgressive tension in the work comes from the frisson produced through these oppositional juxtapositions, and through this frisson new possibilities for the configuration of gender identity are made visible.

The most powerful combination of seemingly contradictory elements in the work was that of the 'masculinised' *neue Frau* and the mother. The figure of the artist was represented as an androgynous New Woman with extremely short hair and a boyish face and figure. As discussed at length in Chapter 5, this androgynous female type, the *garçonne*, was the subject of much contemporary debate since it was perceived to threaten the heterosexual order through associations with lesbianism and the so-called '*Vermännlichung der Frau*' ('masculinisation of woman').[11] Probably the most severe retaliation against the New Woman was directed toward this so-called masculinisation, seen to be a physical and visual manifestation of the changing order of gender hierarchies. In 1925, the *Berliner Illustrirte Zeitung* ran its article 'Enough is Enough! Against the Masculinisation of Woman', from which the following suggests the threat of 'masculine' women to the status quo:

> What started as a playful game in women's fashion is gradually becoming a distressing aberration. . . . It is high time that sound male judgment take a stand against these odious fashions, the excesses of which have been transplanted here from America. . . . the look of a sickeningly sweet boy is detested by every real boy or man.[12]

Diatribes were launched against the masculinisation of woman by a number of more 'respectable' critics as well, including Paul Valéry writing

in Paris. In 1928, the lesbian paper *Die Freundin* carried a news item regarding the anti-masculine-woman campaign which Valéry was organising in France as a warning to its women readers of the anti-feminist backlash with which they had to contend.[13] In the same issue, they featured a witty riposte in the form of a photo-feature on *Die Frau als Mann* ('the woman as man'); a series of performative fashion photos of women in menswear. Anti-feminist backlash, such as the poster campaigns used against suffragettes in Britain, had for decades concentrated on the loss of 'feminine' appearance by emancipated women. Envisaging emancipation as a lack of 'beauty' or physical desirability reinforced the significance of woman as object within an economy of heterosexual power and desire. Hence the *neue Frau* as an empowered, articulate public figure was pejoratively imaged as 'masculinised' and de-sexed.

Critics argued that 'woman' was becoming 'man' in more than just performative variations; that in addition to taking men's jobs and developing the manners and morals of men, women would soon lose or obscure their biological, *natural,* differences from men and be unable to bear children.[14] 'Nature' here was defined through female reproductive processes and the intellectual, independent woman was thought to render herself literally 'masculine', that is unable to reproduce. The 'masculinisation' of woman, therefore, threatened the natural order structured through the opposition of the masculine as mind, culture and creativity with the feminine as body, nature and procreativity. Diehn-Bitt's self-portrait, with its integration of the figure of the mother and the 'masculine' woman, was a challenge to the conservative critics of female emancipation. Here a new configuration of woman was posited in which intellectual and creative activities combined with maternity rather than negated its possibility. As a woman artist and the mother of a son, Diehn-Bitt was both a public, professional maker of culture and a domestic, maternal woman: the 'Madonna-as-artist'.

Diehn-Bitt confounded traditional concepts of 'woman' and 'artist', 'nature' and 'culture' by combining the types of the masculinised *neue Frau* and mother with specific references to the Western canonical tradition. As a student in Dresden's Academy, she knew the conventions associated with representations of the mother and child as well as the avant garde tendencies of the early twentieth century. Dresden cultivated both a strong monumental figurative tradition derived from Renaissance religious painting and a radical communist avant garde particularly empow-

ering for women artists. Diehn-Bitt merged the traditional and the radical in this work: she set the figures of herself and her son in 'nature', yet used the stylish pictorial fragmentation associated with cubist-inspired, avant-garde painting to remind the viewer of 'culture'. Her self-portrait made apparent the male modernist conceit of seamlessly linking the fecund body of woman with the 'primitive' in a quest for originary aesthetic inspiration. Placing her own image into the frame as a mother and contemporary, 'masculinised' woman provided a fulsome critique of the eternal, 'natural' woman, and one which located Diehn-Bitt within a modernist tradition while simultaneously challenging its gender bias.

Self-Portrait with Son neither caricatured nor uncritically celebrated the *neue Frau* or mother, yet it entered into dialogue with each. In this work, a woman living the complexities of changing gender roles found a visual form through which to interrogate her own situation as artist and mother, public and private, creative and procreative. Rather than asserting an essential one-dimensional stereotype of 'woman', the work speaks of the negotiation and reconfiguration of gender identity perpetually undertaken by women artists and described throughout this volume. In that way, it points to one of the key features of these practices for contemporary scholars – that, as embodied female subjects, women artists both used and refigured the tropes of woman available in their day. Their articulation of gender identity came from within the language and culture of their moment and not from an essential origin point located elsewhere, determined by their biology. To explore the work of women artists as productive of meaning within particular cultural contexts means acknowledging the significance of their embodiment, their situation as knowing subjects, without reducing them to mere biology. Rather than seeking the essential underlying meaning of maternity for women in the self-portrait by Diehn-Bitt we can explore the significance of the conditions of motherhood for a woman who was an artist in Germany in 1930. Putting the voices of women back into the historical polylogue implies thinking through difference and exploring female subjectivity as diverse and fluid.

SEEING WOMEN AS ARTISTS

In the history of Western fine art since the Renaissance much attention has been paid to the person of the artist as a unique creative individual.

The status of self-portraiture has depended upon its link with this individual and its ability to reveal *his* nature. The representation of the male artist and the female nude model is one of the principal visual tropes through which the power of the masculine practitioner has been made manifest for some five centuries. This trope reinforced the gender politics of the studio and of traditional art practices themselves. Literally, male artists enacted material power over the women whom they employed as models, and figuratively this empowerment was transposed into the languages of art. The male artist, empowered as the active subject, made works of art from a passive object, the body of woman. This body was taken from 'nature' to 'culture', from base matter to aesthetic form, through the intervention of the masculine subject and his genius. Structures of vision which implied a dominant masculine viewer were also reinforced through the standardised images of male-artist-and-female-model.

In this trope, the masculine subject is represented as the locus of vision, structuring the objects in the world, and concomitantly knowledge of the world, according to the power of his gaze. By contrasting the central, masculine viewpoint with the mute, 'unseeing' but 'always-seen' body of woman as difference, the male artist assumes the place of the transcendent, universal subject. The logic of the disembodied masculine gaze is envisaged within Western self-portraiture by the male artist and nude female model trope – hence its popularity and continued usage over many centuries. If self-portraiture has long been the preserve of the masculine subject in theory and in practice, the figure of the woman artist suggests an anomaly in theoretical terms. Women artists, in making self-portraits which signified through references to the traditions of the genre, enacted a double negotiation with aesthetics: they placed themselves as women into an historical tradition from which they had been excluded and they acceded to voice by using the extant languages of gender difference to their own ends.

Lotte Laserstein practised in Berlin throughout the 1920s and early 1930s as a successful fine artist. Her monumental figurative paintings received good reviews even from conservative art critics, her works were shown in venues such as the Prussian Academy in Berlin and the 1937 Paris World Fair and she had a solo exhibition in the Galerie Gurlitt during 1930. In *Self-Portrait with Model, Berlin Wilmersdorf* (1927), Laserstein revisited the trope of the artist and nude female model by placing her own self-portrait as a young, urban *neue Frau* into the posi-

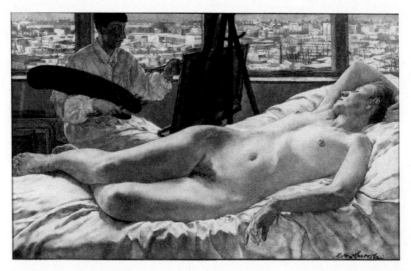

LOTTE LASERSTEIN

Self-Portrait with Model, Berlin Wilmersdorf 1927

Courtesy of Michael Hornstein, Montreal

tion of the active maker of the work of art. She represented herself in the act of painting, wearing a smock and holding brushes and palette. In the painting, Laserstein performed the woman as artist and countered the historical traditions which excluded women from this position in no uncertain terms. This strategy worked for Laserstein during the years of her Berlin career, and indeed this very painting was sought for purchase by the City of Berlin at its 1937 Paris showing.[15]

It would be a mistake to think that Laserstein's *Self-Portait with Model, Berlin Wilmersdorf* simply replaced the figure of the male artist with that of a woman, leaving the gendered viewing structures unaltered. The self-portrait likeness, the body-type of her friend and model Traute Rose and the specific reference to her studio in Wilmersdorf all particularised this representation and located it within the changing conditions of modern women in Berlin. The explicit visual signs of the 'masculinised' *neue Frau* are reminiscent of the work of Diehn-Bitt described above and challenge passive, essential definitions of woman as object. The area of Berlin in which Laserstein kept her studio and the timely hairstyles and body-types of herself and her model in the representation connect contemporary, mass cultural constructions of woman with the traditional rendering of the fine art nude; like so many of the works described in this volume,

Laserstein's painting operated at the interstices of elite and popular culture, recombining popular tropes of woman into new forms.

If Diehn-Bitt's work reiterated the embodiment of female subjectivity as a counter to biological determinism, Laserstein's invites us to reconsider the privilege of masculine-normative viewing structures. The viewer/maker constructed through Laserstein's clever artist-and-*her*-model conceit cannot accede to the position of a transcendent, disembodied subject since the nude female object is not wholly 'other' to her. The artist and the model participate in an intersubjective viewing space – woman both sees and is seen, the gaze of the artist can never be from outside the circumstances which make looking a reciprocal, social process. Such a construction of the artist as an embodied viewer gives the lie to the traditional structures which occlude the embodiment and locatedness of the masculine subject in a myth of universality. Moreover, it locates pleasure and desire in women's spectatorial situation as both subject and object. Rather than theorising the gaze as masculine and mastering by definition, women's encounters with visuality in Weimar as simultaneous subjects and objects of the look give rise to alternative concepts of visual practice by and for women. By attending to the specific viewing structures with which women engaged in the period as makers and consumers of images of themselves and other women, more sophisticated theories of the intersubjectivity of the gaze have been suggested in each of the previous chapters. Laserstein's relationship as a woman artist with her nude female model and friend invite such new readings and problematise historical and theoretical models in which women cannot see or be seen.

HISTORIES AND EMBODIED FEMALE SUBJECTS

As the Second World War neared its tragic end, Allied bombing raids on Germany were stepped up and whole cities decimated with little concern for civilian lives or for targeting particular military installations. In the most infamous of the campaigns, Dresden was destroyed utterly over three days in May of 1945. Hanover was the target of saturation bombing in 1944 and its buildings were levelled across a two-mile radius from the city centre. Included in the bombed area were a number of buildings on the Podbielskistraße – the street which housed the attic

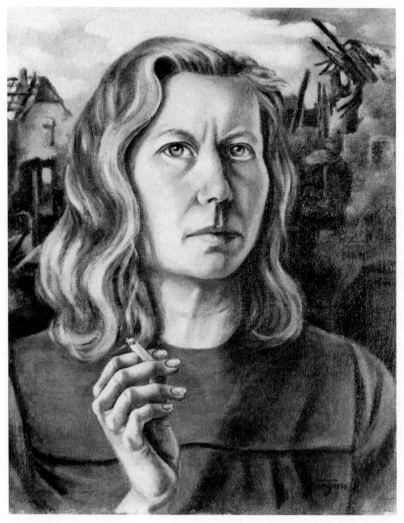

GRETHE JÜRGENS
Self-Portrait in Front of Ruins 1944

Courtesy of the Historisches Museum Hanover

studio of Grethe Jürgens. In *Self-Portrait in Front of Ruins* from that year, Jürgens depicted the scene of smouldering, bombed wreckage which had been her studio and her street. The self-portrait image in the immediate foreground of the painting is striking; she is represented as visibly shaken, smoking a cigarette, but still in the clear and monumental realist style which was the trademark of her practice.

This sober realist image, today housed in the Historical Museum in Hanover, rather than in an art museum, is more than just documentary evidence of the bombing of the city in Lower Saxony. In this painting world history has collided with female subjectivity; the strategies of war and international politics may have been conducted at a distance from Jürgens, but their effects were known and understood in all their terrible proximity to her. It is no coincidence that the international events described in the work are localised to a particular time, place and personal experience: therein resides the power of this work. Jürgens's painting does not picture 'the' war, it locates the consequences of macro-histories in the circumstances of individual loss and devastation. There is no place from which to stand back and take in the overview with such a work; we are immersed in the contingencies of history and unable to escape from its effects upon our own, particular location.

Localising the trauma of the Second World War in imagery of her home and studio connected the historical event to Jürgens's identity as a Hanoverian realist painter. Declared degenerate by the National Socialists, Jürgens was permitted to remain in Hanover but forbidden to exhibit work in public. She thus went into what has come to be called 'inner exile' and her studio became the absolute centre of her life. [16] During this period, her studio was raided by the Gestapo on several occasions and she suffered from bouts of severe nervous depression brought on by this externally-imposed 'inner exile' and surveillance. Economically, she was obliged to rely upon local commissions for chil-dren's portraits and some illustration work to get by, and her immediate artistic circle of friends dispersed – Hans Mertens, Ernst Thoms and Erich Wegner went to war (Mertens died in service in 1944) and Gerta Overbeck moved back near her family in the Ruhrgebiet. The war years thus represented a painful hiatus in Jürgens's career as it did with so many other Weimar artists, both male and female.

Picking up the pieces after the war was frequently hard for artists who had been in 'inner exile', and for Jürgens it was doubly difficult since the aesthetic and political climate shifted such that her work was subject to critical misreading. As she later explained in an interview: 'This time was very hard for me, and I no longer wanted to paint in a "sachlich" way. . . . I was always afraid that the neue Sachlichkeit could be confused with Nazi art.' [17] Thus it was that Jürgens began her artistic life anew after the war, choosing to remain an illustrator and graphic artist and working in abstract modes. Indeed, Self-Portrait in Front of Ruins was the final self-

portrait she would make and one of her last figurative paintings. Given her absolute commitment to figuration in the Weimar years and her repeated use of self-portraiture and recognisable local scenes, such a change was momentous and signalled more than just formal experimentation. The horrors of the Third Reich, the Holocaust and the Second World War changed Jürgens's artistic orientation and redefined her identity as an artist.

Self-Portrait in Front of Ruins raises questions about the relationship between macro-historical events, such as the Second World War, and the micro-historical experiences of individuals, such as women artists in the Weimar Republic. Jürgens was not a Nazi or part of the political or military regimes making decisions, she was not a soldier, she was not interred in a camp and she did not leave Germany; yet her life was changed at a fundamental level by her experiences of the Third Reich and the Second World War. Moreover, the effects of these events were particular to her role as both a woman and an artist; changes in the post-war climate in regard to gender and aesthetics impacted upon her subsequent career potential and reputation. The same can be seen to have occurred with the other women artists discussed in this volume and the patterns which emerge are fascinating instances of the conjunctions between gender, politics and aesthetics at mid-century. Significantly, the similarities in their situations as women artists at this historical moment can be seen only through the registers of radical difference. Their experiences were not simply the *same*, rather they were patterned *similarly* across differences in detail. Once again, the value of working through difference in the production of women's histories cannot be over-emphasised, since to occlude specificities of 'racial', regional and political variations in understanding these artists' paths would reduce their complex stories to a falsely unified narrative of 'woman' beyond historical intervention.

None of the artists discussed in this volume worked for the National Socialists or joined the party. Nearly all fell foul of the new regime before the beginning of the war and were declared 'degenerate', forbidden to exhibit and/or to practise as artists altogether. Of the women artists here considered, the most severely treated was Elfriede Lohse-Wächtler, who was murdered in a concentration camp in Pirna. As discussed in the first chapter, Lohse-Wächtler had been institutionalised due to the instability of her mental condition during the years of the Weimar Republic and had begun to live an itinerant life with gypsies. Clearly these factors defined her well beyond the bounds of Aryan womanhood for the Nazis and her

internment and subsequent death were not particularly connected with any political or artistic activity.

By contrast, Alice Lex-Nerlinger in Berlin and the Dresden radicals Lea Grundig and Eva Schulze-Knabe all suffered imprisonment under the fascist leaders for their political activities, which very much included their art practices. Lex-Nerlinger and her husband Oskar Nerlinger were periodically arrested and had their studio raided throughout the years of the Reich, but their status within Berlin's artistic circles made it impossible to mete out long-term sentences to them. By contrast, after a 'warning' arrest in 1934, Fritz Schulze was sentenced to death and executed in 1942. Significantly, Eva Schulze-Knabe received the lesser penalty of a life sentence; this was common for women associated with radical art groups since it was assumed that they usually followed rather than led and were less 'political' by 'nature'. Lea and Hans Grundig also received differential treatment by gender, but their Jewish identity was a crucial factor in their sentencing. Both of the Grundigs were imprisoned for their political activity in the early 1930s, but while Lea was released and able to emigrate (eventually spending most of the war years in Palestine), Hans was sent to a concentration camp and saved from death only by the liberation of the camp by the Red Army.

These well-known, politically-active, women artists were treated with less severity than their husbands and only threatened with death by virtue of 'racial' links; women artists such as Martha Schrag in Chemnitz and Kate Diehn-Bitt who had moved from Dresden to Rostock, as communists working in more provincial and less 'threatening' regional centres, were merely subjected to 'inner exile'. Moreover, women artists such as Hannah Höch, Grethe Jürgens and Jeanne Mammen, who had all been producing radical, socio-critical art during the 1920s, were not even read as political by conservative factions. Their works, frequently focused upon women as they were, seemed unconnected to the masculinist realm of politics as defined by Nazi party officials. Thus it was that Höch could remain in Berlin throughout the war with boxes of Berlin Dada documentation and her own works hidden in her garden while artists such as George Grosz were forced to flee the city in 1933. The marginalisation of gender issues from mainstream politics had as its corollary the marginalisation of many women artists from direct political persecution.

Not so for women who were Jewish. Lotte Laserstein and Charlotte Berend-Corinth, both successful fine artists with flourishing studios and commissions in Berlin, and less associated with radical politics than Höch

or Mammen, were forced to emigrate because they were Jews. Laserstein went to Sweden and Berend-Corinth to the United States. Having surrendered their hard-earned financial gains and professional status, neither ever returned to Germany. Lou Albert-Lasard, Alsatian by birth, chose to take up French citizenship and moved to Paris, also never to return. Rarely was emigration by choice, yet those who were allowed to stay also faced grave difficulties.

Mammen, Jürgens, Höch and Elsa Haensgen-Dingkuhn remained in the centres which had supported their practices during the Weimar Republic, though the war years were mainly fallow in working terms. However, many of the women artists who remained in Germany during the war moved back to their families or home towns: Gerta Overbeck returned to Cappenberg, Hanna Nagel to Heidelberg, Tina Bauer-Pezellen to Weimar and Marta Hegemann from city to city as and when members of her family would or could take her in. Overbeck and Nagel had left their partners, choosing to raise their daughters alone, Bauer-Pezellen's husband was killed in action, leaving her a single mother, and Hegemann's husband, the painter Anton Räderscheidt, abandoned her and their two children, emigrating with his mistress. Thus domestic responsibilities were passed solely into the hands of these women artists, regardless of their professional career aspirations or successes. Hence, the localised pattern which typified Weimar women's post-war practices frequently arose through domestic necessity and not by virtue of any professional inability to be part of the well-known art circles in larger cities.

Certain recognisable patterns begin to emerge across the disparate circumstances of Weimar's women artists under the Third Reich. They were more likely to be persecuted as Jews than as political activists, they were less frequently forced out of Germany than their well-known male counterparts, their strategies for survival were silence and self-imposed marginality through provincial relocation (most never returned to a major art centre) and their activities were often complicated by their domestic duties. In the period after the war, these patterns were marked further by the distinctions made between women artists in East and West Germany and by the reconstruction of exclusive modernist histories from which women's participation was notably excluded.

Quite simply, women artists active during the Weimar Republic as anti-fascists who managed to survive the years of the Third Reich were treated as heroes by the officials of the East German establishment. Lea

Grundig received a professorship, Eva Schulze-Knabe and Alice Lex-Nerlinger became important state-sponsored artists and Martha Schrag was given a medal by the city of Chemnitz. Women's artwork received equal exhibition space and critical attention in the East, but the critical literature was so unified in its party line as to be of little scholarly use.[18] Moreover, artists generally were expected to practise within certain defined limits of style and represent subject-matter which reinforced party ideologies in order to receive sponsorship. While this did not inhibit all creativity, as western critical literature would have had us believe during the period of the Cold War, it did limit practice. Therefore, without under-estimating the significance of a place in which women were treated equally with men in their art careers, it is imperative to recognise that fame in the East meant near-total exclusion from the international scene. These women artists may have been important within their own countries, but they were merely part of the 'socialist realist' tradition so fully excluded from Western modernism after the war.

Women artists active during the Weimar Republic who lived in West Germany were even less well treated by the art critics and historians of the post-war years. As exclusive art histories made masculine, formalist experimentation and abstraction the dominant modes of modernist practice, many women realists were written out of the frame. Jürgens and Mammen began to work in abstraction, for example, but never received the critical attention of their male contemporaries. Hegemann and her 'magic realism' were obscured completely, as were many male artists who had been associated with the neue Sachlichkeit. Even when, in the late 1960s, scholars began to research this movement again, the many women artists associated with this form of realism were left out.

In retrospect, these are the ruins described by Jürgens's Self-Portrait in Front of Ruins; the burgeoning Frauenkultur of the Weimar Republic, the lives and works of numerous women artists from the inter-war years, the multiplicity and polyvocality of the themes and debates of Weimar culture were all excluded by the unified voice of a history written in fearful Cold War rhetoric. While such a particular anachronistic reading can only be enacted with hindsight, the work described within its own frame the confrontation between history on a grand scale and its effects on the female subject as situated. This, as we have explored throughout this volume, is a significant feature of using the works of women from the Weimar Republic as a central position from which to explore the multiple production of histories and knowledges within and about that period.

Their works refute the logic which makes one particular historical perspective, that of the empowered, Western, masculine subject, appear transcendent and universal. Their located histories challenge the centrality of traditional accounts of that moment in which woman was generalised, 'othered' and made to signify only in relation to a masculine norm. Women artists, operating between material and discursive formations of woman, re-embody history, art and the subject. To be able to find the ways to see women's interventions into the tumultuous cultural life of the Weimar Republic is to change the histories of that moment and our own.

NOTES

1 Hans Hildebrandt, *Die Frau als Künstlerin* (Berlin, Rudolf Mosse Buchverlag, 1928).
2 See, for example, Anton Hirsch, *Die Frauen in der Bildenden Kunst* (Stuttgart, 1905); K. Kuzmany,'Die Kunst der Frau' *Die Kunst für Alle*, vol. XXVI, 1910, pp. 193ff.
3 There were a number of such shows, such as *Die Frau von Heute* of 1929.
4 Else Lasker-Schüler, 'Milly Steger', *Die Schaubuhne*, vol. 12, no. 24, 1916, p. 582; Luise Strauß-Ernst, the critic of her friend Marta Hegemann, is cited in *Marta Hegemann (1894–1970): Leben und Werk*, (exhibition catalogue), edited by Michael Euler-Schmidt (Cologne, Kölnisches Stadtmuseum, 1990), pp. 39–40; Rosa Schapire, writing about Elsa Haensgen-Dingkuhn is cited in *Elsa Haensgen-Dingkuhn: Arbeiten aus den Jahren 1920–1980*, (exhibition catalogue) (Hamburg, Kunsthaus, 1981), pp. 69–70.
5 Rosa Schapire, 'Der Frauenbund zur Förderung der deutscher bildende Kunst', *Neue Blätter für Kunst und Dichtlung*, vol. 2, November 1919, pp. 166–7; Lu Märten, *Die Künstlerin*, vol. 2 in the series *Kleine Monographien zur Frauenfrage*, edited by Adele Schreiber (Munich, Albert Langen Verlag, 1914).
6 Margot Riess, 'Die Frau als Bildhauerin', *Frau und Gegenwart*, vol. 27, no. 15, May 1931, pp. 390–1; 'Vom Wesen weiblichen Künstlertums' *Der Kunstwanderer*, vol. 1–2, April 1931, pp. 225ff.
7 This period saw the publication of women artists' own writings, such as the memoirs of Phillipine Wolff-Arndt, *Wir Frauen von Einst: Erinnerungen einer Malerin* (Munich, 1929).
8 See: Ilse Fehling-Witting, 'Eine junge Bildhauerin: Ilse Fehling-Witting', *Die Dame*, vol. 4, 1927–8, pp. 5–7; Berend-Corinth photo from vol. 14, 1929–30 and reprints in *Die Dame: Ein deutsches Journal für den verwöhnten Geschmack 1912 bis 1943*, edited by Christian Ferber, Berlin, Ullstein Verlag, 1980; of Madame d'Ora, 'Josephine Baker' (pp. 260–1), the photoshoot of Riefenstahl (p. 198) and Sintenis (p. 247).
9 Marie-Luise von Bern, 'Der Klub der Freundinnen' in *Die Freundin*, vols 9–12, 1928.
10 Marsha Meskimmon, *The Art of Reflection: Women Artists' Self-Portraiture in the Twentieth Century* (London, Scarlet Press and New York, Columbia University Press, 1996).
11 Lynne Frame, 'Gretchen, Girl, Garçonne? Weimar Science and Popular Culture in Search of the Ideal New Woman' in *Women in the Metropolis: Gender and Modernity in Weimar Culture*, edited by Katharina von Ankum (Berkeley, University of California Press, 1997)', pp. 12–40.
12 'Enough is Enough' (originally published in the *BIZ*, 29 March 1925) translated and reprinted in *The Weimar Republic Sourcebook*, edited by Martin Jay, Anton Kaes and Edward Dimendberg (Berkeley, University of California Press, 1994), p. 659.
13 This news item appeared in *Die Freundin*, 4. Jahrgang, no. 5, 5 March 1928.
14 Katharina von Ankum, 'Introduction' to *Women in the Metropolis*, op. cit. , pp. 1–11, pp. 2–3.
15 Caroline Stroude, *Lotte Laserstein: Paintings and Drawings from Germany and Sweden, 1920–1970*, exhibition catalogue (London, Agnew and Belgrave Galleries, 1987), p. 5.
16 Inner exile is the term commonly used to descibe the experiences of those artists and activists who remained in Germany throughout the period of the Third Reich, but who were not permitted to practise or voice their dissent.
17 Hildegard and Georg Reinhardt, 'Grethe Jürgens, Künstlerin der Neuen Sachlichkeit', *Artis*, vol. 2, February 1981, pp. 12–13. p. 12. Translation the author's.
18 See, for example, Karl Brix, 'Die Malerin Martha Schrag (1870–1957)', *Bildende Kunst*, vol. 26, pt. 4, 1978, pp. 187–90; Horst Zimmermann, 'Aus 30 Jahren DDR-Kunst: Nachdenken über Rostocker Kunsttraditionen', *Bildende Kunst*, vol. 27, pt. 8, 1979, pp. 392–6; Joachim Uhlitzsch, 'Unser ist ihr Werk', *Dresdener Kunstblätter*, vol. XXI, pt. 1, 1977, pp. 15–9. Journals such as *Bildende Kunst, Tendenzen* and the *Dresdener Kunstblätter* were typical of the East German sources on these artists which negated all differences in their practice to affirm their proletarian-revolutionary stance.

SELECT BIOGRAPHY

PREFACE

The vast majority of research undertaken for this volume was done at source – in the family homes of heirs and friends of the artists, through interviews and correspondence, in direct contact with the works, sketchbooks and notebooks of the artists themselves and through the help of a few museums and organisations which have collected or catalogued these works (such as the Künstlerinnen Archiv and Jeanne-Mammen-Gesellschaft). The relative lack of published primary sources for most of the artists included here (often confined to a few lines' notice in reviews) is a feature of their more general historical marginalisation. Where, however, they have been the subject of later attention, I have included references to those secondary sources most easily available or most relevant to this volume.

With regard to the selection of other sources, principal emphasis has been given to women's writings of the period – the occluded *Frauenkultur* which was an important context for women's work in the visual arts. It was my intention not simply to replicate the extant conventions through which German modernism has been understood, but to locate in the less privileged materials sources of alternative voices and ideas.

PRIMARY SOURCES

BAUM, VICKI, Menschen im Hotel (1929), 28th edition (Berlin, Ullstein, 1991).

BÄUMER, GERTRUD, Die Frau im Deutschen Staat (Berlin, Junker und Dünnhaupt Verlag, 1932).

BÄUMER, GERTRUD and AGNES BLUHM, IKA FREUDENBERG, ANNA KRAUßNECK, HELENE LANGE, ANNA PAPPRITZ, ALICE SALOMON and MARIANNE WEBER, Frauenbewegung und Sexualethik: Beiträge zur modernen Ehekritik (Heilbronn am Neckar, 1909).

BRÜCK, CHRISTA ANITA, Schicksale hinter Schreibmaschinen (Berlin, Sieben Stäbe, 1930).

ELBERSKIRCHEN, JOHANNA, Die Prostitution des Mannes (Zürich, Verlag Magazin, 1896).

FEHLING-WITTING, ILSE, 'Eine junge Bildhauerin: Ilse Fehling-Witting', Die Dame, vol. 4, 1927–8, pp. 5–7.

FRANZEN-HELLERSBERG, LISBETH, Die Jugendliche Arbeiterin: Ihre Arbeitsweise und Lebensform (Tübingen, Verlag von J. C. B. Mohr, 1932).

GIESE, FRITZ, Die Girlkultur: Vergleiche zwischen amerikanischem und europäischem Rythmus und Lebensgefühl (Munich, Delphin Verlag, 1925).

HILDEBRANDT, HANS, Die Frau als Künstlerin (Berlin, Rudolf Mosse Buchverlag, 1928).

HIRSCH, ANTON, Die Frauen in der Bildenden Kunst (Stuttgart, 1905).

HIRSCHFELD, MAGNUS, Berlins Drittes Geschlecht (Berlin, 1904).

— *Die Homosexualität des Mannes und des Weibes* (Berlin, 1914).

KERN, ELGA, *Wie Sie dazu Kamen: 35 Lebensfragmente bordellierte Mädchen nach Untersuchungen in badischen Bordellen* (Munich, Verlag von Ernst Reinhardt, 1928).

KIENLE, ELSE, *Frauen: Aus dem Tagebuch einer Ärztin* (Berlin, Gustav Kiepenheuer Verlag, 1932).

KOLLONTAI, ALEXANDRA, *Die neue Moral und die Arbeiterklasse* (1918) (Berlin 1920).

— *Wege der Liebe* (Berlin, Malik Verlag, 1925).

KRACAUER, SIEGFRIED, *Die Angestellten: Aus dem neuesten Deutschland* (1930) (Frankfurt, Suhrkamp, 1971).

KUZMANY, K. , 'Die Kunst der Frau', *Die Kunst für Alle*, vol. XXVI, 1910, pp. 193ff.

LASKER-SCHÜLER, ELSE, 'Milly Steger', *Die Schaubuhne*, vol. 12, no. 24, 1916, p. 582.

LEUN-LENZ, LUDWIG, (ed.), *Sexual-Katastrophen: Bilder aus dem modernen Geschlechts- und Eheleben* (Leipzig, A. H. Banne, 1926).

LINDSEY, BEN, *The Companionate Marriage* (1927) (New York, Arno Press, 1972).

MÄRTEN, LU, *Die Künstlerin*, vol. 2 in the series *Kleine Monographien zur Frauenfrage*, edited by Adele Schreiber (Munich, Albert Langen Velag, 1914).

MORECK, CURT, *Führer durch das 'lasterhafte' Berlin* (Leipzig, Verlag moderner Stadtführer, 1931).

OEKINGHAUS, EMMA, *Die Gesellschaftliche und Rechtliche Stellung der Deutschen Frau* (Jena, Verlag von Gustav Fischer, 1925).

PAPPRITZ, ANNA, *Einführung in das Studium der Prostitutionsfrage* (Leipzig, 1921).

RIESE, HERTHA, *Die Sexuelle Not unserer Zeit* (Leipzig, 1927).

RIESS, MARGOT, 'Die Frau als Bildhauerin', *Frau und Gegenwart*, vol. 27, no. 15, May 1931, pp. 390–1.

— 'Vom Wesen weiblichen Künstlertums', *Der Kunstwanderer*, vol. 1–2, April 1931, pp. 225ff.

ROELLIG, RUTH MARGARETE, *Berlins lesbische Frauen* (Berlin, 1929).

RÜHLE-GERSTEL, ALICE, *Das Frauenproblem der Gegenwart: Eine Psychologische Bilanz* (Leipzig, Verlag von S. Hirzel, 1932).

SANZARA, RAHEL, *Die Glückliche Hand* (1936) (Frankfurt, Suhrkamp, 1985).

SCHAPIRE, ROSA, 'Ein Wort zur Frauenemanzipation', *Sozialistische Monatshefte*, vol. 1, 1897, pp. 510–17.

— 'Der Frauenbund zur Förderung der deutscher bildende Kunst', *Neue Blätter für Kunst und Dichtlung*, vol. 2, November 1919, pp. 166–7.

SCHEFFEN-DÖRING, Luise, *Frauen von Heute* (Leipzig, Verlag Quelle und Meyer, 1929).

SUHR, SUSANNE, *Die weibliche Angestellten: Arbeits- und Lebensverhältnisse* (Berlin, Verlag: Zentralverband der Angestellten, 1930).

VELDE, THEODOR VAN DE, *Die Vollkommene Ehe* (1928) (Rüschlikon, Muller, 1967).

WEX, ELSE, *Staatsbürgerliche Arbeit deutscher Frauen 1865–1928* (Berlin, F. A. Herbig Verlagsbuchhandlung, 1929).

WOLFF-ARNDT, PHILLIPINE, *Wir Frauen von Einst: Erinnerungen einer Malerin* (Munich, 1929).

Primary Sources (translations, collections)

ADORNO, THEODOR W. , *The Culture Industry: Selected Essays on Mass Culture*, edited by Jay
 Bernstein (London and New York, Routledge, 1991).

BEBEL, AUGUST, *Woman Under Socialism*, translated from the 33rd edition by Daniel de Leon (New
 York, New York Labor News Press, 1904).

BENJAMIN, WALTER, 'Central Park' (1938), translated by Lloyd Spencer in *New German Critique*, no.
 34, Winter 1985, pp. 32–58.

— *Illuminations*, edited and introduced by Hanna Arendt, translated by Henry Zohn (Hammersmith,
 Fontana, 1992).

— *One-Way Street and Other Writings*, translated by Edmund Jephcott and Kingsley Shorter
 (London, Verso, 1985).

BLOCH, ERNST, et. al. , *Aesthetics and Politics*, translation editor, Ronald Taylor and with an afterword
 by Fredric Jameson (London, New Left Books, 1977).

FERBER, CHRISTIAN (ed.), *Die Dame: Ein deutsches Journal für den verwöhnten Geschmack 1912 bis
 1943* (Berlin, Ullstein Verlag, 1980).

HARRISON, CHARLES and PAUL WOOD, (eds), *Art in Theory: An Anthology of Changing Ideas* (Oxford,
 Blackwell Publishers, 1992).

JAY, MARTIN, ANTON KAES and EDWARD DIMENDBERG, eds, *The Weimar Republic Sourcebook* (Berkeley,
 University of California Press, 1994).

LONG, R. C. W. , (ed.), *German Expressionism: Documents from the End of the Wilhelmine Empire to
 the Rise of National Socialism* (Berkeley, University of California Press, 1995).

SIMMEL, GEORG, *On Individuality and Social Forms: Selected Writings,* edited and with an introduction
 by D. N. Levine (Chicago and London, University of Chicago Press, 1971).

Journals

(dates indicate the volumes used in the preparation of this work, not necessarily the start and/or
end date of the journal's publication)

Die Arbeitende Frau (1923–36)
Arbeiter Illustrierte Zeitung (1922–6)
Berliner Illustrirte Zeitung (1918–34)
Berliner Tageblatt (1925–33)
Blätter für die Jüdische Frau (1933–4)
Die Frau (1921–33)
Die Freundin (1924–33)
Die Garçonne (1930–2)
Illustrierter Beobachter (1926–33)

die junge dame (1934–6)

Ledige Frauen (1928)

Nationalsozialistische Mädchenerziehung (1934–7)

Rote Fahne (illegal publication, 1934–8)

Uhu (1924–34)

Volk und Rasse (1926–7)

Weg der Frau (1931)

General Sources on Women Artists

BEHR, SHULAMITH, *Women Expressionists* (Oxford, Phaidon, 1988).

BERGER, RENATE, *Malerinnen auf dem Weg ins 20. Jahrhundert: Kunstgeschichte als Sozialgeschichte* (Cologne, DuMont, 1982).

— (ed.), *'Und ich sehe nichts, nichts als die Malerei': Autobiographische Texte von Künstlerinnen des 18. –20. Jahrhunderts* (Frankfurt am Main, Fischer Taschenbuch Verlag, 1987).

BETTERTON, ROSEMARY, *An Intimate Distance: Women, Artists and the Body* (London and New York, Routledge, 1996).

BREITLING, GISELA and RENATE FLAGMEIER, (eds), *Das Verborgene Museum I: Dokumentation der Kunst von Frauen in Berliner Öffentlichen Sammlungen* exhibition catalogue (Berlin, Neue Gesellschaft für Bildende Kunst and Edition Hentrich, 1987).

CHADWICK, WHITNEY, *Women Artists and the Surrealist Movement* (London, Thames and Hudson, 1985).

DEEPWELL, KATY, (ed.), *Women Artists and Modernism* (Manchester, Manchester University Press, 1998).

ESKILDSEN, UTE, *Aenne Biermann, Fotografien* (Berlin, Nishen, 1987).

EVERS, ULRIKE, *Deutsche Künstlerinnen des 20. Jahrhunderts: Malerei - Bildhauerei - Tapisserie* (Hamburg, Ludwig Schulteis, 1983).

FRAUEN IN DER KUNST, (eds), *Künstlerinnen International 1877–1977* exhibition catalogue (Berlin, 1977).

GARB, TAMAR, *Sisters of the Brush: Women's Artistic Culture in Late Nineteenth-Century Paris* (New Haven, Yale University Press, 1994).

GAZE, DELIA, (ed.), *Dictionary of Women Artists* (2 volumes) (London and Chicago, Fitzroy Dearborn, 1997).

Gegenlicht - 60 Jahre GEDOK, exhibition catalogue (Berlin, GEDOK and Staatliche Kunsthalle, 1986).

Künstlerinnen des 20. Jahrhunderts, exhibition catalogue (Wiesbaden, Museum Wiesbaden, 1990).

MESKIMMON, MARSHA, *The Art of Reflection: Women Artists' Self-Portraiture in the Twentieth Century* (London, Scarlet Press and NY, Columbia University Press, 1996).

— *Domesticity and Dissent*, exhibition catalogue (Leicester Museums, Arts and Records Service, 1992).

MESKIMMON, MARSHA and SHEARER WEST (ed.), *Visions of the Neue Frau: Women and the Visual Arts in Weimar Germany*, Aldershot, Scolar Press, 1995.

PERRY, GILL, *Women Artists and the Parisian Avant-Garde: Modernism and 'Feminine' Art, 1900 to the Late 1920s* (Manchester, Manchester University Press, 1995).

VEREIN DER BERLINER KÜNSTLERINNEN (eds), *Profession ohne Tradition: 125 Jahre Verein der Berliner Künstlerinnen*, exhibition catalogue (Berlin, Berlinische Galerie, 1992).

WAGNER, ANNE MIDDLETON, *Three Artists (Three Women)* (Berkeley, University of California Press, 1997).

WALLER, SUSAN, (ed.), *Women Artists in the Modern Era: A Documentary History* (Metuchen, NJ and London, The Scarecrow Press, 1991).

ZEGHER, CATHERINE DE, (ed.), *Inside the Visible: An Elliptical Traverse of 20th Century Art In, Of and From the Feminine* (Cambridge, MA, MIT Press, 1996).

Women Artists in Weimar (monographs)

LOU ALBERT-LASARD

Lou Albert-Lasard: 1885–1969 Gemälde, Aquarelle, Grafik (Berlin, Berlinische Galerie, 1983).

Dauriac, Jacques Paul, 'Die "Montmartre-Suite" von Loulou Albert-Lasard', *Kunst und das Schöne Heim*, vol. 88. pt. 3, March 1976, pp. 161–8.

TINA BAUER-PEZELLEN

Tina Bauer-Pezellen (exhibition catalogue), Weimar, Galerie im Schloß, 1977 (with an essay by Helmut Scherf).

Penndorf, Jutta, *Tina Bauer-Pezellen* (Dresden, VEB Verlag der Kunst, 1987).

CHARLOTTE BEREND-CORINTH

Berend-Corinth, Charlotte, *Mein Leben mit Lovis* (Munich, P. List, 1958).

Wirth, Irmgard, *Charlotte Berend-Corinth* (Berlin, 1969).

KATE DIEHN-BITT

Zimmermann, Horst, 'Aus 30 Jahren DDR-Kunst: Nachdenken über Rostocker Kunsttraditionen', *Bildende Kunst*, pt. 8, 1979. pp. 392–6.

LEA GRUNDIG

Lea Grundig: Jüdin, Kommunistin, Grafikerin, exhibition catalogue (Berlin, Ladengalerie, 1996).

Grundig, Lea, *Gesichte und Geschichte* (Berlin, Dietz Verlag, 1960).

Grundig, Lea, *Über Hans Grundig und des Kunst der Bildermachens* (Berlin, Volk und Wissen Volkseigener Verlag, 1978).

ELSA HAENSGEN-DINGKUHN

Elsa Haensgen-Dingkuhn: Arbeiten aus den Jahren 1920–1980, exhibition catalogue (Hamburg, Kunsthaus, 1981).

Elsa Haensgen-Dingkuhn (1898–1991): Kinder und Heranwachsende im Zentrum eines Malerischen Lebenswerks (Hamburg, Galerie im Elysee, 1998).

MARTA HEGEMANN

Berents, Catharina, 'Marta Hegemann: Elemente einer Befreiungsikonographie', *Kritische Berichte: Zeitschrift für Kunst- und Kulturwissenschaft*, vol. 18, no. 10, pp. 39–54.

Euler-Schmidt, Michael, ed, *Marta Hegemann (1894–1970): Leben und Werk*, exhibition catalogue (Cologne, Kölnisches Stadtmuseum, 1990).

HANNAH HÖCH

Hannah Höch 1889–1978: Ihr Werk, Ihr Leben, Ihre Freunde (Berlin, Berlinische Galerie, 1989).

Lavin, Maud, *Cut with the Kitchen Knife: The Weimar Photomontages of Hannah Höch* (New Haven and London, Yale University Press, 1993).

GRETHE JÜRGENS

Reinhardt, Hildegard and Georg with Margarete Jochimsen, *Grethe Jürgens, Gerta Overbeck: Bilder der Zwanziger Jahre*, exhibition catalogue (Bonn, Rheinisches Museum, 1982).

Reinhardt, Hildegard and Georg, 'Grethe Jürgens, Künstlerin der neuen Sachlichkeit', *Artis*, vol. 2, February 1981, pp. 12–13.

Sailer, Harald, *Grethe Jürgens* (Göttingen, Musterschmidt Verlag, 1976).

D. W. KOEPPEN

no monographic sources available

KÄTHE KOLLWITZ

Käthe Kollwitz: Artist of the People, exhibition catalogue (London, South Bank Centre, 1995).

Prelinger, Elizabeth, *Käthe Kollwitz* (New Haven, Yale University Press, 1992).

LOTTE LASERSTEIN

Stroude, Caroline, *Lotte Laserstein: Paintings and Drawings from Germany and Sweden, 1920–1970*, exhibition catalogue (London, Agnew and Belgrave Galleries, 1987).

Stroude, Caroline and Adrian, 'Lotte Laserstein and the German Naturalist Tradition', *Woman's Art Journal*, vol. 9, pt. 1, Spring-Summer, 1988, pp. 35–8.

ALICE LEX-NERLINGER

Alice Lex-Nerlinger, Oskar Nerlinger: Malerei, Graphik, Foto-Graphik, exhibition catalogue (Berlin, Akademie der Künste der Deutschen Demokratischen Republik, 1975).

ELFRIEDE LOHSE-WÄCHTLER

Peters, Anne, (ed.), *Paula Lauenstein, Elfriede Lohse-Wächtler, Alice Sommer: Drei Dresdener Künstlerinnen in den Zwanziger Jahren*, exhibition catalogue (Städtische Galerie Albstadt, 1996–7).

Reinhardt, Georg, (ed.), *Im Malstrom des Liebens Versunken: Elfriede Lohse-Wächtler, 1899–1940: Leben und Werk* (Cologne, Wienand, 1996).

JEANNE MAMMEN

Jeanne-Mammen-Gesellschaft with the Berlinische Galerie, (eds), *Jeanne Mammen, 1890–1976* (Berlin, 1978).

Jeanne Mammen: Köpfe und Szenen Berlin 1920 bis 1933, exhibition catalogue (Berlin, Jeanne-Mammen-Gesellschaft, 1991).

Reinhardt, Hildegard, 'Jeanne Mammen (1890–1976): Gesellschaftsszenen und Porträt Studien der Zwanziger Jahre', *Niederdeutsche Beitrage für Kunstgeschichte*, vol. XXI, 1982, pp. 163–88.

HANNA NAGEL

Hanna Nagel: Frühe Arbeiten 1926-1934, exhibition catalogue (Karlsruhe, 1981).

Hesse, Herta, *Hanna Nagel: Zeichnungen und Lithographien*, exhibition catalogue (Hagen, Osthaus Museum, 1972).

Nagel, Hanna, *Ich zeichne weil es mein Leben ist*, edited by Irene Fischer-Nagel (Karlsruhe, Verlag G. Braun, 1977).

GERTA OVERBECK

Reinhardt, Hildegard and Georg with Margarete Jochimsen, *Grethe Jürgens, Gerta Overbeck: Bilder der Zwanziger Jahre*, exhibition catalogue (Bonn, Rheinisches Museum, 1982).

Reinhardt, Hildegard, 'Gerta Overbeck (1898-1977): Eine Westfälische Malerin der Neuen Sachlichkeit in Hannover', *Niederdeutsche Beitrage für Kunstgeschichte*, vol. 18, 1979, pp. 225–48.

MARTHA SCHRAG

Brix, Karl, 'Die Malerin Martha Schrag (1870–1957)', *Bildende Kunst*, vol. 26, pt. 4, 1978, pp. 187–90.

Hahn, Gerhard, *Leben und Werk der Malerin und Gafikerin Martha Schrag (1870–1957)*, exhibition catalogue (Karl-Marx-Stadt, Stadtmuseum, 1982).

EVA SCHULZE-KNABE

Eva Schulze-Knabe: 1907–1976 exhibition catalogue (Dresden, Gemäldegalerie Neue Meister, 1977).

Herkt, Eva-Maria, *Eva Schulze-Knabe* in the series, *Maler und Werke* (Dresden, VEB, Verlag der Kunst, 1977).

Uhlitzsch, Joachim, 'Unser ist ihr Werk', *Dresdener Kunstblätter*, vol. XXI, pt. 1, 1977, pp. 15–9.

RENÉE SINTENIS

Buhlmann, Britta E. , *Renée Sintenis: Werkmonographie der Skulpturen* (Darmstadt, Wissenschaftliche Buchgesellschaft, 1987).

Kiel, Hanna, *Renée Sintenis* (Berlin, 1956).

Renée Sintenis: Plastiken, Zeichnungen, Druckgraphik (Berlin, Georg Kolbe Museum, 1984).

GENERAL SOURCES (SECONDARY)

ALLERT, BEATE (ed.), *Languages of Visuality: Crossings between Science, Art, Politics, and Literature* (Detroit, Wayne State University Press, 1996).

ANKUM, KATHARINA VON (ed.), *Women in the Metropolis: Gender and Modernity in Weimar Culture* (Berkeley, University of California Press, 1997).

BARTON, BRIGID S. , *Otto Dix and Die Neue Sachlichkeit: 1918–1925* (Ann Arbor, Michigan, University of Michigan Press, 1981).

BATTERSBY, CHRISTINE, *Gender and Genius: Towards a Feminist Aesthetics* (London, The Women's Press, 1989).

— *The Phenomenal Woman: Feminist Metaphysics and the Patterns of Identity* (Cambridge, Polity Press, 1998).

BEHR, SHULAMITH (ed.), *Conrad Felixmüller, 1897–1977: Between Politics and the Studio*, exhibition catalogue (Leicester, Leicestershire Museums, Arts and Records Service, 1994).

BERGHAUS, GÜNTER, '*Girlkultur* – Feminism, Americanism and Popular Entertainment in Weimar Germany', *Journal of Design History*, vol. 1, no. 3–4, 1988, pp. 193–219.

BERNSTEIN, RICHARD J. , *Hannah Arendt and the Jewish Question* (Cambridge, Polity Press, 1996).

BODE, URSULA, 'Sachlichkeit Lag in der Luft. Zwanziger Jahre: Bilder einer Malprovinz', *Westermann's Monatshefte*, no. 8, 1976, pp. 34–41.

BRAIDOTTI, ROSI, *Nomadic Subjects: Embodiment and Sexual Difference in Contemporary Feminist Theory* (New York, Columbia University Press, 1994).

BRIDENTHAL, RENATE, 'Beyond *Kinder, Küche, Kirche*: Weimar Women at Work, *Central European History*, vol. 6, no. 2, 1973, pp. 148–66.

BRIDENTHAL, RENATE and ATINA GROSSMANN, MARION KAPLAN (eds), *When Biology Became Destiny: Women in Weimar and Nazi Germany* (New York, Monthly Review Press, 1984).

BUCK-MORSS, SUSAN, *The Dialectics of Seeing: Walter Benjamin and the Arcades Project* (Cambridge, MA, MIT Press, 1989).

BUTLER, JUDITH, *Bodies That Matter: On the Discursive Limits of 'Sex'* (London and NY, Routledge, 1993).

— *Excitable Speech: A Politics of the Performative* (New York and London, Routledge, 1997).

CARLSON, MARVIN, *Performance: A Critical Introduction* (London and New York, Routledge, 1996).

CHAPMAN, HELEN C. , *Memory in Perspective: Women Photographers' Encounters with History*, vol. 3 of the series *Nexus: Theory and Practice in Contemporary Women's Photography* (London, Scarlet Press, 1997).

COHEN, RICHARD A. (ed.), *Face to Face with Levinas* (New York, State University of New York Press, 1986).

DIAMOND, ELIN (ed.), *Performance and Cultural Politics* (London and New York, Routledge, 1996).

DYER, RICHARD, *Now You See It: Studies on Lesbian and Gay Film* (London and New York, Routledge, 1990).

Eldorado: Homosexuelle Frauen und Männer in Berlin 1850–1950. Geschichte, Alltag und Kultur exhibition catalogue (Berlin Museum, Fröhlich und Kaufmann, 1984).

FELMAN, SHOSHANA, *What Does a Woman Want?: Reading and Sexual Difference* (Baltimore and London, The Johns Hopkins University Press, 1993).

FOSTER, HAL, *Compulsive Beauty* (Cambridge, MA, MIT Press, 1993).

FRASER, NANCY and SANDRA L. BARTKY (eds), *Revaluing French Feminism: Critical Essays on Difference, Agency and Culture* (Bloomington and Indianapolis, Indiana University Press, 1992).

FREVERT, UTE, *Women in German History: From Bourgeois Emancipation to Sexual Liberation* (1986)

translated by Stuart McKinnon-Evans (New York and Oxford, Berg, 1989).

FRISBY, DAVID, *The Alienated Mind: The Sociology of Knowledge in Germany 1918–33*, London, Heinemann Educational Books (New Jersey, Humanities Press, 1983).

— *Fragments of Modernity: Theories of Modernity in the Work of Simmel, Kracauer and Benjamin* (Cambridge University Press, 1985).

FRITZSCHE, PETER, *Reading Berlin 1900* (Cambridge, MA, Harvard University Press, 1996).

FUSS, DIANA (ed.), *Inside/Out: Lesbian Theories, Gay Theories* (New York and London, Routledge, 1991).

GROSZ, ELIZABETH, *Space, Time and Perversion: Essays on the Politics of Bodies* (London and New York, Routledge, 1995).

— *Volatile Bodies: Toward a Corporeal Feminism* (Bloomington, Indiana University Press, 1994).

HAKE, SABINE, 'Girls in Crisis: The Other Side of Diversion', *New German Critique*, no. 40, Winter 1987, pp. 147–65.

HARAWAY, DONNA, *Simians, Cyborgs and Women: The Reinvention of Nature* (London, Free Association Books, 1991).

HARRISON, CHARLES and PAUL WOOD (eds), *Art in Theory* (Oxford, Blackwell, 1992).

HAXTHAUSEN, CHARLES and HEIDRUN SUHR (eds), *Berlin: Culture and Metropolis* (Minneapolis and Oxford, University of Minnesota Press, 1990).

HELLER, REINHOLD, *Art in Germany: 1909–1936: From Expressionism to Resistance. The Marvin and Janet Fishman Collection* (Munich, Prestel Verlag, 1990).

HORN, URSULA, 'Zum Schaffen einer progressiven Künstlergruppe der zwanziger Jahre – in Hannover', *Bildende Kunst*, vol. 23, pt. 4, 1975, pp. 172–6.

HÜLSEWIG-JOHNEN, JUTTA, *Neue Sachlichkeit – Magischer Realismus*, exhibition catalogue (Bielefeld, Kunsthalle, 1990).

HUMM, MAGGIE (ed.), *Feminisms: A Reader* (New York and London, Harvester Wheatsheaf, 1992).

HUYSSEN, ANDREAS, *After the Great Divide: Modernism, Mass Culture, Postmodernism* (London and New York, Macmillan Press, 1986).

Ich bin meine eigene Frauenbewegung: Frauen-Ansichten aus der Geschichte einer Großstadt, exhibition catalogue organised/edited by Bezirksamt Schöneberg and Kunstamt Schöneberg (Berlin, Edition Hentrich, 1991).

IRIGARAY, LUCE, *This Sex Which Is Not One* (1977), translated by Catherine Porter with Carolyn Burke (Ithaca, New York, Cornell University Press, 1985).

— *The Irigaray Reader*, edited by Margaret Whitford (Oxford,Basil Blackwell 1991).

— *Je, Tu, Nous: Toward a Culture of Difference*, translated by A. Martin (London, Routledge, 1993).

JACKSON, STEVI, et. al. (eds), *Women's Studies: A Reader*, (New York and London, Harvester Wheatsheaf, 1993).

JAY, MARTIN, *The Dialectical Imagination: A History of the Frankfurt School and the Institute of Social Research 1923–1950* (London, Heinemann Educational Books, 1973).

— Downcast Eyes: The Denigration of Vision in Twentieth-Century French Thought (Berkeley, University of California Press, 1993).

JOBLING, PAUL, 'Playing Safe: The Politics of Pleasure and Gender in the Promotion of Condoms in Britain, 1970–1982', Journal of Design History, vol. 10, no. 1, 1997, pp. 53–70.

JONES, AMELIA, Body Art: Performing the Subject (Minneapolis and London, University of Minnesota Press, 1998).

KAPLAN, MARION A. , The Jewish Feminist Movement in Germany: The Campaigns of the Jüdischer Frauenbund 1904–1938 (Westport, CN, Greenwood Press, 1979).

KOONZ, CLAUDIA, Mothers in the Fatherland: Women, the Family and Nazi Politics (New York, St Martin's Press, 1978).

KRISTEVA, JULIA, Desire in Language: A Semiotic Approach to Literature and Art, translated by Thomas Gora, Alice Jardine and Leon S. Roudiez (Oxford, Basil Blackwell, 1981).

— The Kristeva Reader, edited by Toril Moi (Oxford, Basil Blackwell Ltd, 1986).

LAVIN, MAUD, 'Ringl and Pit: The representation of women in German advertising, 1929–1933', Print Collector's Newsletter, vol. XVI, no. 3, July/August 1985, pp. 89–93.

MASON, T. W. , 'Women in Germany 1925–40: Family Welfare and Work', History Workshop Journal, no. 1, 1976, pp. 74–113 and vol. 2, 1976, pp. 5–32.

MCCLOSKEY, George Grosz and the Communist Party: Art and Radicalism in Crisis, 1918–1935 (Princeton, NJ, Princeton University Press, 1997).

MERLEAU-PONTY, MAURICE, The Phenomenology of Perception, translated by Colin Smith (London, Routledge and Kegan Paul, 1962).

MICHALSKI, SERGIUSZ, New Objectivity: Painting,Graphic Art and Photography in Weimar Germany 1919–1933 (Cologne, Benedikt Taschen Verlag, 1994).

MODLESKI, TANIA, Feminism without Women: Culture and Criticism in a "Postfeminist" Age (London, Routledge, 1991).

Museum für Kunst und Gewerbe (ed.), Bubikopf und Gretchenkopf – Die Frau der Zwanziger Jahre, exhibition catalogue (Hamburg, Susanne Meyer-Büser Verlag, 1995).

NEAD, LYNDA, The Female Nude: Art, Obscenity and Sexuality (London, Routledge, 1992).

Neue Sachlichkeit in Hannover, exhibition catalogue (Hannover Kunstverein, 1974).

NIESTER, SIBYLLE, 'Die GEDOK: Interessenverband der Künstlerinnen 1926–76', Tendenzen, vol. 17, no. 107, May–June 1976, pp. 28–30.

Otto Dix, 1891–1969, exhibition catalogue (London, Tate Gallery, 1992).

PETERSON, BRIAN, 'The Politics of Working-Class Women in the Weimar Republic', Central European History, vol. 10, 1977, pp. 87–111.

PETRO, PATRICE, Joyless Streets: Women and Melodramatic Representation in Weimar Germany (Princeton NJ, Princeton University Press, 1989).

PEUKERT, DETLEV, The Weimar Republic: The Crisis of Classical Modernity, translated by Richard Deveson (London, Allen Lane, 1991).

POLLOCK, GRISELDA, *Vision and Difference: Femininity, Feminism and the Histories of Art* (London, Routledge, 1988).

— (ed.), *Generations and Geographies in the Visual Arts: Feminist Readings* (London and New York, Routledge, 1996).

ROGOFF, IRIT (ed.), *The Divided Heritage: Themes and Problems in German Modernism* (Cambridge, Cambridge University Press, 1991).

ROTERS, EBERHARD and WOLFGANG JEAN STOCK (eds), *Weltstadt sinfonie: Berliner Realismus 1900–1950*, exhibition catalogue (Munich, Kunstverein, 1984).

SCHULTZ, VIOLET, *In Berlin in Stellung: Dienstmädchen im Berlin der Jahrhundertwende* (Berlin, Edition Hentrich, 1989).

SIEGLOHR, ULRIKE, *Focus on the Maternal: Female Subjectivity and Images of Motherhood* (London, Scarlet Press, 1998).

SODEN, KRISTINE VON, *Die Sexualberatungsstellen der Weimarer Republik 1919–1933* (Berlin, Edition Hentrich, 1988).

SODEN, KRISTINE VON and MARUTA SCHMIDT (eds), *Neue Frauen die Zwanziger Jahre: BilderLeseBuch* (Berlin, Elefanten Press, 1988).

SPENCER, LLOYD, 'Allegory in the World of the Commodity: The Importance of *Central Park*', *New German Critique,* no. 34, Winter 1985, pp. 59–77.

SYKORA, KATHARINA and ANNETTE DORGERLOH, DORIS NOELL-RUMPELTES, ADA RAEV (eds), *Die Neue Frau* (Marburg, Jonas Verlag, 1993).

THEWELEIT, KLAUS, *Male Fantasies*, vol. I: *Women, Floods, Bodies, History* (Minneapolis, University of Minnesota Press, 1987).

USBORNE, CORNELIE, *The Politics of the Body in Weimar Germany: Women's Reproductive Rights and Duties* (New York and London, Macmillan Press, 1992).

VASSELEU, CATHRYN, *Textures of Light: Vision and Touch in Irigaray, Levinas and Merleau-Ponty* (London and New York, Routledge, 1998).

WARHOL, ROBYN R. and DIANE PRICE HERNDL (eds), *Feminisms: An Anthology of Literary Theory and Criticism* (New Jersey, Rutgers University Press, 1991).

WEIGEL, SIGRID, *Body- and Image-Space: Re-reading Walter Benjamin*, translated by Georgina Paul (London and New York, Routledge, 1997).

WHITFORD, MARGARET, *Luce Irigaray: Philosophy in the Feminine* (London and New York, Routledge, 1991).

WILSON, ELIZABETH, *The Sphinx in the City: Urban Life, The Control of Disorder and Women* (Berkeley, University of California Press, 1991).

WILTON, TAMSIN, *Lesbian Studies: Setting an Agenda* (London and New York, Routledge, 1995).

YOUNG, IRIS MARION, *Throwing Like a Girl and Other Essays in Feminist Philosophy and Social Theory* (Bloomington and Indianapolis, Indiana University Press, 1990).

I N D E X